A Bibliography of the Caribbean

by
Marian Goslinga

Scarecrow Area Bibliographies, No. 8

The Scarecrow Press, Inc.
Lanham, Md., & London

SCARECROW PRESS, INC.

Published in the United States of America
by Scarecrow Press, Inc.
4720 Boston Way
Lanham, Maryland 20706

4 Pleydell Gardens, Folkestone
Kent CT20 2DN, England

Copyright © 1996 by Marian Goslinga

British Cataloguing-in-Publication Information Available

Library of Congress Cataloging-in-Publication Data

Goslinga, Marian
A bibliography of the Caribbean / by Marian Goslinga
p. cm.—(Scarecrow area bibliographies ; no. 8)
Includes bibliographical references and index.
1. Caribbean area—Bibliography. I. Title. II. Series: Scarecrow area
bibliographies ; no. 8.
Z1595.G68 1996 016.9729—dc20 95-41042 CIP

ISBN 0-8108-3097-3 (cloth : alk. paper)

♾ ™The paper used in this publication meets the minimum requirements of
American National Standard for Information Sciences—Permanence of
Paper for Printed Library Materials, ANSI Z39.48—1984.
Manufactured in the United States of America.

CONTENTS

EDITOR'S FOREWORD

Strategically located near North, Central, and South America, the Caribbean is an exceptionally important region. What happens there is of interest to many other countries. This applies not only to politics; there are also economic, social, and cultural ramifications. And it is the source of significant artistic, literary, and musical trends. Last but not least, people of Caribbean origin live throughout the hemisphere.

Despite its relatively small geographical extension, the Caribbean is amazingly varied, consisting of a large number of countries with different histories, cultures, and languages. That may explain why we have had to wait so long for another comprehensive bibliography, which has taken the form of a selective guide to literature on the Caribbean, 1492–1992.

This very impressive *Bibliography of the Caribbean* is bound to be of great assistance to all who study the region.

It was surely not easy to compile such a bibliography. It required familiarity with the literature of numerous countries as well as the different languages in which this literature was produced: English, French, Spanish, and Dutch. Yet the imposing difficulties have been successfully overcome by Marian Goslinga. She is not only familiar with the countries and the languages, she also has the essential background, having studied international relations and Latin American history as well as library science. For nearly two decades she has been a librarian at Florida International University, presently holding the title of Latin American and Caribbean Librarian. During this period she has been an indexer, bibliographer, and reviewer, experience which paved the way for this major work—a welcome addition to the Area Bibliography series of Scarecrow Press.

Jon Woronoff
Series Editor

INTRODUCTION

A bibliography, in the words of Theodore Besterman, is "a list of books arranged according to some permanent principle."[1] This bibliography will list books (i.e., monographs) on the Caribbean region, as a whole as well as on the individual islands or countries, published since earliest times until the end of 1992.

A Bibliography of the Caribbean is the first comprehensive general bibliography on the region since the publication, in 1977, of Lambros Comitas' *Complete Caribbeana*. There have been a variety of works dealing with a limited time frame or a specific topic; for instance, *The Caribbean, 1975–1980: A Bibliography of Economic and Rural Development,* by Manuel J. Carvajal (Metuchen, NJ: Scarecrow Press; 1993), or the latest volume of *Women in the Caribbean: A Bibliography,* by Irene Rolfes (Leiden: Caraïbische Afdeling, Koninklijk Instituut voor Taal-, Land- en Volkenkunde; 1993).[2] A general compilation continuing the work begun by Comitas has been lacking, however.

This bibliography represents an attempt to fill this gap by providing in an easy-to-use format a balanced and representative overview of the bibliographic output on and of the region.This work does not pretend to be exhaustive; on the contrary, it is strongly suggested that it be used in conjunction with existing sources.

SCOPE

For purposes of this bibliography, the Caribbean has been defined to include the entire range of islands from Bermuda in the north to Trinidad and Tobago in the south as well as the culturally and historically related mainland countries of Belize, Guyana, Suriname, and French Guiana.

Using a language/culture-area concept, this bibliography will provide as comprehensive a coverage as possible of the four distinct language groups represented within this heterogeneous region, although primary emphasis will be on items dealing with the Caribbean as a whole. Regional groupings (i.e., Commonwealth Caribbean, Netherlands Antilles) will be next, while individual countries/islands will be dealt with on the most selective basis. Inevitably, this bibliography will lean toward emphasizing the larger islands (i.e., Cuba, Puerto Rico, Jamaica) in accordance with their considerably higher bibliographic output; however, the smaller islands are also well represented.

Materials in the four major languages spoken in the region (i.e., English, Span-

[1]*The Beginnings of Systematic Bibliography* (New York, NY: B. Franklin; 1968), p. 2.
[2]For others see the listings under "Bibliographies" in Chapter II.

ish, French, and Dutch) are featured—with an occasional title in German and Portuguese—, although English-language works have been given preference. Whenever both English and another version exist, the work will be entered under the English title with a cross-reference in the title index. Similarly, translations into English have been listed whenever possible, accompanied by a brief annotation at the end of the entry as to the original title and with a cross-reference in the title index. At times, it was unavoidable that a foreign title be listed. In that case, it was decided to translate only the Dutch titles.The supplied information immediately follows the title and has been bracketed.[3]

Although several Creole languages (i.e., Papiamento in the Dutch islands, Sranan in Suriname, and Kreyol in Haiti), have gained in legitimacy and prominence, for the sake of brevity items written in these languages have not been included.

The end of 1992 was established as the cutoff date of this work in order to ensure that the user would have a well-defined starting point for further bibliographic investigation.

The criteria for inclusion in this bibliography were carefully considered and follow those set by Series Editor Jon Woronoff for the Area Bibliography series as a whole. It was decided, for instance, to list only monographs (fifty pages and up) and to exclude periodical articles, dissertations, theses, pamphlets, government documents, book reviews, newspaper clippings, most so-called occasional papers, audiovisual, juvenile, and clearly ephemeral materials. Conference papers and proceedings were likewise omitted unless published separately with a distinctive title.

No limitations were put on the range of disciplines covered although the focus throughout the work is on the social sciences and the humanities. Even here, certain restrictions had to be applied for reasons of space. In the section on Literature, for instance, individual works of fiction have been omitted and the section on Criticism and Interpretation is a highly selective listing of only those authors with a distinct Caribbean impact.

SEARCH AND SELECTION PROCEDURES

The selection of titles for this bibliography was based on a variety of sources, the most important being the holdings of the University of Florida (Gainesville) Libraries as accessed through LUIS.[4] Standard reference sources were also consulted, although the information acquired in this manner was of secondary importance and served mostly to verify data already gathered through LUIS.

The OCLC database[5] was frequently searched to verify data and was used as the ultimate justification for inclusion. OCLC was also the definitive source for determining personal names, latest editions, reprints, translations, etc.

[3]See, for instance, #2944: *Roosenburg en Mon Bijou: twee Surinaamse plantages, 1720–1870 [Roosenburg and Mon Bijou: Two Surinamese Plantations, 1720–1870]* Gert Oostindie. Leiden: Caraïbische Afdeling, Koninklijk Instuut voor Taal-, Land- en Volkenkunde; 1989.

[4]Library Users Information System.

[5]Online Computer Library Center, Dublin, OH.

The OCLC holdings record (i.e., holdings by major libraries) was a crucial factor for selection. For instance, the OCLC holdings record for *Cuban Communism*, by Irving Louis Horowitz (#2996) is "2002" meaning that 2,002 libraries hold this particular item.

ORGANIZATION

The 3,600 entries in this bibliography have been numbered and organized into several main categories, each of which has been subdivided into smaller sections as required. Under each section, the entries have been listed alphabetically by title. The numbering, ranging from 1001 to 4600 as determined by the Pro-Cite bibliographic software used, remains continuous throughout the entire listing.

A frequent question arose as to which category would best accommodate certain works dealing with more than one topic or with multifaceted issues. In these cases, it was decided, for consistency's sake, to follow Library of Congress cataloging and to place the book according to the first subject heading assigned. For instance, Horowitz' *Cuban Communism* (#2996) has "Economic Conditions" as its first access point and can be found in the Economics category. Similarly, Barbara Bush's *Slave Women in Caribbean Society* (#3868) was classed by LC with Slavery rather than Women.

All main categories are organized by subject except for the section on Historical Materials, which is arranged chronologically, and that on Reference and Source Materials, which is arranged by format.

Historical Materials

This category lists materials published prior to the twentieth century and is arranged chronologically by centuries. As many of these early items are travel accounts, general descriptions, etc., it was reasoned that this type of arrangement would be more useful. Preference has been given to those items which have, at one time or another, been reprinted, making them more accessible. In the last twenty years, U.S. publishers (e.g., Arno Press, Negro Universities Press, Greenwood Press) as well as local Caribbean publishers (e.g., Editora de Santo Domingo) have reprinted and made available a vast amount of material formerly secluded in archives. Inclusion in this category was determined by the original date of publication rather than the reprint date.

Reference and Source Materials

This category has been subdivided into several sections which, to a reader, should be self-explanatory.

Contemporary Works

This third major category makes up the bulk of the bibliography and has a topical arrangement. An effort has been made to deal with a variety of contemporary topics as well as with more traditional ones.

In addition, in each major section, attention has been given to a so-called Special Topic of timely importance. Women, the Sugar Complex, and the Military have each been designated as such.

At the end of the bibliography are three indexes: a geographical index, an author index, and a title index.

The Geographical Index lists all individual countries/islands mentioned in the main listing. Where, for instance, country names have changed (e.g., British Honduras to Belize), a cross-reference will direct the user to the new heading. Used together with the Table of Contents, the Geographical Index provides additional subject access to this topical bibliography.

The Author Index is an alphabetical listing of all authors, editors, corporate bodies, and named conferences, whether appearing in the body of the entry or in a note, mentioned in the bibliography. In accordance with Library of Congress cataloging practice, there are no entries for translators and/or illustrators.In the case of compound names and/or pseudonyms, the appropriate cross-references have been provided and interfiled. In general, the form of the name was determined by the OCLC authority record.

The Title Index lists in one single alphabetical file all titles, whether appearing in the body of the entry or in a note, cited in the main text. Original and variant titles have been interfiled.

In all three indexes, the numbers are keyed to the items listed in the main text.

ARRANGEMENT

All entries are listed according to the following format: title, author(s) and/or editor(s), place of publication, publisher, date of publication, pagination, and a brief annotation (if warranted).

The style used for entries conforms with the International Standard Bibliographic Description for Monographs (ISBD) and the revised Anglo-American Cataloging Rules (AACR II). Brackets have been used in bibliographic entries to indicate information not appearing on the title page. Long titles (i.e., in the Historical Materials section) have been abbreviated whenever possible without losing their meaning. In the imprint, preference has been given to those publishers located in, or with addresses in, the United States.

For brevity's sake, annotations have been kept to a minimum and have been used only in cases of changes in titles, editions, translations, etc.

Many works bearing "Caribbean" or "Antilles" in the title refer only to a particular area or subregion dependent upon the author's background or nationality. For instance, Michael Howard's *Public Finance in Small Open Economies: The Caribbean Experience* (#3294) is a treatise on the Commonwealth Caribbean. Joseph Rennard's *Le commerce aux Antilles* (#3161) deals with the French Antilles, while *Apuntes sobre poesía popular y poesía negra en las Antillas,* by Tomás Rafael Hernández Franco (#4015) analyzes poetry from the Spanish Caribbean.

ACKNOWLEDGMENTS

Grateful acknowledgement is made to Florida International University for the professional development leave of one semester which permitted the uninter-

rupted research for this project. I am indebted to Dr. Laurence Miller, Director of the University Libraries, for his permission to use the facilities at the University Park Library, most notably the electronic databases which made this work feasible.

My thanks to the FIU Libraries' Systems staff, in particular, Ms. Judith Rasoletti, for their support and belief in this project. It was Judith who was instrumental in setting up the program parameters and the final layout as well as the coordination of the indexes for this bibliography.

My gratitude also goes to Dr. Mark Rosenberg, Director of FIU's Latin American and Caribbean Center, for having put me in contact with Mr. Jon Woronoff of Scarecrow Press.

I also wish to thank the Center's René Ramos for his original map.

A special word of appreciation to my friend Dr. Aaron Segal, Professor of Political Science, University of Texas at El Paso, and visiting professor at FIU during the 1991–1992 academic year, for his many useful suggestions, words of advice, and constant encouragement.

I would also like to extend my thanks to the many others, too numerous to mention individually, who provided indispensable assistance. However, the responsibility for any errors or omissions remains mine alone.

Last but not least, I would like to dedicate this work to my father and to the memory of my mother.

CURRENT PROFESSIONAL PERIODICALS

[This list is, for the most part, based on HAPI (Hispanic American Periodicals Index)]

Belizean Studies
Belize City: Belize Institute of Social Research and Action, 1973– . Bimonthly.

Bulletin of Eastern Caribbean Affairs
Cave Hill, Barbados: Institute of Social and Economic Research, University of the West Indies, 1975– . Bimonthly.

Caribbean Geography
Kingston: Longman Jamaica, 1983– . Annual.

Caribbean Insight.
London: West India Committee, 1977– . Monthly.
(continues *Caribbean Chronicle*)

Caribbean Journal of Education
Mona, Jamaica: School of Education, University of the West Indies, 1974– . Three times a year.

Caribbean Journal of Religious Studies
Kingston, Jamaica: United Theological College of the West Indies, 1975– . Twice a year.

Caribbean Quarterly
Mona, Jamaica: Dept. of Extra-Mural Studies, University of the West Indies, 1949– . Quarterly.

Caribbean Review of Books
Mona, Jamaica: University of the West Indies, 1991– . Quarterly.

Caribbean Studies
Río Piedras, P.R.: Institute of Caribbean Studies, University of Puerto Rico, 1961– . Quarterly.

El Caribe contemporáneo
México City, DF: Facultad de Ciencias Políticas y Sociales, Universidad Nacional Autónoma de México, 1980– . Quarterly.

Casa de las Américas
Havana: Empresa "Ediciones Cubanas," 1960– . Quarterly.

Conjonction
Port-au-Prince: Institut Français d'Haiti, 1946– . Irregular.

Conjunto
Havana: Empresa "Ediciones Cubanas," 1964– . Quarterly.

Cuban Studies/Estudios cubanos
Pittsburgh, PA: Center for Latin American Studies, University of Pittsburgh, 1975– . Semiannual, 1975–1985; annual, 1986–

Diálogos (Puerto Rico)
Río Piedras, P.R.: Depto. de Filosofía, Facultad de Humanidades, Universidad de Puerto Rico, 1964– . Biannual.

Estudios Sociales (Dominican Republic)
Santo Domingo: Centro de Investigación y Acción Social (CIAS), 1968– . Quarterly.

European Review of Latin American and Caribbean Studies/Revista Europea de Estudios Latinoamericanos y del Caribe
Amsterdam: Center for Latin American Research and Documentation (CEDLA); Leiden, Netherlands: Caribbean Department, Royal Institute of Linguistics and Anthropology, 1965– . Biannual.
(formerly *Boletín de Estudios Latinoamericanos y del Caribe*)

Hemisphere
Miami, FL: Latin American and Caribbean Center, Florida International University, 1988– . Three times a year.

Homines
Hato Rey, P.R.: Depto. de Ciencias Sociales, Universidad Interamericana de Puerto Rico, 1977– . Semiannual.

Islas (Cuba)
Havana: Empresas "Ediciones Cubanas," 1958–
Three times a year.

Jamaica Journal
Kingston: Institute of Jamaica, 1967– . Quarterly.

Journal of Caribbean History
Cave Hill: Dept. of History, University of the West Indies, 1970– . Semiannual.

Journal of Caribbean Studies
Coral Gables, FL: Association of Caribbean Studies, 1980– . Quarterly.

Nieuwe West-Indische Gids/New West Indian Guide
Dordrecht, Netherlands: Foris Publications for the Stichting Nieuwe West-Indische Gids, in collaboration with the Program in Atlantic History, Culture and Society, Johns Hopkins University, Baltimore, MD, 1919– . Quarterly.
(continues *West-Indische Gids*)

Revista/Review Interamericana
San Juan, P.R.: Inter-American University, 1971– . Quarterly.

Revista de Ciencias Sociales (Puerto Rico)
Río Piedras, P.R.: Colegio de Ciencias Sociales, Universidad de Puerto Rico, 1957– . Semiannual.

Revista de Indias
Madrid: Departamento de Historia de América, Centro de Estudios Históricos, Consejo Superior de Investigaciones Científicas, 1940– . Three times a year.

Revista de la Biblioteca Nacional (José Martí)
Havana: Biblioteca Nacional José Martí, 1959– . Irregular.

Social and Economic Studies
Mona, Jamaica: Institute of Social and Economic Research, University of the West Indies, 1953– . Quarterly.

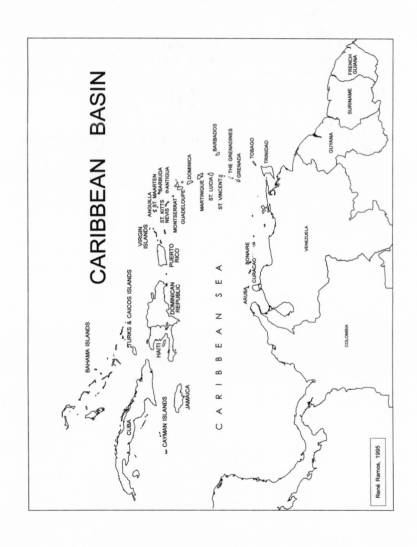

CARIBBEAN BASIN

BAHAMA ISLANDS

TURKS & CAICOS ISLANDS

VIRGIN ISLANDS

ANGUILLA
ST. MAARTEN
ST. KITTS
NEVIS
MONTSERRAT
GUADELOUPE
BARBUDA
ANTIGUA
DOMINICA

MARTINIQUE
ST. LUCIA
ST. VINCENT
THE GRENADINES
GRENADA
BARBADOS

CUBA

CAYMAN ISLANDS

JAMAICA

HAITI

DOMINICAN REPUBLIC

PUERTO RICO

CARIBBEAN SEA

ARUBA
CURACAO
BONAIRE

TOBAGO
TRINIDAD

COLOMBIA

VENEZUELA

GUYANA

SURINAME

FRENCH GUIANA

René Ramos, 1995

I. HISTORICAL MATERIALS

A. Works Published in the 16th–18th Centuries

1001. *An Account of the Black Charaibs in the Island of St. Vincent's: With the Charaib Treaty of 1773 and Other Original Documents.* William Young, ed. Totowa, NJ: Cass; 1971. 125 pp. Reprint of the 1795 ed.

1002. *An Account of the Expedition to the West Indies: Against Martinico, Guadelupe, and Other Leeward Islands Subject to the French King.* Richard Gardiner. 2d ed. London: Z. Stuart; 1760. 75 pp.

1003. *An Account of the Island of Jamaica: With Reflections on the Treatment, Occupation, and Provision of the Slaves.* Peter Marsden. Newcastle, Eng.: S. Hodgson; 1788. 87 pp.

1004. *Adriaan van Berkel's Travels in South America Between the Berbice and Essequibo Rivers and in Surinam, 1670–1689.* Adriaan van Berkel; Walter Edmund Roth, ed. and tr. Georgetown: Daily Chronicle; 1942. 145 pp. Translation of *Amerikaansche voyagien* (1695).

1005. *Beschrijving van Guiana, of de Wilde Kust, in Zuid-Amerika: betreffende de aardrijkskunde en historie des lands [Description of Guiana, or the Wild Coast, in South America: With Respect to the Geography and History of the Country].* Jan Jacob Hartsinck. Amsterdam: Emmering; 1974. 2 vols. Reprint of the 1770 ed.

1006. *The Buccaneers of America: A True Account of the Most Remarkable Assaults Committed of Late Years upon the Coasts of the West Indies.* Alexandre Olivier Exquemelin. Annapolis, MD: Naval Institute Press; 1993. 506 pp. Originally published in Dutch under title *De Americaensche zee-rovers* (1678); reprint of the 1924 ed.

1007. *C. G. A. Oldendorp's History of the Mission of the Evangelical Brethren on the Caribbean Islands of St. Thomas, St. Croix, and St. John.* Christian Georg Andreas Oldendorp; Johann Jakob Bossart, ed.; Arnold R. Highfield, Vladimir Barac, English eds. and trs. Ann Arbor, MI: Karoma; 1987. 737 pp. Translation of *Geschichte der Mission der evangelischen Brüder auf den Caraibischen Inseln S. Thomas, S. Croix und S. Jan* (1777).

1008. *The Capacity of Negroes for Religious and Moral Improvement Considered: With Cursory Hints, to Proprietors and to Government, for the Immediate Melioration of the Condition of Slaves in the Sugar Colonies.*

2 Bibliography

Richard Nisbet. Westport, CT: Negro Universities Press; 1970. 207 pp. Reprint of the 1789 ed.

1009. *Caribbeana: Containing Letters and Dissertations, Together with Poetical Essays, on Various Subjects and Occasions.* Samuel Keimer. Millwood, NY: Kraus Reprint; 1978. 2 vols. Reprint of the 1741 ed.

1010. *The Civil and Natural History of Jamaica.* Patrick Browne. New York, NY: Arno Press; 1972. 547 pp. Reprint of the 1756 ed.

1011. *A Civilization That Perished: The Last Years of White Colonial Rule in Haiti.* Médéric Louis Elie Moreau de Saint-Méry; Ivor D. Spencer, ed. and tr. Lanham, MD: University Press of America; 1985. 295 pp. Translation of *Description topographique, physique, civile, politique et historique de la partie française de l'isle Saint-Domingue* (1797–1798).

1012. *The Coffee Planter of Saint Domingo: With an Appendix Containing a View of the Constitution, Government, Laws, and State of That Colony Previous to the Year 1789.* P. J. Laborie. London: T. Cadell and W. Davies; 1798. 338 pp.

1013. *The Conquest and Settlement of the Island of Boriquen or Puerto Rico.* Gonzalo Fernández de Oviedo y Valdés; Daymond Turner, ed. and tr. Avon, CT: Limited Editions Club; 1975. 143 pp. Translation of selections from *Historia general y natural de las Indias* (1547).

1014. *Descripción geográfica de la Guayana.* Jacques Nicolas Bellin; Jaime Tello, tr. Caracas: Ediciones de la Presidencia; 1986. 298 pp. Translation of *Description géographique de la Guiane* (1763).

1015. *Description géographique des isles Antilles possédées par les anglois.* Jacques Nicolas Bellin. Paris: Didot; 1758. 171 pp.

1016. *A Description of the Island of Jamaica: With the Other Isles and Territories in America to Which the English Are Related.* Thomas Lynch; Richard Blome, ed. London: T. Milbourn; 1672. 192 pp.

1017. *A Description of the Spanish Islands and Settlements on the Coast of the West Indies.* Thomas Jefferys. New York, NY: AMS Press; 1970. 106 pp. Reprint of the 1762 ed.

1018. *A Descriptive Account of the Island of Jamaica: With Remarks upon the Cultivation of the Sugar-Cane and Reflections upon the Consequences of an Abolition of the Slave-Trade and of the Emancipation of the Slaves.* William Beckford. London: T. and J. Egerton; 1790. 2 vols.

1019. *Dictionnaire caraïbe-français, français-caraïbe.* Raymond Breton. Leipzig: B. G. Teubner; 1892–1900. 2 vols. Reprint of the 1665–1666 ed. 23

1020. *The Discovery of the Large, Rich, and Beautiful Empire of Guiana.* Walter Raleigh; Robert Hermann Schomburgk, ed. New York, NY: B. Franklin; 1970. 240 pp. Originally published in 1596; this is a reprint of the 1848 ed.

1021. *An Essay on the Natural History of Guiana.* Edward Bancroft. New York, NY: Arno Press; 1971. 402 pp. Reprint, with a new introd., of the 1769 ed.

1022. *An Essay on the Treatment and Conversion of African Slaves in the British Sugar Colonies.* James Ramsay. London: J. Phillips; 1784. 298 pp.

1023. *Grammaire caraïbe: suivi du Catéchisme caraïbe.* Raymond Breton; Lucien Adam, Charles Leclerc, eds. Millwood, NY: Kraus Reprint; 1968. 127 pp. Originally published as two separate works (1667 and 1664); this is a reprint of the 1877 joint ed.

1024. *Histoire générale des Antilles habitées par les français.* Jean Baptiste Du Tertre. Paris: Edition et diffusion de la culture antillaise; 1978. 4 vols. Reprint of the 1667–1671 ed.; see also #1036.

1025. *Historia de la Isla Española o de Santo Domingo: escrita particularmente sobre las memorias manuscritas del padre Jean Bautista Le Pers.* Pierre-François-Xavier de Charlevoix. Santo Domingo: Editora de Santo Domingo; 1977. 2 vols. Translation of *Histoire de l'Isle espagnole ou de S. Domingue* (1730–1731).

1026. *Historia geográfica, civil y natural de la isla de San Juan Bautista de Puerto Rico.* Iñigo Abbad y Lasierra; Isabel Gutiérrez del Arroyo, ed. Río Piedras, P.R.: Editorial Universitaria, Universidad de Puerto Rico; 1979. 320 pp. Originally published in 1788; this is a reprint of the 1959 ed.

1027. *An Historical Account of the Rise and Growth of the West-India Collonies.* Dalby Thomas. New York, NY: Arno Press; 1972. 53 pp. Reprint of the 1690 ed.

1028. *Historical Essay on the Colony of Surinam.* Simon Cohen, tr.; Jacob R. Marcus, Stanley F. Chyet, eds. Cincinnati, OH: American Jewish Archives; 1974. 258 pp. Translation of an anonymous work, *Essai historique sur la colonie de Surinam* (1788).

1029. *An Historical Survey of the French Colony in the Island of St. Domingo.* Bryan Edwards. London: Stockdale; 1797. 247 pp.

1030. *The History of Jamaica.* Edward Long. New York, NY: Arno Press; 1972. 3 vols. Reprint of the 1774 ed.

1031. *The History of the Caribby-Islands.* César de Rochefort; John Davies, tr. London: Printed by J. M. for T. Dring and J. Starkey; 1666. 351 pp. Translation of *Histoire naturelle et morale des îles Antilles de l'Amérique* (1658).

1032. *The History of the Island of Dominica.* Thomas Atwood. Totowa, NJ: Cass; 1971. 285 pp. Reprint of the 1791 ed.

1033. *The History, Civil and Commercial, of the British Colonies in the West Indies.* Bryan Edwards. New York, NY: Arno Press; 1972. 965 pp. Reprint of the 1793 ed.

1034. *Iaerlyck verhael van de verrichtinghen der Geoctroyeerde West-Indische Compagnie [Annual Report of the Activitiesof the Chartered West India Company]*. Joannes de Laet; Samuel Pierre L'Honoré Naber, ed. Boston, MA: M. Nijhoff; 1931–1937. 4 vols. Reprint of the 1644 ed. published under title *Historie ofte iaerlijck verhael van de verrichtinghen der Geoctroyeerde West-Indische Compagnie.*

1035. *Jamaica Viewed: With All the Ports, Harbours, and Their Several Soundings, Towns, and Settlements Thereunto Belonging.* Edmund Hickeringill. London: J. Williams; 1661. 106 pp.

1036. *Jean-Baptiste DuTertre on the French in St. Croix and the Virgin Islands.* Jean Baptiste Du Tertre; Aimery Caron, Arnold R. Highfield, eds. and trs. Charlotte Amalie, V.I.: Dept. of Conservation and Cultural Affairs, Bureau of Libraries, Museums and Archeological Services; 1978. 79 pp. Translation of parts of J. B. Du Tertre's *Histoire générale des Antilles* (1667–1671); see #1024.

1037. *Letters on Slavery: To Which Are Added, Addresses to the Whites and to the Free Negroes of Barbadoes.* William Dickson. Westport, CT: Negro Universities Press; 1970. 190 pp. Reprint of the 1789 ed.

1038. *Letters Relative to the Capture of Saint Eustatius, 1781.* George Brydges Rodney. Shannon: Irish University Press; 1972. 185 pp. Reprint, with a new introd. and index, of the 1789 ed.

1039. *The Memoirs of Père Labat, 1693–1705.* Jean Baptiste Labat; John Eaden, ed. and tr. Totowa, NJ : Cass; 1970. 262 pp. Translation of *Nouveau voyage aux isles de l'Amérique* (1722); reprint of the 1931 ed.

1040. *A Narrative of the Revolt and Insurrection in the Island of Grenada.* Gordon Turnbull. 2d ed. London: A. Paris; 1796. 183 pp.

1041. *The Natural History of Barbados.* Griffith Hughes. New York, NY: Arno Press; 1972. 314 pp. Reprint of the 1750 ed.

1042. *A Natural History of Nevis and the Rest of the English Leeward Charibee Islands in America.* William Smith. Cambridge: J. Bentham; 1745. 318 pp.

1043. *Natural History of the West Indies.* Gonzalo Fernández de Oviedo y Valdés; Sterling A. Stoudemire, tr. Chapel Hill, NC: University of North Carolina Press; 1959. 140 pp. Translation of *De la natural hystoria de las Indias* (1535).

1044. *Plaine Description of the Barmudas: Now Called Sommer Ilands.* Silvester Jourdain. New York, NY: Da Capo Press; 1971. 54 pp. Reprint of the 1613 ed.

1045. *The Proceedings of the Governor and Assembly of Jamaica in Regard to the Maroon Negroes.* Jamaica, Assembly. Westport, CT: Negro Universities Press; 1970. 109 pp. Reprint of the 1796 ed.

1046. *Relation de l'establissement d'une colonie françoise dans la Gardeloupe, isle de l'Amérique, et des moeurs des sauvages*. Mathias Du Puis. Basse-Terre: Société d'histoire de la Guadeloupe; 1972. 248 pp. Reprint of the 1652 ed.

1047. *A Relation of a Voyage to Guiana*. Robert Harcourt; Charles Alexander Harris, ed. Millwood, NY: Kraus Reprint; 1967. 191 pp. Originally published in 1613; this is a reprint of the 1928 ed.

1048. *Relato de las misiones de los padres de la Compañía de Jesús en las islas y en Tierra Firme de América Meridional*. Pierre Pelleprat; José del Rey, ed. Caracas: Academia Nacional de la Historia; 1965. 112 pp. Translation of *Relation des mission des pères de la Compagnie de Jésus dans les îles et dans la Terre ferme de l'Amérique méridionale* (1655).

1049. *Stedman's Surinam: Life in Eighteenth-Century Slave Society*. John Gabriel Stedman; Richard Price, Sally Price, eds. Baltimore, MD: Johns Hopkins University Press; 1992. 350 pp. Abridged and rev. ed. of *Narrative of a Five Years' Expedition Against the Revolted Negroes of Surinam* (1790).

1050. *A True and Exact History of the Island of Barbadoes*. Richard Ligon. Totowa, NJ: Cass; 1970. 122 pp. Reprint of the 1673 (2d) ed.

1051. *Voyage d'un suisse dans les colonies d'Amérique*. Justin Girod-Chantrans; Pierre Pluchon, ed. Paris: J. Tallandier; 1980. 278 pp. Reprint of the 1785 ed.

1052. *A Voyage to Saint Domingo in the Years 1788, 1789, and 1790*. François Alexandre-Stanislas, baron de Wimpffen; J. Wright, tr. London: Cadell and Davies; 1817. 371 pp. Translation of *Voyage à Saint Domingue, pendant les années 1788, 1789 et 1790* (1797).

B. Works Published in the 19th Century

1053. *An Account of Jamaica and Its Inhabitants*. A Gentleman [John Stewart]. Freeport, NY: Books for Libraries Press; 1971. 305 pp. Reprint of the 1808 ed.

1054. *An Address to the Right Hon. Earl Bathurst [Relative to the Claims Which the Coloured Population of Trinidad Have to the Same Civil and Political Privileges with Their Fellow-Subjects]*. A Free Mulatto of the Island [John Baptista Philip]. Port of Spain: Paria; 1987. 313 pp. Reprint of the 1824 ed.

1055. *Among the Indians of Guiana: Being Sketches Chiefly Anthropologic from the Interior of British Guiana*. Everard Ferdinand Im Thurn. New York, NY: Dover; 1967. 445 pp. Reprint of the 1883 ed.

1056. *The Annals of Jamaica*. George Wilson Bridges. Westport, CT: Negro Universities Press; 1970. 2 vols. Reprint of the 1828 ed.

1057. *Antigua and the Antiguans: A Full Account of the Colony and Its Inhabitants from the Time of the Caribs to the Present Day.* Mrs. Flannigan [supposed author]. London: Spottiswoode, Ballantyne; 1967. 2 vols. Reprint of the 1844 ed.

1058. *Bahama Songs and Stories: A Contribution to Folk-lore.* Charles Lincoln Edwards. Millwood, NY: Kraus Reprint; 1976. 111 pp. Reprint of the 1895 ed.

1059. *La belle Zoa; or, The Insurrection of Hayti.* Frances Hammond Pratt. Freeport, NY: Books for Libraries Press; 1972. 96 pp. Reprint of the 1853 ed.

1060. *Beschrijving van het eyland Curaçao: uit verschillende bronnen bijeengezameld [Description of the Island of Curaçao: Collected from Various Sources].* G. J. Simons. Amsterdam: Emmering; 1968. 156 pp. Reprint of the 1868 ed.

1061. *Beschrijving van Suriname: historisch-, geographisch- en statistisch overzigt, uit officiele bronnen bijeengebragt [Description of Surinam: A Historical, Geographical, and Statistical Overview, Collected from Official Sources].* Cornelis Ascanius van Sypesteyn. The Hague: Van Cleef; 1854. 296 pp.

1062. *Bibliografía puerto-riqueña.* Manuel María Sama. Mayagüez, P.R.: Tip. Comercial-Marina; 1887. 159 pp.

1063. *The Birds of the West Indies.* Charles Barney Cory. Boston, MA: Estes and Lauriat; 1889. 324 pp.

1064. *The Black Man; or, Haytian Independence.* Mark Baker Bird. Freeport, NY: Books for Libraries Press; 1971. 461 pp. Originally published under title *The Republic of Hayti and Its Struggles* (1867); reprint of the 1869 ed.

1065. *The Black Rebellion in Haiti: The Experience of One Who Was Present During Four Years of Tumult and Massacre.* Peter Stephen Chazotte; Charles Platt, ed. Philadelphia, PA: [s.n.]; 1927. 122 pp. Originally published under title *Historical Sketches of the Revolutions and the Foreign and Civil Wars in the Island of St. Domingo* (1840).

1066. *Bosquejo de la historia de Puerto Rico, 1493–1891.* Juan Gualberto Gómez, Antonio Sendras y Burín. San Juan: [s.n.]; 1974. 206 pp. Reprint of the 1891 ed. published under title *La isla de Puerto Rico.*

1067. *Camps in the Caribbees: The Adventures of a Naturalist in the Lesser Antilles.* Frederick Albion Ober. Boston, MA: Lothrop, Lee and Shepard; 1907. 366 pp. Reprint of the 1880 ed.

1068. *The Caribbean Confederation: A Plan for the Union of the Fifteen British West Indian Colonies.* Charles Spencer Salmon. Totowa, NJ: Cass; 1971. 175 pp. Reprint of the 1888 ed.

1069. *A Christmas in the West Indies.* Charles Kingsley. Plymouth, Eng.: Writers and Readers Press; 1987. 352 pp. Reprint of the 1871 ed. published under title *At Last, a Christmas in the West Indies.*

1070. *Chronological History of the Discovery and Settlement of Guiana, 1493–1796.* James Rodway, Thomas Watt. Georgetown: Royal Gazette; 1888–1889. 2 vols. in 1.

1071. *Chronological History of the West Indies.* Thomas Southey. Totowa, NJ: Cass; 1968. 3 vols. Reprint of the 1827 ed.

1072. *The Church in the West Indies.* Alfred Caldecott. Totowa, NJ: Cass; 1970. 275 pp. Reprint of the 1898 ed.

1073. *Colección de papeles científicos, históricos, políticos y de otros ramos sobre la isla de Cuba: ya publicados, ya inéditos.* José Antonio Saco. Havana: Dirección de Cultura, Ministerio de Educación; 1960–1963. 3 vols. Reprint of the 1858 ed.

1074. *The Colony of British Guiana and Its Labouring Population: Containing a Short Account of the Colony, and Brief Descriptions of the Black Creole, Portuguese, East Indian, and Chinese Coolies.* H. V. P. Bronkhurst. London: T. Woolmer; 1883. 479 pp.

1075. *Compendio de la historia de Santo Domingo.* José Gabriel García. Santo Domingo: Editora de Santo Domingo; 1979. 2 vols. Reprint of the 1893 (3d) ed.

1076. *Correspondence on the Present State of Slavery in the British West Indies and in the United States of America.* John Gladstone, James Cropper. Shannon: Irish University Press; 1972. 122 pp. Reprint of the 1824 ed. published under title *The Correspondence Between John Gladstone and James Cropper on the Present State of Slavery.*

1077. *The Crisis of the Sugar Colonies; or, An Enquiry into the Objects and Probable Effects of the French Expedition to the West Indies.* James Stephen. Westport, CT: Negro Universities Press; 1969. 222 pp. Reprint of the 1802 ed.

1078. *Cristóbal Colón en Puerto Rico: llegada de los conquistadores españoles a Boriquén.* Cayetano Coll y Toste. Sharon, CT: Troutman Press; 1991. 239 pp. Originally published under title *Colón en Puerto Rico* (1893); reprint of the 1972 ed.

1079. *Cuba and International Relations: A Historical Study in American Diplomacy.* James Morton Callahan. New York, NY: AMS Press; 1972. 503 pp. Reprint of the 1899 ed.

1080. *Cuba and Porto Rico: With the Other Islands of the West Indies.* Robert Thomas Hill. New York, NY: Century; 1898. 429 pp.

1081. *Cuba and the Cubans.* Raimundo Cabrera; Laura Guitéras, tr. Philadelphia, PA: Levytype; 1896. 442 pp. Translation of *Cuba y sus jueces.*

1082. *Cuba Past and Present.* Richard Patrick Boyle Davey. New York, NY: Scribner's; 1898. 284 pp.

1083. *Cuba primitiva: origen, lenguas, tradiciones e historia de los indios de las Antillas Mayores y las Lucayas.* Antonio Bachiller y Morales. 2a ed., corr. y aum. Havana: M. de Villa; 1883. 399 pp.

1084. *Cuba with Pen and Pencil*. Samuel Hazard. Miami, FL: Editorial Cubana; 1989. 584 pp. Reprint of the 1871 ed.

1085. *The Cuban and Porto Rican Campaigns*. Richard Harding Davis. Freeport, NY: Books for Libraries Press; 1970. 360 pp. Reprint of the 1898 ed.

1086. *The Demerara Martyr: Memoirs of the Rev. John Smith, Missionary to Demerara*. John Smith; Edwin Angel Wallbridge, ed. New York, NY: Negro Universities Press; 1969. 274 pp. Reprint of the 1848 ed.

1087. *Des colonies françaises: abolition immédiate de l'esclavage*. Victor Schoelcher. Basse-Terre: Société d'histoire de la Guadeloupe; 1976. 443 pp. Reprint of the 1842 ed.

1088. *A Description of British Guiana, Geographical and Statistical: Exhibiting Its Resources and Capabilities, Together with the Present and Future Condition and Prospects of the Colony*. Robert Hermann Schomburgk. New York, NY: A. M. Kelley; 1970. 155 pp. Reprint of the 1840 ed.

1089. *Diccionario biográfico cubano*. Francisco Calcagno. New York, NY: N. Ponce de León; 1878. 727 pp.

1090. *Diccionario geográfico, estadístico, histórico, de la isla de Cuba*. Jacobo de la Pezuela y Lobo. Madrid: Impr. de Mellado; 1863–1866. 4 vols.

1091. *Diccionario provincial casi razonado de vozes y frases cubanas*. Esteban Pichardo y Tapia; Gladys Alonso, Angel Luis Fernández, eds. Havana: Editorial de Ciencias Sociales; 1985. 639 pp. Reprint of the 1875 ed.

1092. *Domestic Manners and Social Condition of the White, Coloured, and Negro Population of the West Indies*. A. C. Carmichael. New York, NY: Negro Universities Press; 1969. 2 vols. Reprint of the 1833 ed.

1093. *Down the Islands: A Voyage to the Caribbees*. William Agnew Paton. Westport, CT: Negro Universities Press; 1969. 301 pp. Reprint of the 1887 ed.

1094. *Due South; or, Cuba Past and Present*. Maturin Murray Ballou. New York, NY: Negro Universities Press; 1969. 316 pp. Reprint of the 1885 ed.

1095. *Emancipation in the West Indies*. James A. Thome, Joseph Horace Kimball. New York, NY: Arno Press; 1969. 128 pp. Reprint of the 1838 ed.

1096. *The English in the West Indies; or, The Bow of Ulysses*. James Anthony Froude. New York, NY: Negro Universities Press; 1969. 373 pp. Reprint of the 1888 ed.; see also #1099.

1097. *L'esclavage aux Antilles françaises avant 1789: d'après des documents inédits des archives coloniales*. Lucien Pierre Peytraud. Paris: Edition et diffusion de la culture antillaise; 1984. 553 pp. Reprint of the 1897 ed.

1098. *Estado actual de las colonias españolas*. William Walton; Nora Read Espaillat, Tony Rodríguez Cabral, trs. Santo Domingo: Editora de Santo Domingo; 1976. 2 vols. Translation of *Present State of the Spanish Colonies* (1810).

1099. *Froudacity: West Indian Fables by James Anthony Froude.* John Jacob Thomas. London: New Beacon; 1969. 195 pp. Reprint of the 1889 ed.; see also #1096.

1100. *Geografía de la isla de Cuba.* Esteban Pichardo y Tapia. Havana: D. M. Soler; 1854–1855. 4 vols. in 1.

1101. *Geschiedenis van Suriname [History of Surinam].* J. Wolbers. Amsterdam: Emmering; 1970. 849 pp. Reprint of the 1861 ed.

1102. *The Gold Fields of St. Domingo: With a Description of the Agricultural, Commercial and Other Advantages of Dominica.* Wilshire S. Courtney. New York, NY: A. P. Norton; 1860. 144 pp.

1103. *Gosse's Jamaica, 1844–45.* Philip Henry Gosse, Richard Hill; David Bradshaw Stewart, ed. Kingston: Institute of Jamaica; 1984. 195 pp. Excerpts from *A Naturalist's Sojourn in Jamaica* (1851) and *The Birds of Jamaica* (1847).

1104. *Guía geográfica y administrativa de la isla de Cuba.* Pedro José Imbernó. Havana: Est. Tip. "La Lucha"; 1891. 312 pp.

1105. *A Guide to Hayti.* James Redpath, ed. Westport, CT: Negro Universities Press; 1970. 180 pp. Reprint of the 1861 ed.

1106. *Hayti; or, The Black Republic.* Spenser St. John. Totowa, NJ: Cass; 1971. 389 pp. Reprint of the 1889 (2d) ed.

1107. *Haytian Papers: A Collection of the Very Interesting Proclamations and Other Official Documents.* Prince Saunders, ed. Westport, CT: Negro Universities Press; 1969. 288 pp. Reprint of the 1816 ed.

1108. *Histoire d'Haïti.* Thomas Madiou. Port-au-Prince: Editions Fardin [etc.]; 1985– [vols. 1–7+]. Reprint of the 1847–1848 ed.

1109. *Histoire de l'expédition des français à Saint Domingue: sous le consulat de Napoléon Bonaparte, 1802–1803.* Antoine Métral. Paris: Karthala; 1985. 348 pp. Reprint of the 1825 ed.

1110. *Histoire de la Guadeloupe.* Auguste Lacour. Paris: E. Kolodziej; 1976. 4 vols. Reprint of the 1855–1860 ed.

1111. *Histoire de la Martinique: depuis la colonisation jusque'en 1815.* Sidney Daney de Marcillac. Fort-de-France: Société d'histoire de la Martinique; 1976. 6 vols. in 3. Reprint of the 1846 ed.

1112. *Historia económico-política y estadística de la isla de Cuba.* Ramón de la Sagra. Havana: Impr. de las Viudas de Arazoza y Soler; 1831. 386 pp.

1113. *A Historical Account of St. Thomas, W.I.: With Its Rise and Progress in Commerce and Incidental Notices of St. Croix and St. Johns.* John P. Knox. New York, NY: Negro Universities Press; 1970. 271 pp. Reprint of the 1852 ed.

1114. *An Historical Account of the Island of Saint Vincent.* Charles Shephard. Totowa, NJ: Cass; 1971. 216 pp. Reprint of the 1831 ed.

1115. *An Historical Account of the Black Empire of Hayti.* Marcus Rainsford. Totowa, NJ: Cass; 1972. 467 pp. Reprint of the 1805 ed.

1116. *The History and Present Condition of St. Domingo.* Jonathan Brown. Totowa, NJ: Cass; 1971. 2 vols. Reprint, with a new pref., of the 1837 ed.

1117. *The History of Barbados: From the First Discovery of the Island in the Year 1605 till the Accession of Lord Seaforth, 1801.* John Poyer. Totowa, NJ: Cass; 1971. 668 pp. Reprint of the 1808 ed.

1118. *The History of Barbados: Comprising a Geographical and Statistical Description of the Island.* Robert Hermann Schomburgk. Totowa, NJ: Cass; 1971. 722 pp. Reprint of the 1848 ed.

1119. *The History of British Guiana: Comprising a General Description of the Colony, a Narrative of Some of the Principal Events from the Earliest Period of Its Discovery to the Present Time.* Henry G. Dalton. London: Longman, Brown, Green and Longman; 1855. 2 vols.

1120. *History of British Guiana: From the Year 1668 to the Present Time.* James Rodway. Georgetown: J. Thomson; 1891–1894. 3 vols.

1121. *History of Cuba; or, Notes of a Traveller in the Tropics.* Maturin Murray Ballou. New York, NY: AMS Press; 1972. 230 pp. Reprint of the 1854 ed.

1122. *A History of Jamaica: From Its Discovery by Christopher Columbus to the Year 1872.* William James Gardner. Totowa, NJ: Cass; 1971. 510 pp. Reprint of the 1873 ed.

1123. *History of the Colonies Essequebo, Demerary and Berbice: From the Dutch Establishment to the Present Day.* Pieter Marinus Netscher; Walter Edmund Roth, tr. Boston, MA: M. Nijhoff; 1929. 150 pp. Translation of *Geschiedenis van de koloniën Essequebo, Demerary, en Berbice, van de vestiging der Nederlanders aldaar tot op onzen tijd* (1888).

1124. *History of the Island of St. Domingo: From Its First Discovery by Columbus to the Present Period.* James Barskett [supposed author]. Westport, CT: Negro Universities Press; 1971. 266 pp. Reprint of the 1824 ed.

1125. *A History of the West Indies: Containing the Natural, Civil, and Ecclesiastical History of Each Island.* Thomas Coke. Miami, FL: Mnemosyne; 1969. 3 vols. Reprint of the 1808–1811 ed.

1126. *A History of Tobago.* Henry Iles Woodcock. Totowa, NJ: Cass; 1971. 195 pp. Reprint of the 1867 ed.

1127. *The History of Trinidad Under the Spanish Government.* Pierre-Gustave-Louis Borde; James Alva Bain, A. S. Mavrogordato, trs. Port of Spain: Paria; 1982. 2 vols. Translation of *Histoire de l'île de la Trinidad sous le gouvernement espagnol* (1876–1882).

1128. *History of Trinidad.* Edward Lanzer Joseph. Totowa, NJ: Cass; 1970. 272 pp. Reprint of the 1838 ed.

1129. *History of Trinidad.* Lionel Mordaunt Fraser. Totowa, NJ: Cass; 1971. 2 vols. Reprint of the 1891–1896 ed.

1130. *The Historye of the Bermudaes or Summer Islands.* John Smith [supposed author] or Nathaniel Boteler [supposed author]; John Henry Lefroy, ed. New York, NY: B. Franklin; 1964. 327 pp. Reprint of the 1882 ed.

1131. *In the Guiana Forest: Studies of Nature in Relation to the Struggle for Life.* James Rodway. New York, NY: Negro Universities Press; 1969. 242 pp. Reprint of the 1894 ed.

1132. *In the Tropics.* A Settler in Santo Domingo [Joseph Warren Fabens]; Richard Burleigh Kimball, ed. Freeport, NY: Books for Libraries Press; 1973. 308 pp. Also published under title *Life in Santo Domingo;* reprint of the 1863 ed.

1133. *The Indian Tribes of Guiana: Their Condition and Habits.* William Henry Brett. New York, NY: R. Carter; 1852. 352 pp.

1134. *Isla de Cuba: pintoresca, histórica, política, literaria, mercantil e industrial.* José María de Andueza. Madrid: Boix; 1841. 182 pp.

1135. *Isla de Cuba: reflexiones sobre su estado social, político y económico.* Antonio López de Letona. Madrid: J. M. Ducazcal; 1865. 118 pp.

1136. *The Island of Cuba.* Alexander von Humboldt; John S. Thrasher, ed. and tr. New York, NY: Negro Universities Press; 1969. 397 pp. Translation of *Essai politique sur l'île de Cuba* (1826); reprint of the 1856 ed.

1137. *The Island of Cuba: Its Resources, Progress, and Prospects.* Richard Robert Madden. London: C. Gilpin; 1849. 252 pp.

1138. *The Isles of Summer; or, Nassau and the Bahamas.* Charles Ives. New Haven, CT: [s.n.]; 1880. 356 pp.

1139. *Jamaica in 1850; or, The Effects of Sixteen Years of Freedom on a Slave Colony.* John Bigelow. Westport, CT: Negro Universities Press; 1970. 214 pp. Reprint of the 1851 ed.

1140. *The Jamaica Movement for Promoting the Enforcement of the Slave-Trade Treaties, and the Suppression of the Slave-Trade.* David Turnbull. New York, NY: Negro Universities Press; 1969. 430 pp. Reprint of the 1850 ed.

1141. *Jamaica: As It Was, as It Is, and as It May Be.* A Retired Military Officer [Bernard Martin Senior]. New York, NY: Negro Universities Press; 1969. 312 pp. Reprint of the 1835 ed.

1142. *Jamaica: Its Past and Present State.* James Mursell Phillippo. London: Dawsons; 1969. 488 pp. Reprint of the 1843 ed.

1143. *Journal of a Residence Among the Negroes in the West Indies.* Matthew Gregory Lewis. Freeport, NY: Books for Libraries Press; 1973. 408 pp. Originally published under title *Journal of a West India Proprietor* (1834); reprint of the 1845 ed.

1144. *Lady Nugent's Journal of Her Residence in Jamaica from 1801 to 1805.* Maria Skinner Nugent; Philip Wright, ed. New and rev. ed. Kingston: Institute of Jamaica; 1966. 331 pp. Based on the 1839 manuscript.

1145. *The Land of the Pink Pearl; or, Recollections of Life in the Bahamas.* Louis Diston Powles. London: Low, Marston, Searle and Rivington; 1888. 321 pp.

1146. *Leaflets from the Danish West Indies: Descriptive of the Social, Political, and Commercial Condition of These Islands.* Charles Edwin Taylor. Westport, CT: Negro Universities Press; 1970. 208 pp. Reprint of the 1888 ed.

1147. *Letters from Jamaica: The Land of Streams and Woods.* Charles Joseph Galliari Rampini. Freeport, NY: Books for Libraries Press; 1973. 182 pp. Reprint of the 1873 ed.

1148. *Letters from the Bahama Islands Written in 1823–4.* Miss Hart [pseud.]; Jack Culmer, ed. Nassau: Providence Press; 1967. 115 pp. Reprinted from the 1827 ed.

1149. *Letters Written in the Interior of Cuba.* Abiel Abbot. Freeport, NY: Books for Libraries Press; 1971. 256 pp. Reprint of the 1829 ed.

1150. *The Life and Poems of a Cuban Slave: Juan Francisco Manzano, 1797–1854.* Juan Francisco Manzano; Edward J. Mullen, ed. Hamden, CT: Archon Books; 1981. 237 pp. Originally published under title *Poems by a Slave in the Island of Cuba* (1840).

1151. *The London Missionary Society's Report on the Proceedings Against the Late Rev. J. Smith of Demerara: Who Was Tried Under Martial Law and Condemned to Death, on a Charge of Aiding and Assisting in a Rebellion of the Negro Slaves.* London Missionary Society. New York, NY: Negro Universities Press; 1969. 204 pp. Reprint of the 1824 ed.

1152. *Memorials of the Discovery and Early Settlement of the Bermudas or Somers Islands.* John Henry Lefroy, ed. Hamilton: Bermuda Historical Society; 1981. 2 vols. Reprint of the 1877–1879 ed.

1153. *Mitigation of Slavery in Two Parts [Letters and Papers].* Joshua Steele, William Dickson. Westport, CT: Negro Universities Press; 1970. 528 pp. Reprint of the 1814 ed.

1154. *A Narrative of a Journey Across the Unexplored Portion of British Honduras: With a Short Sketch of the History and Resources of the Colony.* Henry Fowler. Belize City: Government Press; 1928. 64 pp. Reprint of the 1879 ed.

1155. *Narrative of a Visit to the West Indies.* George Truman, John Jackson, Thomas B. Longstreth. Freeport, NY: Books for Libraries Press; 1972. 130 pp. Reprint of the 1844 ed.

1156. *The Narrative of General Venables: With an Appendix of Papers Relating to the Expedition to the West Indies and the Conquest of Jamaica,*

1654–1655. Robert Venables; Charles Harding Firth, ed. New York, NY: Johnson Reprint; 1965. 180 pp. Reprint of the 1900 ed.

1157. *De Nederlandsche West-Indische eilanden in derzelver tegenwoordigen toestand [The Dutch West Indian Islands Under Present Conditions].* Marten Douwes Teenstra. Amsterdam: Emmering; 1977. 2 vols. Reprint of the 1836–1837 ed.

1158. *The Negro and Jamaica.* Bedford Pim. Freeport, NY: Books for Libraries Press; 1971. 72 pp. Reprint of the 1866 ed.

1159. *Negro's Memorial; or, Abolitionist's Catechism.* Thomas Fisher. New York, NY: B. Franklin; 1969. 127 pp. Reprint of the 1825 ed.

1160. *Notes on Cuba.* John George F. Wurdemann. New York, NY: Arno Press; 1971. 359 pp. Reprint of the 1844 ed.

1161. *Notes on Haiti: Made During a Residence in That Republic.* Charles MacKenzie. Totowa, NJ: Cass; 1971. 2 vols. Reprint of the 1830 ed.

1162. *Notes on the West Indies: Written During the Expedition Under the Command of the Late General Sir Ralph Abercromby.* George Pinckard. Westport, CT: Negro Universities Press; 1970. 3 vols. Reprint of the 1806 ed.

1163. *Obeah: Witchcraft in the West Indies.* Henry Hesketh Joudou Bell. Westport, CT: Negro Universities Press; 1970. 200 pp. Reprint of the 1889 ed.

1164. *The Ordeal of Free Labor in the British West Indies.* William Grant Sewell. New York, NY: A. M. Kelley; 1968. 325 pp. Reprint of the 1862 ed.

1165. *The Pearl of the Antilles.* Antonio Carlo Napoleone Gallenga. New York, NY: Negro Universities Press; 1970. 202 pp. Reprint of the 1873 ed.

1166. *The Picaroons; or, One Hundred and Fifty Years Ago.* Richard Hill. Freeport, NY: Books for Libraries Press; 1971. 80 pp. Reprint of the 1869 ed.

1167. *Practical Rules for the Management and Medical Treatment of Negro Slaves in the Sugar Colonies.* A Professional Planter [Dr. Collins]. Freeport, NY: Books for Libraries Press; 1971. 400 pp. Reprint of the 1811 ed.

1168. *The Present State of Hayti (Saint Domingo): With Remarks on Its Agriculture, Commerce, Laws, Religion, Finances, and Population.* James Franklin. Westport, CT: Negro Universities Press; 1970. 411 pp. Reprint of the 1828 ed.

1169. *Régimen político de las Antillas españolas.* Francisco de Armas y Céspedes. 2a ed. Palma: Biblioteca Popular; 1882. 210 pp.

1170. *Reizen in West-Indië [Travels in the West Indies].* G. B. Bosch. Amsterdam: Emmering; 1985– [vols. 1–2+]. Reprint of the 1829 ed.

1171. *Remarks on the Condition of the Slaves in the Island of Jamaica.* William Sells. Shannon: Irish University Press; 1972. 50 pp. Reprint of the 1823 ed.

1172. *Report on the Island of Porto Rico.* Henry King Carroll. New York, NY: Arno Press; 1975. 813 pp. Reprint of the 1899 ed.

1173. *La República Dominicana: reseña general geográfico-estadística.* José Ramón Abad. Santo Domingo: Banco Central de la República; 1973. 397 pp. Reprint of the 1888 ed.

1174. *A Review of the Colonial Slave Registration Acts.* African Institution (London, Eng.). Freeport, NY: Books for Libraries Press; 1971. 139 pp. Reprint of the 1820 ed.

1175. *Richard Schomburgk's Travels in British Guiana, 1840–1844.* Moritz Richard Schomburgk; Walter Edmund Roth, ed. and tr. Georgetown: Daily Chronicle; 1922–1923. 2 vols. Translation of *Reisen in Britisch-Guiana in den Jahren 1840–1844* (1847–1848).

1176. *The Right Way, the Safe Way [Proved by Emancipation in the British West Indies and Elsewhere].* Lydia Maria Francis Child. New York, NY: Arno Press; 1969. 96 pp. Reprint of the 1860 ed.

1177. *Santo Domingo Past and Present: With a Glance at Hayti.* Samuel Hazard. Santo Domingo: Editora de Santo Domingo; 1982. 511 pp. Reprint of the 1873 ed.

1178. *Santo Domingo: pinceladas y apuntes de un viaje.* De Benneville Randolph Keim. Santo Domingo: Editora de Santo Domingo; 1978. 272 pp. Originally published in English under title *San Domingo: Pen Pictures and Leaves of Travel, Romance, and History* (1870).

1179. *Secret History; or, The Horrors of St. Domingo.* Mary Hassal. Freeport, NY: Books for Libraries Press; 1971. 225 pp. Reprint of the 1808 ed.

1180. *Six Months in the West Indies in 1825.* Henry Nelson Coleridge. New York, NY: Negro Universities Press; 1970. 332 pp. Reprint of the 1825 ed.

1181. *Sketches of Bermuda.* Susette Harriet Lloyd. Freeport, NY: Books for Libraries Press; 1973. 258 pp. Reprint of the 1835 ed.

1182. *Sketches of Hayti: From the Expulsion of the French to the Death of Christophe.* William Woodis Harvey. Westport, CT: Negro Universities Press; 1970. 416 pp. Reprint of the 1827 ed.

1183. *The Slavery of the British West India Islands Delineated.* James Stephen. Millwood, NY: Kraus Reprint; 1969. 2 vols. Reprint of the 1824 ed.

1184. *A Soldier's Sojourn in British Guiana, 1806–1808.* Thomas Staunton St. Clair; Vincent Roth, ed. Georgetown: Daily Chronicle; 1947. 281 pp. Reprinted from *A Residence in the West Indies and America* (1834).

1185. *The Spanish Main; or, Thirty Days on the Caribbean.* Edward T. Hall. Buffalo, NY: Courier; 1888. 139 pp.

1186. *St. Lucia: Historical, Statistical, and Descriptive.* Henry Hegart Breen. Totowa, NJ: Cass; 1970. 423 pp. Reprint of the 1844 ed.

1187. *A Statement of Facts Submitted to the Right Hon. Lord Glenelg, His Majesty's Principal Secretary of State for the Colonies, with an Exposure of the Present System of Jamaica Apprenticeship.* Henry Sterne. New York, NY: Negro Universities Press; 1969. 282 pp. Reprint of the 1837 ed.

1188. *A Statistical Account of the West India Islands: Together with General Descriptions of the Bermudas, Bay Islands, and Belize, and the Guayana Colonies.* Richard S. Fisher. New York, NY: J. H. Colton; 1855. 68 pp.

1189. *A Statistical, Commercial, and Political Description of Venezuela, Trinidad, Margarita, and Tobago.* Jean-J. Dauxion Lavaysse. Westport, CT: Negro Universities Press; 1969. 479 pp. Translation of *Voyage aux îles de Trinidad, de Tabago, de la Marguerite, et dans diverses parties de Vénézuela* (1813); reprint of the 1820 ed.

1190. *The Story of Beautiful Porto Rico: A Graphic Description of the Garden Spot of the World by Pen and Camera.* Charles H. Rector. New York, NY: Gordon Press; 1977. 184 pp. Reprint of the 1898 ed.

1191. *The Story of the West Indies.* Arnold Kennedy. London: H. Marshall; 1899. 154 pp.

1192. *A Summer on the Borders of the Caribbean Sea.* J. Dennis Harris. Westport, CT: Negro Universities Press; 1969. 179 pp. Reprint of the 1860 ed.

1193. *To Cuba and Back.* Richard Henry Dana; Clinton Harvey Gardiner, ed. Carbondale, IL: Southern Illinois University Press; 1966. 138 pp. Reprint of the 1859 ed.

1194. *Toussaint L'Ouverture: A Biography and Autobiography.* John Relly Beard; James Redpath, ed. Freeport, NY: Books for Libraries Press; 1971. 366 pp. Reprint, with some omissions, of *The Life of Toussaint L'Ouverture* (1853).

1195. *Travels in the West: Cuba, with Notices of Porto Rico and the Slave Trade.* David Turnbull. New York, NY: AMS Press; 1973. 574 pp. Reprint of the 1840 ed.

1196. *A Trip to Cuba.* Julia Ward Howe. New York, NY: Negro Universities Press; 1969. 251 pp. Reprint of the 1860 ed.

1197. *Truths from the West Indies.* Studholme Hodgson. Freeport, NY: Books for Libraries Press; 1973. 372 pp. Reprint of the 1838 ed.

1198. *A Twelve Months' Residence in the West Indies: During the Transition from Slavery to Apprenticeship.* Richard Robert Madden. Westport, CT: Negro Universities Press; 1970. 2 vols. Reprint of the 1835 ed.

1199. *Twenty-five Years in British Guiana.* Henry Kirke. Westport, CT: Negro Universities Press; 1970. 364 pp. Reprint of the 1898 ed.

1200. *Two Years in the French West Indies.* Lafcadio Hearn. Upper Saddle River, NJ: Literature House; 1970. 431 pp. Reprint of the 1890 ed.

1201. *Viaje a La Habana*. María de las Mercedes Santa Cruz y Montalvo, comtesse de Merlin. Havana: Editorial Arte y Literatura; 1974. 218 pp. Abridged translation of *La Havane* (1844).

1202. *Vida de J. J. Dessalines: gefe de los negros de Santo Domingo*. Louis Dubroca; D. M. G. C., tr.; Juan López Cancelada, ed. Mexico City: Editorial Porrúa; 1983. 106 pp. Translation of *La vie de J. J. Dessalines* (1804); reprint, with a new pref., of the 1806 ed.

1203. *Vie de Toussaint Louverture*. Victor Schoelcher. Paris: Karthala; 1982. 455 pp. Reprint of the 1889 ed.

1204. *A View of the Past and Present State of the Island of Jamaica: With Remarks on the Moral and Physical Condition of the Slaves*. John Stewart. New York, NY: Negro Universities Press; 1969. 363 pp. Reprint of the 1823 ed.

1205. *A Voice from the West Indies: Being a Review of the Character and Results of Missionary Efforts in the British and Other Colonies in the Charibbean Sea*. John Horsford. London: A. Heylin; 1856. 492 pp.

1206. *Voyage d'un naturaliste en Haïti, 1799–1803*. Michel Etienne Descourtilz. Paris: Librairie Plon; 1935. 232 pp. Abridged reprint of *Voyages d'un naturaliste au continent de l'Amérique septentrionale, à Saint-Yago de Cuba, et à St.-Domingue* (1809).

1207. *A Voyage in the West Indies: Containing Various Observations Made During a Residence in Barbadoes and Several of the Leeward Islands*. John Augustine Waller. London: R. Phillips; 1820. 106 pp.

1208. *A Voyage to Demerary, 1799–1806*. Henry Bolingbroke; Vincent Roth, ed. Georgetown: Daily Chronicle; 1941. 270 pp. Reprint of the 1807 ed.

1209. *The War in Cuba*. Gonzalo de Quesada, Henry Davenport Northrop. New York, NY: Arno Press; 1970. 758 pp. Also published under title *Cuba's Great Struggle for Freedom;* reprint of the 1896 ed.

1210. *The West India Colonies: The Calumnies and Misrepresentations Circulated Against Them by the "Edinburgh Review."* James MacQueen. New York, NY: Negro Universities Press; 1969. 427 pp. Reprint of the 1825 ed.

1211. *West Indian Slavery: Selected Pamphlets*. Westport, CT: Negro Universities Press; 1970. 1 vol. (various pagings). Originally published 1816–1827.

1212. *The West Indies and the Spanish Main*. James Rodway. New York, NY: Putnam's; 1896. 371 pp.

1213. *The West Indies and the Spanish Main*. Anthony Trollope. Gloucester, Eng.: A. Sutton; 1985. 301 pp. Reprint of the 1859 ed.

1214. *The West Indies Before and Since Slave Emancipation*. John Davy. Totowa, NJ: Cass; 1971. 551 pp. Reprint of the 1854 ed.

1215. *The West Indies Enslaved and Free: A Concise Account of the Islands and Colonies.* William Moister. London: T. Woolmer; 1883. 394 pp.

1216. *The West Indies in 1837: Being the Journal of a Visit to Antigua, Montserrat, Dominica, St. Lucia, Barbados and Jamaica.* Joseph Sturge, Thomas Harvey. Totowa, NJ: Cass; 1968. 380 pp. Reprint of the 1838 ed.

1217. *The West Indies.* Charles Washington Eves. London: Low, Marston, Searle and Rivington; 1889. 322 pp.

1218. *The West Indies: A History of the Islands of the West Indian Archipelago.* Amos Kidder Fiske. New York, NY: Putnam's; 1911. 414 pp. Reprint of the 1899 ed.

1219. *The West Indies: The Natural and Physical History of the Windward and Leeward Colonies.* Andrew Halliday. London: J. W. Parker; 1837. 408 pp.

1220. *The West Indies: Their Social and Religious Condition.* Edward Bean Underhill. Westport, CT: Negro Universities Press; 1970. 493 pp. Reprint of the 1862 ed.

1221. *The West-India Common-Place Book: Compiled from Parliamentary and Official Documents, Shewing the Interest of Great Britain in Its Sugar Colonies.* William Young. London: R. Phillips; 1807. 256 pp.

1222. *Where Black Rules White: A Journey Across and About Hayti.* Hesketh Vernon Hesketh Prichard. Freeport, NY: Books for Libraries Press; 1971. 288 pp. Reprint of the 1900 ed.

1223. *A Winter in the West Indies: Described in Familiar Letters to Henry Clay of Kentucky.* Joseph John Gurney. New York, NY: Negro Universities Press; 1969. 282 pp. Reprint of the 1840 ed.

II. REFERENCE AND SOURCE MATERIALS

A. Bibliographies and Indexes

1224. *Aimé Césaire: bibliographie.* Frederick Ivor Case. Toronto: Manna; 1973. 57 pp.

1225. *Alejo Carpentier: Bibliographical Guide.* Roberto González Echevarría, Klaus Müller-Bergh. Westport, CT: Greenwood Press; 1983. 271 pp.

1226. *Amerindians of the Lesser Antilles: A Bibliography.* Robert A. Myers. New Haven, CT: Human Relations Area Files Press; 1981. 158 pp.

1227. *An Annotated Bibliography of West Indian Plant Ecology.* Philip W. Rundel. Charlotte Amalie, V.I.: Dept. of Conservation and Cultural Affairs, Bureau of Libraries and Museums; 1974. 70 pp.

1228. *An Annotated Bibliography to the Fauna (Excluding Insects) of Trinidad and Tobago, 1817–1977.* Peter R. Bacon. St. Augustine, Trinidad/Tobago: Dept. of Zoology, University of the West Indies; 1978. 177 pp.

1229. *An Annotated Bibliography on Puerto Rican Materials and Other Sundry Matters.* Luis Antonio Cardona. Bethesda, MD: Carreta Press; 1983. 156 pp.

1230. *Annotated Bibliography of Puerto Rican Bibliographies.* Fay Fowlie-Flores. Westport, CT: Greenwood Press; 1990. 167 pp.

1231. *An Annotated Selected Puerto Rican Bibliography/Bibliografía puertorriqueña selecta y anotada.* Enrique R. Bravo; Marcial Cuevas, tr. New York, NY: Urban Center, Columbia University; 1972. 229 pp.

1232. *Anthropological Bibliography of Aboriginal Guatemala, British Honduras/Bibliografía antropológica aborigen de Guatemala, Belice.* Jorge A. Lines. San José, C.R.: Tropical Science Center; 1967. 309 pp.

1233. *Anuario bibliográfico dominicano.* Ciudad Trujillo [etc.]: Oficina de Canje y Difusión Cultural [etc.]; 1945– [vol. 1–]. First ed. (1945) has title *Boletín bibliográfico dominicano.*

1234. *Anuario bibliográfico puertorriqueño.* Río Piedras, P.R.: Biblioteca de la Universidad de Puerto Rico; 1948– [vol. 1–]. Annual (1948–1956); biennial (1957–).

1235. *Anuario bibliográfico cubano (Havana, Cuba)*. Fermín Peraza Sarausa. Havana: Ediciones Anuario Bibliográfico Cubano; 1938–1967. 30 vols. Continued by *Revolutionary Cuba* [#1424].

1236. *Anuario bibliográfico cubano (Coral Gables, FL)*. Elena Vérez Peraza. Coral Gables, FL: [s.n.]; 1977–1979. 2 vols. [1969–1970]. Continues *Revolutionary Cuba* [#1424].

1237. *Archivo José Martí: repertorio crítico—medio siglo de estudios martianos*. Carlos Ripoll. New York, NY: E. Torres; 1971. 276 pp.

1238. *Asians in Latin America and the Caribbean: A Bibliography*. Lamgen Leon. Flushing, NY: Asian/American Center, Queens College; 1990. 149 pp.

1239. *The Bahamas Index*. Decatur, IL: White Sound Press; 1987–1990. 4 vols. Continued by *The Bahamas Index and Yearbook* [#1240].

1240. *The Bahamas Index and Yearbook*. Decatur, IL: White Sound Press; 1991– [vol. 1–]. Continues *The Bahamas Index* [#1239].

1241. *The Bahamas*. Paul G. Boultbee. Santa Barbara, CA: Clio Press; 1989. 195 pp.

1242. *Barbados*. Robert B. Potter, Graham Dann. Santa Barbara, CA: Clio Press; 1987. 356 pp.

1243. *Belize*. Ralph Lee Woodward; Sheila R. Herstein, ed. Santa Barbara, CA: Clio Press; 1980. 229 pp.

1244. *Bermuda in Periodical Literature: With Occasional References to Other Works*. George Watson Cole. Brookline, MA: [s.n.]; 1907. 275 pp.

1245. *Bermuda in Print: A Guide to the Printed Literature on Bermuda*. Archibald Cameron Hollis Hallett. Hamilton: Hallett; 1985. 210 pp.

1246. *Bermuda National Bibliography*. Hamilton: Bermuda Library; 1984– [vol. 1–].

1247. *Bibliografía actual del Caribe/Current Caribbean Bibliography/Bibliographie courante de la Caraïbe*. Caribbean Regional Library. Hato Rey, P.R.: Biblioteca Regional del Caribe; 1962– [vol. 1–]. Continues *Current Caribbean Bibliography* [#1347]; ceased with 1973 volume?

1248. *Bibliografía agrícola latinoamericana y del Caribe*. Asociación Interamericana de Bibliotecarios y Documentalistas Agrícolas. Turrialba, C.R.: AIBDA; 1966–1974. 9 vols. Continues *Bibliografía agrícola latinoamericana;* continued by *Indice agrícola de América Latina y el Caribe* [#1380].

1249. *Bibliografía anotada sobre la música en Puerto Rico*. Annie Figueroa Thompson. San Juan: Instituto de Cultura Puertorriqueña; 1977. 70 pp.

1250. *Bibliografía antropológica para el estudio de los pueblos indígenas en el Caribe*. Jalil Sued Badillo. Santo Domingo: Fundación García-Arévalo; 1977. 579 pp.

1251. *Bibliografía cubana del siglo XIX.* Carlos Manuel Trelles. Millwood, NY: Kraus Reprint; 1965. 8 vols. in 4. Reprint of the 1911–1915 ed.; continues *Bibliografía cubana de los siglos XVII y XVIII* [#1252]; continued by: *Bibliografía cubana del siglo XX* [#1253].

1252. *Bibliografía cubana de los siglos XVII y XVIII.* Carlos Manuel Trelles. Millwood, NY: Kraus Reprint; 1965. 463 pp. Reprint of the 1927 (2d) ed.; first ed. (1907) has title *Ensayo de bibliografía cubana de los siglos XVII y XVIII;* continued by *Bibliografía cubana del siglo XIX* [#1251].

1253. *Bibliografía cubana del siglo XX.* Carlos Manuel Trelles. Millwood, NY: Kraus Reprint; 1965. 2 vols. in 1. Reprint of the 1916–1917 ed.; continues *Bibliografía cubana del siglo XIX* [#1251].

1254. *Bibliografía cubana, 1900–1916.* Elena Graupera Arango. Havana: Depto. de Investigaciones Bibliográficas, Biblioteca Nacional José Martí; 1986. 244 pp.

1255. *Bibliografía cubana.* Biblioteca Nacional José Martí. Havana: La Biblioteca [etc.]; 1917– [vol. 1–].

1256. *Bibliografía de arte cubana.* Biblioteca Nacional José Martí. Havana: Editorial Pueblo y Educación; 1985. 346 pp.

1257. *Bibliografía de bibliografías cubanas.* Tomás Fernández Robaina. Havana: Biblioteca Nacional José Martí; [1974 or 1975]. 340 pp.

1258. *Bibliografía de Centroamérica y del Caribe.* Agrupación Bibliográfica Cubana José Toribio Medina. Madrid: Dirección General de Archivos y Bibliotecas de España; 1956–1958. 3 vols.

1259. *Bibliografía de la bibliografía dominicana.* Luis Florén Lozano. Ciudad Trujillo: Roques Román; 1948. 66 pp.

1260. *Bibliografía de la mujer cubana.* Tomás Fernández Robaina. Havana: Biblioteca Nacional José Martí; 1985. 210 pp.

1261. *Bibliografía de Nicolás Guillén.* María Luisa Antuña, Josefina García-Carranza. Havana: Biblioteca Nacional José Martí; 1975. 379 pp.

1262. *Bibliografía de teatro puertorriqueño: siglos XIX y XX.* Nilda González. Río Piedras, P.R.: Editorial Universitaria, Universidad de Puerto Rico; 1977. 223 pp.

1263. *Bibliografía de temas afrocubanos.* Tomás Fernández Robaina. Havana: Biblioteca Nacional José Martí; 1985. 581 pp.

1264. *Bibliografía de Trujillo.* Emilio Rodríguez Demorizi. Ciudad Trujillo: Impresora Dominicana; 1955. 326 pp.

1265. *Bibliografía del teatro cubano.* José Rivero Muñiz. Havana: Biblioteca Nacional; 1957. 120 pp.

1266. *Bibliografía general de la isla de Santo Domingo: contribución a su estudio.* Dato Pagán Perdomo. San Pedro de Macorís, D.R.: Universidad Central del Este; 1979. 2 vols.

1267. *Bibliografía geológica y paleontológica de Centroamérica y el Caribe.* Luis Diego Gómez P. San José, C.R.: Depto. de Historia Natural, Museo Nacional de Costa Rica; 1973. 123 pp.

1268. *Bibliografía geológica y paleontológica de la isla de Santo Domingo (República Dominicana, República de Haití).* Dato Pagán Perdomo. Santo Domingo: Universidad Autónoma de Santo Domingo; 1976. 222 pp.

1269. *Bibliografía martiana, 1853–1955.* Fermín Peraza Sarausa. Havana: Anuario Bibliográfico Cubano; 1956. 720 pp.

1270. *Bibliografía puertorriqueña.* José Géigel y Zeñón, Abelardo Morales Ferrer. Barcelona: Editorial Araluce; 1934. 453 pp.

1271. *Bibliografía puertorriqueña, 1493–1930.* Antonio Salvador Pedreira. New York, NY: B. Franklin; 1974. 707 pp. Reprint of the 1932 ed.

1272. *Bibliografía puertorriqueña de ciencias sociales.* University of Puerto Rico, Social Science Research Center. Río Piedras, P.R.: Editorial Universitaria, Universidad de Puerto Rico; 1977. 2 vols.

1273. *Bibliografía selectiva sobre educación superior en América Latina y el Caribe/Selective Bibliography on Higher Education in Latin America and the Caribbean Region.* UNESCO. Regional Center for Higher Education in Latin America and the Caribbean. Caracas: CRESALC-UNESCO; 1981. 155 pp.

1274. *Bibliografía selectiva sobre estudios de postgrado en América Latina y el Caribe/Selective Bibliography on Post-Graduate Studies in Latin America and the Caribbean Region.* UNESCO. Regional Center for Higher Education in Latin America and the Caribbean. Caracas: CRESALC-UNESCO; 1984. 61 pp.

1275. *Bibliografía sobre el español del Caribe hispánico.* Rafael Angel Rivas Dugarte [et al.]. Caracas: Depto. de Castellano, Literatura y Latín, Instituto Universitario Pedagógico de Caracas; 1985. 294 pp.

1276. *Bibliografie van de Nederlandse Antillen [Bibliography of the Netherlands Antilles].* Stichting voor Culturele Samenwerking. Amsterdam: STICUSA; 1975. 271 pp.

1277. *Bibliografie van Suriname [Bibliography of Suriname].* W. Gordijn. Amsterdam: Stichting voor Culturele Samenwerking (STICUSA); 1972. 255 pp.

1278. *Bibliografisch overzicht van de Indianen in Suriname/Bibliographical Survey of the Indians of Surinam, 1700–1977.* Gerard A. Nagelkerke. Leiden: Caraïbische Afdeling, Koninklijk Instituut voor Taal-, Land- en Volkenkunde; 1977. 55 pp.

1279. *Bibliographia Jamaicensis: A List of Jamaica Books and Pamphlets, Magazine Articles, Newspapers, and Maps, Most of Which Are in the Library of the Institute of Jamaica.* Frank Cundall. New York, NY: B. Franklin; 1971. 83 pp. Reprint of the 1902 ed.

1279a. *Bibliographic Guide to Caribbean Mass Communication.* John A. Lent. Westport, CT: Greenwood Press; 1992. 301 pp.

1280. *A Bibliographical Guide to Law in the Commonwealth Caribbean.* Keith Patchett, Valerie Jenkins. Mona, Jamaica: Institute of Social and Economic Research, University of the West Indies; 1973. 80 pp.

1281. *Bibliographie annotée de l'anthropologie physique des Antilles.* Norman Clermont. Montreal: Centre de recherches caraïbes, Université de Montréal; 1972. 51 pp.

1282. *Bibliographie de la Martinique.* Jean-Pierre Jardel, Maurice Nicolas, Claude Relouzat. Fort-de-France: Centre d'études régionales Antilles-Guyane (CERAG); 1969– [vol. 1–].

1283. *Bibliographie de la Guyane française.* Emile Abonnenc, Jean Hurault, Roger Saban. Paris: Larose; 1957. 1 vol. (unpaged).

1284. *Bibliographie des études littéraires haïtiennes, 1804–1984: actualités bibliographiques francophones.* Léon-François Hoffman. Paris: EDICEF; 1992. 240 pp.

1285. *Bibliographie du négro-anglais du Surinam: avec une appendice sur les langues créoles parlées à l'intérieur du pays.* Jan Voorhoeve, Antoon Donicie. Boston, MA: M. Nijhoff; 1963. 115 pp.

1286. *Bibliographie générale et méthodique d'Haïti.* Ulrick Duvivier. Port-au-Prince: Impr. de l'Etat; 1941. 2 vols.

1287. *Bibliography and Index of the Geology of Puerto Rico and Vicinity, 1866–1968.* Marjorie Hooker. San Juan: Geological Society of Puerto Rico; 1969. 53 pp.

1288. *A Bibliography of Articles on the Danish West Indies and the United States Virgin Islands in the "New York Times," 1867–1975.* Arnold R. Highfield, Max Bumgarner. Gainesville, FL: Center for Latin American Studies, University of Florida; 1978. 209 pp.

1289. *A Bibliography of Caribbean Migration and Caribbean Immigrant Communities.* Rosemary Brana-Shute, Rosemarijn Hoefte. Gainesville, FL: Reference and Bibliographic Dept., University of Florida Libraries; 1983. 339 pp.

1290. *Bibliography of Commissions of Enquiry and Other Government-Sponsored Reports on the Commonwealth Caribbean, 1900–1975.* Audrey Roberts. Madison, WI: Seminar on the Acquisition of Latin American Library Materials (SALALM); 1985. 89 pp.

1291. *A Bibliography of Cuban Belles-Lettres.* Jeremiah D. M. Ford, Maxwell I. Raphael. New York, NY: Russell and Russell; 1970. 204 pp. Reprint of the 1933 ed.

1291a. *Bibliography of Cuban Mass Communications.* John A. Lent. Westport, CT: Greenwood Press; 1992. 357 pp.

1292. *A Bibliography of Education in the Caribbean/Bibliographie de l'en-seignement dans la Caraïbe.* Valeria Ortiz Batson Alcalá. Port of Spain: Caribbean Commision; 1959. 144 pp.

1293. *Bibliography of Latin American and Caribbean Bibliographies.* Lionel V. Loroña. Madison, WI [etc.]: Seminar on the Acquisition of Latin American Library Materials (SALALM); 1986– [(1984/85)–]. Continues *Bibliography of Latin American Bibliographies.*

1294. *Bibliography of Literature from Guyana.* Robert Eugene McDowell. Arlington, TX: Sable; 1975. 117 pp.

1295. *A Bibliography of Plant Disease Investigations in the Commonwealth Caribbean, 1880–1980.* Chelston W. D. Brathwaite, Miranda Alcock, Rawwida Soodeen. St. Augustine, Trinidad/Tobago: Inter-American Institute for Cooperation on Agriculture; 1981. 280 pp.

1296. *Bibliography of the Virgin Islands of the United States.* Charles Frederick Reid. New York, NY: Wilson; 1941. 225 pp.

1297. *Bibliography of the West Indies (Excluding Jamaica).* Frank Cundall. New York, NY: Johnson Reprint; 1971. 179 pp. Reprint of the 1909 ed.

1298. *A Bibliography of the Caribbean Area for Geographers.* A. V. Norton. Mona, Jamaica: Geography Dept., University of the West Indies; 1971. 3 vols.

1299. *A Bibliography of the Caribbean.* Audine Wilkinson. Cave Hill, Barbados: Institute of Social and Economic Research (Eastern Caribbean), University of the West Indies; 1974. 167 pp.

1300. *Bibliography of the English-Speaking Caribbean.* Robert J. Neymeyer. Parkersburg, IA: R. J. Neymeyer; 1979–1984. 6 vols.

1301. *Bibliography of West Indian Geology.* Louis M. R. Rutten. Utrecht: Oosthoek; 1938. 103 pp.

1302. *Bibliography of Women Writers from the Caribbean, 1831–1986.* Brenda F. Berrian, Aart G. Broek. Washington, DC: Three Continents Press; 1989. 360 pp.

1303. *Bibliography on Haiti: English and Creole Items.* Robert Lawless. Gainesville, FL: Center for Latin American Studies, University of Florida; 1985. 146 pp.

1304. *Bibliography on the Latin American and Caribbean Rural Woman.* Inter-American Institute of Agricultural Sciences. San José, C.R.: The Institute; 1980– [vol. 1–].

1305. *A Bibliography, with Some Annotations, on the Creole Languages of the Caribbean.* Roberto Nodal. Milwaukee, WI: Dept. of Afro-American Studies, University of Wisconsin; 1972. 53 pp.

1306. *Biobibliografía de Alejo Carpentier.* Araceli García-Carranza. Havana: Editorial Letras Cubanas; 1984. 644 pp.

1307. *Breve antología bibliográfica de Puerto Rico, 1493–1989.* José Nilo Dávila Lanausse. San Juan: Editorial Académica; 1990. 83 pp.

1308. *Business Information Sources of Latin America and the Caribbean.* Ellen G. Schaffer. Washington, DC: Columbus Memorial Library, Organization of American States; 1982. 60 pp.

1309. *CAGRINDEX: Abstracts of the Agricultural Literature of the Caribbean.* Caribbean Information System for the Agricultural Sciences. St. Augustine, Trinidad/Tobago: CAGRIS; 1980?– [vol. 1–].

1310. *La Caraïbe politique et internationale: bibliographie politologique avec références économiques et socio-culturelles, 1980–1988.* Michel L. Martin. Paris: L'Harmattan; 1990. 287 pp.

1311. *Caraïbes: agriculture, économie—guide des sources documentaires.* Michelle Mounier. Paris: Institut national de la recherche agronomique (INRA); 1991. 52 pp.

1312. *Caribbean Environmental Law Index.* Sylvia G. Moss. Bridgetown: [s.n.]; 1987. 166 pp. Updates *Environmental Legislation of the Commonwealth Caribbean.*

1313. *Caribbean Fiction and Poetry.* Marjorie Engber. New York, NY: Center for Inter-American Relations; 1970. 86 pp.

1314. *Caribbean Livestock Bibliography.* Caribbean Agricultural Research and Development Institute. St. Augustine, Trinidad/Tobago: CARDI; 1984. 192 pp.

1315. *Caribbean Mass Communications: A Comprehensive Bibliography.* John A. Lent. Los Angeles, CA: Crossroads Press; 1981. 152 pp.

1316. *The Caribbean Sugar Industry: A Select Bibliography.* Audine Wilkinson. Cave Hill, Barbados: Institute of Social and Economic Research (Eastern Caribbean), University of the West Indies; 1976. 87 pp.

1317. *Caribbean Writers: A Bio-Bibliographical-Critical Encyclopedia.* Donald E. Herdeck, Maurice A. Lubin, Margaret Laniak-Herdeck. Washington, DC: Three Continents Press; 1979. 943 pp.

1318. *The Caribbean: A Basic Annotated Bibliography for Students, Librarians and General Readers.* Roger Hughes. London: Commonwealth Institute Library Services; 1987. 71 pp.

1319. *Caribbeana 1900–1965: A Topical Bibliography.* Lambros Comitas. Seattle, WA: University of Washington Press; 1968. 909 pp. Updated by *The Complete Caribbeana* [#1330].

1320. *The CARICOM Bibliography.* Caribbean Community, Secretariat. Georgetown: The Secretariat [etc.]; 1977–1986. 10 vols. Annual (1977–1978); semiannual (1979–1986).

1321. *CARINDEX.* Association of Caribbean University and Research Libraries, Indexing Committee. St. Augustine, Trinidad/Tobago: ACURIL;

1977– [vol. 1–]. Title: *CARINDEX, Social Sciences* (1977–1981); *CARINDEX, Social Sciences and Humanities* (1982–).

1322. *CARISPLAN Abstracts*. United Nations, Caribbean Development and Co-operation Committee. Port of Spain: Office for the Caribbean, Economic Commission for Latin America, United Nations; 1980– [no. 1–].

1323. *Catálogo de música clásica contemporánea de Puerto Rico/Puerto Rican Contemporary Classical Music Catalogue*. Kerlinda Degláns, Luis E. Pabón Roca. Río Piedras, P.R.: Pro-Arte Contemporáneo; 1989. 197 pp.

1324. *Civil Rights with Special Reference to the Commonwealth Caribbean: A Select Bibliography*. Velma Newton. Cave Hill, Barbados: Institute of Social and Economic Research (Eastern Caribbean), University of the West Indies; 1981. 110 pp.

1325. *Colonial British Caribbean Newspapers: A Bibliography and Directory*. Howard S. Pactor. Westport, CT: Greenwood Press; 1990. 144 pp.

1326. *Commonwealth Caribbean Writers: A Bibliography*. Stella E. Merriman, Joan Christiani. Georgetown: Guyana Public Library; 1970. 98 pp.

1327. *Commonwealth Caribbean Legal Literature: A Bibliography of All Primary Sources to Date and Secondary Sources for 1971–85*. Velma Newton. 2d ed. Cave Hill, Barbados: Faculty of Law Library, University of the West Indies; 1987. 492 pp. Rev. ed. of *Legal Literature and Conditions Affecting Legal Publishing in the Commonwealth Caribbean*.

1328. *Commonwealth Elections, 1945–1970: A Bibliography*. Valerie Bloomfield. Westport, CT: Greenwood Press; 1976. 306 pp.

1329. *A Companion to West Indian Literature*. Michael Hughes. London: Collins; 1979. 135 pp.

1330. *The Complete Caribbeana, 1900–1975: A Bibliographic Guide to the Scholarly Literature*. Lambros Comitas. Millwood, NY: KTO Press; 1977. 4 vols. Updates *Caribbeana 1900–1965: A Topical Bibliography* [#1319].

1331. *The Complete Haitiana: A Bibliographic Guide to the Scholarly Literature, 1900–1980*. Michel S. Laguerre. Millwood, NY: Kraus International; 1982. 2 vols.

1332. *Conservation in the Caribbean: A Review of Literature on the Destruction and Conservation of Renewable Natural Resources in the Caribbean Area*. Jan Hugo Westermann. Utrecht: Natuurwetenschappelijke Studiekring voor Suriname en de Nederlandse Antillen; 1952. 121 pp.

1333. *Creative Literature of Trinidad and Tobago: A Bibliography*. Beverly D. Wharton-Lake. Washington, DC: Columbus Memorial Library, Organization of American States; 1988. 102 pp.

1334. *Creole and Pidgin Languages in the Caribbean: A Select Bibliography*. Wilma Judith Primus. St. Augustine, Trinidad/Tobago: University of the West Indies; 1972. 80 pp.

1335. *A Critical Survey of Studies on Dutch Colonial History.* Willem Ph. Cool-haas, G. J. Schutte. 2d. rev. ed. Boston, MA: M. Nijhoff; 1980. 264 pp.

1336. *Critical Writings on Commonwealth Literatures: A Selective Bibliography to 1970, with a List of Theses and Dissertations.* William H. New. University Park, PA: Pennsylvania State University Press; 1975. 333 pp.

1337. *Critics on West Indian Literature: A Selected Bibliography.* Jeniphier R. Carnegie. Mona, Jamaica: Research and Publications Committee, University of the West Indies; 1979. 74 pp.

1338. *Cuba, 1953–1978: A Bibliographic Guide to the Literature.* Ronald H. Chilcote, Sheryl Lutjens. Millwood, NY: Kraus International; 1986. 2 vols.

1339. *Cuba.* Rosa Quintero Mesa. Ann Arbor, MI: University Microfilms; 1969. 207 pp. Lists government publications.

1340. *Cuba: An Annotated Bibliography.* Louis A. Pérez. New York, NY: Greenwood Press; 1988. 301 pp.

1341. *Cuba: viajes y descripciones, 1493–1949.* Rodolfo Tro. Havana: [s.n.]; 1950. 188 pp.

1342. *Cuban Acquisitions and Bibliography: Proceedings and Working Papers.* International Conference on Cuban Acquisitions and Bibliography (1970, Library of Congress); Earl J. Pariseau, ed. Washington, DC: Library of Congress; 1970. 164 pp.

1343. *Cuban Literature: A Research Guide.* David William Foster. New York, NY: Garland; 1985. 522 pp.

1344. *The Cuban Revolution of Fidel Castro Viewed from Abroad: An Annotated Bibliography.* Gilberto V. Fort. Lawrence, KS: University of Kansas Libraries; 1969. 140 pp.

1345. *The Cuban Revolution: A Research-Study Guide, 1959–1969.* Nelson P. Valdés, Edwin Lieuwen. Albuquerque, NM: University of New Mexico Press; 1971. 230 pp.

1346. *The Cuban Revolutionary War, 1953–1958: A Bibliography.* Louis A. Pérez. Metuchen, NJ: Scarecrow Press; 1976. 225 pp.

1347. *Current Caribbean Bibliography/Bibliographie courante de la Caraïbe.* Caribbean Commission. Millwood, NY: Kraus Reprint; 1978. 9 vols. Reprint of the 1951–1961 ed.; continued by *Bibliografía actual del Caribe* [#1247].

1348. *Current Caribbean Periodicals and Newspapers: A Guide for the English-Speaking Region.* Shirley Evelyn. St. Augustine, Trinidad/Tobago: Association of Caribbean University, Research, and Institutional Libraries (ACURIL); 1988. 88 pp.

1349. *Derek Walcott: An Annotated Bibliography of His Works.* Irma E. Gold-straw. New York, NY: Garland; 1984. 238 pp.

1350. *A Descriptive and Chronological Bibliography (1950–1982) of the Work of Edward Kamau Brathwaite.* Doris Monica Brathwaite. London: New Beacon; 1988. 97 pp.

1351. *Dictionnaire de bibliographie haïtienne.* Max Bissainthe. Metuchen, NJ: Scarecrow Press; 1951–1973. 2 vols.

1352. *Dominica.* Robert A. Myers. Santa Barbara, CA: Clio Press; 1987. 190 pp.

1353. *Dominican Republic.* Kai P. Schoenhals. Santa Barbara, CA: Clio Press; 1990. 210 pp.

1354. *East Indian Women of Trinidad and Tobago: An Annotated Bibliography with Photographs and Ephemera.* Noor Kumar Mahabir. San Juan, Trinidad/Tobago: Chakra Publishing House; 1992. 346 pp.

1355. *East Indians in the Caribbean: A Bibliography of Imaginative Literature in English, 1894–1984.* Jeremy Poynting. St. Augustine, Trinidad/ Tobago: Library, University of the West Indies; 1984. 59 pp.

1356. *Economic Literature on the Commonwealth Caribbean: A Select Bibliography Based on Material Available in Barbados.* Audine Wilkinson, Andrew S. Downes. Cave Hill, Barbados: Institute of Social and Economic Research (Eastern Caribbean), University of the West Indies; 1987. 503 pp.

1357. *Education in Puerto Rico and of Puerto Ricans in the U.S.A.: Abstracts of American Doctoral Dissertations.* Franklin Parker, Betty June Parker. San Juan: Inter American University Press; 1978. 601 pp.

1358. *The English-Speaking Caribbean: A Bibliography of Bibliographies.* Alma Theodora Jordan, Barbara Comissiong. Boston, MA: G. K. Hall; 1984. 411 pp.

1359. *Essai bibliographique sur l'histoire réligieuse des Antilles françaises.* Joseph Rennard. Paris: Sécrétariat Général; 1931. 95 pp.

1360. *Etudes sur le vodou haïtien: bibliographie analytique.* Michel S. Laguerre. Montreal: Centre de recherches caraïbes, Université de Montréal; 1979. 50 pp.

1361. *Fifty Caribbean Writers: A Bio-Bibliographical Critical Sourcebook.* Daryl Cumber Dance. New York, NY: Greenwood Press; 1986. 530 pp.

1362. *Forty Years of Steel: An Annotated Discography of Steel Band and Pan Recordings, 1951–1991.* Jeffrey Ross Thomas. Westport, CT: Greenwood Press; 1992. 307 pp.

1363. *Grenada Bibliography.* Beverley A. Steele. St. George's, Grenada: Extra-Mural Dept., University of the West Indies; 1983. 119 pp.

1364. *Grenada.* Kai P. Schoenhals. Santa Barbara, CA: Clio Press; 1990. 179 pp.

1365. *Grenada: A Select Bibliography—A Guide to Material Available in Barbados.* Audine Wilkinson. Cave Hill, Barbados: Institute of Social and

Economic Research (Eastern Caribbean), University of the West Indies; 1988. 105 pp.

1366. *The Guiana Maroons: A Historical and Bibliographical Introduction.* Richard Price. Baltimore, MD: Johns Hopkins University Press; 1976. 184 pp.

1367. *A Guide for the Study of British Caribbean History, 1763–1834: Including the Abolition and Emancipation Movements.* Lowell Joseph Ragatz. New York, NY: Da Capo Press; 1970. 725 pp. Reprint of the 1932 ed.

1368. *A Guide to Caribbean Music History.* Robert Murrell Stevenson. Lima: Ediciones Cultura; 1975. 101 pp.

1369. *A Guide to Latin American and Caribbean Census Material: A Bibliography and Union List.* Carole Travis, ed. Boston, MA: G. K. Hall; 1990. 739 pp.

1370. *A Guide to the Law and Legal Literature of Cuba, the Dominican Republic, and Haiti.* Crawford Morrison Bishop, Anyda Marchant. Washington, DC: Library of Congress; 1944. 276 pp.

1371. *Guyana.* Frances Chambers. Santa Barbara, CA: Clio Press; 1989. 206 pp.

1372. *Guyanese National Bibliography.* Georgetown: National Library; 1974– [vol. 1–].

1373. *Haiti.* Frances Chambers. Santa Barbara, CA: Clio Press; 1983. 177 pp.

1374. *Haiti: A Research Handbook.* Robert Lawlesss [et al.]. New York, NY: Garland; 1990. 354 pp.

1375. *Haiti: Guide to the Periodical Literature in English, 1800–1990.* Frantz Pratt. New York, NY: Greenwood Press; 1991. 310 pp.

1376. *Haitian Publications: An Acquisitions Guide and Bibliography.* Lygia María F. C. Ballantyne. Madison, WI: Seminar for the Acquisition of Latin American Library Materials (SALALM); 1980. 52 pp.

1377. *Historiography in the Revolution: A Bibliography of Cuban Scholarship, 1959–1979.* Louis A. Pérez. New York, NY: Garland; 1982. 318 pp.

1378. *Human Services in Postrevolutionary Cuba: An Annotated International Bibliography.* Larry R. Oberg. Westport, CT: Greenwood Press; 1984. 433 pp.

1379. *Index to Puerto Rican Collective Biography.* Fay Fowlie-Flores. New York, NY: Greenwood Press; 1987. 214 pp.

1380. *Indice agrícola de América Latina y del Caribe.* Inter-American Center for Documentation and Agriculture Information. Turrialba, C.R.: Instituto Interamericano de Ciencias Agrícolas, Centro Interamericano de Documentación e Información Agrícola; 1975– [vol. 1–]. Quarterly. Continues *Bibliografía agrícola latinoamericana y del Caribe* [#1248].

1381. *Indice hemero-bibliográfico de Eugenio María de Hostos, 1863–1940.* Adolfo de Hostos. Havana: Cultural; 1940. 756 pp.

1382. *Inventory of Caribbean Studies: An Overview of Social Scientific Publications on the Caribbean by Antillean, Dutch and Surinamese Authors in the Period 1945–1978/79.* Theo M. P. Oltheten. Leiden: Caraïbische Afdeling, Koninklijk Instituut voor Taal-, Land- en Volkenkunde; 1979. 280 pp.

1383. *Investigación y crítica literaria y lingüística cubana.* Alberto Gutiérrez de la Solana. New York, NY: Senda Nueva de Ediciones; 1978– [vol. 1–].

1384. *Jamaica.* Kenneth E. Ingram. Santa Barbara, CA: Clio Press; 1984. 369 pp.

1385. *Jamaican National Bibliography.* Institute of Jamaica. Kingston: The Institute; 1975– [vol. 1–]. Quarterly with annual and quinquennial cumulations; continues *The Jamaican National Bibliography, 1964–1974* [#1386].

1386. *The Jamaican National Bibliography, 1964–1974.* Institute of Jamaica. Millwood, NY: Kraus International; 1981. 439 pp. Continued by *Jamaican National Bibliography* [#1385].

1387. *Jean Rhys: A Descriptive and Annotated Bibliography of Works and Criticism.* Elgin W. Mellown. New York, NY: Garland; 1984. 218 pp.

1388. *Karibische Inseln.* Hamburgisches Welt-Wirtschafts-Archiv. Hamburg: Das Archiv; 1957–1960. 2 vols. in 3.

1389. *Latin America and the Caribbean: A Bibliographical Guide to Works in English.* Stojan Albert Bayitch. [New, rev., ed.]. Coral Gables, FL: University of Miami Press; 1967. 943 pp.

1390. *Latin America and the Caribbean: A Dissertation Bibliography.* Carl W. Deal. Ann Arbor, MI: University Microfilms International; 1978. 164 pp. Updated by *Latin America and the Caribbean II* [#1391].

1391. *Latin America and the Caribbean II: A Dissertation Bibliography.* Marian C. Walters. Ann Arbor, MI: University Microfilms International; 1980. 78 pp. Updates *Latin America and the Caribbean* [#1390].

1392. *Latin America and Caribbean: A Directory of Resources.* Thomas P. Fenton, Mary J. Heffron. Maryknoll, NY: Orbis Books; 1986. 142 pp.

1393. *Latin America and the Caribbean: A Critical Guide to Research Sources.* Paula Hattox Covington [et al.], eds. New York, NY: Greenwood Press; 1992. 924 pp.

1394. *Law in Caribbean Society: An Annotated Guide to University of the West Indies Law-in-Society Dissertations, 1973–77.* Velma Newton, Sylvia G. Moss. Cave Hill, Barbados: Research and Publications Fund Committee, University of the West Indies; 1980. 151 pp.

1395. *Literatuur-overzicht van Suriname tot 1940: literatuur aanwezig in de bibliotheek van het Koninklijk Instituut voor Taal-, Land- en Volkenkunde te Leiden [Literature Survey of Surinam Until 1940: Literature in the Library of the Royal Institute of Linguistics and Anthropology in Leiden].* Gerard A. Nagelkerke. Leiden: De Bibliotheek; 1972. 199 pp.

1396. *Literatuur-overzicht van de Nederlandse Antillen vanaf de 17e eeuw tot 1970: literatuur aanwezig in de bibliotheek van het Koninklijk Instituut voor Taal-, Land- en Volkenkunde te Leiden [Literature Survey of the Netherlands Antilles from the Seventeenth Century to 1970: Literature in the Library of the Royal Institute of Linguistics and Anthropology in Leiden].* Gerard A. Nagelkerke. Leiden: De Bibliotheek; 1973. 147 pp.

1397. *Literatuuroverzicht van de Nederlandse Antillen [Literature Survey of the Netherlands Antilles].* S. R. Criens. 7e ed. Amsterdam: Stichting voor Culturele Samenwerking; 1985. 415 pp.

1398. *Manual bibliográfico sobre la arquitectura y el urbanismo en la historia del Gran Caribe, 1492–1900.* Gustavo Luis Moré. Santo Domingo: Museo de las Casas Reales; 1987. 267 pp.

1399. *Marcus Mosiah Garvey, 1887–1940: An Annotated List of Materials in the National Library of Jamaica.* 3d ed. Debbie McGinnis; June Vernon, ed. Kingston: National Library of Jamaica; 1987. 67 pp.

1400. *Medical Caribbeana: An Index to the Caribbean Health Sciences Literature.* Laxmi Mansingh. Mona, Jamaica: Library, University of the West Indies; 1988. 965 pp.

1401. *The Memorias of the Republics of Central America and of the Antilles.* James Bennett Childs. Washington, DC: GPO; 1932. 170 pp.

1402. *Les migrations antillaises: bibliographie sélective et annotée.* Marianne Kempeneers, Raymond Massé. Montreal: Centre de recherches caraïbes, Université de Montréal; 1981. 53 pp.

1403. *Montserrat.* Riva Berleant-Schiller. Santa Barbara, CA: Clio Press; 1991. 102 pp.

1404. *Movimiento femenino cubano: bibliografía.* Dania de la Cruz. Havana: Editora Política; 1980. 152 pp.

1405. *Music and Dance in Puerto Rico from the Age of Columbus to Modern Times: An Annotated Bibliography.* Donald Thompson, Annie Figueroa Thompson. Metuchen, NJ: Scarecrow Press; 1991. 339 pp.

1406. *National Bibliography of Barbados.* Bridgetown: Barbados Public Library; 1975– [vol. 1–].

1407. *Netherlands Antilles: A Bibliography, Seventeenth Century-1980.* Gerard A. Nagelkerke. Leiden: Caraïbische Afdeling, Koninklijk Instituut voor Taal-, Land- en Volkenkunde; 1982. 422 pp.

1408. *The Netherlands Antilles and Aruba: A Research Guide.* Ingrid Koulen [et al.]. Leiden: Caraïbische Afdeling, Koninklijk Instituut voor Taal-, Land-en Volkenkunde; 1987. 162 pp.

1409. *Our Ancestral Heritage: A Bibliography of the English-Speaking Carib-bean Designed to Record and Celebrate the Several Origins of our Struc-tural, Material, and Creative Culture.* Edward Kamau Brathwaite. Kings-ton: Savacou; 1977. 194 pp.

1410. *A Partially Annotated Bibliography of Agricultural Development in the Caribbean Region.* Clarence Zuvekas. Washington, DC: Rural Develop-ment Division, Bureau for Latin America and the Caribbean, Agency for International Development; 1978. 202 pp.

1411. *Peasant Literature: A Bibliography of Afro-American Nationalism and Social Protest from the Caribbean.* Joan V. Feeney. Monticello, IL: Coun-cil of Planning Librarians; 1975. 71 pp.

1412. *Population Research in Latin America and the Caribbean: A Reference Bibliography.* Barry Edmonston. Ann Arbor, MI: University Microfilms International; 1979. 161 pp.

1413. *Population Research, Policy, and Related Studies in Puerto Rico: An In-ventory.* Kent C. Earnhardt. Río Piedras, P.R.: Editorial de la Universidad de Puerto Rico; 1984. 132 pp.

1414. *Los primeros pasos: una bibliografía para empezar a investigar la histo-ria de Puerto Rico.* María de los Angeles Castro, María Dolores Luque de Sánchez, Gervasio Luis García. 2a ed., rev. y aum. Río Piedras, P.R.: Edi-ciones Huracán; 1987. 130 pp.

1415. *Principaux ouvrages de langue néerlandaise, anglaise et allemande sur les Guyanes.* Silvia W. de Groot. Paris: Leyde; 1958– [vol. 1–].

1416. *Prontuario literario biográfico puertorriqueño: sobre 3,500 autores nue-stros.* Salvador Arana Soto. San Juan: Impr. San Rafael; 1990. 512 pp.

1417. *Puerto Rican Authors: A Biobibliographic Handbook.* Marnesba D. Hill, Harold B. Schleifer. Metuchen, NJ: Scarecrow Press; 1974. 267 pp.

1418. *Puerto Rican Literature: A Bibliography of Secondary Sources.* David William Foster. Westport, CT: Greenwood Press; 1982. 232 pp.

1419. *The Puerto Ricans: An Annotated Bibliography.* Paquita Vivó. New York, NY: Bowker; 1973. 299 pp.

1420. *The Puerto Ricans: Migration and General Bibliography.* New York, NY: Arno Press; 1975. 366 pp. (in various pagings). Reprints of previ-ously published (and unpublished) works.

1421. *Puerto Rico.* Elena E. Cevallos; Sheila R. Herstein, ed. Santa Barbara, CA: Clio Press; 1985. 193 pp.

1422. *Regional Bibliography of Caribbean Geology.* L. K. Fink. Miami, FL: In-stitute of Marine Science, University of Miami; 1964. 65 pp.

1423. *A Resource Guide to Dominica, 1493–1986.* Robert A. Myers. New Haven, CT.: Human Relations Area Files; 1987. 3 vols.

1424. *Revolutionary Cuba: A Bibliographical Guide.* Fermín Peraza Sarausa. Coral Gables, FL: University of Miami Press; 1967–1970. 3 vols. Continues *Anuario bibliográfico cubano (Havana, Cuba)* [#1235]; continued by *Anuario bibliográfico cubano (Coral Gables, FL)* [#1236].

1425. *La science politique des jeunes états caraïbes.* S. Milacic, J. P. Charbonneau. [S.l.]: Centre universitaire Antilles-Guyane; 1977. 331 pp.

1426. *A Select Bibliography of Publications and Studies Relating to Human Resources in the Commonwealth Caribbean: Material Available in Trinidad and Tobago.* Marianne Ramesar. St. Augustine, Trinidad/Tobago: Institute of Social and Economic Research, University of the West Indies; 1981. 127 pp.

1427. *A Selected Bibliography of the Dominican Republic: A Century After the Restoration of Independence.* Debora S. Hitt, Larman Curtis Wilson. Washington, DC: Center for Research in Social Systems, American University; 1968. 142 pp.

1428. *A Selected Bibliography of Materials and Resources on Women in the Caribbean Available at WAND's Research and Documentation Centre.* [New ed.]. Diana Inniss. St. Michael, Barbados: Women and Development Unit (WAND), University of the West Indies; 1988. 97 pp.

1429. *A Selected, Annotated Bibliography of Caribbean Bibliographies in English.* Henry C. Chang. St. Thomas, V.I.: Caribbean Research Institute; 1975. 54 pp.

1430. *A Selective Guide to the English Literature on the Netherlands West Indies: With a Supplement on British Guiana.* Philip Hanson Hiss. New York, NY: Netherlands Information Bureau; 1943. 129 pp.

1431. *Sobre José Lezama Lima y sus lectores: guía y compendio bibliográfico.* Justo C. Ulloa. Boulder, CO: Society of Spanish and Spanish-American Studies; 1987. 101 pp.

1432. *Sociologie de la famille antillaise: bibliographie analytique.* Université de Montréal, Centre de recherches caraïbes. Montreal: Le Centre; 1977. 86 pp.

1433. *Sources of Jamaican History, 1655–1838: A Bibliographical Survey with Particular Reference to Manuscript Sources.* Kenneth E. Ingram. Zug: Inter Documentation; 1976. 2 vols.

1434. *St. Vincent and the Grenadines.* Robert B. Potter. Santa Barbara, CA: Clio Press; 1992. 212 pp.

1435. *Suriname and the Netherlands Antilles: An Annotated English-Language Bibliography.* Enid Brown. Metuchen, NJ: Scarecrow Press; 1992. 275 pp.

1436. *Suriname.* Rosemarijn Hoefte. Santa Barbara, CA: Clio Press; 1990. 227 pp.

1437. *Suriname: A Bibliography, 1940–1980.* Gerard A. Nagelkerke. Leiden: Caraïbische Afdeling, Koninklijk Instituut voor Taal-, Land- en Volkenkunde; 1980. 336 pp.

1438. *Suriname: A Bibliography, 1980–1989.* Jo Derkx, Irene Rolfes. Leiden: Caraïbische Afdeling, Koninklijk Instituut voor Taal-, Land- en Volkenkunde; 1990. 297 pp.

1439. *A Tentative Bibliography of the Belles-Lettres of Porto Rico.* Guillermo Rivera. Cambridge, MA: Harvard University Press; 1931. 61 pp.

1440. *Tesauro de datos históricos: índice compendioso de la literatura histórica de Puerto Rico.* Adolfo de Hostos. [Nueva ed.]. Río Piedras, P.R.: Editorial Universitaria, Universidad de Puerto Rico; 1990– [vol. 1 (A-E)–].

1441. *Theses on Caribbean Topics, 1778–1968.* Enid M. Baa. San Juan: Institute of Caribbean Studies, University of Puerto Rico; 1970. 146 pp.

1442. *Theses on the Commonwealth Caribbean, 1891–1973.* Commonwealth Caribbean Resource Centre. London, Ont.: Office of International Education, University of Western Ontario; 1974. 136 pp.

1443. *Travel Accounts and Descriptions of Latin America and the Caribbean, 1800–1920: A Selected Bibliography.* Thomas L. Welch, Myriam Figueras. Washington, DC: Columbus Memorial Library, Organization of American States; 1982. 293 pp.

1444. *Trinidad and Tobago National Bibliography.* Port of Spain: Central Library of Trinidad and Tobago [etc.]; 1975– [vol. 1–]. Quarterly; annual cumulation.

1445. *Trinidad and Tobago.* Frances Chambers; Sheila R. Herstein, ed. Santa Barbara, CA: Clio Press; 1986. 213 pp.

1446. *Turks and Caicos Islands.* Paul G. Boultbee. Santa Barbara, CA: Clio Press; 1991. 97 pp.

1447. *Twentieth-Century Caribbean and Black African Writers.* Bernth Lindfors, Reinhard Sander. Detroit, MI: Gale Research; 1992. 406 pp.

1448. *Universities of the Caribbean Region: Struggles to Democratize—An Annotated Bibliography.* Barbara Ashton Waggoner, George R. Waggoner. Boston, MA: G. K. Hall; 1986. 310 pp.

1449. *V. S. Naipaul: A Selective Bibliography with Annotations, 1957–1987.* Kelvin Jarvis. Metuchen, NJ: Scarecrow Press; 1989. 205 pp.

1450. *The Virgin Islands of the United States: Social, Economic, and Political Conditions Referred to in Recent Periodical Literature.* Robert V. Vaughn. Christiansted, V.I.: Aye-Aye Press; 1974. 166 pp.

1451. *Virgin Islands.* Verna Penn Moll. Santa Barbara, CA: Clio Press; 1991. 210 pp.

1452. *West Indian Bookplates: Being a First List of Plates Relating to Those Islands.* Vere Langford Oliver. London: Mitchell, Hughes and Clarke; 1914. 100 pp.

1453. *West Indian Literature: An Index to Criticism, 1930–1975.* Jeannette B. Allis. Boston, MA: G. K. Hall; 1981. 353 pp.

1454. *Women in the Caribbean: An Annotated Bibliography—A Guide to Material Available in Barbados.* Joycelin Massiah, Audine Wilkinson, Norma Shorey. Cave Hill, Barbados: Institute of Social and Economic Research (Eastern Caribbean), University of the West Indies; 1979. 133 pp.

1455. *Women in the Caribbean: A Bibliography.* Bertie A. Cohen Stuart, Irene Rolfes. Leiden: Caraïbische Afdeling, Koninklijk Instituut voor Taal-, Land- en Volkenkunde; 1979–1992. 3 vols.

1456. *Writers of the Caribbean and Central America: A Bibliography.* M. J. Fenwick. New York, NY: Garland; 1992. 2 vols.

B. Dictionaries and Encyclopedias

1457. *A-Z of Jamaican Heritage.* Olive Senior. Kingston: Heinemann Educational Books (Caribbean); 1987. 176 pp. Reprint of the 1983 ed.

1458. *Biographical Dictionary of Latin American and Caribbean Political Leaders.* Robert Jackson Alexander. New York, NY: Greenwood Press; 1988. 509 pp.

1459. *Breve enciclopedia de la cultura puertorriqueña.* Rubén del Rosario, Esther Melón de Díaz, Edgar Martínez Masdeu. San Juan: Editorial Cordillera; 1976. 447 pp.

1460. *The Cambridge Encyclopedia of Latin America and the Caribbean.* Simon Collier, Thomas E. Skidmore, Harold Blakemore, eds. 2d ed. New York, NY: Cambridge University Press; 1992. 480 pp.

1461. *5600 refranes y frases de uso común entre los dominicanos.* José Antonio Cruz Brache. Santo Domingo: Editorial Galaxia; 1978. 311 pp.

1462. *50 biografías de figuras dominicanas.* Pablo Clase. Santo Domingo: Libreros Dominicanos Unidos; 1990. 241 pp.

1463. *Cuba en la mano: enciclopedia popular ilustrada.* Esteban Roldán Oliarte. Miami, FL: Mnemosyne; 1969. 1,302 pp. Reprint of the 1940 ed.

1464. *Del español jíbaro: vocabulario.* Aníbal Díaz Montero. Santurce, P.R.: Editorial Díaz-Mont; 1989. 172 pp. Reprint of the 1984 (3d, rev.) ed.

1465. *Diccionario biográfico cubano.* Fermín Peraza Sarausa. Gainesville, FL [etc.]: Peraza Sarausa; 1965–1968. 14 vols. Vols. 1–11 are reprints of the 1951–1960 ed.

1466. *Diccionario biográfico-histórico dominicano, 1821–1930.* Rufino Martí-
nez. Santo Domingo: Universidad Autónoma de Santo Domingo; 1971.
541 pp.

1467. *Diccionario de cubanismos más usuales: cómo habla el cubano.* José
Sánchez-Boudy. Miami, FL: Ediciones Universal; 1978– [vols. 1–6+].

1468. *Diccionario de dominicanismos.* Carlos Esteban Deive. 2a ed. Santo
Domingo: Politécnia Ediciones; 1987. 259 pp.

1469. *Diccionario de la literatura cubana.* Instituto de Literatura y Lingüística
(Academia de Ciencias de Cuba). Havana: Editorial Letras Cubanas;
1980–1984. 2 vols.

1470. *Diccionario de la música cubana: biográfico y técnico.* Helio Orovio. Ha-
vana: Editorial Letras Cubanas; 1981. 442 pp.

1471. *Diccionario de literatura puertorriqueña.* Josefina Rivera de Alvarez. 2a
ed. rev. y aum. San Juan: Instituto de Cultura Puertorriqueña; 1970–1974.
2 vols. in 3.

1472. *Diccionario de voces indígenas de Puerto Rico.* Luis Hernández Aquino.
2a ed. Río Piedras, P.R.: Editorial Cultural; 1977. 456 pp.

1473. *Diccionario de voces coloquiales de Puerto Rico.* Gabriel Vicente Maura.
San Juan: Editorial Zemi; 1984. 567 pp.

1474. *Diccionario enciclopédico dominicano.* Alejandro Paulino Ramos [et al.].
Santo Domingo: Sociedad Editorial Dominicana; 1988. 3 vols.

1475. *Diccionario geográfico de la isla de Cuba.* José de Jesús Márquez. Ha-
vana: Impr. Pérez, Sierra; 1926. 170 pp.

1476. *Diccionario geográfico de Puerto Rico.* Salvador Arana Soto. Río Pie-
dras, P.R.: Editorial Edil; 1978. 228 pp.

1477. *Diccionario histórico bibliográfico comentado de Puerto Rico.* Adolfo de
Hostos. San Juan: Academia Puertorriqueña de la Historia; 1976. 952 pp.

1478. *Diccionario histórico dominicano.* Ulises Rutinel Domínguez, Manuel
Darío de León. Santo Domingo: Universidad Autónoma de Santo Do-
mingo; 1986. 365 pp.

1479. *Diccionario laboral dominicano.* Luis Pichardo Cabral. Santo Domingo:
Tiempo; 1989. 381 pp.

1480. *Dictionary of Afro-Latin American Civilization.* Benjamín Núñez. West-
port, CT: Greenwood Press; 1980. 525 pp.

1481. *Dictionary of Bahamian English.* John A. Holm, Alison Watt Shilling.
Cold Spring, NY: Lexik House; 1982. 228 pp.

1482. *Dictionary of Caribbean Biography.* Ernest Kay. London: Melrose Press;
1969. 335 pp. Updated by *Dictionary of Latin American and Caribbean
Biography* [#1488].

1483. *A Dictionary of Central American Carib.* John J. Stochl; Richard E. Hadel, Román Zúñiga, eds. Belize City: Belize Institute of Social Research and Action (BISRA); 1975. 3 vols.

1484. *The Dictionary of Contemporary Politics of Central America and the Caribbean.* Phil Gunson, Greg Chamberlain, Andrew Thompson. New York, NY: Simon and Schuster; 1991. 397 pp.

1485. *Dictionary of Guyanese Biography.* Arthur J. Seymour, Elma Seymour. Georgetown: [s.n.]; 1984– [vols. 1–2+].

1486. *Dictionary of Guyanese Folklore.* National History and Arts Council (Guyana). Georgetown: The Council; 1975. 74 pp.

1487. *Dictionary of Jamaican English.* Frederic Gomes Cassidy, Robert Brock Le Page. 2d ed. New York, NY: Cambridge University Press; 1980. 509 pp.

1488. *Dictionary of Latin American and Caribbean Biography.* Ernest Kay. London: Melrose Press; 1971– [vol. 1–]. Updates *Dictionary of Caribbean Biography* [#1482].

1489. *Dictionary of St. Lucian Creole.* Jones E. Mondesir; Lawrence D. Carrington, ed. New York, NY: Mouton de Gruyter; 1992. 621 pp.

1490. *Dictionary of Twentieth-Century Cuban Literature.* Julio A. Martínez. Westport, CT: Greenwood Press; 1990. 537 pp.

1491. *Dictionnaire créole-français.* Louis Peleman. Port-au-Prince: Bon Nouvel; 1978. 209 pp. Cover title *Diksyonnè kréyòl-fransé.*

1492. *Dictionnaire créole-français (Guadeloupe): avec un abrégé de grammaire créole, un lexique français-créole, les comparaisons courantes, les locutions et plus de 1000 proverbes.* Ralph Ludwig [et al.]. Paris: Servedit/Editions Jasor; 1990. 471 pp.

1493. *Dictionnaire des expressions du créole guadeloupéen.* Hector Poullet, Sylviane Telchid, Danièle Montbrand. Fort-de-France: Hatier Antilles; 1984. 349 pp.

1494. *Dictionnaire français-créole.* Jules Faine. Paris: Michèle et Montagut; 1982. 479 pp. Reprint of the 1974 ed.

1495. *Dictionnaire pratique du créole de Guadeloupe (Marie Galante): suivi d'un index français-créole.* Henry Tourneux, Maurice Barbotin, Marie-Huberte Tancons. Paris: Karthala; 1990. 486 pp.

1496. *Dictionnaire wayãpi-français/Lexique français-wayãpi (Guyane française).* Françoise Grenand. Paris: Société d'études linguistiques et anthropologiques de France (SELAF); 1989. 538 pp.

1497. *Dikshonario: papiamentu-ulandés, ulandés-papiamentu/Woordenboek: Papiaments-Nederlands, Nederlands-Papiaments [Dictionary: Papiamento-Dutch, Dutch-Papiamento].* Mario Dijkhoff, Magalis Vos de Jesús. Zutphen: Walburg Pers; 1980. 310 pp.

1498. *Enciclopedia Clásicos de Puerto Rico*. Lucas Morán Arce. Barcelona: Ediciones Latinoamericanas; 1971. 7 vols. in 6.

1499. *La Enciclopedia de Cuba*. 2a ed. San Juan: Enciclopedia y Clásicos Cubanos; 1975–1977. 14 vols.

1500. *Enciclopedia de las artes plásticas dominicanas, 1844–1988*. Cándido Gerón. Santo Domingo: Editora Tele 3; 1989. 331 pp.

1501. *Enciclopedia dominicana*. 3a ed. ampliada, corr. y actualizada. Santo Domingo: Enciclopedia Dominicana; 1986–1988. 8 vols.

1502. *Enciclopedia puertorriqueña ilustrada/The Puerto Rican Heritage Encyclopedia*. Federico Ribes Tovar. New York, NY: Plus Ultra; 1970. 3 vols.

1503. *Encyclopaedie van Nederlandsch West-Indië [Encyclopedia of the Netherlands West Indies]*. Herman Daniel Benjamins, Johannes François Snelleman. Amsterdam: Emmering; 1981. 782 pp. Reprint of the 1914–1917 ed.

1504. *L'encyclopédie des Caraïbes*. W. Ahlbrinck; Doude van Herwijnen, tr. Paris: [s.n.]; 1956. 544 pp. Translation of *Encyclopaedie der Karaïben*.

1505. *Encyclopedie van de Nederlandse Antillen [Encyclopedia of the Netherlands Antilles]*. 2. herziende druk. Julius Philip de Palm. Zutphen: Walburg Pers; 1985. 552 pp. First ed. (1969) by Harmannus Hoetink.

1506. *Encyclopedie van Suriname [Encyclopedia of Surinam]*. W. Gordijn; Conrad Friederich Albert Bruijning, Jan Voorhoeve, eds. Amsterdam: Elsevier; 1977. 716 pp.

1507. *La gran enciclopedia de Puerto Rico*. Madrid: Ediciones R; 1976. 14 vols.

1508. *La gran enciclopedia martiana*. Ramón Cernuda. Miami, FL: Editorial Martiana; 1978. 14 vols.

1509. *Haitian Creole-English-French Dictionary*. Albert Valdman [et al.]. Bloomington, IN: Creole Institute, Indiana University; 1981. 2 vols.

1510. *L'Historial antillais*. Tony Djian, Daniel Rouche. Pointe-à-Pitre: Société Dajani Editions; 1981. 6 vols.

1511. *Historical Dictionary of Puerto Rico and the U.S. Virgin Islands*. Kenneth R. Farr. Metuchen, NJ: Scarecrow Press; 1973. 148 pp.

1512. *Historical Dictionary of the British Caribbean*. William Lux. Metuchen, NJ: Scarecrow Press; 1975. 266 pp.

1513. *Historical Dictionary of Haiti*. Roland I. Perusse. Metuchen, NJ: Scarecrow Press; 1977. 124 pp.

1514. *Historical Dictionary of the French and Netherlands Antilles*. Albert L. Gastmann. Metuchen, NJ: Scarecrow Press; 1978. 162 pp.

1515. *Historical Dictionary of Cuba*. Jaime Suchlicki. Metuchen, NJ: Scarecrow Press; 1988. 368 pp.

1516. *Language of the Puerto Rican Street: A Slang Dictionary with English Cross-References.* Cristino Gallo. Santurce, P.R.: Gallo; 1980. 214 pp.

1517. *Léxico mayor de Cuba.* Esteban Rodríguez Herrera. Havana: Editorial Lex; 1958–1959. 2 vols.

1518. *Lexicón histórico-documental de Puerto Rico, 1812–1899.* Luis de la Rosa Martínez. San Juan: Centro de Estudios Avanzados de Puerto Rico y el Caribe; 1986. 139 pp.

1519. *Lexicon van de Surinaamse Winti-kultuur [Dictionary of the Surinamese Winti Cult].* Henri J. M. Stephen. Amsterdam: De West; 1988. 120 pp.

1520. *New English-Creole Dictionary: With Creole-English.* George Brenton. Port-au-Prince: Impr. Nouvelle; 1985. 218 pp.

1521. *Nuevo catauro de cubanismos.* Fernando Ortiz. Havana: Editorial de Ciencias Sociales; 1985. 526 pp. Rev. ed. of *Un catauro de cubanismos;* reprint of the 1974 ed.

1522. *Obras lexicográficas.* Manuel Antonio Patín Maceo. Santo Domingo: Sociedad Dominicana de Bibliófilos; 1990. 355 pp. Joint reprint of *Dominicanismos* (1947) and *Americanismos en el lenguaje dominicano* (1944).

1523. *Personalidades cubanas.* Fermín Peraza Sarausa. Gainesville, FL: [s.n.]; 1964– [vols. 1–10+]. Vols. 1–7 are reprints of the 1957–1959 ed.; vols. 8– have subtitle *Cuba en el exilio.*

1524. *Personalities Caribbean.* Kingston: Personalities; 1965– [2d ed.–]. Continues *Personalities in the Caribbean* [#1525].

1525. *Personalities in the Caribbean.* Kingston: Personalities; 1962. 1 vol. Continued by *Personalities Caribbean* [#1524].

1526. *Political and Economic Encyclopaedia of South America and the Caribbean.* Peter Beck [et al.]; Peter Calvert, ed. Harlow, Eng.: Longman; 1991. 363 pp.

1527. *Political Parties of the Americas: Canada, Latin America and the West Indies.* Robert Jackson Alexander, ed. Westport, CT: Greenwood Press; 1982. 2 vols.

1528. *Political Parties of the Americas and the Caribbean: A Reference Guide.* John Coggins, David Stephen Lewis, eds. Harlow, Eng.: Longman; 1992. 341 pp.

1529. *Puerto Rico A-Zeta: enciclopedia alfabética.* Lucas Morán Arce, Sarah Díez de Morán, eds. Barcelona: Ediciones Nauta; 1987. 6 vols.

1530. *Race and Ethnic Relations in Latin America and the Caribbean: An Historical Dictionary and Bibliography.* Robert M. Levine. Metuchen, NJ: Scarecrow Press; 1980. 252 pp.

1531. *Rastafari and Reggae: A Dictionary and Sourcebook.* Rebekah Michele Mulvaney, Carlos I. H. Nelson. Westport, CT: Greenwood Press; 1990. 253 pp.

1532. *Ti diksyonnè kreyòl-franse/Dictionnaire élémentaire créole-haïtien-français.* Pierre Nougayrol [et al.]; Alain Bentolila, ed. Port-au-Prince: Editions Caraïbes; 1976. 511 pp.

1533. *Vocabulario de Puerto Rico.* Augusto Malaret. New York, NY: Las Américas; 1967. 293 pp. Reprint of the 1937 ed.

1534. *What a Pistarckle! A Dictionary of Virgin Islands English Creole.* Lito Valls. St. John, V.I.: Valls; 1981. 139 pp. (+ Suppl. [74 pp.] published in 1990).

C. Handbooks, Guides, and Directories

1535. *Addendum, CSA Directory.* Caribbean Studies Association. San Juan: The Association; 1989– [vol. 1–]. Updates *Directory of Caribbeanists* [#1578].

1536. *Agricultural Marketing Handbook for Caribbean Basin Products.* United States, Dept. of Agriculture, Office of International Cooperation and Development [and] United States, Agency for International Development. 2d ed. Washington, DC: U.S. Dept. of Agriculture; 1991. 434 pp.

1537. *Almanaque puertorriqueño: libro de información general de Puerto Rico.* José A. Toro Sugrañes. Río Piedras, P.R.: Editorial Edil; 1990. 427 pp.

1538. *Alphabetical Listing of Organizations and Individuals Involved in Agricultural Research and Development in Eastern (and Other Regionally Selected) Caribbean Countries.* Robert Webb, Walter Knausenberger, Houston Holder, eds. Frederiksted, V.I.: College of the Virgin Islands–Eastern Caribbean Centre; 1986. 98 pp.

1539. *Anuario estadístico de América Latina y el Caribe/ Statistical Yearbook for Latin America and the Caribbean.* United Nations, Economic Commission for Latin America and the Caribbean. Santiago, Chile: CEPAL; 1986– [vol. 1–]. Continues *Anuario estadístico de América Latina.*

1540. *Area Handbook for Guyana.* William Burton Mitchell [et al.]. Washington, DC: GPO; 1969. 378 pp.

1541. *Area Handbook for Jamaica.* Irving Kaplan [et al.]. Washington, DC: GPO; 1976. 332 pp.

1542. *Area Handbook for Trinidad and Tobago.* Jan Knippers Black [et al.]. Washington, DC: GPO; 1976. 304 pp.

1543. *The Atlas of Central America and the Caribbean.* Diagram Group. New York, NY: Macmillan; 1985. 144 pp.

1544. *Atlas of Medicinal Plants of Middle America: Bahamas to Yucatan.* Julia F. Morton. Springfield, IL: C. C. Thomas; 1981. 1,420 pp.

1545. *Bahamas Handbook and Businessman's Annual.* Nassau: E. Dupuch; 1960– [vol. 1–].

1546. *The Bahamas Reference Annual*. Cyril St. John Stevenson, ed. Nassau: Interpress Public Relations Consultants; 1985– [vol. 1–].

1547. *Belize: Country Guide*. Tom Barry. 2d ed. Albuquerque, NM.: Inter-Hemispheric Education Resource Center; 1990. 74 pp.

1548. *The Bermuda Directory*. Hamilton: Bermuda Press; 1990– [vol. 1–].

1549. *Caribbean and Central American Databook*. Caribbean/Central American Action. Washington, DC: C/CAA; 1985–1991. 7 vols. Updates *C/CAA's Caribbean Databook* (1981) and *C/CAA's Caribbean and Central American Databook* (1984); continued by *Caribbean Basin Databook* [#1550].

1550. *Caribbean Basin Databook*. Caribbean/Central American Action. Washington, DC: C/CAA; 1992– [vol. 1–]. Continues *Caribbean and Central American Databook* [#1549].

1551. *Caribbean Basin Financing Opportunities: A Guide to Financing Trade and Investment in Central America and the Caribbean Basin*. Julie M. Rauner. Washington, DC: International Trade Administration, Dept. of Commerce; 1990. 110 pp.

1552. *Caribbean Basin Initiative: Guidebook*. Washington, DC: U.S. Dept. of Commerce; 1986– [vol. 1–].

1553. *Caribbean Basin Trade and Investment Guide*. Kevin P. Power. Washington, DC: Washington International Press; 1984. 373 pp.

1554. *Caribbean Business Directory*. Grand Cayman: Caribbean Publishing; 1987– [vol. 1–]. Some issues have title *Caribbean Business Directory and Yellow Pages*.

1555. *Caribbean Catholic Directory*. St. James, Trinidad/Tobago: St. James Press; 1989– [vol. 1–].

1556. *Caribbean Companion: The A-Z Reference—A Handbook to the People, Places, Plants, Animals, Culture and Major Historical Events of the West Indies*. Brian Dyde. London: Macmillan Caribbean; 1992. 181 pp.

1557. *Caribbean Directory of Human Resources in Social Development/Directorio caribeño de recursos humanos en áreas de desarrollo social*. Betsaida Vélez. San Juan: Association of Caribbean Universities and Research Institutes; 1977. 186 pp.

1558. *Caribbean Economic Almanac*. Max B. Ifill, ed. Port of Spain: Economic and Business Research Information and Advisory Service; 1962– [vol. 1–]. No more published?

1559. *Caribbean Economic Handbook*. Peter D. Fraser, Paul Hackett. London: Euromonitor; 1985. 241 pp.

1560. *The Caribbean Handbook*. St. Johns, Antigua: FT Caribbean; 1983– [vol. 1–]. Annual.

1561. *Caribbean Investment Handbook.* Claude M. Jonnard. Park Ridge, NJ: Noyes Data Corp.; 1974. 306 pp.

1562. *Caribbean Islands Handbook.* Bath, Eng.: Trade and Travel Publications; 1990– [vol. 1–]. Annual. Continues the Caribbean section of the *South American Handbook.*

1563. *Caribbean Media Directory: With Profiles of the English-Speaking Caribbean Countries.* Joseph McPherson, ed. 2d ed. Kingston: Jamaica Institute of Political Education; 1990. 84 pp.

1564. *Caribbean Statistical Digest/Recueil statistique de la région caraïbe.* Caribbean Commission. Port of Spain: The Commission; 1951– [vol. 1–].

1565. *The Caribbean Yearbook.* Toronto [etc.]: Caribook [etc.]; 1927– [vol. 1–]. Also published under title *Year Book of the Bermudas, the Bahamas, British Guiana, British Honduras and the British West Indies* (1927–1935); *West Indies Year Book* (1936–1948); *Year Book of the West Indies and Countries of the Caribbean* (1948–1953); and the *West Indies and Caribbean Yearbook.*

1566. *The Caribbean Yearbook of International Relations.* Leslie François Manigat, ed. Leiden: A. W. Sijthoff; 1975–1977. 3 vols.

1567. *Caribbean/American Directory.* Washington, DC: Caribbean/American Directory; 1983– [vol. 1–]. Annual. Lists U.S. corporations in the Caribbean.

1568. *The Caribbean: Who, What, Why.* Lloyd Sydney Smith, ed. 2d ed. Amsterdam: L. S. Smith; 1965. 844 pp. First ed. has title *The British Caribbean: Who, What, Why.*

1569. *CARICOM Statistics Digest.* Caribbean Community. Georgetown: CARICOM Secretariat; 1980– [vol. 1–]. First issue (1980) has title: *CARICOM Statistics Yearbook.*

1570. *Commonwealth Caribbean Directory of Aid Agencies: Charities, Trusts, Foundations and Official Bodies Offering Assistance in Commonwealth Countries in the Caribbean Region.* Norman Tett, Ronald Macfarlane. London: Commonwealth Foundation; 1978. 128 pp.

1571. *Countries of the Caribbean Community: A Regional Profile.* Faye Henderson, Thomas Philippi. 2d ed. Washington, DC: Office of Foreign Disaster Assistance, Agency for International Development; 1980. 338 pp.

1572. *Cuba Annual Report.* Radio Martí Program (U.S.). New Brunswick, NJ: Transaction Books; 1988– [vol. 1–].

1573. *Cuba: A Country Study.* James D. Rudolph, ed. 3d ed. Washington, DC: Dept. of the Army; 1985. 368 pp. Previous eds. have title: *Area Handbook for Cuba,* by Howard I. Blutstein [et al.] (1971), and by Jan Knippers Black [et al.] (1976).

1574. *Cuba: A Handbook of Historical Statistics.* Susan Schroeder. Boston, MA: G. K. Hall; 1982. 589 pp.

1575. *Detailed Statistics on the Urban and Rural Population of Cuba, 1950 to 2010.* Patricia M. Rowe, Susan J. O'Connor. Washington, DC: Center for International Research, U.S. Bureau of the Census; 1984. 297 pp.

1576. *Directorio de bases de datos de América Latina y el Caribe (DIBALC).* Julia de la Fuente [et al.]; Elsa Barberena Blásquez, ed. Mexico City: Facultad de Filosofía y Letras, Universidad Nacional Autónoma de México; 1992. 144 pp.

1577. *Directorio de organizaciones de derechos humanos, América Latina y el Caribe/Human Rights Directory, Latin America and the Caribbean.* Laurie S. Wiseberg, Guadalupe López, Sarah Meselson. Cambridge, MA: Human Rights Internet; 1990. 528 pp.

1578. *Directory of Caribbeanists.* Caribbean Studies Association. San Juan: Editorial Académica; 1989– [vol. 1–]. Updates *World-Wide Directory of Caribbeanists* [#1603]; updated by *Addendum* [#1535].

1579. *Directory of Caribbean Scholars.* Roland I. Perusse. New York, NY: Gordon Press; 1978. 314 pp.

1580. *A Directory of Caribbean Studies Programs at Colleges and Universities in the United States and Canada.* Harry G. Matthews. Lanham, MD: North-South Publishing; 1989. 75 pp.

1581. *Directory of Caribbean Tertiary Institutions.* Euclid S. King. Mona, Jamaica: Association of Caribbean Tertiary Institutions; 1992. 128 pp.

1582. *A Directory of Natural Resource Management Organizations in Latin America and the Caribbean.* Julie Buckley-Ess, ed. Washington, DC: Partners of the Americas; 1988. 205 pp. Cover title *Natural Resources Directory: Latin America and the Caribbean.*

1583. *Dominican Republic and Haiti: Country Studies.* Richard A. Haggerty, ed. 2d ed. Washington, DC: Federal Research Division, Library of Congress; 1991. 456 pp. Rev. ed. of *Dominican Republic: A Country Study* and *Haiti: A Country Study;* these were rev. eds. of *Area Handbook for the Dominican Republic* and *Area Handbook for Haiti,* by Thomas E. Weil [et al.].

1584. *Economic Survey of Latin America and the Caribbean.* United Nations, Economic Commision for Latin America and the Caribbean. Santiago, Chile: ECLAC; 1984– [vol. 1–]. Annual. Continues *Economic Survey of Latin America.*

1585. *Funding for Research, Study and Travel: Latin America and the Caribbean.* Karen Cantrell, Denise Wallen, eds. Phoenix, AZ: Oryx Press; 1987. 301 pp.

1586. *The Grenada Handbook and Directory.* Bridgetown: Advocate; 1946– [vol. 1–].

1587. *Haiti: A Country Profile*. Evaluation Technologies, Inc., ed. Washington, DC: Office of Foreign Disaster Assistance, U.S. Agency for International Development; 1984. 51 pp. Previous ed. (1981) by Faye Henderson.

1588. *Handbook of Churches in the Caribbean*. Lisa Bessil-Watson, ed. Bridgetown: Cedar Press; 1982. 134 pp. Previous ed. (1973) by Joan A. Brathwaite.

1589. *The Handbook of National Population Censuses: Latin America and the Caribbean, North America, and Oceania*. Doreen S. Goyer, Elaine Domschke. Westport, CT: Greenwood Press; 1983. 711 pp.

1590. *How to Get to Know the Caribbean: A Fact-Finder*. Peter Meel. 2d rev. ed. Leiden: Caraïbische Afdeling, Koninklijk Instituut voor Taal-, Land- en Volkenkunde; 1988. 109 pp.

1591. *Information Services on Research in Progress: An Inventory in Latin America and the Caribbean*. Alberto Araya, Francisco García, Rafael Pozo, eds. Paris: UNESCO; 1988. 100 pp.

1592. *Islands of the Commonwealth Caribbean: A Regional Study*. Sandra W. Meditz, Dennis Michael Hanratty, eds. Washington, DC: Federal Research Division, Library of Congress; 1989. 771 pp.

1593. *Jamaica Handbook*. Karl Luntta. Chico, CA: Moon Publications; 1991. 213 pp.

1594. *Latin America and Caribbean Contemporary Record*. Jack W. Hopkins, Abraham F. Lowenthal, eds. New York, NY: Holmes and Meier; 1983– [vol. 1–].

1595. *Latin America and the Caribbean: A Handbook*. Claudio Véliz, ed. New York, NY: Praeger; 1968. 840 pp.

1596. *Manual para las relaciones europeo-latinoamericanas: instituciones y organizaciones europeas y sus relaciones con América Latina y el Caribe/Handbook for European-Latin American Relations: European Institutions and Organizations and Their Relations with Latin America and the Caribbean*. Brigitte Farenholtz, Wolfgang Grenz, eds. Madrid: Institute for European-Latin American Relations (IRELA); 1987. 772 pp.

1597. *Mexico, Central America and the Caribbean: Economic Structure and Analysis—The Region and Its Organisations, Together with Separate Country Studies*. Economist Intelligence Unit. London: The Unit; 1985. 298 pp.

1598. *Register of Development Research Projects Concerning the English-Speaking Caribbean*. Organisation for Economic Co-operation and Development, Development Centre [and] University of the West Indies, Institute of Social and Economic Research. Paris: OECD; 1987. 320 pp.

1599. *Report on a Comprehensive Review of the Programmes, Institutions and Organisations of the Caribbean Community*. Gladstone E. Mills [et al.]. Georgetown: Caribbean Community Secretariat; 1990. 178 pp.

1600. *South America, Central America, and the Caribbean.* London: Europa Publications; 1985– [vol. 1–]. Biennial.

1601. *Who's Who and Handbook of Trinidad and Tobago.* Donna Yawching. Port of Spain: Inprint Caribbean; 1991. 295 pp.

1602. *Women of the World: Latin America and the Caribbean.* Elsa M. Chaney. Washington, DC: U.S. Bureau of the Census; 1984. 173 pp.

1603. *World-Wide Directory of Caribbeanists.* Roland I. Perusse. Hato Rey, P.R.: Caribbean Studies Association; 1975. 1 vol. Updated by *Directory of Caribbeanists* [#1578].

D. Libraries, Archives, and Special Collections

1604. *An Annotated Catalogue of Medical Americana in the Library of the Wellcome Institute for the History of Medicine: Books and Printed Documents, 1557–1821, from Latin America and the Caribbean Islands and Manuscripts from the Americas, 1575–1927.* Robin Price. London: Wellcome Institute for the History of Medicine; 1983. 319 pp.

1605. *Archives of British Honduras.* John Alder Burdon, ed. London: Sifton, Praed; 1931–1935. 3 vols.

1605a. *Los archivos históricos de Puerto Rico.* Lino Gómez Canedo. San Juan: Instituto de Cultura Puertorriqueña; 1964. 146 pp.

1606. *A Bibliography of Books on Belize in the National Collection.* Belize, Central Library. 4th ed. Belize City: The Library; 1977. 102 pp. (+ Suppl. [12 pp.] published in 1979). Previous eds. have title *A Bibliography of Published Material on the Country as Found in the National Collection, the Central Library, Bliss Institute, Belize City.*

1607. *A Bibliography of Latin America and the Caribbean: The Hilton Library.* Ronald Hilton. Metuchen, NJ: Scarecrow Press; 1980. 675 pp.

1608. *Books on the West Indies; or, by West Indian Writers, Held in the Richard B. Moore Library, Barbados.* Sylvia G. Moss. St. Michael, Barbados: S. G. Moss; 1986. 127 pp.

1609. *Caribbean Abstracts.* Leiden: Caraïbische Afdeling, Koninklijk Instituut voor Taal-, Land- en Volkenkunde; 1990– [vol. 1–]. Continues *Centrale catalogus Caraïbiana* [#1615].

1610. *Caribbean Collections: Recession Management Strategies for Libraries—Papers.* Seminar on the Acquisition of Latin American Library Materials (Thirty-second, 1987, Miami); Mina Jane Grothey, ed. Madison, WI: SALALM Secretariat, Memorial Library, University of Wisconsin-Madison; 1988. 336 pp.

1611. *Catalog of the Cuban and Caribbean Library.* University of Miami, Cuban and Caribbean Library. Boston, MA: G. K. Hall; 1977. 6 vols.

1612. *Catálogo de la colección de la literatura cubana en la Biblioteca Colón.* Myriam Figueras. Washington, DC: Columbus Memorial Library, Organization of American States; 1984. 114 pp.

1613. *Catalogue du fonds local, 1883–1985.* Biliothèque Schoelcher (Fort-de-France, Martinique). Fort-de-France: La Bibliothèque; 1987. 327 pp.

1614. *The Catalogue of the West India Reference Library.* West India Reference Library (Jamaica). Millwood, NY: Kraus International; 1980. 2 vols. in 6.

1615. *Centrale Catalogus Caraïbiana [Central Caribbean Catalog].* Leiden: Caraïbische Afdeling, Koninklijk Instituut voor Taal-, Land- en Volkenkunde; 1978–1989. [Microfiches] + manual (55 pp.). Continued by *Caribbean Abstracts* [#1609].

1616. *La centralización de los servicios en las bibliotecas académicas y de investigación: documentos oficiales.* Association of Caribbean University and Research Libraries, Conference (Sixth, 1974, Charlotte Amalie, V.I.). Caracas: Asociación de Bibliotecas Universitarias y de Investigación del Caribe; 1982. 188 pp.

1617. *Cuban Periodicals in the University of Pittsburgh Libraries.* Eduardo Lozano. 5th ed. Pittsburgh, PA: University of Pittsburgh Libraries; 1991. 172 pp.

1618. *Desarrollo económico y social de América Latina y el Caribe: índice anotado de publicaciones periódicas por países y documentos existentes en la biblioteca de la CEPAL.* United Nations, Economic Commission for Latin America, Library. Santiago, Chile: CEPAL; 1974. 222 pp.

1619. *The Development of Library Service in the West Indies Through Interlibrary Cooperation.* Alma Theodora Jordan. Metuchen, NJ: Scarecrow Press; 1970. 433 pp.

1620. *Directory of Information Units in Jamaica: Libraries, Archives, and Documentation Services.* Kingston: National Council on Libraries, Archives, and Documentation Services; 1980. 177 pp.

1621. *Guide des sources de l'histoire de l'Amérique latine et des Antilles dans les archives françaises.* Archives nationales (France). Paris: Les Archives; 1984. 711 pp.

1622. *A Guide to Cuban Collections in the United States.* Louis A. Pérez. New York, NY: Greenwood Press; 1991. 179 pp.

1623. *Guide to Libraries and Archives in Central America and the West Indies, Panama, Bermuda, and British Guiana: Supplemented with Information on Private Libraries, Bookbinding, Bookselling, and Printing.* Arthur E. Gropp. New Orleans, LA: Middle American Research Institute, Tulane University; 1941. 721 pp.

1624. *A Guide to Manuscript Sources for the History of Latin America and the Caribbean in the British Isles.* Peter Walne. London: Oxford University Press; 1973. 580 pp.

1625. *A Guide to Manuscript Sources in United States and West Indian Depositories Relating to the British West Indies During the Era of the American Revolution.* George F. Tyson. Wilmington, DE: Scholarly Resources; 1978. 96 pp.

1626. *A Guide to Records in the Leeward Islands.* Edward Cecil Baker. Oxford: B. Blackwell; 1965. 102 pp.

1627. *A Guide to Records in Barbados.* Michael John Chandler. Oxford: B. Blackwell; 1965. 204 pp.

1628. *A Guide to Records in the Windward Islands.* Edward Cecil Baker. Oxford: B. Blackwell; 1968. 95 pp.

1629. *A Guide to Source Materials for the Study of Barbados History, 1627–1834.* Jerome S. Handler. Carbondale, IL: Southern Illinois University Press; 1971. 205 pp. (+ Suppl. [1991]).

1630. *A Guide to the Records of Bermuda.* Helen Rowe. Hamilton: Bermuda Archives; 1980– 1 vol. (loose-leaf).

1631. *Guide to the Records of the Bahamas.* Gail Saunders, Edward Carson. Nassau: Govt. Printing Dept.; 1973–1980. 2 vols.

1632. *A Handbook of Latin American and Caribbean National Archives/Guía de los archivos nacionales de América Latina y el Caribe.* Ann Keith Nauman. Detroit, MI: Blaine Ethridge; 1983. 127 pp.

1633. *Información y desarrollo en el Caribe: documentos oficiales.* Association of Caribbean University and Research Libraries, Conference (Thirteenth, 1982, Caracas). Caracas: Asociación de Bibliotecas Universitarias, de Investigación e Institucionales del Caribe; 1983. 224 pp.

1634. *Inventory of French Documents Pertaining to the U.S. Virgin Islands (1642 to 1737).* Aimery Caron, ed. Charlotte Amalie, V.I.: Dept. of Conservation and Cultural Affairs, Bureau of Libraries, Museums, and Archaeological Services; 1978. 62 pp.

1635. *Libraries and Special Collections on Latin America and the Caribbean: A Directory of European Resources.* Roger Macdonald, Carole Travis. 2d ed. Atlantic Highlands, NJ: Athlone Press; 1988. 339 pp. Rev. ed. of *Directory of Libraries and Special Collections on Latin America and the West Indies,* by Bernard Naylor, Laurence Hallewell, and Colin Steele.

1636. *The Libraries of Bermuda, the Bahamas, the British West Indies, British Guiana, British Honduras, Puerto Rico, and the American Virgin Islands: A Report to the Carnegie Corporation of New York.* Ernest Albert Savage. London: Library Association; 1934. 102 pp.

1638. *Manuscripts Relating to Commonwealth Caribbean Countries in United States and Canadian Repositories.* Kenneth E. Ingram. St. Lawrence, Barbados: Caribbean Universities Press; 1975. 422 pp.

1639. *Maps and Charts of North America and the West Indies, 1750-1789: A Guide to the Collections in the Library of Congress.* John R. Sellers, Pa-

tricia Molen Van Ee. Washington, DC: Library of Congress; 1981. 495 pp.

1640. *Preliminary Report on Manuscript Materials in British Archives Relating to the American Revolution in the West Indian Islands.* George F. Tyson, Carolyn Tyson. Millwood, NY: Kraus Reprint; 1978. 56 pp. Reprint of the 1974 ed.

1641. *Los recursos bibliotecarios para la investigación en el Caribe: documentos oficiales/Library Resources for Research in the Caribbean: Official Documents.* Association of Caribbean University and Research Libraries, Conference (Third, 1971, Caracas). San Juan: Asociación de Bibliotecas Universitarias y de Investigación del Caribe; 1978. 459 pp.

1642. *Research Guide to Central America and the Caribbean.* Kenneth J. Grieb [et al.], eds. Madison, WI: University of Wisconsin Press; 1985. 431 pp.

1643. *Research Library Cooperation in the Caribbean.* Alma Theodora Jordan, ed. Chicago, IL: American Library Association; 1973. 143 pp.

1644. *Scholars' Guide to Washington, D.C., for Latin American and Caribbean Studies.* Michael Grow, William P. Glade, Joseph S. Tulchin; Zdeněk V. David, ed. 2d ed., rev. by Craig VanGrasstek. Washington, DC: Woodrow Wilson Center Press; 1992. 427 pp.

1645. *Sources for West Indian Studies: A Supplementary Listing, with Particular Reference to Manuscript Sources.* Kenneth E.,Ingram. Zug: Inter Documentation Co.; 1983. 412 pp.

1646. *Tinker Guide to Latin American and Caribbean Policy and Scholarly Resources in Metropolitan New York.* Ronald G. Hellman, Beth Kempler Pfannl. New York, NY: Bildner Center for Western Hemisphere Studies, Graduate School and University Center, City University of New York; 1988. 217 pp.

1647. *West Indian Primary Legal Materials: A Checklist of West Indian Law Reports, Mimeographed Judgments, Government Departmental Reports, Legislation and Parliamentary Records Held by the Faculty of Law Library on June 30th, 1977.* Velma Newton. Cave Hill, Barbados: Faculty of Law Library, University of the West Indies; 1977. 58 pp.

1648. *The West Indies: A Bibliography of the William L. Bryant Foundation Collection.* 2d ed., rev. and expanded. University of Central Florida, Library. Orlando, FL: The Library; 1990. 340 pp. First ed. has title *Bryant West Indies Collection: A Bibliography.*

1649. *Windward, Leeward, and Main: Caribbean Studies and Library Resources—Final Report.* Seminar on the Acquisition of Latin American Library Materials (Twenty-fourth, 1979, University of California, Los Angeles); Laurence Hallewell, ed. Madison, WI: SALALM Secretariat; 1980. 354 pp.

III. CONTEMPORARY WORKS

A. The Physical Terrain: Land and Resources

1. GEOGRAPHY

1650. *The Bahamas Today: An Introduction to the Human and Economic Geography of the Bahamas.* Neil E. Sealey. London: Macmillan Caribbean; 1990. 120 pp.

1651. *Bahamian Landscapes: An Introduction to the Geography of the Bahamas.* Neil E. Sealey. London: Collins Caribbean; 1985. 96 pp.

1652. *The Bermuda Islands: An Account of Their Scenery, Climate, Productions, Physiography, Natural History and Geology.* Addison Emery Verrill. New Haven, CT: A. E. Verrill; 1902. 548 pp.

1653. *The Caribbean in the Wider World, 1492–1992: A Regional Geography.* Bonham C. Richardson. New York, NY: Cambridge University Press; 1992. 235 pp.

1654. *Le climat des Antilles.* Pierre Pagney. Paris: Institut des hautes études de l'Amérique latine; 1966. 379 pp.

1655. *A Complete Geography of Jamaica.* Rupert Mortimer Bent, Enid Bent-Golding. London: Collins; 1966. 128 pp.

1656. *Elementos de geografía de Cuba.* Rolando Espinosa. Miami, FL: Editorial AIP; 1967. 116 pp.

1657. *A Gazetteer of Cuba.* Henry Gannett. Washington, DC: GPO; 1902. 112 pp.

1658. *A Gazetteer of Porto Rico.* Henry Gannett. Washington, DC: GPO; 1901. 51 pp.

1659. *Geografía de Cuba.* Antonio Núñez Jiménez. 4a ed. Havana: Editorial Pueblo y Educación; 1972. 4 vols.

1660. *Geografía de Cuba.* Leví Marrero, Gerardo A. Canet Alvarez. 5a ed., ampliada. Miami, FL: La Moderna Poesía; 1981. 707 pp.

1661. *La geografía en Santo Domingo.* Amparo Chantada. Santo Domingo: Universidad Autónoma de Santo Domingo; 1987. 388 pp.

1662. *Geography of Guyana: The Co-operative Republic.* Leslie P. Cummings. London: Collins; 1976. 64 pp. Reprint of the 1965 ed.

1663. *The Geography of Puerto Rico*. Rafael Picó. Chicago, IL: Aldine; 1974.
 439 pp. Based on his *Nueva geografía de Puerto Rico* (1969) and *The Ge-
 ographic Regions of Puerto Rico* (1950).

1664. *Geovisión de Puerto Rico: aportaciones recientes al estudio de la geo-
 grafía*. María Teresa Blanco de Galiñanes, ed. Río Piedras, P.R.: Editor-
 ial Universitaria, Universidad de Puerto Rico; 1977. 413 pp.

1665. *La Guadeloupe: étude géographique*. Guy Lasserre. Fort-de-France: E.
 Kolodziej; 1978. 3 vols. Reprint of the 1961 ed.

1666. *Historia de los temporales de Puerto Rico y las Antillas, 1492 a 1970*.
 Luis Alfredo Salivia. 2a ed., rev. y aum. San Juan: Editorial Edil; 1972.
 385 pp.

1667. *Hurricanes of the Caribbean and Adjacent Regions, 1492–1800*. José
 Carlos Millás. Miami, FL: Academy of the Arts and Sciences of the Amer-
 icas; 1968. 328 pp.

1668. *Hurricanes: Their Nature and History, Particularly Those of the West In-
 dies and the Southern Coasts of the United States*. Ivan Ray Tannehill.
 New York, NY: Greenwood Press; 1969. 257 pp. Reprint of the 1938 ed.

1669. *Introducción a la geografía de Cuba*. Salvador Massip, Sarah A. Ysalgué
 de Massip. Havana: [s.n.]; 1942. 250 pp.

1670. *Jamaica in Maps: Graphic Perspectives of a Developing Country*. Colin
 G. Clarke, Alan G. Hodgkiss. New York, NY: Africana; 1974. 104 pp.

1671. *Jamaica Surveyed: Plantation Maps and Plans of the Eighteenth and
 Nineteenth Centuries*. B. W. Higman. Kingston: Institute of Jamaica;
 1988. 307 pp.

1672. *Land Resources of the Bahamas: A Summary*. B. G. Little. Surbiton, Eng.:
 Land Resources Division, Ministry of Overseas Development; 1977. 133
 pp.

1673. *The Lesser Antilles*. William Morris Davis. New York, NY: American Ge-
 ographical Society; 1926. 207 pp.

1674. *Nelson's West Indian Geography: A New Study of the Commonwealth
 Caribbean and Guyana*. W. Williams-Bailey, Patricia Honor Pemberton.
 Rev. ed. London: Nelson; 1979. 164 pp.

1675. *Surinam: A Geographic Study*. John Warren Nystrom. New York, NY:
 Netherlands Information Bureau; 1942. 109 pp.

1676. *Symposium on the Geography of Puerto Rico*. Clarence Fielden Jones,
 Rafael Picó, eds. Río Piedras, P.R.: University of Puerto Rico Press; 1955.
 503 pp.

1677. *The West Indies: A Geography of the West Indies with Special Reference
 to the Commonwealth Islands and the Mainland Commonwealth Coun-
 tries of Guyana and Belize*. F. C. Evans. London: Cambridge University
 Press; 1973. 128 pp.

2. GEOLOGY

1678. *Antigua: Reefs, Rocks and Highroads of History.* H. Gray Multer, Malcolm Pickett Weiss, Desmond V. Nicholson. St. Johns, Antigua: Leeward Islands Science Associates; 1986. 1 vol. (various pagings).

1679. *The Bahama Islands.* George Burbank Shattuck, ed. New York, NY: Macmillan; 1905. 630 pp.

1680. *Caribbean Geological Investigations.* Harry Hammond Hess [et al.]. Boulder, CO: Geological Society of America; 1966. 310 pp.

1681. *Caribbean Geophysical, Tectonic, and Petrologic Studies.* Caribbean Geological Conference (Fifth, 1968, St. Thomas, V.I.); Thomas W. Donnelly, ed. Boulder, CO: Geological Society of America; 1971. 224 pp.

1682. *Caribbean Gravity Field and Plate Tectonics.* Carl Bowin. Boulder, CO: Geological Society of America; 1976. 79 pp.

1683. *The Caribbean Region.* Gabriel Dengo, James E. Case, eds. Boulder, CO: Geological Society of America; 1990. 528 pp.

1684. *The Caribbean–South American Plate Boundary and Regional Tectonics.* William Emory Bonini, Robert B. Hargraves, Reginald Shagam, eds. Boulder, CO: Geological Society of America; 1984. 421 pp.

1685. *Coastlines of the Caribbean.* Symposium on Coastal and Ocean Management (Seventh, 1991, Long Beach, CA); Gillian Cambers, ed. New York, NY: American Society of Civil Engineers; 1991. 187 pp.

1686. *Conceptions actuelles sur l'origine des Antilles.* Serge Warin. Pointe-à-Pitre: Centre départemental de documentation pédagogique de la Guadeloupe; 1981. 91 pp.

1687. *La constitution géologique et la structure des Antilles.* Jacques Butterlin. Paris: Centre national de la recherche scientifique; 1956. 442 pp.

1688. *Contribución a la geología de Cuba.* Yuri M. Pushcharovskiĭ [et al.]. Havana: Academia de Ciencias de Cuba; 1974. 183 pp.

1689. *Contributions to the Geology and Paleobiology of the Caribbean and Adjacent Areas.* Peter Jung, ed. Basel: Birkhäuser Verlag; 1974. 520 pp.

1690. *General and Economic Geology of Trinidad.* Hans Heinrich Suter. 2d ed. London: HMSO; 1960. 145 pp.

1691. *Geología de Cuba.* Gustavo Furrazola-Bermúdez [et al.]. Havana: Editora del Consejo Nacional de Universidades; 1964. 239 pp.

1692. *Geología del área del Caribe y de la costa del Golfo de México.* Constantino M. Judoley, Gustavo Furrazola-Bermúdez. Havana: Instituto Cubano del Libro; 1971. 286 pp.

1693. *Géologie générale et régionale de la République d'Haïti.* Jacques Butterlin. Paris: Institut des hautes études de l'Amérique latine; 1960. 194 pp.

1694. *Géologie structurale de la région des Caraïbes: Mexique, Amérique cen-trale, Antilles, cordillère caraïbe.* Jacques Butterlin. New York, NY: Masson; 1977. 259 pp.

1695. *Geology of Puerto Rico.* Howard Augustus Meyerhoff. San Juan: University of Puerto Rico; 1933. 306 pp.

1696. *The Geology of Saba and St. Eustatius: With Notes on the Geology of St. Kitts, Nevis and Montserrat (Lesser Antilles).* Jan Hugo Westermann, H. Kiel. Utrecht: Natuurwetenschappelijke Studiekring voor Suriname en de Nederlandse Antillen; 1961. 175 pp.

1697. *The Geology of the Goldfields of British Guiana.* John Burchmore Harrison, Frank Fowler, Charles Wilgress Anderson. London: Dulau; 1908. 320 pp.

1698. *The Geology of the Island of Trinidad, B.W.I.* Gerald Ashley Waring, Gilbert Dennison Harris. Baltimore, MD: Johns Hopkins University Press; 1926. 180 pp.

1699. *Geology of the Republic of Haiti.* Wendell Phillips Woodring, John Stafford Brown, Wilbur S. Burbank. Baltimore, MD: Lord Baltimore Press; 1924. 631 pp.

1700. *The Geology of Venezuela and Trinidad.* Ralph Alexander Liddle. 2d ed., rev. and enl. Ithaca, NY: Paleontological Research Institution; 1946. 890 pp.

1701. *Historical Geology of the Antillean-Caribbean Region; or, The Lands Bordering the Gulf of Mexico and the Caribbean Sea.* Charles Schuchert. New York, NY: Hafner; 1968. 811 pp. Reprint of the 1935 ed.

1702. *Minerals and Rocks of Jamaica: A Guide to Identification, Location, Occurrence and Geological History.* Anthony R. D. Porter, Trevor A. Jackson, Edward Robinson. Kingston: Jamaica Publishing House; 1982. 174 pp.

1703. *Natural Hazards in the Caribbean: Papers.* International Conference on Recent Advances in Caribbean Geology (1988, Kingston); Rafi Ahmad, ed. Mona, Jamaica: Geological Society of Jamaica; 1992. 108 pp.

1704. *Un reconocimiento geológico de la República Dominicana.* Thomas Wayland Vaughn. Santo Domingo: Editora de Santo Domingo; 1983. 302 pp. Reprint of the 1922 ed.

1705. *Reports on the Geology of the Leeward and British Virgin Islands.* Peter Hilary Alexander Martin-Kaye. Castries, St. Lucia: Voice Publishing; 1959. 117 pp.

1706. *Scientific Survey of Porto Rico and the Virgin Islands.* New York Academy of Sciences. New York, NY: The Academy; 1919–1942. 19 vols.

1707. *Stratification and Circulation in the Antillean-Caribbean Basins.* Georg Wüst. New York, NY: Columbia University Press; 1964. 2 vols.

1708. *Tropical Hydrology and Caribbean Water Resources: Proceedings.* International Symposium on Tropical Hydrology (1990, San Juan) [and] Caribbean Islands Water Resources Congress (Fourth, 1990, San Juan); J. Hari Krishna [et al.], eds. Bethesda, MD: American Water Resources Association; 1990. 570 pp.

1709. *West Indies Island Arcs.* Peter H. Mattson, ed. Stroudsburg, PA: Dowden, Hutchinson and Ross; 1977. 382 pp.

3. FLORA AND FAUNA

1710. *Amphibians and Reptiles of the West Indies: Descriptions, Distributions, and Natural History.* Albert Schwartz, Robert W. Henderson. Gainesville, FL: University of Florida Press; 1991. 720 pp.

1711. *Aves de la República Dominicana.* Annabelle Stockton Dod; José Osorio, Laura Rathe de Cambiaso [ill.]. 2a ed. Santo Domingo: Museo Nacional de Historia Natural; 1987. 354 pp.

1712. *Las aves de Puerto Rico.* Virgilio Biaggi. 3a ed., rev. y aum. Río Piedras, P.R.: Editorial Universitaria, Universidad de Puerto Rico; 1983. 373 pp.

1713. *Beneath the Seas of the West Indies: Caribbean, Bahamas, Florida, Bermuda.* Hans W. Hannau, Bernd H. Mock. London: Hale; 1984. 104 pp. Reprint of the 1973 ed.

1714. *Birds of the Caribbean.* Robert Porter Allen. New York, NY: Viking Press; 1961. 256 pp.

1715. *Birds of the West Indies.* James Bond. Norwalk, CT: Easton Press; 1990. 256 pp. Reprint of the 1961 (1st American) ed.

1716. *Butterflies and Other Insects of the Eastern Caribbean.* Peter D. Stiling. London: Macmillan Caribbean; 1986. 85 pp.

1717. *The Butterflies of Hispaniola.* Albert Schwartz. Gainesville, FL: University Press of Florida; 1989. 580 pp.

1718. *Caribbean Flora.* Charles Dennis Adams. London: Nelson Caribbean; 1976. 61 pp.

1719. *Caribbean Gardening.* Aimée Webster. 3d ed., updated and enl. [S.l.: s.n.]; 1986. 167 pp.

1720. *Caribbean Marine Resources: Opportunities for Economic Development and Management.* United States, Agency for International Development [and] United States, National Oceanic and Atmospheric Administration. Washington, DC: U.S. Agency for International Development; 1987. 91 pp.

1721. *Caribbean Reef Fishes.* John E. Randall. 2d ed., rev. Neptune City, NJ: T.F.H. Publications; 1983. 350 pp.

1722. *Caribbean Reef Invertebrates and Plants: A Field Guide to the Invertebrates and Plants Occurring on Coral Reefs of the Caribbean, the Bahamas and Florida.* Patrick L. Colin. Neptune City, NJ: T.F.H. Publications; 1978. 512 pp.

1723. *Caribbean Seashells: A Guide to the Marine Mollusks of Puerto Rico and Other West Indian Islands, Bermuda and the Lower Florida Keys.* Germaine Le Clerc Warmke, Robert Tucker Abbott. New York, NY: Dover; 1975. 348 pp. Reprint of the 1961 ed.

1724. *Caribbean Treasure.* Ivan Terence Sanderson. New York, NY: Viking Press; 1945. 292 pp. Reprint of the 1939 ed.

1725. *Caribbean Wild Plants and Their Uses: An Illustrated Guide to Some Medicinal and Wild Ornamental Plants of the West Indies.* Penelope N. Honychurch. London: Macmillan Caribbean; 1980. 163 pp.

1726. *Common Trees of Puerto Rico and the Virgin Islands.* Elbert Luther Little, Frank Howard Wadsworth, Roy O. Woodbury. Washington, DC: [s.n.]; 1989. 2 vols. Vol. 2 has title *Trees of Puerto Rico and the Virgin Islands;* reprint, with an added suppl., of the 1964–1974 ed.

1727. *The Ephemeral Islands: A Natural History of the Bahamas.* David G. Campbell. London: Macmillan; 1978. 151 pp.

1728. *A Field Guide to Coral Reefs: Caribbean and Florida.* Eugene Herbert Kaplan. Boston, MA: Houghton Mifflin; 1988. 289 pp. Reprint of the 1982 ed. published under title *A Field Guide to Coral Reefs of the Caribbean and Florida.*

1729. *A Field Guide to Southeastern and Caribbean Seashores: Cape Hatteras to the Gulf Coast, Florida, and the Caribbean.* Eugene Herbert Kaplan. Boston, MA: Houghton Mifflin; 1988. 425 pp.

1730. *A Field Guide to the Butterflies of the West Indies.* Norman Denbigh Riley. New York, NY: Quadrangle; 1975. 224 pp.

1731. *Fishery Management Options for Lesser Antilles Countries: Antigua and Barbuda, Barbados, Dominica, Grenada, Saint Kitts and Nevis, Saint Lucia, Saint Vincent and the Grenadines.* Robin Mahon. Rome: Food and Agriculture Organization of the United Nations; 1990. 126 pp.

1732. *Fishes of the Caribbean Reefs.* Ian F. Took. London: Macmillan Caribbean; 1984. 92 pp. Reprint of the 1979 ed.

1733. *Flora de Cuba.* Brother León, Brother Alain. Koenigstein, Germany: Koeltz Science Publishers; 1974. 5 vols. in 3. Reprint of the 1946–1953 ed.

1734. *Flora of Hispaniola.* Alain H. Liogier. Plainfield, NJ [etc.]: Moldenke [etc.]; 1981– [vols. 1–5+]. Vols. [3–5+] published in San Pedro de Macorís, D.R. by the Universidad Central del Este under title *La flora de la Española.*

1735. *Flora of Jamaica: Containing Descriptions of the Flowering Plants Known from the Island.* William Fawcett, Alfred Barton Rendle. Dehra Dun, India: Bishen Singh Mahendra Pal Singh; 1982– [vol. 1–]. Reprint of the 1910 ed.

1736. *Flora of Puerto Rico and Adjacent Islands: A Systematic Synopsis.* Alain H. Liogier, Luis F. Martorell. Río Piedras, P.R.: Editorial de la Universidad de Puerto Rico; 1982. 342 pp.

1737. *Flora of the Bahamian Archipelago: Including the Turks and Caicos Islands.* Donovan Stewart Correll, Helen B. Correll. Vaduz: J. Cramer; 1982. 1,692 pp.

1738. *Flora of the Lesser Antilles: Leeward and Windward Islands.* Richard A. Howard, ed. Jamaica Plain, MA: Arnold Arboretum, Harvard University; 1974– [vols. 1–3+].

1739. *Flowers from St. Martin: The Nineteenth Century Watercolours of Westindian Plants Painted by Hendrik van Rijgersma.* Henry E. Coomans, Maritza Coomans-Eustatia. Zutphen: Walburg Pers; 1988. 159 pp.

1740. *Flowers of the Caribbean.* G. William Lennox, S. Anthony Seddon. London: Macmillan Caribbean; 1989. 72 pp. Reprint of the 1978 ed.

1741. *Forest Research Within the Caribbean Area.* Arthur Thaddeus Upson, ed. Washington, DC: Committee on Agriculture, Nutrition, Fisheries and Forestry, Caribbean Research Council; 1947. 128 pp.

1742. *Glimpses of Jamaican Natural History.* C. Bernard Lewis, ed. 2d ed. Kingston: Institute of Jamaica; 1946–1949. 2 vols.

1743. *Guide to Corals and Fishes of Florida, the Bahamas and the Caribbean.* Idaz Greenberg, Jerry Greenberg. Miami, FL: Seahawk Press; 1986. 64 pp. Reprint of the 1977 ed.

1744. *Hacia una farmacopea caribeña: investigación científica y uso popular de plantas medicinales en el Caribe.* Seminario TRAMIL (Fourth, 1989, Tela, Honduras); Lionel Robineau, ed. Santo Domingo: Enda-Caribe; 1991. 474 pp.

1745. *The Herpetology of Hispaniola.* Doris Mabel Cochran. Washington, DC: GPO; 1941. 398 pp.

1746. *The Integration of Marine Space in National Development Strategies of Small Island States: The Case of the Caribbean States of Grenada and St. Lucia.* Carlyle L. Mitchell, Edgar Gold. Halifax, N.S.: Dalhousie Ocean Studies Programme; 1982. 346 pp.

1747. *The Islands and the Sea: Five Centuries of Nature Writing from the Caribbean.* John A. Murray, ed. New York, NY: Oxford University Press; 1991. 329 pp.

1748. *Jaguar: One Man's Battle to Establish the World's First Jaguar Preserve.* Alan Rabinowitz. New York, NY: Anchor Books; 1991. 370 pp. Reprint

of the 1986 ed. published under title *Jaguar: Struggle and Triumph in the Jungles of Belize.*

1749. *Journey to Red Birds.* Jan Lindblad; Gweynne Vevers, tr. New York, NY: Hill and Wang; 1969. 176 pp. Translation of: *Resa till röda fåglar;* about Trinidad.

1750. *Jungle Peace.* William Beebe. New York, NY: Modern Library; 1925. 297 pp. Reprint of the 1918 ed.; about Guyana.

1751. *Man and the Variable Vulnerability of Island Life: A Study of Recent Vegetation Change in the Bahamas.* Roger Byrne. Washington, DC: Smithsonian Institution; 1980. 200 pp.

1752. *Man's Influence on the Vegetation of Barbados, 1627 to 1800.* H. David Watts. Hull, Eng.: University of Hull; 1966. 96 pp.

1753. *Marine Life of the Caribbean.* Alick Rowe Jones, Nancy Sefton. London: Macmillan Caribbean; 1988. 90 pp. Reprint of the 1979 ed.

1754. *Marine Plants of the Caribbean: A Field Guide from Florida to Brazil.* Diane Scullion Littler [et al.]. Washington, DC: Smithsonian Institution Press; 1989. 263 pp.

1755. *Martinique Revisited: The Changing Plant Geographies of a West Indian Island.* Clarissa Thérèse Kimber. College Station, TX: Texas A & M University Press; 1988. 458 pp.

1756. *A Natural History of the Island of Grenada, West Indies.* John R. Groome. Port of Spain: Caribbean Printers; 1970. 115 pp.

1757. *The Natural Vegetation of the Windward and Leeward Islands.* John Stewart Beard. Oxford: Clarendon Press; 1949. 192 pp.

1758. *A Naturalist in Cuba.* Thomas Barbour. Boston, MA: Little, Brown; 1945. 317 pp.

1759. *A Naturalist in the Bahamas.* John I. Northrop; Henry Fairfield Osborn, ed. New York, NY: AMS Press; 1967. 281 pp. Reprint of the 1910 ed.

1760. *A Naturalist in the Guiana Forest.* Richard William George Hingston. New York, NY: Longmans, Green; 1932. 384 pp.

1761. *A Naturalist in Trinidad.* Charles Brooke Worth. Philadelphia, PA: Lippincott; 1967. 292 pp.

1762. *A Naturalist on Desert Islands.* Percy Roycroft Lowe. New York, NY: Scribner's; 1911. 230 pp.

1763. *The Orchids of Puerto Rico and the Virgin Islands/Las orquídeas de Puerto Rico y de las Islas Vírgenes.* James David Ackerman; María del Castillo [ill.]. Río Piedras, P.R.: Editorial de la Universidad de Puerto Rico; 1992. 167 pp.

1764. *Parrots' Wood.* Erma J. Fisk. New York, NY: Norton; 1985. 240 pp. About Belize.

1765. *Plantas medicinales de Puerto Rico y del Caribe.* Alain H. Liogier. San Juan: Iberoamericana de Ediciones; 1990. 566 pp.

1766. *Plantas venenosas de Puerto Rico (y las que producen dermatitis).* Esteban Núñez-Meléndez. Río Piedras, P.R.: Editorial de la Universidad de Puerto Rico; 1990. 290 pp.

1767. *Plantes fabuleuses des Antilles.* Claude Sastre, Jacques Portécop. Paris: Editions caribéennes; 1985. 187 pp.

1768. *Quelques aspects de la nature aux Antilles.* Robert Pinchon. Fort-de-France: Ozanne; 1967. 254 pp.

1769. *Reptiles of the Eastern Caribbean.* Garth Underwood. Mona, Jamaica: Dept. of Extra-Mural Studies, University of the West Indies; 1962. 192 pp.

1770. *Safari, South America [The Saki Monkeys of Guyana and Other Wildlife].* Christina Wood. New York, NY: Taplinger; 1973. 224 pp. British ed. has title *The Magic Sakis.*

1771. *Sea Shells of the West Indies: A Guide to the Marine Molluscs of the Caribbean.* Michael Humfrey. New York, NY: Taplinger; 1975. 351 pp.

1772. *Sea Turtles and the Turtle Industry of the West Indies, Florida, and the Gulf of Mexico.* Thomas Paul Rebel. Rev. ed. Coral Gables, FL: University of Miami Press; 1974. 250 pp. First ed. (1949) by Robert M. Ingle and Frederick George Walton Smith.

1773. *Seashell Treasures of the Caribbean.* Lesley Sutty; Robert Tucker Abbott, ed. New York, NY: E. P. Dutton; 1986. 128 pp. Translation of *Cent coquillages rares des Antilles.*

1774. *Studies on the Fauna of Curaçao, Aruba, Bonaire and the Venezuelan Islands.* Pieter Wagenaar Hummelinck, ed. Boston, MA: M. Nijhoff; 1940– [vols. 1–4+]. Vols. 4+ (1988–) have title *Studies on the Fauna of Curaçao and Other Caribbean Islands.*

1775. *Studies on the Fauna of Suriname and Other Guyanas.* D. C. Geijakes, Pieter Wagenaar Hummelinck. Boston, MA: M. Nijhoff; 1957– [vols. 1–11+].

1776. *Trees of the Caribbean.* S. Anthony Seddon, G. William Lennox. London: Macmillan Caribbean; 1980. 74 pp.

1777. *The Useful and Ornamental Plants in Trinidad and Tobago.* William George Freeman, Robert Orchard Williams, Robert Orchard Williams, Jr. 4th ed., rev. Port of Spain: Guardian Commercial Printery; 1951. 335 pp.

1778. *The Windward Road: Adventures of a Naturalist on Remote Caribbean Shores.* Archie Fairly Carr. Tallahassee, FL: University Presses of Florida; 1979. 266 pp. Reprint, with a new pref., of the 1956 ed.

1779. *Zoo Quest to Guiana.* David Attenborough. New York, NY: Crowell; 1957. 252 pp.

4. ECOLOGY AND ENVIRONMENTAL PROTECTION

1780. *Bermuda's Delicate Balance: People and the Environment.* Stuart J. Hayward, Vicki Holt Gomez, Wolfgang Sterrer, eds. Hamilton: Bermuda National Trust; 1981. 402 pp.

1781. *Biodiversity and Conservation in the Caribbean: Profiles of Selected Islands.* Timothy H. Johnson. Cambridge: International Council for Bird Preservation; 1988. 144 pp.

1782. *Caribbean Ecology and Economics.* Norman Girvan, David Alan Simmons, eds. St. Michael, Barbados: Caribbean Conservation Association; 1991. 260 pp.

1783. *The Caribbean Peoples and Their Environment: Papers.* Commonwealth Conference on Development and Human Ecology (Fifth, 1979, Georgetown); Michael Pugh Thomas, ed. London: Commonwealth Human Ecology Council; 1982. 255 pp.

1784. *The Caribbean Seminars on Environmental Impact Assessment: Case Studies.* Tighe Geoghegan, ed. Cave Hill, Barbados: Centre for Resource Management and Environmental Studies, University of the West Indies; 1986. 189 pp.

1785. *The Caribbean: Natural Resources.* Conference on the Caribbean (Ninth, 1958, University of Florida); Alva Curtis Wilgus, ed. Gainesville, FL: University of Florida Press; 1961. 315 pp.

1786. *Conservation and Caribbean Regional Progress.* Carl A. Carlozzi, Alice A. Carlozzi. Yellow Springs, OH: Antioch Press; 1968. 151 pp.

1787. *Conservation in the Eastern Caribbean: Proceedings.* Eastern Caribbean Conservation Conference (First, 1965, St. John, V.I.). Charlotte Amalie, V.I.: Caribbean Research Institute; 1965. 252 pp.

1788. *Cultura, ambiente, desarrollo: el caso del Caribe insular.* Andrés Bansart. Caracas: Instituto de Altos Estudios de América Latina, Universidad Simón Bolívar; 1991. 274 pp.

1789. *Environment and Resources: From Conservation to Ecomanagement.* Jaro Mayda. Río Piedras, P.R.: School of Law, University of Puerto Rico; 1968. 254 pp.

1790. *Environmental Issues with Special Reference to Antigua-Barbuda: Including Environmental Education Activities.* Eustace Hill, Kate Irvine, Candia Williams. Cave Hill, Barbados: Centre for Resource Management and Environmental Studies, University of the West Indies; 1991. 79 pp.

1791. *Environmental Laws of the Commonwealth Caribbean: Analysis and Needs Assessment.* Duke E. Pollard, ed. Bridgetown: Caribbean Law Institute; 1991. 518 pp.

1792. *Essai sur le milieu naturel de la Guyane française*. Philippe Blanca-neaux. Paris: Office de la recherche scientifique et technique outre-mer (ORSTOM); 1981. 126 pp.

1793. *Flora and Fauna of the Caribbean: An Introduction to the Ecology of the West Indies*. Peter R. Bacon. Port of Spain: Key Caribbean; 1978. 319 pp.

1794. *The Natural Resources of Trinidad and Tobago*. St. George Clerona Cooper, Peter R. Bacon, eds. London: E. Arnold; 1981. 223 pp.

1795. *Nature Preservation in the Caribbean: A Review of Literature on the Destruction of Flora and Fauna in the Caribbean Area*. Jan Hugo Wester-mann. Utrecht: Natuurwetenschappelijke Studiekring voor Suriname en de Nederlandse Antillen; 1953. 106 pp.

1796. *Perceptions of the Environment: A Selection of Interpretative Essays*. Yves Renard, ed. Bridgetown: Caribbean Conservation Association; 1980. 87 pp.

1797. *Plants, Animals, and Man in the Outer Leeward Islands, West Indies: An Ecological Study of Antigua, Barbuda, and Anguilla*. David Russell Harris. Berkeley, CA: University of California Press; 1965. 184 pp.

1798. *The Puerto Rico Plan: Environmental Protection Through Development Rights Transfer*. John J. Costonis, Robert S. DeVoy. Washington, DC: Urban Land Institute; 1975. 52 pp.

1799. *Quelques notions d'écologie antillaise*. Robert Pinchon. Fort-de-France: Impr. Ozanne; 1971. 62 pp.

1800. *La situación ambiental en Centroamérica y el Caribe*. Ingemar Hedström, ed. San José, C.R.: Editorial DEI; 1989. 318 pp.

1801. *Survey of Conservation Priorities in the Lesser Antilles: Country Environmental Profiles*. Eastern Caribbean Natural Area Management Program [and] Caribbean Conservation Association [and] University of Michigan, School of Natural Resources. Christiansted, V.I.: The Program; 1980–1991. 25 vols. (+ Final Report [30 pp.] by Allen D. Putney).

1802. *The Voyage of Sabra: An Ecological Cruise Through the Caribbean, with Extras*. Michael L. Frankel. New York, NY: Norton; 1990. 256 pp.

5. DESCRIPTION AND TRAVEL

1803. *Adventure in Belize*. Robert P. L. Straughan. South Brunswick, NJ: A. S. Barnes; 1975. 215 pp.

1804. *Angry Men, Laughing Men: The Caribbean Caldron*. Wenzell Brown. New York, NY: Greenberg; 1947. 369 pp.

1805. *Antilles*. Robert Hollier. Paris: Seuil; 1976. 189 pp.

1806. *Around the Spanish Main: Travels in the Caribbean and the Guianas*. Hugh O'Shaughnessy. London: Century; 1991. 183 pp.

1807. *The Barbados Book*. Louis Lynch. 2d ed. rev. by E. L. Cozier. New York, NY: Coward, McCann and Geoghegan; 1973. 262 pp.

1808. *Barbados: Our Island Home*. F. A. Hoyos. 4th ed. London: Macmillan Caribbean; 1989. 224 pp.

1809. *Beautiful Jamaica*. Evon Blake. 6th ed. Kingston: Kingston Publishers; 1991. 220 pp.

1810. *Behind the Lianas: Exploration in French Guiana*. Henry A. Larsen, May Pellaton; A. Reid, G. Reid, trs. Edinburgh: Oliver and Boyd; 1958. 211 pp. Translation of *Pirogues sous les lianes*.

1811. *Behold the West Indies*. Amy Ewing Oakley. New York, NY: Longmans, Green; 1951. 540 pp. Reprint of the 1941 ed.

1812. *Bermudiana*. Ronald John Williams; Walter Rutherford [ill.]. New York, NY: Rinehart; 1946. 249 pp.

1813. *Best Nightmare on Earth: A Life in Haiti*. Herbert Gold. New York, NY: Prentice Hall; 1991. 303 pp.

1814. *Black Caribbean*. Reginald William Thompson. London: MacDonald; 1946. 286 pp.

1815. *Black Martinique, Red Guiana*. Nicol Smith. Indianapolis, IN: Bobbs-Merrill; 1942. 312 pp.

1816. *Bonjour Blanc: A Journey Through Haiti*. Ian Thomson. London: Hutchinson; 1992. 352 pp.

1817. *Bons baisers de la colonie: la Guadeloupe en 1900*. Jean-Michel Renault. Montpellier: Editions du Pélican; 1991. 159 pp.

1818. *The Book of the West Indies*. Alpheus Hyatt Verrill. New York, NY: Dutton; 1917. 458 pp.

1819. *Caribbean Circuit*. Harry Luke. London: Nicholson and Watson; 1950. 262 pp.

1820. *The Caribbean Heritage*. Virginia Radcliffe. New York, NY: Walker; 1976. 271 pp.

1821. *The Caribbean Islands*. Helmut Blume; Johannes Maczewski, Ann Norton, trs. London: Longman; 1976. 464 pp. Translation of *Die Westindischen Inseln*.

1822. *The Caribbean Islands*. Mary Slater. New York, NY: Viking Press; 1968. 244 pp.

1823. *Caribbean Isles*. Peter Wood. New York, NY: Time-Life Books; 1981. 184 pp. Reprint of the 1975 ed.

1824. *The Caribbean: A Journey with Pictures*. Fritz Henle, P. E. Knapp. New York, NY: Studio Publications; 1957. 207 pp.

1825. *The Caribbean: Essence of the Islands.* Bill Smith. Boston, MA: Bulfinch Press; 1989. 160 pp.

1826. *Caribbee Cruise: A Book of the West Indies.* John Womack Vandercook. New York, NY: Reynal and Hitchcock; 1938. 349 pp.

1827. *Cartas desde Cuba.* Fredrika Bremer; Margarita Goulard, tr. Havana: Editorial Arte y Literatura; 1980. 199 pp. Translation of *Hemmen i den Nya verlden.*

1828. *The Cradle of the Deep: An Account of a Voyage to the West Indies.* Frederick Treves. New York, NY: Dutton; 1934. 378 pp. Reprint of the 1908 ed.

1829. *Crusoe's Island in the Caribbean.* Heath Bowman, Jefferson Bowman. New York, NY: Bobbs-Merrill; 1939. 339 pp. About Tobago.

1830. *Cuba in the 1850's: Through the Lens of Charles DeForest Fredricks.* Robert M. Levine. Tampa, FL: University of South Florida Press; 1990. 86 pp.

1831. *Cuba Today.* Lee Chadwick. Westport, CT: L. Hill; 1976. 212 pp. British ed. has title *A Cuban Journey.*

1832. *Cuba.* Erna Fergusson. New York, NY: Knopf; 1946. 308 pp.

1833. *Cuba: A Journey.* Jacobo Timerman; Toby Talbot, tr. New York, NY: Vintage Books; 1992. 129 pp. Translation of *Cuba hoy y después.*

1834. *De San Juan a Ponce en el tren/From San Juan to Ponce on the Train.* Jack Delano. Río Piedras, P.R.: Editorial de la Universidad de Puerto Rico; 1990. 123 pp.

1835. *Driving Through Cuba: Rare Encounters in the Land of Sugar Cane and Revolution.* Carlo Gébler. New York, NY: Simon and Schuster; 1988. 293 pp.

1836. *Ethiopia in Exile: Jamaica Revisited.* Bessie Pullen-Burry. Freeport, NY: Books for Libraries Press; 1971. 288 pp. Reprint of the 1905 ed.

1837. *The European Possessions in the Caribbean Area: A Compilation of Facts Concerning Their Population, Physical Geography, Resources, Industries, Trade, Government and Strategic Importance.* Raye Roberts Platt [et al.]. New York, NY: American Geographical Society; 1941. 112 pp.

1838. *The Fortunate Islands: Being Adventures with the Negro in the Bahamas.* Amelia Dorothy Defries. London: C. Palmer; 1929. 160 pp.

1839. *La France d'Amérique: Martinique, Guadeloupe, Guyane, Saint-Pierre et Miquelon.* Eugène Revert. 2e éd., refondue et mise à jour. Paris: Société d'éditions géographiques, maritimes et coloniales; 1955. 255 pp.

1840. *Golden Islands of the Caribbean.* Fred Ward; Ted Spiegel [ill.]. New York, NY: Crown Publishers; 1972. 160 pp.

1841. *Green Turtle Cay: An Island in the Bahamas.* Alan G. LaFlamme. Prospect Heights, IL: Waveland Press; 1985. 110 pp.

1842. *The Grenadines: Undiscovered Islands of the Caribbean.* Bruce G. Lynn. Hollywood, FL: Dukane Press; 1968. 52 pp.

1843. *Guadeloupe and Its Islands: French West Indies.* Roger Fortuné; Bernard Gérard, René Moser [ill.]; Mostyn Mowbray, tr. New York, NY: Vilo; 1982. 160 pp. Translation of *La Guadeloupe et ses îles.*

1844. *Guadeloupe [Guadeloupe, Marie Galante, La Désirade, Les Saintes, Saint Barthélémy, Saint Martin].* Maryse Condé; Jean Du Boisberranger [ill.]. Paris: Richer; 1988. 126 pp.

1845. *Guyane française: terre de l'espace.* Alix Resse. Paris: Berger-Levrault; 1964. 232 pp.

1846. *Haiti in Pictures.* Lerner Publications Company, Geography Dept. Rev. ed. Minneapolis, MN: The Company; 1989. 64 pp. First ed. by Ken Weddle.

1847. *Haiti.* Michèle Montas; Bernard Hermann [ill.]. New York, NY: Two Continents Publishing Group; 1976. 128 pp.

1848. *Haiti: Black Peasants and Voodoo.* Alfred Métraux; Peter Lengyel, tr. New York, NY: Universe Books; 1960. 109 pp. Translation of *Haïti, la terre, les hommes et les dieux;* British ed. has title *Haiti: Black Peasants and Their Religion.*

1849. *Haiti: Its Dawn of Progress After Years in a Night of Revolution.* John Dryden Kuser. Westport, CT: Negro Universities Press; 1970. 108 pp. Reprint of the 1921 ed.

1850. *Highway Across the West Indies.* Herbert Charles Lanks. New York, NY: Appleton-Century-Crofts; 1948. 197 pp.

1851. *In Cuba.* Ernesto Cardenal; Donald D. Walsh, tr. New York, NY: New Directions; 1974. 340 pp. Translation of *En Cuba.*

1852. *In the West Indies: Sketches and Studies in Tropic Seas and Islands.* John Charles Van Dyke. New York, NY: Scribner's; 1932. 211 pp.

1853. *Inside Belize.* Tom Barry. Albuquerque, NM: Inter-Hemispheric Education Resource Center; 1992. 193 pp.

1854. *Inside Cuba Today.* Fred Ward. New York, NY: Crown Publishers; 1978. 308 pp.

1855. *La isla de Cuba en el siglo XIX vista por los extranjeros.* Juan Pérez de la Riva, ed. Havana: Editorial de Ciencias Sociales; 1981. 265 pp.

1856. *Isla de la simpatía.* Juan Ramón Jiménez; Arcadio Díaz Quiñones, Raquel Sárraga, eds. Río Piedras, P.R.: Ediciones Huracán; 1981. 117 pp. About Puerto Rico.

1857. *The Islands of Bermuda: Another World.* David F. Raine. London: Macmillan Caribbean; 1990. 144 pp.

1858. *Islands on Guard.* Helen Follett. New York, NY: Scribner's; 1943. 170 pp.

1859. *Islands to Windward: Cruising the Caribbees.* Carleton Mitchell. 2d ed. New York, NY: Van Nostrand; 1955. 295 pp.

1860. *Isles of Eden: Life in the Southern Family Islands of the Bahamas.* Harvey Lloyd. Akron, OH: Benjamin; 1991. 90 pp.

1861. *Isles of Spice and Palm.* Alpheus Hyatt Verrill. New York, NY: D. Appleton; 1915. 203 pp.

1862. *Isles of the Caribbean.* National Geographic Society (U.S.), Special Publications Division. Washington, DC: The Society; 1980. 215 pp. Reprint of the 1971 ed. by Carleton Mitchell published under title *Isles of the Caribbees.*

1863. *Jamaica: An Island Microcosm.* Barry Floyd. New York, NY: St. Martin's Press; 1979. 164 pp.

1864. *Jamaica: Babylon on a Thin Wire.* Adrian Boot, Michael Thomas. New York, NY: Schocken Books; 1977. 93 pp.

1865. *Jamaica: Land of Wood and Water.* Fernando Henriques. New York, NY: London House and Maxwell; 1964. 217 pp. Reprint of the 1957 ed.

1866. *Jamaica: The Fairest Isle.* Philip Manderson Sherlock, Barbara Preston. [New ed.]. London: Macmillan; 1992. 212 pp. Previous ed. has title *Keeping Company with Jamaica.*

1867. *Jamaica: The Land, the People.* Christopher Issa, ed. Kingston: Hampton and Brooks Caribbean; 1989. 68 pp.

1868. *Journey to Guyana.* Margaret Bacon. Highworth, Eng.: Hill House; 1988. 208 pp. Reprint of the 1970 ed.

1869. *The Jungles of Dutch Guiana: Bush Master.* Nicol Smith. Garden City, NY: Blue Ribbon Books; 1943. 315 pp. Reprint of the 1941 ed. published under title *Bush Master.*

1870. *Katherine Dunham's Journey to Accompong.* Katherine Dunham. Westport, CT: Negro Universities Press; 1971. 162 pp. Reprint of the 1946 ed.

1871. *The Land Columbus Loved: The Dominican Republic.* Bertita Harding. New York, NY: Gordon Press; 1978. 246 pp. Reprint of the 1949 ed.

1872. *Lands of the Inner Sea: The West Indies and Bermuda.* Walter Adolphe Roberts. New York, NY: Coward-McCann; 1948. 301 pp.

1873. *Love and the Caribbean: Tales, Characters and Scenes of the West Indies.* Alec Waugh. New York, NY: Paragon House; 1991. 310 pp. Reprint of the 1959 ed.

1874. *Martinique et Guadeloupe: terres françaises des Antilles.* Jean Jacques Bourgois. Paris: Horizons de France; 1958. 154 pp.

1875. *Martinique, French West Indies*. Robert Rose-Rosette; Bernard Gérard [ill.]; Mostyn Mowbray, tr. New York, NY: Vilo; 1982. 168 pp. Translation of *Martinique, terre française*.

1876. *The Middle Passage: Impressions of Five Societies—British, French, and Dutch—in the West Indies and South America*. V. S. Naipaul. New York, NY: Vintage Books; 1981. 232 pp. Reprint of the 1962 ed.

1877. *Le monde caraïbe: entre les deux Amériques*. Eugène Revert. Paris: Editions françaises; 1958. 252 pp.

1878. *Netherlands America: The Dutch Territories in the West*. Philip Hanson Hiss. New York, NY: Duell, Sloan and Pearce; 1943. 225 pp.

1879. *The Netherlands West Indies: The Islands and Their People*. Willem van de Poll; Joop Dolman, tr. The Hague: Van Hoeve; 1951. 60 pp. Translation of *De Nederlandse Antillen*.

1880. *The Netherlands Windward Islands; or, The Windward Group of the Netherlands Antilles*. S. J. Kruythoff. 3d ed. Oranjestad: De Wit; 1964. 133 pp. First ed. has title *The Netherlands Windward Islands and a Few Interesting Items on French St. Martin*.

1881. *Nevis: Queen of the Caribees*. Joyce Gordon. 2d ed. London: Macmillan Caribbean; 1990. 104 pp.

1882. *Ninety Miles from Home: The Face of Cuba Today*. Warren Miller. Boston, MA: Little, Brown; 1961. 279 pp. British ed. has title *The Lost Plantation*.

1883. *Noel Norton's Trinidad and Tobago*. Noel Norton; Geoffrey MacLean, ed. Port of Spain: Aquarela Galleries; 1988. 156 pp.

1884. *Orchids on the Calabash Tree*. George Teeple Eggleston. New York, NY: Putnam; 1970. 255 pp. Reprint of the 1962 ed.; about Saint Lucia.

1885. *The Other Puerto Rico*. Kathryn Robinson. Santurce, P.R.: Permanent Press; 1992. 158 pp. Reprint of the 1984 ed.

1886. *Our West Indian Neighbors: The Islands of the Caribbean Sea, "America's Mediterranean."* Frederick Albion Ober. New York, NY: J. Pott; 1916. 433 pp. Reprint of the 1904 ed.

1887. *País de sol y sonrisas, República Dominicana/Sunshine and Smiles/Soleil et sourires*. Wifredo García, Wolfgang Scheidig. 2a ed. Santo Domingo: Editora Tele 3; 1988. 224 pp.

1888. *Paysages de la Guadeloupe*. Joseph Coussin. Basse-Terre: Société d'histoire de la Guadeloupe; 1986. 125 pp.

1889. *The People and Places of Jamaica*. Sandy Lesberg, Nicolai Canetti [ill.]. New York, NY: Peebles Press International; 1976. 125 pp.

1890. *The People Time Forgot: A Photographic Portrayal of the People of the Cayman Islands*. H. G. Novak [et al.]. Grand Cayman: Cayman Free Press; 1987. 1 vol. (various pagings).

1891. *Pleasure Island: The Book of Jamaica.* Esther Chapman, ed. 5th ed. Kingston: Arawak Press; 1961. 324 pp.

1892. *The Pocket Guide to the West Indies and British Guiana, British Honduras, Bermuda, the Spanish Main, Surinam, the Panama Canal.* Algernon Edward Aspinall. 10th rev. ed. (reprinted with corrections) by John Sydney Dash. London: Methuen; 1960. 474 pp.

1893. *Portrait of Cuba.* Wayne S. Smith; Michael Reagan [ill.]; James W. Porges, ed. Atlanta, GA: Turner; 1991. 192 pp.

1894. *Puerto Rico mío: Four Decades of Change/cuatro décadas de cambio.* Jack Delano [ill]. Washington, DC: Smithsonian Institution Press; 1990. 229 pp.

1895. *Puerto Rico: A Guide to the Island of Boriquén.* United States, Puerto Rico Reconstruction Administration [and] Writers' Program (Puerto Rico). New York, NY: Gordon Press; 1977. 409 pp. Reprint of the 1940 ed.

1896. *La República Dominicana: tesoro del Caribe.* Domingo Batista, Julio González. Santiago de los Caballeros, D.R.: Grupo Financiero Popular; 1988. 203 pp.

1897. *Roaming Through the West Indies.* Harry Alverson Franck. New York, NY: Blue Ribbon Books; 1930. 486 pp. Reprint of the 1920 ed.

1898. *Sambumbia: A Discovery of the Dominican Republic, the Modern Hispaniola.* Page Cooper. New York, NY: Caribbean Library; 1947. 203 pp.

1899. *Six Islands in the Sun/Zes eilanden in de zon (Aruba, Bonaire, Curaçao, Saba, St. Eustatius, St. Maarten).* Hans Hermans. Oranjestad: De Wit; 1965. 178 pp.

1900. *Sixty Years in Cuba.* Edwin Farnsworth Atkins. New York, NY: Arno Press; 1980. 362 pp. Reprint of the 1926 ed.

1901. *Sketches of Summerland: Giving Some Account of Nassau and the Bahama Islands.* George J. H. Northcroft. 2d ed. Nassau: Nassau Guardian; 1912. 290 pp.

1902. *St. Vincent and the Grenadines: A Plural Country.* Jill Bobrow [et al.]; Dana Jinkins [ill.]. Stockbridge, MA: Concepts Publishing; 1985. 123 pp.

1903. *The Sugar Islands: A Caribbean Travelogue.* Alec Waugh. New York, NY: Farrar, Straus; 1949. 278 pp.

1904. *Tales of the Caribbean: A Feast of the Islands.* Fritz Seyfarth. Charlotte Amalie, V.I.: Spanish Main Press; 1988. 125 pp. Reprint of the 1978 ed.

1905. *These Are the Virgin Islands.* Hamilton Cochran. New York, NY: Prentice-Hall; 1937. 236 pp.

1906. *Time Among the Maya: Travels in Belize, Guatemala, and Mexico.* Ronald Wright. New York, NY: H. Holt; 1991. 451 pp.

1907. *Trading with the Enemy: Yankee Travels Through Castro's Cuba.* Tom
Miller. New York, NY: Atheneum; 1992. 353 pp.

1908. *The Traveller's Tree: A Journey Through the Caribbean Islands.* Patrick
Leigh Fermor. New York, NY: Viking Penguin; 1984. 368 pp. Reprint of
the 1950 ed.

1909. *Trinidad and Tobago: Isles of the Immortelles.* Robin Bryans. London:
Faber; 1967. 306 pp.

1910. *Trinidad Sweet: The People, Their Culture, Their Island.* Adrian Curtis
Bird. Port of Spain: Inprint Caribbean; 1992. 281 pp.

1911. *The Turks and Caicos Islands: Lands of Discovery.* Amelia Smithers.
London: Macmillan Caribbean; 1990. 80 pp.

1912. *The Virgin Islands and Their People.* Jose Antonio Jarvis. New York, NY:
Farlyn; 1971. 178 pp. Reprint of the 1944 ed.

1913. *Virgin Islands.* George Teeple Eggleston. Rev. ed. Huntington, NY: R. E.
Krieger; 1973. 210 pp.

1914. *Voir les Antilles: Guadeloupe-Martinique.* Alain Gillot-Pétré. Paris: Ha-
chette Réalités; 1980. 130 pp.

1915. *Voodoo Fire in Haiti.* Richard A. Loederer; Desmond Ivo Vesey, tr. New
York, NY: Literary Guild; 1935. 274 pp. Translation of *Wudu-feuer auf
Haiti.*

1916. *Wai-Wai: Through the Forests North of the Amazon.* Nicholas Guppy.
New York, NY: Dutton; 1958. 373 pp.

1917. *A Wayfarer in the West Indies.* Algernon Edward Aspinall. Boston, MA:
Houghton; 1928. 245 pp.

1918. *The West Indian Islands in Full Colour.* Hans W. Hannau. Rev. ed. Lon-
don: R. Hale; 1977. 133 pp. Rev. ed. of *The Caribbean Islands in Full
Colour.*

1919. *The West Indian Islands.* George Hunte. New York, NY: Viking Press;
1972. 246 pp.

1920. *The West Indies with British Guiana and British Honduras.* George Man-
ington. Rev. ed. London: E. Nash and Grayson; 1930. 304 pp.

1921. *The West Indies.* Carter Harman [et al.]. New York, NY: Time-Life; 1972.
159 pp. Reprint of the 1963 ed.

1922. *The West Indies.* John Henderson; Archibald Stevenson Forrest [ill.]. Lon-
don: A. and C. Black; 1905. 270 pp.

1923. *Whisperings of the Caribbean: Reflections of a Missionary.* Joseph John
Williams. New York, NY: Benziger; 1925. 252 pp.

1924. *White Elephants in the Caribbean: A Magic Journey Through All the West
Indies.* Henry Albert Phillips. New York, NY: R. M. McBride; 1936. 301
pp.

1925. *Windward of the Caribbean: A Look at Barbados*. S. W. C. Pack. London: A. Redman; 1964. 226 pp.

6. TOURISM

1926. *Caribbean Tourism Markets: Structures and Strategies—Proceedings*. CTRC Regional Marketing Seminar (1978); Cynthia Wilson, ed. Christ Church, Barbados: Caribbean Tourism Research and Development Centre; 1980. 231 pp.

1927. *Caribbean Tourism Statistical Report*. Caribbean Tourism Research and Development Centre. Christ Church, Barbados: CTRC; 1980– [vol. 1–]. Previously published under title *Caribbean Tourism Statistics*.

1928. *Caribbean Tourism: Profits and Performance Through 1980*. Timothy S. S. Prime; Jean S. Holder, Cynthia Wilson, eds. Port of Spain: Key Caribbean Publications; 1976. 121 pp.

1929. *Caribbean Tourism: Policies and Impacts*. Jean S. Holder, ed. Christ Church, Barbados: Caribbean Tourism Research and Development Centre; 1979. 325 pp.

1930. *Caribbean Tourist Trade: A Regional Approach*. Coert Du Bois. Port of Spain: Caribbean Commission; 1945. 171 pp.

1931. *Cultural Patrimony and the Tourism Product: Towards a Mutually Beneficial Relationship—Final Report*. OAS/CTR Regional Seminar (1983, Hastings, Barbados). Washington, DC: International Trade and Tourism Division, Organization of American States; 1983. 120 pp.

1932. *Economic Impact of Tourism in Antigua*. Timothy S. S. Prime. Christ Church, Barbados: Caribbean Tourism Research and Development Centre; 1981. 144 pp.

1933. *The Future of Tourism in the Eastern Caribbean*. H. Zinder and Associates. Washington, DC: The Associates; 1969. 288 pp.

1934. *The Impact of Tourism Investment Incentives in theCaribbean Region*. Organization of American States, Dept. of Regional Development. Washington, DC: General Secretariat, OAS; 1990. 1 vol. (various pagings).

1935. *Impacto económico del turismo en la República Dominicana*. Frank Moya Pons, ed. Santo Domingo: FORUM; 1986. 118 pp.

1936. *North American Demand Study for Caribbean Tourism*. Travel and Tourism Consultants International. New York, NY: TTCI; 1982. 7 vols.

1937. *The Optimum Size and Nature of New Hotel Development in the Caribbean*. Organization of American States, Dept. of Regional Development. Washington, DC: General Secretariat, OAS; 1987. 1 vol. (various pagings).

1938. *La question du tourisme en Martinique.* Henri Aimé Pastel. Fort-de-France: Editions Désormeaux; 1986. 419 pp.

1939. *Reference Guidelines for Enhancing the Positive Socio-Cultural and Environmental Impacts of Tourism.* Organization of American States, International Trade and Tourism Division. Washington, DC: The Division; 1984. 5 vols.

1940. *The Role of Tourism in Caribbean Development: Report.* Caribbean Ecumenical Consultation for Development (1971, Trinidad and Tobago). Bridgetown: CADEC; 1971. 59 pp.

1941. *The Social Impact of Tourism on Tobago.* Norma Abdulah [et al.]. St. Augustine, Trinidad/Tobago: Institute of Social and Economic Research, University of the West Indies; 1974. 150 pp.

1942. *Tourism and Development: A Case Study of the Commonwealth Caribbean.* John M. Bryden. Cambridge: Cambridge University Press; 1973. 236 pp.

1943. *Tourism and Employment in Barbados.* Dawn I. Marshall. Cave Hill, Barbados: Institute of Social and Economic Research (Eastern Caribbean), University of the West Indies; 1978. 66 pp.

1944. *Tourism Education and Human Resources Development for the Decade of the Nineties: Proceedings.* Caribbean Conference on Tourism Education (First, 1990, Barbados); University of the West Indies (Nassau, Bahamas), Centre for Hotel and Tourism Management, ed. Kingston: Dept. of Managament Studies, University of the West Indies; 1991. 174 pp.

1945. *Tourism in the Caribbean: Essays on Problems in Connection with Its Promotion.* Hubert Stanslake Trotman [et al.]. Assen: Van Gorcum; 1964. 141 pp.

1946. *Tourism in the Caribbean: The Economic Impact.* François J. Bélisle [et al.]; Shirley B. Seward, Bernard K. Spinrad, eds. Ottawa: International Development Research Centre; 1982. 163 pp.

1947. *Tourism in the Caribbean.* Neil E. Sealey. London: Hodder and Stoughton; 1982. 60 pp.

1948. *Turismo en Cuba.* Armando Maribona. Havana: Editorial Lex; 1959. 234 pp

1949. *Why Does the Tourist Dollar Matter? An Introduction to the Economics of Tourism in the British Virgin Islands.* Pierre Encontre. Road Town, B.V.I.: British Virgin Islands Tourist Board; 1989. 139 pp.

B. The People: Culture and Society

1. ARCHITECTURE AND HISTORIC SITES

1950. *Architecture in Puerto Rico.* José Antonio Fernández. New York, NY: Architectural Book Publishing; 1965. 267 pp.

1951. *La arquitectura colonial cubana.* Joaquín E. Weiss. Havana: Editorial Pueblo y Educación; 1985. 2 vols. Reprint of the 1973–1979 ed.

1952. *Arquitectura y arte colonial en Santo Domingo.* Erwin Walter Palm. Santo Domingo: Universidad Autónoma de Santo Domingo; 1974. 251 pp.

1953. *Arquitectura y urbanismo de la revolución cubana.* Roberto Segre. Havana: Editorial Pueblo y Educación; 1989. 254 pp.

1954. *Bermuda Houses.* John Sanford Humphreys. Boston, MA: Marshall Jones; 1923. 317 pp.

1955. *Building Up the Future from the Past: Studies on the Architecture and Historic Monuments in the Dutch Caribbean.* Henry E. Coomans, Michael A. Newton, Maritza Coomans-Eustatia, eds. Zutphen: Walburg Pers; 1990. 268 pp.

1956. *Caribbean Georgian: The Great and Small Houses of the West Indies.* Pamela Gosner. Washington, DC: Three Continents Press; 1982. 296 pp.

1957. *Caribbean Style.* Suzanne Slesin [et al.]. New York, NY: C. N. Potter; 1985. 290 pp.

1958. *Caribbean Traditional Architecture: The Traditional Architecture of Philipsburg, St. Martin (N.A.).* Joan D. van Andel. Leiden: Caraïbische Afdeling, Koninklijk Instituut voor Taal-, Land- en Volkenkunde; 1986. 87 pp.

1959. *A Collaborative Caribbean Preservation Strategy.* Jashina Alexandra Tarr. Washington, DC: Partners for Livable Places; 1982. 88 pp.

1960. *Gingerbread Houses: Haiti's Endangered Species.* Anghelen Arrington Phillips. Port-au-Prince: H. Deschamps; 1984. 92 pp. Reprint of the 1975 ed.

1961. *Historic Architecture of the Caribbean.* David Buisseret. Exeter, NH: Heinemann; 1980. 93 pp.

1962. *Historic Churches of Barbados.* Barbara Hill; Henry Fraser, ed. St. Michael, Barbados: Art Heritage; 1984. 128 pp.

1963. *Historic Churches of the Virgin Islands.* William Chapman; William Taylor [ill.]. Christiansted, V.I.: St. Croix Landmarks Society; 1986. 137 pp.

1964. *Historic Jamaica.* Frank Cundall. New York, NY: Johnson Reprint; 1971. 424 pp. Reprint of the 1915 ed.

1965. *Historic Site Preservation in the Caribbean: A Status Report.* Judith A. Towle. Charlotte Amalie, V.I.: Island Resources Foundation; 1978. 58 pp.

1966. *Kaz antiyé jan moun ka rété/Caribbean Popular Dwelling/ L'habitat populaire aux Antilles.* Jack Berthelot, Martine Gaumé; Karen Bowie [et al.], trs. Paris: Editions caribéennes; 1982. 167 pp.

1967. *Lugares y monumentos históricos de Santo Domingo.* Emilio Rodríguez Demorizi. Santo Domingo: Editora Taller; 1980. 279 pp.

1968. *Los monumentos arquitectónicos de La Española.* Erwin Walter Palm. 2a ed., ampliada. Santo Domingo: Editora de Santo Domingo; 1984. 1 vol. (various pagings).

1969. *El pre-barroco en Cuba: una escuela criolla de arquitectura morisca.* Francisco Prat Puig. Havana: Burgay; 1947. 438 pp.

1970. *Puerto Rican Houses in Sociohistorical Perspective.* Carol F. Jopling. Knoxville, TN: University of Tennessee Press; 1988. 300 pp.

1971. *Raíces cubanas: iglesias y camposantos coloniales.* Fernando Fernández Escobio. Miami, FL: [s.n.]; 1991. 166 pp.

1972. *Reliquias históricas de La Española.* Bernardo Pichardo. Santo Domingo: Editora de Santo Domingo; 1982. 146 pp. Reprint of the 1944 ed.

1973. *República Dominicana: monumentos históricos y arqueológicos.* Eugenio Pérez Montás. Mexico City: Instituto Panamericano de Geografía e Historia; 1984. 533 pp.

1974. *Restauración de antiguos monumentos dominicanos: planos e imágenes.* José Ramón Báez López-Penha, Eugenio Pérez Montás. Santo Domingo: Universidad Nacional Pedro Henríquez Ureña; 1986. 286 pp.

2. ART

a. Creative Arts

1975. *Afro-American Arts of the Suriname Rain Forest.* Sally Price, Richard Price. Berkeley, CA: University of California Press; 1980. 237 pp.

1976. *Antología de la pintura dominicana/Anthology of Dominican Painting.* Cándido Gerón; Guillermina Nadal, tr. Santo Domingo: Editora Tele 3; 1990. 148 pp.

1977. *The Art of Haiti.* Eleanor Ingalls Christensen. Philadelphia, PA: Art Alliance Press; 1975. 124 pp.

1978. *The Art of Revolution.* Dugald Stermer, ed. New York, NY: McGraw Hill; 1970. 96 pp. About Cuban political posters.

1979. *Arte contemporáneo dominicano.* Gary Nicolás Nader. Santo Domingo: Amigo del Hogar; 1984. 145 pp.

1980. *El arte en Cuba.* Martha de Castro. Miami, FL: Ediciones Universal; 1970. 151 pp.

1981. *Arte neotaíno.* Bernardo Vega. Santo Domingo: Fundación Cultural Dominicana; 1987. 97 pp.

1982. *Artes dominicanas.* Emilio Rodríguez Demorizi. [Nueva ed.]. Santo Domingo: Caribe Grolier; 1982. 174 pp. First ed. has title *Pintura y escultura en Santo Domingo.*

1983. *The Artist in West Indian Society: A Symposium.* Errol Hill, ed. Mona, Jamaica: Dept. of Extra-Mural Studies, University of the West Indies; 1963. 79 pp.

1984. *The Arts of an Island: The Development of the Culture and of the Folk and Creative Arts in Jamaica, 1494–1962.* Ivy Baxter. Metuchen, NJ: Scarecrow Press; 1970. 407 pp.

1985. *Las bellas artes en Cuba.* José Manuel Carbonell. Havana: Impr. "El Siglo XX"; 1928. 451 pp.

1986. *Bush Negro Art: An African Art in the Americas.* Philip John Crosskey Dark. [2d ed.]. New York, NY: St. Martin's Press; 1973. 54 pp.

1987. *The Caribbean Artists Movement: A Literal and Cultural History.* Anne Walmsley. London: New Beacon Books; 1992. 356 pp.

1988. *Discover the Arts in the United States Virgin Islands: A Sampling of Facts and Figures, Projects and Dreams.* Ruth S. Moore. Christiansted, V.I.: Virgin Islands Council on the Arts; 1985. 83 pp.

1989. *El gótico y el renacimiento en las Antillas: arquitectura, escultura, pintura, azulejos, orfebrería.* Diego Angulo Iñiguez. Seville: Escuela de Estudios Hispano-Americanos; 1947. 101 pp.

1990. *Haiti.* Philippe Thoby-Marcelin; Eva Thoby-Marcelin, tr. Washington, DC: Pan American Union; 1959. 59 pp.

1991. *Haiti: Voodoo Kingdom to Modern Riviera.* John Allen Franciscus. Chicopee, MA: Burt; 1980. 278 pp.

1992. *Haitian Art.* Ute Stebich, ed. New York, NY: Brooklyn Museum; 1978. 176 pp.

1993. *A Haitian Celebration: Art and Culture.* Ute Stebich. Milwaukee, WI: Milwaukee Art Museum; 1992. 151 pp.

1994. *Haitian Painting: Art and Kitsch.* Eva Pataki. Jamaica Estates, NY: E. Pataki; 1986. 161 pp.

1995. *Historia de la pintura dominicana.* Jeannette Miller. 2a ed. Santo Domingo: Amigo del Hogar; 1979. 106 pp.

1996. *Journal de voyage chez les peintres de la Fête et du Vaudou en Haïti.* Jean-Marie Drot. Geneva: Skira; 1974. 89 pp.

1997. *The Living Arts and Crafts of the West Indies.* Walter Lewisohn, Florence Lewisohn. Christiansted, V.I.: Virgin Islands Council on the Arts; 1973. 56 pp.

1998. *Memories of Underdevelopment: The Revolutionary Films of Cuba.* Michael Myerson, ed. New York, NY: Grossman; 1973. 194 pp.

1999. *The Miracle of Haitian Art.* Selden Rodman. Garden City, NY: Doubleday; 1974. 95 pp.

2000. *Painting and Sculpture of the Puerto Ricans.* Peter Bloch. New York, NY: Plus Ultra; 1978. 259 pp.

2001. *Peinture et sculpture en Martinique.* René Louise. Paris: Editions caribéennes; 1984. 67 pp.

2002. *La peinture haïtienne/Haitian Arts.* Marie-José Nadal-Gardère, Gérald Bloncourt; Elizabeth Bell, tr. Paris: Nathan; 1986. 207 pp.

2003. *La rebelión de los santos/The Rebellion of the Santos.* Marta Traba. Río Piedras, P.R.: Ediciones Puerto Rico; 1972. 154 pp.

2004. *Renaissance in Haiti: Popular Painters in the Black Republic.* Selden Rodman. New York, NY: Pellegrini and Cudahy; 1948. 134 pp.

2005. *Santos of Puerto Rico and the Americas/Santos de Puerto Rico y las Américas.* Florencio García Cisneros; Roberta West, tr. Detroit, MI: Blaine Ethridge; 1979. 122 pp.

2006. *Where Art Is Joy: Haitian Art—The First Forty Years.* Selden Rodman. New York, NY: Ruggles de Latour; 1988. 236 pp.

b. Performing Arts

2007. *La africanía de la música folklórica de Cuba.* Fernando Ortiz. 2a ed., rev. Havana: Editorial Universitaria; 1965. 489 pp.

2008. *Antología del merengue/Anthology of the Merengue.* José del Castillo, Manuel A. García Arévalo; Jeannie Ash de Pou, Giselle Scanlow, trs. Santo Domingo: Banco Antillano; 1988. 91 pp.

2009. *Los bailes y el teatro de los negros en el folklore de Cuba.* Fernando Ortiz. Havana: Editorial Letras Cubanas; 1985. 602 pp. Reprint of the 1981 (2d) ed.

2010. *Chansons des Antilles: comptines, formulettes.* Marie-Christine Hazael-Massieux. Paris: Editions du Centre national de la recherche scientifique; 1987. 280 pp.

2011. *Chanté domnitjen/Folk Songs of Dominica.* Alan Gamble, ed. Roseau: Dominica Institute; 1986. 64 pp.

2012. *La clave xilofónica de la música cubana: ensayo etnográfico.* Fernando Ortiz. Havana: Editorial Letras Cubanas; 1984. 105 pp.

2013. *Contemporary Puerto Rican Drama.* Jordan Blake Phillips. New York, NY: Plaza Mayor; 1972. 220 pp.

2014. *Cradle of Caribbean Dance: Beryl McBurnie and the Little Carib Theatre.* Molly Ahye. Petit Valley, Trinidad/Tobago: Heritage Cultures; 1983. 166 pp.

2015. *Cronología del cine cubano.* Arturo Agramonte. Havana: Instituto Cubano del Arte e Industria Cinematográficos (ICAIC); 1966. 172 pp.

2016. *Cuba y sus sones.* Natalio Galán. Valencia [Spain]: Pre-Textos; 1983. 359 pp.

2017. *The Cuban Image: Cinema and Cultural Politics in Cuba.* Michael Chanan. Bloomington, IN: Indiana University Press; 1985. 314 pp.

2018. *Cut 'n' Mix: Culture, Identity, and Caribbean Music.* Dick Hebdige. New York, NY: Methuen; 1990. 177 pp. Reprint of the 1987 ed.

2019. *Dances of Haiti.* Katherine Dunham. Los Angeles, CA: Center for Afro-American Studies, University of California; 1983. 78 pp.

2020. *Dancing Gods.* Lisa Lekis. Metuchen, NJ: Scarecrow Press; 1960. 220 pp.

2021. *Danzas y bailes folklóricos dominicanos.* Fradique Lizardo. Santo Domingo: Fundación García Arévalo; 1975– [vol. 1–].

2022. *Deep the Water, Shallow the Shore: Three Essays on Shantying in the West Indies.* Roger D. Abrahams. Austin, TX: University of Texas Press; 1974. 125 pp.

2023. *Essays on Cuban Music: North American and Cuban Perspectives.* Peter Manuel, ed. Lanham, MD: University Press of America; 1991. 327 pp.

2024. *From the Drum to the Synthesizer.* Leonardo Acosta; Margarita Zimmerman, tr. Havana: José Martí Publishing House; 1988. 134 pp. Translation of *Del tambor al sintetizador.*

2025. *Géneros musicales de Cuba: de lo afrocubano a la salsa.* Olavo Alén Rodríguez. San Juan: Editorial Cubanacán; 1992. 122 pp.

2026. *Golden Heritage: The Dance in Trinidad and Tobago.* Molly Ahye. Petit Valley, Trinidad/Tobago: Heritage Cultures; 1978. 176 pp.

2027. *Haiti Singing.* Harold Courlander. New York, NY: Cooper Square; 1973. 273 pp. Reprint of the 1939 ed.

2028. *Histoire de la musique en Haïti.* Constantin Dumervé. Port-au-Prince: Impr. des Antilles; 1968. 319 pp.

2029. *Historia de la música cubana.* Elena Pérez Sanjurjo. Miami, FL: Moderna Poesía; 1986. 593 pp.

2030. *Instrumentos musicales folklóricos dominicanos.* Fradique Lizardo. Santo Domingo: UNESCO; 1988– [vol. 1–].

2031. *Introducción a Cuba: la música.* José Ardevol. Havana: Instituto del Libro; 1969. 195 pp.

2032. *Isles of Rhythm.* Earl Leaf. New York, NY: A. S. Barnes; 1948. 211 pp.

2033. *The Jamaican Stage, 1655–1900: Profile of a Colonial Theatre.* Errol Hill. Amherst, MA: University of Massachusetts Press; 1992. 346 pp.

2034. *Kaiso and Society.* Hollis Urban Lester Liverpool. Charlotte Amalie, V.I.: Virgin Islands Commission on Youth; 1986. 62 pp.

2035. *Kaiso! The Trinidad Calypso: A Study of the Calypso as Oral Literature.*
Keith Q. Warner. 2d printing, rev. Washington, DC: Three Continents
Press; 1985. 152 pp. British ed. has title *The Trinidad Calypso.*

2036. *La-Le-Lo-Lai: Puerto Rican Music and Its Performers.* Peter Bloch. New
York, NY: Plus Ultra Educational Publishers; 1973. 197 pp.

2037. *Land of the Calypso: The Origin and Development of Trinidad's Folk
Song.* Charles S. Espinet, Harry Pitts. Port of Spain: Guardian Commer-
cial Printery; 1944. 74 pp.

2038. *Material para una pre-historia del cine haitiano/Matériel pour une pré-
histoire du cinéma haïtien.* Arnold Antonin. Caracas: Fornacine; 1983.
175 pp.

2039. *El merengue y la realidad existencial del hombre dominicano.* Luis
Manuel Brito Ureña. Santo Domingo: Editora Universitaria, Universidad
Autónoma de Santo Domingo; 1987. 275 pp.

2040. *La música afrocubana.* Fernando Ortiz. Madrid: Ediciones Júcar; 1975.
339 pp.

2041. *Música cubana del areyto a la nueva trova.* Cristóbal Díaz Ayala. San
Juan: Editorial Cubanacán; 1981. 383 pp.

2042. *La música dominicana: siglos XIX-XX.* Bernarda Jorge. Santo Domingo:
Editora Universitaria, Universidad Autónoma de Santo Domingo; 1982.
207 pp.

2043. *La música en Cuba.* Alejo Carpentier. Havana: Editorial Letras Cubanas;
1988. 346 pp. Reprint of the 1946 ed.

2044. *La música en el Caribe: colección de partituras.* Carlos Cabrer, Ana M.
Fabián, Carlos Vázquez, eds. Río Piedras, P.R.: Editorial de la Universi-
dad de Puerto Rico; 1990– [vol. 1–].

2045. *La música en Puerto Rico: panorama histórico-cultural.* María Luisa
Muñoz Santaella. Sharon, CT: Troutman Press; 1966. 167 pp.

2046. *Música tradicional dominicana.* Julio Alberto Hernández. Santo Do-
mingo: Librería Dominicana; 1969. 204 pp.

2047. *Música y baile en Santo Domingo.* Emilio Rodríguez Demorizi. Santo
Domingo: Librería Hispaniola; 1971. 227 pp.

2048. *Música y músicos de la República Dominicana.* Jacob Maurice Cooper-
smith; María Hazera, Elizabeth M. Tylor, trs. Santo Domingo: La Mo-
derna; 1974. 87 pp. Translation of *Music and Musicians of the Dominican
Republic.*

2049. *Música y músicos puertorriqueños.* Fernando Callejo Ferrer. 2a ed. San
Juan: Editorial Coquí; 1971. 283 pp.

2050. *The Musical Heritage of Bermuda and Its People.* Dale Butler, ed.
Southampton: Bermuda for Bermudians; 1978. 266 pp.

2051. *Musique aux Antilles/Mizik bô kay*. Maurice Jallier, Yollen Lossen. Paris: Editions caribéennes; 1985. 145 pp.

2052. *La musique dans la société antillaise, 1635–1902: Martinique, Guadeloupe*. Jacqueline Rosemain. Paris: Editions L'Harmattan; 1986. 183 pp.

2053. *Les musiques guadeloupéennes dans le camp culturel afro-américain, au sein des musiques du monde: colloque de Pointe-à-Pitre, novembre 1986*. Office régional du patrimoine guadeloupéen. Paris: Editions caribéennes; 1988. 261 pp.

2054. *Muziek en musici van de Nederlandse Antillen [Music and Musicians from the Netherlands Antilles]*. Edgar Palm. Willemstad: [s.n.]; 1978. 229 pp.

2055. *Orbita del Ballet Nacional de Cuba, 1948–1978*. Miguel Cabrera. Havana: Editorial ORBE; 1978. 148 pp.

2056. *Orígenes y desarrollo de la afición teatral en Puerto Rico*. Emilio Julio Pasarell. Santurce, P.R.: Editorial del Depto. de Instrucción Pública; 1970. 465 pp. Reprint of the 1951–1967 ed.

2057. *Panorama del teatro dominicano*. Danilo Ginebra, ed. Santo Domingo: Editora Corripio; 1984. 2 vols.

2058. *Parang of Trinidad*. Daphne Pawan Taylor, George Alexander Thomas. Port of Spain: National Cultural Council of Trinidad and Tobago; 1977. 63 pp.

2059. *Puerto Rican Music Following the Spanish American War: 1898, the Aftermath of the Spanish American War and Its Influence on the Musical Culture of Puerto Rico*. Catherine Dower. Lanham, MD: University Press of America; 1983. 203 pp.

2060. *Rastafarian Music in Contemporary Jamaica: A Study of Socioreligious Music of the Rastafarian Movement in Jamaica*. Yoshiko S. Nagashima. Tokyo: Institute for the Study of Languages and Cultures of Asia and Africa; 1984. 227 pp.

2061. *Reggae Bloodlines: In Search of the Music and Culture of Jamaica*. Stephen Davis; Peter Simon [ill.]. New York, NY: Da Capo Press; 1992. 216 pp. Reprint of the 1977 ed.

2062. *Revels in Jamaica, 1682–1838: Plays and Players of a Century, Tumblers and Conjurors, Musical Refugees and Solitary Showmen, Dinners, Balls and Cockfights, Darky Mummers and Other Memories of High Times and Merry Hearts*. Richardson Wright. Kingston: Bolivar Press; 1986. 378 pp. Reprint of the 1937 ed.

2063. *Roots and Rhythms: Jamaica's National Dance Theatre*. Rex M. Nettleford. New York, NY: Hill and Wang; 1970. 128 pp.

2064. *El teatro en Puerto Rico: notas para su historia*. Antonia Sáez. 2a ed. Río Piedras, P.R.: Editorial Universitaria, Universidad de Puerto Rico; 1972. 134 pp.

2065. *The Theater of Belize [An Illustrated Study of the Emergence and Growth of a Young Nation's "Theatrical Impulse"]*. Lolo Bob Johnston. North Quincy, MA: Christopher Publishing House; 1973. 96 pp.

2066. *Le théâtre à Saint-Domingue*. Jean Fouchard. [Nouv. éd.]. Port-au-Prince: H. Deschamps; 1988. 294 pp.

2067. *Le théâtre haïtien des origines à nos jours*. Robert Cornevin. Montreal: Leméac; 1973. 301 pp.

2068. *Theatre in the Caribbean*. Ken Corsbie. London: Hodder and Stoughton; 1984. 58 pp.

3. CIVILIZATION

2069. *Africa and the Caribbean: The Legacies of a Link*. Margaret E. Crahan, Franklin W. Knight, eds. Baltimore, MD: Johns Hopkins University Press; 1979. 159 pp.

2070. *The African-Caribbean Connection: Historical and Cultural Perspectives*. Alan Gregor Cobley, Alvin O. Thompson, eds. Cave Hill, Barbados: Dept. of History, University of the West Indies; 1990. 171 pp.

2071. *Antigua Black: Portrait of an Island People*. Gregson Davis; Margo Baumgarten Davis [ill.]. San Francisco, CA: Scrimshaw Press; 1973. 141 pp.

2072. *Antología del pensamiento puertorriqueño, 1900–1970*. Eugenio Fernández Méndez, ed. Río Piedras, P.R.: Editorial de la Universidad de Puerto Rico; 1975. 2 vols.

2073. *Aspects of Bahamian Culture*. Anastasia Elaine Dahl Smith. New York, NY: Vantage Press; 1978. 78 pp.

2074. *British Guiana: Problems of Cohesion in an Immigrant Society*. Peter K. Newman. New York, NY: Oxford University Press; 1964. 104 pp.

2075. *British Guiana: The Land of Six Peoples*. Michael Swan. London: HMSO; 1957. 235 pp.

2076. *Caribbean Contours*. Sidney Wilfred Mintz, Sally Price, eds. Baltimore, MD: Johns Hopkins University Press; 1985. 254 pp.

2077. *Caribbean Cultural Identity: The Case of Jamacia—An Essay in Cultural Dynamics*. Rex M. Nettleford. Los Angeles, CA: Center for Afro-American Studies, University of California; 1979. 238 pp.

2078. *Caribbean Discourse: Selected Essays*. Edouard Glissant; J. Michael Dash, ed. and tr. Charlottesville, VA: University Press of Virginia; 1989. 272 pp. Translation of *Le discours antillais*.

2079. *Caribbean Life and Culture: A Citizen Reflects*. Fred Phillips. Kingston: Heinemann Caribbean; 1991. 252 pp.

2080. *Caribbean Popular Culture.* John A. Lent, ed. Bowling Green, OH: Bowling Green State University Popular Press; 1990. 157 pp.

2081. *The Caribbean: Its Culture.* Conference on the Caribbean (Fifth, 1954, University of Florida); Alva Curtis Wilgus, ed. Gainesville, FL: University of Florida Press; 1955. 277 pp.

2082. *The Caribbean: Peoples, Problems, and Prospects.* Conference on the Caribbean (Second, 1951, University of Florida); Alva Curtis Wilgus, ed. Gainesville, FL: University of Florida Press; 1952. 240 pp.

2083. *El Caribe hacia el 2000: desafíos y opciones.* Andrés Serbín [et al.]. Caracas: Editorial Nueva Sociedad; 1991. 354 pp.

2084. *El Caribe y América Latina/The Caribbean and Latin America: Actas/Papers.* Interdisciplinary Colloquium About the Caribbean (Third, 1984, Berlin); Ulrich Fleischmann, Ineke Phaf, eds. Frankfurt/Main: Vervuert; 1987. 274 pp.

2085. *El Caribe: identidad cultural y desarrollo.* Andrés Bansart, ed. Caracas: Equinoccio, Editorial de la Universidad Simón Bolívar; 1989. 166 pp.

2086. *Central America and the Caribbean: Today and Tomorrow.* Barbara Armstrong Lafford, ed. Tempe, AZ: Center for Latin American Studies, Arizona State University; 1987. 133 pp.

2087. *Contacts de civilisations en Martinique et en Guadeloupe.* Michel Leiris. Paris: Gallimard; 1987. 192 pp. Reprint of the 1955 ed.

2088. *La crisis de la alta cultura en Cuba [y] Indagación del choteo.* Jorge Mañach; Rosario Rexach, ed. Miami, FL: Ediciones Universal; 1991. 96 pp. Reprint of two works published in 1925 and in 1940 respectively.

2089. *Cuba et les Antilles: actes du colloque de Pointe-à-Pitre, 3–5 décembre 1984.* Centre interuniversitaire d'études cubaines (France) [et] Université Antilles-Guyane, Centre d'études et de recherches caraïbéennes. Talence [France]: Presses universitaires de Bordeaux; 1988. 199 pp.

2090. *Cuba: cultura y sociedad, 1510–1985.* Francisco López Segrera. Havana: Editorial Letras Cubanas; 1989. 328 pp.

2091. *Cuba: Its People, Its Society, Its Culture.* Wyatt MacGaffey [et al.]. Westport, CT: Greenwood Press; 1974. 392 pp. Also published under title *Twentieth-Century Cuba;* reprint of the 1962 ed.

2092. *Cuba: la isla fascinante.* Juan Bosch. Santo Domingo: Editora Alfa y Omega; 1987. 252 pp. Reprint of the 1955 ed.

2093. *Cuba: Twenty-five Years of Revolution, 1959–1984.* Sandor Halebsky, John M. Kirk, eds. New York, NY: Praeger; 1985. 466 pp.

2094. *La cultura en Cuba socialista.* Salvador Arias [et al.]. Havana: Editorial Letras Cubanas; 1982. 253 pp.

2095. *Cultural Action and Social Change: The Case of Jamaica—An Essay in Caribbean Cultural Identity.* Rex M. Nettleford. Ottawa: International Development Research Centre; 1979. 239 pp.

2096. *Cultural Pluralism and Nationalist Politics in British Guiana.* Leo A. Despres. Chicago, IL: Rand McNally; 1967. 310 pp.

2097. *Cultural Policy in Guyana.* Arthur J. Seymour. Paris: UNESCO; 1977. 68 pp.

2098. *The Cultural Revolution in Cuba.* Roger Reed. Geneva: Latin American Round Table; 1991. 272 pp.

2099. *Cultural Traditions and Caribbean Identity: The Question of Patrimony.* Latin American Conference (Twenty-eighth, 1978, University of Florida); Samuel Jeffrey Keith Wilkerson, ed. Gainesville, FL: Center for Latin American Studies, University of Florida; 1980. 445 pp.

2100. *Culture et dictadure en Haïti: l'imaginaire sous contrôle.* Laënnec Hurbon. Port-au-Prince: H. Deschamps; 1987. 207 pp. Reprint of the 1979 ed.

2101. *Culture et politique en Guadeloupe et Martinique.* Jean Blaise [et al.]. Paris: Karthala; 1981. 98 pp.

2102. *Cultureel mozaïek van de Nederlandse Antillen: constanten en varianten [Cultural Mosaic of the Netherlands Antilles: Constants and Variants].* René A. Römer [et al.]. Zutphen: Walburg Pers; 1977. 359 pp.

2103. *Cultures et pouvoir dans la Caraïbe: langue créole, vaudou, sectes religieuses en Guadeloupe et en Haïti.* Dany Bébel-Gisler, Laënnec Hurbon. Paris: L'Harmattan; 1987. 140 pp. Reprint of the 1975 ed.

2104. *Le défi culturel guadeloupéen: devenir ce qui nous sommes.* Dany Bébel-Gisler. Paris: Editions caribéennes; 1989. 258 pp.

2105. *Ensayos sobre cultura dominicana.* Bernardo Vega [et al.]. 2a ed. Santo Domingo: Fundación Cultural Dominicana; 1988. 255 pp.

2106. *Entre cubanos: psicología tropical.* Fernando Ortiz. [Nueva ed.]. Havana: Editorial de Ciencias Sociales; 1987. 126 pp.

2107. *Evolución de la cultura cubana, 1608–1927.* José Manuel Carbonell, ed. Havana: Impr. "El Siglo XX" [etc.]; 1928. 18 vols.

2108. *Forging Identities and Patterns of Development in Latin America and the Caribbean/Le façonnement d'identités et modèles de développement en Amérique Latine et aux Caraïbes.* Harry P. Diaz, Joanna W. A. Rummens, Patrick Taylor, eds. Toronto: Canadian Scholars' Press; 1991. 364 pp.

2109. *Formación de la nación cubana.* Carlos Chain. 2a ed., corr. Havana: Ediciones Granma; 1968. 124 pp.

2110. *Los franceses en el Caribe y otros ensayos de historia y antropología.* Eugenio Fernández Méndez. San Juan: Ediciones El Cemí; 1983. 274 pp.

2111. *A Guide to Cultural Policy Development in the Caribbean.* Institute of Jamaica. Washington, DC: General Secretariat, Organization of American States; 1984– [vol. 1–].

2112. *Guinea's Other Suns: The African Dynamic in Trinidad Culture.* Maureen Warner Lewis. Dover, MA: Majority Press; 1991. 207 pp.

2113. *Haiti's Bad Press: Origins, Development, and Consequences.* Robert Lawless. Rochester, VT: Schenkman; 1992. 261 pp.

2114. *Haïti: une nation pathétique.* Jean Métellus. Paris: Denoël; 1987. 250 pp.

2115. *Harnessing the Intellectuals: Censoring Writers and Artists in Today's Cuba.* Carlos Ripoll. Washington, DC: Cuban American National Foundation; 1985. 59 pp. Also published under title *The Heresy of Words in Cuba.*

2116. *Historia de la cultura dominicana.* Mariano Lebrón Saviñón. Santo Domingo: Universidad Nacional Pedro Henríques Ureña; 1981– [vols. 1–5+].

2117. *Las ideas y la filosofía en Cuba.* Medardo Vitier. Havana: Editorial de Ciencias Sociales; 1970. 477 pp. Reprint of *Las ideas en Cuba* (1938) and *La filosofía en Cuba* (1948).

2118. *La identidad y la cultura: críticas y valoraciones en torno a la historia social de Puerto Rico.* Eugenio Fernández Méndez. 2a ed., rev. y aum. San Juan: Instituto de Cultura Puertorriqueña; 1970. 267 pp.

2119. *Identité antillaise: contribution à la connaissance psychologique et anthropologique des guadeloupéens et des martiniquais.* Julie Lirus. Paris: Editions caribéennes; 1982. 263 pp. Reprint of the 1979 ed.

2120. *Identité caraïbe et apports culturels africains.* Henri Bangou. Pointe-à-Pitre: Office municipal de la culture; 1979. 74 pp.

2121. *In the Shadow of Powers: Dantès Bellegarde in Haitian Social Thought.* Patrick Bellegarde-Smith. Atlantic Highlands, NJ: Humanities Press; 1985. 244 pp.

2122. *Insularismo.* Antonio Salvador Pedreira. [Nueva ed.]. Río Piedras, P.R.: Editorial Edil; 1985. 158 pp. First ed. (1934) has subtitle *Ensayos de interpretación puertorriqueña.*

2123. *Intellectuals in the Twentieth-Century Caribbean.* Charles Alistair Michael Hennessy, ed. London: Macmillan Caribbean; 1992. 2 vols.

2124. *Into Cuba.* Barry Lewis, Peter H. Marshall. New York, NY: Alfred van der Marck Editions; 1985. 191 pp.

2125. *The Islands: The Worlds of the Puerto Ricans.* Stan Steiner. New York, NY: Harper and Row; 1974. 535 pp.

2126. *Jamaica: The Search for an Identity.* Katrin Norris. New York, NY: Oxford University Press; 1962. 103 pp.

2127. *Literatura y arte nuevo en Cuba.* Mario Benedetti [et al.]. Barcelona: Editorial Laia; 1977. 287 pp. Reprint of the 1971 ed.

2128. *Main Currents in Caribbean Thought: The Historical Evolution of Caribbean Society in Its Ideological Aspects, 1492–1900.* Gordon K. Lewis. Baltimore, MD: Johns Hopkins University Press; 1987. 375 pp. Reprint of the 1983 ed.

2129. *La máscara y el marañón: la identidad nacional cubana.* Lucrecia Artalejo. Miami, FL: Ediciones Universal; 1991. 197 pp.

2130. *The Narrative of Liberation: Perspectives on Afro-Caribbean Literature, Popular Culture, and Politics.* Patrick Taylor. Ithaca, NY: Cornell University Press; 1989. 251 pp.

2131. *De Nederlandse Antillen: land, volk, cultuur [The Netherlands Antilles: Land, People, Culture].* J. van de Walle. Baarn: Wereldvenster; 1954. 204 pp.

2132. *New Mission for a New People: Voices from the Caribbean.* David I. Mitchell, ed. New York, NY: Friendship Press; 1977. 144 pp.

2133. *El ocaso de la nación dominicana.* Manuel Núñez. Santo Domingo: Editora Alfa y Omega; 1990. 347 pp.

2134. *Orígen y desarrollo del pensamiento cubano.* Raimundo Menocal y Cueto. Havana: Editorial Lex; 1945. 547 pp.

2135. *Over Antilliaanse cultuur [About Antillean Culture].* Cola Debrot. Amsterdam: Meulenhoff; 1985. 245 pp.

2136. *Panorama de la cultura cubana.* Félix Lizaso. Mexico City: Fondo de Cultura Económica; 1949. 155 pp.

2137. *Panorama de la cultura puertorriqueña.* María Teresa Babín. New York, NY: Las Américas; 1958. 509 pp.

2138. *Panorama de la filosofía cubana.* Humberto Piñera. Washington, DC: Pan American Union; 1960. 124 pp.

2139. *Papers in Caribbean Anthropology.* Sidney Wilfred Mintz, ed. New Haven, CT: Human Relations Area Files Press; 1970. 8 nos. in 1. Reprint of the 1960 ed.

2140. *El pensamiento sociopolítico moderno en el Caribe.* Gérard Pierre-Charles. Mexico City: Instituto de Investigaciones Sociales, Universidad Nacional Autónoma de México; 1985. 264 pp.

2141. *People of Passion.* Dana Samuel Orie. Charlotte Amalie, V.I.: Coral Reef Publications; 1983. 109 pp. About the Virgin Islands of the United States.

2142. *Peoples and Cultures of the Caribbean: An Anthropological Reader.* Michael M. Horowitz, ed. Garden City, NY: Natural History Press; 1971. 606 pp.

2143. *Perspectives 2004: vers un nouvel ordre culturel en Haïti.* Christophe Charles. Port-au-Prince: Editions Choucoune; 1984. 267 pp.

2144. *Problemas domínico-haitianos y del Caribe.* Gérard Pierre-Charles [et al.]. Mexico City: Universidad Nacional Autónoma de México; 1973. 228 pp.

2145. *Psychologically Speaking: Attitudes and Cultural Patterns in the Bahamas.* Mizpah C. Tertullien. Boynton Beach, FL: Star Publishing; 1976. 244 pp.

2146. *The Puerto Ricans' Spirit: Their History, Life, and Culture.* María Teresa Babín; Barry Luby, tr. New York, NY: Collier Books; 1971. 180 pp. Translation of *La cultura de Puerto Rico.*

2147. *Puerto Rico and Its People.* Trumbull White. New York, NY: Arno Press; 1975. 383 pp. Reprint of 1938 ed.

2148. *Puerto Rico: The Four-Storeyed Country and Other Essays.* José Luis González; Gerald Guinness, tr. Maplewood, NJ: Waterfront Press; 1990. 135 pp. Translation of *El país de cuatro pisos y otros ensayos.*

2149. *Quelques aspects du patrimoine culturel des Antilles.* Centre départemental de documentation pédagogique (Martinique). Fort-de-France: Académie des Antilles et de la Guyane; 1977. 148 pp.

2150. *500 años: hacia un autodesencubrimiento de la identidad caribeña.* Pedro Muamba Tujibikile. Santo Domingo: Ediciones CEDEE; 1991. 89 pp.

2151. *Roots of Jamaican Culture.* Mervyn C. Alleyne. London: Pluto Press; 1988. 186 pp.

2152. *Stains on My Name, War in My Veins: Guyana and the Politics of Cultural Struggle.* Brackette F. Williams. Durham, NC: Duke University Press; 1991. 322 pp.

2153. *Twentieth Century Jamaica.* Herbert George De Lisser. Kingston: Jamaica Times; 1913. 208 pp.

2154. *We, the Puerto Rican People: A Story of Oppression and Resistance.* Juan Angel Silén; Cedric Belfrage, tr. New York, NY: Monthly Review Press; 1971. 134 pp. Translation of *Hacia una visión positiva del puertorriqueño.*

4. EDUCATION

2155. *Americanization in Puerto Rico and the Public-School System, 1900–1930.* Aida Negrón de Montilla. Río Piedras, P.R.: Editorial Edil; 1975. 282 pp. Reprint of the 1970 ed.

2156. *Black Education in the Danish West Indies from 1732 to 1853: The Pioneering Efforts of the Moravian Brethren.* Eva Lawaetz. Frederiksted, V.I.: Friends of Denmark Society; 1980. 90 pp.

2157. *The Caribbean: Contemporary Education.* Conference on the Caribbean (Tenth, 1959, University of Florida); Alva Curtis Wilgus, ed. Gainesville, FL: University of Florida Press; 1960. 290 pp.

2158. *A Century of West Indian Education: A Source Book.* Shirley C. Gordon, ed. London: Longmans; 1963. 312 pp.

2159. *Children of the Revolution: A Yankee Teacher in the Cuban Schools.* Jonathan Kozol. New York, NY: Dell; 1980. 245 pp. Reprint of the 1978 ed.

2160. *Civilisés et énergumènes: de l'enseignement aux Antilles.* André Lucrèce. Paris: Editions caribéennes; 1981. 245 pp.

2161. *Colony and Nation: A Short History of Education in Trinidad and Tobago, 1834–1986.* Carl C. Campbell. Kingston: I. Randle; 1992. 134 pp.

2162. *The Commonwealth Caribbean: A Study of the Educational System of the Commonwealth Caribbean and a Guide to the Academic Placement of Students in Educational Institutions of the United States.* Stephen H. Fisher. Washington, DC: American Association of Collegiate Registrars and Admission Officers; 1979. 238 pp.

2163. *Cuba: territorio libre de analfabetismo.* Gaspar Quintana Alberni. Havana: Editorial de Ciencias Sociales; 1981. 101 pp.

2164. *Cuba: The Political Content of Adult Education.* Richard R. Fagen, ed. Stanford, CA: Hoover Institution on War, Revolution, and Peace, Stanford University; 1964. 77 pp.

2165. *Desarrollo y educación en América Latina y el Caribe.* Germán W. Rama, ed. Buenos Aires: Kapelusz; 1987. 2 vols.

2166. *L'école dans la Guadeloupe coloniale.* Antoine Abou. Paris: Editions caribéennes; 1988. 277 pp.

2167. *L'école, le magique et l'imaginaire: pour une autre approche de l'institution scolaire à la Martinique.* Serge Harpin. Fort-de-France: LARIAMEP; 1985. 184 pp.

2168. *Educación y sociedad en América Latina y el Caribe.* Germán W. Rama, ed. Santiago, Chile: UNICEF; 1980. 276 pp.

2169. *Educating Jamaica for the Twenty-first Century.* W. Val Chambers. Mandeville, Jamaica: Eureka Press; 1991. 104 pp.

2170. *Education and Development: Latin America and the Caribbean.* Thomas J. La Belle, ed. Los Angeles, CA: Latin American Center, University of California; 1972. 732 pp.

2171. *Education and Development in the English-Speaking Caribbean: A Contemporary Survey.* Laurence D. Carrington. Buenos Aires: Economic Commission for Latin America, United Nations; 1978. 127 pp.

2172. *Education and Poverty: Effective Schooling in the United States and Cuba.* Maurice R. Berube. Westport, CT: Greenwood Press; 1984. 163 pp.

2173. *Education and Society in the Commonwealth Caribbean.* Errol Miller, ed. Mona, Jamaica: Institute of Social and Economic Research, University of the West Indies; 1991. 271 pp.

2174. *Education for All: Caribbean Perspectives and Imperatives.* Errol Miller. Baltimore, MD: Johns Hopkins University Press; 1992. 267 pp.

2175. *Education for Development or Underdevelopment? Guyana's Educational System and Its Implications for the Third World.* M. K. Bacchus. Waterloo, Ont.: Wilfrid Laurier University Press; 1980. 302 pp.

2176. *Education in Belize: Toward the Year 2000.* Society for the Promotion of Education and Research (Belize). Benque Viejo del Carmen, Belize: SPEAR; 1991. 264 pp.

2177. *Education in Central America and the Caribbean.* Colin Brock, Donald R. Carlson, eds. New York, NY: Routledge; 1990. 322 pp.

2178. *Education in Latin America and the Caribbean: Trends and Prospects, 1970–2000.* Regional Conference of Ministers of Education and Those Responsible for Economic Planning of Member States in Latin America and the Caribbean (1979, Mexico City); José Blat Gimeno, ed. Paris: UNESCO; 1983. 190 pp.

2179. *Education in the British West Indies.* Eric Eustace Williams. New York, NY: University Place Book Shop; 1968. 167 pp. Reprint of the 1950 ed.

2180. *Education in the Caribbean: Historical Perspectives.* Ruby Hope King, ed. Mona, Jamaica: Faculty of Education, University of the West Indies; 1987. 195 pp.

2181. *Education in the Republic of Haiti.* George Allan Dale. Washington, DC: Office of Education, Dept. of Health, Education, and Welfare; 1959. 180 pp.

2182. *Education in the Virgin Islands: An Almanac of Facts, Figures, a Directory of Personnel, and a Selected Bibliography.* Robert V. Vaughn. Kingshill, V.I.: Aye-Aye Press; 1976– [vols. 1–2+].

2183. *Education in the Windward and Leeward Islands.* Stanley Alfred Hammond, ed. London: HMSO; 1939. 66 pp.

2184. *Educational Change in Postcolonial Jamaica.* Wills S. Jervier. New York, NY: Vantage Press; 1977. 163 pp.

2185. *Educational Deficits in the Caribbean/Los déficits educativos en el Caribe.* Organization of American States, Dept. of Educational Affairs. Washington, DC: General Secretariat, OAS; 1979. 128 pp.

2186. *Educational Development in an Archipelagic Nation: Report of a Review Team Invited by the Government of the Commonwealth of the Bahamas.* James A. Maraj, ed. Nassau: Ministry of Education and Culture; 1974. 172 pp.

2187. *Educational Imperialism: American School Policy and the U.S. Virgin Islands.* Emanuel Hurwitz, Julius Menacker, Ward Weldon. Lanham, MD: University Press of America; 1987. 214 pp.

2188. *Educational Research: The English-Speaking Caribbean.* Errol Miller. Ottawa: International Development Research Centre; 1984. 199 pp.

2189. *Educational Trends in the Caribbean: European Affiliated Areas.* Charles Christian Hauch. Washington, DC: Office of Education, Dept. of Health, Education and Welfare; 1960. 153 pp.

2190. *La escuela puertorriqueña.* Carmen Gómez Tejera, David Cruz López. Sharon, CT: Troutman Press; 1970. 262 pp.

2191. *Foundations of Education in the Caribbean.* Reginald N. Murray, G. L. Gbedemah. London: Hodder and Stoughton; 1983. 128 pp.

2192. *Fundamental, Adult, Literacy and Community Education in the West Indies.* Henry William Howes. Millwood, NY: Kraus Reprint; 1966. 79 pp. Reprint of the 1955 ed.

2193. *Haiti: Education and Human Resources Sector Assessment/ Haïti: évaluation du secteur de l'éducation et des ressources humaines.* USAID Improving the Efficiency of Educational Systems Project [and] Haiti, Ministère de l'éducation nationale [and] United States, Agency for International Development. Tallahassee, FL: IEES/AMESED; 1987. 4 vols.

2194. *Historia de la educación en Puerto Rico, 1512–1826.* Antonio Cuesta Mendoza. New York, NY: AMS Press; 1974. 191 pp. Reprint of the 1937 ed.

2195. *A History of Education in Puerto Rico.* Juan José Osuna. New York, NY: Arno Press; 1975. 657 pp. Reprint of the 1949 (2d) ed.

2196. *Instruction publique en Haïti, 1492–1945.* Edner Brutus. Port-au-Prince: Editions Panorama; 1979. 2 vols. Reprint of the 1948 ed.

2197. *Jamaican Society and High Schooling.* Errol Miller. Mona, Jamaica: Institute of Social and Economic Research, University of the West Indies; 1990. 400 pp.

2198. *The Methodist Contribution to Education in the Bahamas: (Circa 1790 To 1975).* Colbert Williams. Gloucester, Eng.: A. Sutton; 1982. 256 pp.

2199. *Missions of a University in a Small Country.* Millard W. Hansen. Río Piedras, P.R.: Social Science Research Center, University of Puerto Rico; 1975. 158 pp.

2200. *Nonformal Education in Latin America and the Caribbean: Stability, Reform, or Revolution?* Thomas J. La Belle. New York, NY: Praeger; 1986. 367 pp.

2201. *Población y educación en la República Dominicana.* Miriam Díaz Santana, Nelson Ramírez, Pablo Tactuk. Santo Domingo: Depto. de Comunicación y Educación de Profamilia; 1990. 140 pp.

2202. *Politics and Education in Puerto Rico: A Documentary Survey of the Language Issue.* Erwin H. Epstein, ed. Metuchen, NJ: Scarecrow Press; 1970. 257 pp.

2203. *Reports and Repercussions in West Indian Education, 1835-1933.* Shirley C. Gordon. London: Ginn; 1968. 190 pp.

2204. *Secondary Education in the Guianas.* Louis Woolford Bone. Chicago, IL: Comparative Education Center, University of Chicago; 1962. 70 pp.

2205. *A Short History of Education in Jamaica.* Millicent Whyte. 2d ed. London: Hodder and Stoughton; 1983. 164 pp.

2206. *Society, Schools, and Progress in the West Indies.* John J. Figueroa. New York, NY: Pergamon Press; 1971. 208 pp.

2207. *Sociology of Education: A Caribbean Reader.* Peter M. E. Figueroa, Ganga Persaud, eds. New York, NY: Oxford University Press; 1986. 284 pp. Reprint of the 1976 ed.

2208. *Status and Power in Rural Jamaica: A Study of Educational and Political Change.* Nancy Foner. New York, NY: Teachers College Press; 1973. 172 pp.

2209. *Teachers, Education and Politics in Jamaica, 1892–1972.* Harry Goulbourne. London: Macmillan Caribbean; 1988. 198 pp.

2210. *The University of the West Indies: A Caribbean Response to the Challenge of Change.* Philip Manderson Sherlock, Rex M. Nettleford. London: Macmillan Caribbean; 1990. 315 pp.

2211. *University Students and Revolution in Cuba, 1920–1968.* Jaime Suchlicki. Coral Gables, FL: University of Miami Press; 1969. 177 pp.

2212. *Utilization, Misuse, and Development of Human Resources in the Early West Indian Colonies.* M. K. Bacchus. Waterloo, Ont.: Wilfrid Laurier University Press; 1990. 412 pp.

5. FOLKLORE AND PROVERBS

2213. *Afro-Caribbean Folk Medicine.* Michel S. Laguerre. South Hadley, MA: Bergin and Garvey; 1987. 120 pp.

2214. *Almanaque folklórico dominicano.* Ivan Domínguez [et al.]. Santo Domingo: Editora Alfa y Omega; 1978. 166 pp.

2215. *And I Remember Many Things: Folklore of the Caribbean.* Christine Barrow, ed. Kingston: I. Randle; 1992. 53 pp.

2216. *Los animales en el folklore y la magia de Cuba.* Lydia Cabrera. Miami, FL: Ediciones Universal; 1988. 208 pp.

2217. *Bahamian Lore.* Robert Arthur Curry. New York, NY: Gordon Press; 1978. 125 pp. Reprint of the 1928 ed.

2218. No entry.

2219. *Children of Yayoute: Folk Tales of Haiti.* François Marcel-Turenne Des Prés. Port-au-Prince: H. Deschamps; 1949. 180 pp.

2220. *La civilisation du bossale: réflexions sur la littérature orale de la Guadeloupe et de la Martinique.* Maryse Condé. Paris: L'Harmattan; 1978. 70 pp.

2221. *A Classification of the Folktale of the West Indies by Types and Motifs.* Helen Leneva Flowers. New York, NY: Arno Press; 1980. 660 pp. Reprint of the 1952 ed.

2222. *Contes de mort et de vie aux Antilles.* Joëlle Laurent, Ina Césaire, eds. and trs. Paris: Nubia; 1976. 248 pp.

2223. *Contes et légendes des Antilles.* Thérèse Georgel. Paris: F. Nathan; 1963. 255 pp. Reprint of the 1957 ed.

2224. *Contes et légendes d'Haïti.* Philippe Thoby-Marcelin, Pierre Marcelin. Paris: F. Nathan; 1967. 247 pp.

2225. *Les contes haïtiens.* Suzanne Comhaire-Sylvain. New York, NY: AMS Press; 1980. 2 vols. in 1. Reprint of the 1937 ed.

2226. *Cuentos negros de Cuba.* Lydia Cabrera. [Nueva ed.]. Barcelona: Sociedad Estatal V Centenario; 1989. 190 pp.

2227. *Del folklore dominicano.* José Antonio Cruz Brache. Santo Domingo: Editorial Galaxia; 1988– [vol. 1–].

2228. *The Drum and the Hoe: Life and Lore of the Haitian People.* Harold Courlander. Berkeley, CA: University of California Press; 1985. 371 pp. Reprint of the 1960 ed.

2229. *Ears and Tails and Common Sense: More Stories from the Caribbean.* Philip Manderson Sherlock, Hilary Sherlock. London: Macmillan Caribbean; 1982. 121 pp. Reprint of the 1974 ed.

2230. *Earth and Spirit: Healing Lore and More from Puerto Rico.* María Dolores Hajosy Benedetti. Maplewood, NJ: Waterfront Press; 1989. 245 pp.

2231. *Folk Tales of Andros Island, Bahamas.* Elsie Worthington Clews Parsons. Millwood, NY: Kraus Reprint; 1976. 170 pp. Reprint of the 1918 ed.

2232. *Folk-lore from the Dominican Republic.* Manuel José Andrade. Millwood, NY: Kraus Reprint; 1969. 431 pp. Reprint of the 1930 ed.

2233. *Folk-lore of the Antilles, French and English.* Elsie Worthington Clews Parsons. Millwood, NY: Kraus Reprint; 1969–1976. 3 vols. Reprint of the 1933–1943 ed.

2234. *Folklore from Contemporary Jamaicans.* Daryl Cumber Dance. Knoxville, TN: University of Tennessee Press; 1985. 229 pp.

2235. *Folklore of Carriacou.* Christine David. Wildey, Barbados: Coles Printery; 1985. 54 pp.

2236. *The Food and Folklore of the Virgin Islands.* Arona Petersen. Ft. Lauderdale, FL: Romik; 1990. 297 pp.

2237. *Guyana Folklore: Guyanese Proverbs and Stories.* Percy A. Brathwaite; Serena U. Brathwaite, ed. Georgetown: [s.n.]; 1966. 80 pp.

2238. *Guyana Legends.* William Henry Brett, ed. Georgetown: Release Publishers; 1981. 66 pp. Reprint of the 1931 ed.

2239. *I Could Talk Old-Story Good: Creativity in Bahamian Folklore.* Daniel J. Crowley. Berkeley, CA: University of California Press; 1980. 156 pp. Reprint of the 1966 ed.

2240. *The Iguana's Tail: Crick Crack Stories from the Caribbean.* Philip Manderson Sherlock. London: Deutsch; 1976. 97 pp. Reprint of the 1969 ed.

2241. *Indo-Trinidadian Folk Tales in the Oral Tradition.* Ashram B. Maharaj. Port of Spain: [s.n.]; 1990. 74 pp.

2242. *Jamaica Anansi Stories.* Martha Warren Beckwith, Helen Heffron Roberts. Millwood, NY: Kraus Reprint; 1976. 295 pp. Reprint of the 1924 ed.

2243. *Jamaica Folk-lore.* Martha Warren Beckwith, Helen Heffron Roberts. Millwood, NY: Kraus Reprint; 1969. 346 pp. Reprint of the 1928 ed.

2244. *Jamaica Proverbs and Sayings.* Izett Anderson, Frank Cundall, eds. Shannon: Irish University Press; 1972. 128 pp. Reprint of the 1927 (2d) ed. published under title *Jamaica Negro Proverbs and Sayings.*

2245. *Jamaica Proverbs.* Martha Warren Beckwith. Westport, CT: Negro Universities Press; 1970. 137 pp. Reprint of the 1925 ed.

2246. *Jamaican Sayings: With Notes on Folklore, Aesthetics, and Social Control.* G. Llewellyn Watson. Tallahassee, FL: Florida A & M University Press; 1991. 292 pp.

2247. *Jamaican Song and Story: Annancy Stories, Digging Sings, Ring Tunes, and Dancing Tunes.* Walter Jekyll, ed. New York, NY: Dover; 1966. 288 pp. Reprint of the 1907 ed.

2248. *Légendes et contes folkloriques de Guyane.* Michel Lohier, ed. 2e éd. Paris: Editions caribéennes; 1980. 250 pp.

2249. *Leyendas puertorriqueñas.* Cayetano Coll y Toste. [Nueva ed.]. Hato Rey, P.R.: Esmaco; 1988. 226 pp.

2250. *Ma Rose Point: An Anthology of Rare Legends and Folk Tales from Trinidad and Tobago.* Jacob D. Elder. Port of Spain: National Cultural Council of Trinidad and Tobago; 1972. 79 pp.

2251. *The Magic Orange Tree and Other Haitian Folktales.* Diane Wolkstein, ed. New York, NY: Schocken Books; 1980. 212 pp. Reprint of the 1978 ed.

2252. *La magie antillaise.* Eugène Revert. Paris: Annuaire international des Français d'outre-mer; 1977. 201 pp. Reprint of the 1951 ed.

2253. *The Man-of-Words in the West Indies: Performance and the Emergence of Creole Culture.* Roger D. Abrahams. Baltimore, MD: Johns Hopkins University Press; 1983. 203 pp.

2254. *La médecine populaire à la Guadeloupe.* Christiane Bougerol. Paris: Karthala; 1983. 175 pp.

2255. *La medicina folklórica en la República Dominicana.* Wilfredo Mañón Rossi. Santo Domingo: Editora Educativa Dominicana; 1983. 90 pp.

2256. *1,000 proverbes créoles de la Caraïbe francophone.* Agence de coopération culturelle et technique (France), ed. Paris: Editions caribéennes; 1987. 114 pp.

2257. *Mon pays à travers des légendes: contes martiniquais.* Paul Cassius de Linval. Paris: Editions de la Revue Moderne; 1960. 163 pp.

2258. *Ole Time Sayin's: Proverbs of the West Indies.* Lito Valls. St. John, V.I.: Valls; 1983. 100 pp.

2259. *Panorama du folklore haïtien [présence africaine en Haïti].* Emmanuel Casséus Paul. Port-au-Prince: Editions Fardin; 1978. 323 pp. Reprint of the 1962 ed.

2260. *Por qué . . . : cuentos negros de Cuba.* Lydia Cabrera. Madrid: Ramos; 1972. 253 pp. Reprint of the 1948 ed.

2261. *The Proverbs of British Guiana: With an Index of Principal Words, an Index of Subjects, and a Glossary.* James Speirs. Demerara: Argosy; 1902. 88 pp.

2262. *Saban Lore: Tales from My Grandmother's Pipe.* Will Johnson; Lynne Johnson, ed. 3d rev. ed. [Leverock] Saba: W. Johnson; 1989. 132 pp. First ed. has title *Tales from My Grandmother's Pipe.*

2263. *Salt and Roti: Indian Folk Tales of the Caribbean.* Kenneth Vidia Parmassad, ed. Port of Spain: Sankh; 1984. 131 pp.

2264. *So Spoke the Uncle.* Jean Price-Mars; Magdaline W. Shannon, tr. Washington, DC: Three Continents Press; 1983. 252 pp. Translation of *Ainsi parla l'oncle.*

2265. *Suriname Folk-Lore.* Melville Jean Herskovits, Frances Shapiro Herskovits, Mieczyslaw Kolinski. New York, NY: AMS Press; 1969. 766 pp. Reprint of the 1936 ed.

2266. *Tales of Tortola and the British Virgin Islands: Recounting Nearly Five Centuries of Lore, Legend, and History of Las Virgines.* Florence Lewisohn. Rev. ed. Hollywood, FL: Dukane Press; 1986. 89 pp.

2267. *Tall Tales of Trinidad and Tobago.* Carlton Robert Ottley, ed. [New ed.]. Port of Spain: Horsford; 1972. 71 pp. Rev. ed. of *Legends and True Stories of Trinidad and Tobago.*

2268. *3333 Proverbs in Haitian Creole: The Eleventh Romance Language.* Néstor A. Fayó. Port-au-Prince: Editions Fardin; 1980. 428 pp. Reprint of the 1970 ed.

2269. *The Three Wishes: A Collection of Puerto Rican Folktales.* Ricardo E. Alegría, ed.; Elizabeth Culbert, tr. New York, NY: Harcourt, Brace and World; 1969. 128 pp.

2270. *Two Evenings in Saramaka.* Richard Price, Sally Price. Chicago, IL: University of Chicago Press; 1991. 417 pp. About the Saramacca (people of Suriname).

2271. *The Types of the Folktale in Cuba, Puerto Rico, the Dominican Republic, and Spanish South America.* Terrence Leslie Hansen. Berkeley, CA: University of California Press; 1957. 202 pp.

2272. *Under the Storyteller's Spell: An Anthology of Folk-Tales from the Caribbean.* Faustin Charles, ed. London: Puffin; 1991. 192 pp. Reprint of the 1989 ed.

2273. *Volkskunde van Curaçao [Folklore of Curaçao].* Nicolas van Meeteren. Amsterdam: Emmering; 1977. 248 pp. Reprint of the 1947 ed.

2274. *Voz folklórica de Puerto Rico.* Cesáreo Rosa-Nieves. Sharon, CT: Troutman Press; 1991. 128 pp. Reprint of the 1967 ed.

2275. *We Jus Catch Um: Folk Stories from Belize.* Shirley A. Warde, ed. Goshen, IN: Pinchpenny Press; 1974. 60 pp.

2276. *West Indian Folk-Tales.* Philip Manderson Sherlock, ed. New York, NY: H. Z. Walck; 1983. 151 pp. Reprint of the 1966 ed.

2277. *The Woe Shirt: Caribbean Folk Tales.* Paulé Bartón; Howard A. Norman, tr. Port Townsend, WA: Graywolf Press; 1982. 62 pp. Reprint of the 1980 ed.

6. POPULATION AND ETHNICITY

a. General Works

2278. *After the Crossing: Immigrants and Minorities in Caribbean Creole Society.* Howard Johnson, ed. Totowa, NJ: Cass; 1988. 147 pp.

2279. *Caribbean Environmental Health Strategy.* Stephen D. Glazier [et al.]. Georgetown: Caribbean Community Secretariat; 1979. 105 pp.

2280. *Caribbean Ethnicity Revisited.* Stephen D. Glazier, ed. New York, NY: Gordon and Breach; 1985. 164 pp.

2281. *Caribbean Population Dynamics: Emigration and Fertility Challenges.* Conference of Caribbean Parliamentarians on Population and Development (1985, Barbados); Jean-Pierre Guengant, Dawn I. Marshall, eds. [Bridgetown: s.n.]; 1985. 107 pp.

2282. *Caribbean Race Relations: A Study of Two Variants.* Harmannus Hoetink; Eva M. Hooykaas, tr. New York, NY: Oxford University Press; 1971. 207

pp. Translation of *De gespleten samenleving in het Caribisch gebied;* also published under title *The Two Variants in Caribbean Race Relations.*

2283. *Colonialism, Catholicism, and Contraception: A History of Birth Control in Puerto Rico.* Annette B. Ramírez de Arellano, Conrad Seipp. Chapel Hill, NC: University of North Carolina Press; 1983. 219 pp.

2284. *Contraceptive Use and Fertility in the Commonwealth Caribbean.* Norma Abdulah, Jack Harewood. Voorburg: International Statistical Institute; 1984. 55 pp.

2285. *Contribución a la Historia de la gente sin historia.* Pedro Deschamps Chapeaux, Juan Pérez de la Riva. Havana: Editorial de Ciencias Sociales; 1974. 282 pp. About Cuba.

2286. *The Control of Human Fertility in Jamaica.* J. Mayone Stycos, Kurt W. Back. Ithaca, NY: Cornell University Press; 1964. 377 pp.

2287. *Development Planning and Population Policy in Puerto Rico: From Historical Evolution Towards a Plan for Population Stabilization.* Kent C. Earnhardt. Río Piedras, P.R.: Editorial de la Universidad de Puerto Rico; 1982. 214 pp.

2288. *Economie et population en Guadeloupe: la baisse de la fécondité et l'accroissement de l'émigration—les tendances d'un même processus.* Marianne Kempeneers, Jean Poirier. Montreal: Centre de recherches caraïbes, Université de Montréal; 1981. 112 pp.

2289. *Essays in Population History: Mexico and the Caribbean.* Sherburne Friend Cook, Woodrow Wilson Borah. Berkeley, CA: University of California Press; 1971–1979. 3 vols.

2290. *Etnicidad, clase y nación en la cultura política del Caribe de habla inglesa.* Andrés Serbín. Caracas: Academia Nacional de la Historia; 1987. 477 pp.

2291. *La fecundidad en Cuba.* Luisa Alvarez Vázquez. Havana: Editorial de Ciencias Sociales; 1985. 182 pp.

2292. *Fertility and Mating in Four West Indian Populations: Trinidad and Tobago, Barbados, St. Vincent, Jamaica.* George W. Roberts. Mona, Jamaica: Institute of Social and Economic Research, University of the West Indies; 1975. 341 pp.

2293. *Fertility Determinants in Cuba.* Paula E. Hollerbach, Sergio Díaz-Briquets. Washington, DC: National Academy Press; 1983. 242 pp.

2294. *Fertility Trends in Aruba and Curaçao (Netherlands Antilles) Between 1900–1980.* Hans van Leusden. Voorburg: Netherlands Interuniversity Demographic Institute; 1985. 54 pp.

2295. *Geographic Aspects of Population Dynamics in Jamaica.* Lawrence Alan Eyre. Boca Raton, FL: Florida Atlantic University Press; 1972. 172 pp.

2296. *Guyana: Race and Politics Among Africans and East Indians.* Roy Arthur Glasgow. Boston, MA: M. Nijhoff; 1970. 153 pp.

2297. *Levels of Fertility in Commonwealth Caribbean, 1921–1965.* Joycelin Byrne. Mona, Jamaica: Institute of Social and Economic Research, University of the West Indies; 1972. 84 pp.

2298. *Migrants in Aruba: Interethnic Integration.* Vera M. Green. Assen: Van Gorcum; 1974. 137 pp.

2299. *Nacionalismo, etnicidad y política en la república cooperativa de Guyana.* Andrés Serbín. Caracas: Bruguera; 1980. 276 pp.

2300. *Politics and Population in the Caribbean.* Aaron Segal, Kent C. Earnhardt. Río Piedras, P.R.: Institute of Caribbean Studies, University of Puerto Rico; 1969. 158 pp.

2301. *Population and Energy: A Systems Analysis of Resource Utilization in the Dominican Republic.* Gustavo A. Antonini, Katherine Carter Ewel, Howard M. Tupper. Gainesville, FL: University Presses of Florida; 1975. 166 pp.

2302. *Population and Vital Statistics: Jamaica, 1832–1964—A Historical Perspective.* Kálmán Tekse. Kingston: Dept. of Statistics; 1974. 340 pp.

2303. *The Population of Jamaica.* George W. Roberts. Millwood, NY: Kraus Reprint; 1979. 356 pp. Reprint (with a new introduction), of the 1957 ed.

2304. *The Population of Trinidad and Tobago.* Jack Harewood. Paris: Committee for International Coordination of National Research in Demography (CICRED); 1975. 237 pp.

2305. *Population Policies in the Caribbean.* Aaron Segal, ed. Lexington, MA: Lexington Books; 1975. 239 pp.

2306. *Race and Class in Post-Colonial Society: A Study of Ethnic Group Relations in the English-Speaking Caribbean, Bolivia, Chile and Mexico.* United Nations Educational, Scientific, and Cultural Organization. Paris: UNESCO; 1977. 458 pp.

2307. *Race and Guyana: The Anatomy of a Colonial Enterprise.* Henry Jocelyn Makepeace Hubbard. Kingston: [s.n.]; 1969. 86 pp.

2308. *Race and Nationalism in Trinidad and Tobago: A Study of Decolonization in a Multiracial Society.* Selwyn D. Ryan. Toronto: University of Toronto Press; 1972. 509 pp.

2309. *Race Relations in Colonial Trinidad, 1870–1900.* Bridget Brereton. New York, NY: Cambridge University Press; 1979. 251 pp.

2310. *Sterilization and Fertility Decline in Puerto Rico.* Harriet B. Presser. Westport, CT: Greenwood Press; 1976. 211 pp. Reprint of the 1973 ed.

2311. *Suriname, Land of Seven Peoples: Social Mobility in a Plural Society—An Ethno-Historical Study.* Frits Eduard Mangal Mitrasing. Paramaribo: F. E. M. Mitrasing; 1980. 176 pp.

2312. *La vie matérielle des noirs réfugiés Boni et des indiens Wayana du Haut-Maroni (Guyane française): agriculture, économie et habitat.* Jean Hurault. Paris: Office de la recherche scientifique et technique outre-mer (ORSTOM); 1965. 143 pp.

2313. *Windward Children: A Study in Human Ecology of the Three Dutch Windward Islands in the Caribbean.* John Yak Keur, Dorothy L. Keur. Assen: Van Gorcum; 1960. 299 pp.

b. Minorities

aa. Native Caribbeans

2314. *Additional Studies of the Arts, Crafts and Customs of the Guiana Indians: With Special Reference to Those of Southern British Guiana.* Walter Edmund Roth. Washington, DC: GPO; 1929. 110 pp.

2315. *The Amerindians in Guyana, 1803–73: A Documentary History.* Mary Noel Menezes, ed. Totowa, NJ: Cass; 1979. 314 pp.

2316. *Les amérindiens de la Haute-Guyane Française: anthropologie, pathologie, biologie.* Etienne P. Bois. Paris: Desclée; 1967. 180 pp.

2317. *The Barama River Caribs of British Guiana.* John Philip Gillin. Millwood, NY: Kraus Reprint; 1975. 274 pp. Reprint of the 1936 ed.

2318. *The Black Carib of British Honduras.* Douglas MacRae Taylor. New York, NY: Johnson Reprint; 1967. 176 pp. Reprint of the 1951 ed.

2319. *The Carib Reserve: Identity and Security in the West Indies.* Anthony Layng. Washington, DC: University Press of America; 1983. 177 pp.

2320. *Carib-Speaking Indians: Culture, Society, and Language.* Nelly Arvelo-Jimenez [et al.]; Ellen B. Basso, ed. Tucson, AZ: University of Arizona Press; 1977. 122 pp.

2321. *Contribuciones al estudio de la mitología y astronomía de los indios de las Guayanas.* Edmundo Magaña, ed. Amsterdam: CEDLA; 1987. 306 pp.

2322. *Ethnology of the Mayas of Southern and Central British Honduras.* John Eric Sidney Thompson. Millwood, NY: Kraus Reprint; 1973. 213 pp. Reprint of the 1930 ed.

2323. *The Forgotten Tribes of Guyana.* W. M. Ridgwell. London: T. Stacey; 1972. 248 pp.

2324. *Français et indiens en Guyane, 1604–1972.* Jean Hurault. [Nouv. éd.]. Cayenne: Guyane presse diffusion; 1989. 224 pp.

2325. *Heart Drum: Spirit Possession in the Garifuna Communities of Belize.* Byron Foster. Belize City: Cubola Productions; 1986. 50 pp.

2326. *Les indiens Wayana de la Guyane française: structure sociale et coutume familiale.* Jean Hurault. Paris: ORSTOM; 1985. 152 pp. Reprint of the 1968 ed.

2327. *Los indios de las Antillas.* Roberto Cassá. Madrid: Editorial MAPFRE; 1992. 330 pp.

2328. *Individual and Society in Guiana: A Comparative Study of Amerindian Social Organization.* Peter Rivière. New York, NY: Cambridge University Press; 1984. 126 pp.

2329. *The Maroni River Caribs of Surinam.* Peter Kloos. Assen: Van Gorcum; 1971. 318 pp.

2330. *Material Culture of the Waiwái.* Jens Yde. Copenhagen: National Museum; 1965. 319 pp.

2331. *The Mopan: Culture and Ethnicity in a Changing Belizean Community.* James Robert Gregory. Columbia, MO: Museum of Anthropology, University of Missouri-Columbia; 1984. 153 pp.

2332. *Myths of a Minority: The Changing Traditions of the Vincentian Caribs.* C. J. M. R. Gullick. Assen: Van Gorcum; 1985. 211 pp.

2333. *Oral Literature of the Trio Indians of Surinam.* Cees Koelewijn, Peter Rivière. Leiden: Caraïbische Afdeling, Koninklijk Instituut voor Taal-, Land- en Volkenkunde; 1987. 312 pp.

2334. *The Powerless People: An Analysis of the Amerindians of the Corentyne River.* Andrew Sanders. London: Macmillan Caribbean; 1987. 224 pp.

2335. *Pueblos y política en el Caribe amerindio: memoria.* Encuentro del Caribe Amerindio (First, 1988, Santo Domingo). Mexico City: Instituto Indigenista Interamericano; 1990. 117 pp.

2336. No entry.

2337. *Sojourners of the Caribbean: Ethnogenesis and Ethnohistory of the Garifuna.* Nancie L. Solien González. Urbana, IL: University of Illinois Press, 1988. 253 pp.

2338. *Through Indian Eyes: A Journey Among the Indian Tribes of Guiana.* Colin Henfrey. New York, NY: Holt, Rinehart and Winston; 1965. 285 pp. British ed. has title *The Gentle People.*

2339. *Waiwai: Religion and Society of an Amazonian Tribe.* Niels Fock. Copenhagen: National Museum; 1963. 316 pp.

bb. Afro-Caribbeans

2340. *Africains de Guyane: la vie matérielle et l'art des noirs réfugiés de Guyane.* Jean Hurault. Cayenne: Editions Guyane presse diffusion; 1989. 232 pp. Reprint of the 1970 ed.

2341. *Alabi's World.* Richard Price. Baltimore, MD: Johns Hopkins University Press; 1990. 444 pp. About the Saramacca (people of Suriname).

2342. *Between Black and White: Race, Politics, and the Free Coloreds in Jamaica, 1792–1865.* Gad J. Heuman. Westport, CT: Greenwood Press; 1981. 231 pp.

2343. *The Birth of African-American Culture: An Anthropological Perspective.* Sidney Wilfred Mintz, Richard Price. Boston, MA: Beacon Press; 1992. 121 pp. Reprint, with a new pref., of the 1976 ed. published under title *An Anthropological Approach to the Afro-American Past.*

2344. *The Black Bahamian: His Indomitable Quest for Metaphysical, Ontological, and Political Balance.* Lowell A. Moree. New York, NY: Vantage Press; 1990. 100 pp.

2345. *Black Families in Modern Bermuda.* Max Paul. Göttingen [Germany]: Edition Herodot; 1983. 122 pp.

2346. *Black Man in Red Cuba.* John Clytus, Jane Rieker. Coral Gables, FL: University of Miami Press; 1970. 158 pp.

2347. *Black Power in the Caribbean: The Beginnings of the Modern National Movement.* W. F. Elkins. New York, NY: Revisionist Press; 1977. 93 pp.

2348. *Black Roadways: A Study of Jamaican Folk Life.* Martha Warren Beckwith. New York, NY: Negro Universities Press; 1969. 243 pp. Reprint of the 1929 ed.

2349. *Black Separatism and the Caribbean, 1860.* James Theodore Holly, J. Dennis Harris; Howard Holman Bell, ed. Ann Arbor, MI: University of Michigan Press; 1970. 184 pp.

2350. *Componentes africanos en el etnos cubano.* Rafael L. López Valdés. Havana: Editorial de Ciencias Sociales; 1985. 252 pp.

2351. *Crab Antics: The Social Anthropology of English-Speaking Negro Societies of the Caribbean.* Peter J. Wilson. New Haven, CT: Yale University Press; 1973. 258 pp.

2352. *Cultura afrocubana.* Jorge Castellanos, Isabel Castellanos. Miami, FL: Ediciones Universal; 1988– [vols. 1–3+].

2353. *Djuka Society and Social Change: History of an Attempt to Develop a Bush Negro Community in Surinam, 1917–1926.* Silvia W. de Groot. Assen: Van Gorcum; 1969. 256 pp.

2354. *Equatoria.* Richard Price, Sally Price. New York, NY: Routledge; 1992. 295 pp. About Suriname.

2355. *The Fighting Maroons of Jamaica.* Carey Robinson. Kingston: Collins and Sangster; 1969. 160 pp.

2356. *First-Time: The Historical Vision of an Afro-American People.* Richard Price. Baltimore, MD: Johns Hopkins University Press; 1983. 189 pp. About the Saramacca (people of Suriname).

2357. *The Groundings with My Brothers.* Walter Rodney. Chicago, IL: Research Associates School Times Publications; 1990. 68 pp. Reprint of the 1969 ed.

2358. *Ibo: yorubas en tierras cubanas.* Rosalía de la Soledad, María J. Sanjuan de Novas. Miami, FL: Ediciones Universal; 1988. 278 pp.

2359. *Identity, Race, and Protest in Jamaica.* Rex M. Nettleford. New York, NY: Morrow; 1972. 256 pp. Originally published in 1970 under title *Mirror, Mirror.*

2360. *Idéologie de couleur et classes sociales en Haïti.* Micheline Labelle. Montreal: Presses de l'Université de Montréal; 1987. 393 pp. Reprint of the 1978 ed.

2361. *Is Massa Day Dead? Black Moods in the Caribbean.* Orde Coombs, ed. Garden City, NY: Anchor Books; 1974. 260 pp.

2362. *Mind the Onion Seed: Black "Roots" Bermuda.* Nellie Eileen Musson. Hamilton: Musson's; 1979. 329 pp.

2363. *Narciso descubre su trasero: el negro en la cultura puertorriqueña.* Isabelo Zenón Cruz. Humacao, P.R.: Editorial Furidi; 1974–1975. 2 vols.

2364. *Négritude et politique aux Antilles.* Alain Philippe Blérald. Paris: Editions caribéennes; 1981. 91 pp.

2365. *El negro en Cuba, 1902–1958: apuntes para la historia de la lucha contra la discriminación racial.* Tomás Fernández Robaina. Havana: Editorial de Ciencias Sociales; 1990. 225 pp.

2366. *The Negro in the Caribbean.* Eric Eustace Williams. New York, NY: Haskell House; 1971. 119 pp. Reprint of the 1942 ed.

2367. *The Negro in the French West Indies.* Shelby Thomas McCloy. Westport, CT: Negro Universities Press; 1974. 278 pp. Reprint of the 1966 ed.

2368. *Los negros curros.* Fernando Ortiz; Diana Iznaga, ed. Ed. póstuma. Havana: Editorial de Ciencias Sociales; 1986. 320 pp. About Cuba.

2369. *Los negros, los mulatos y la nación dominicana.* Franklin J. Franco. Santo Domingo: Editora Nacional; 1989. 162 pp. Reprint of the 1969 ed.

2370. *Les noirs réfugiés Boni de la Guyane Française.* Jean Hurault. Dakar: Institut Français d'Afrique Noire (IFAN); 1961. 364 pp.

2371. *Le préjugé de race aux Antilles françaises: étude historique.* G. Souquet-Basiège. Paris: Désormeaux; 1979. 511 pp.

2372. *El prejuicio racial en Puerto Rico.* Tomás Blanco. 3a ed., aum. Río Piedras, P.R.: Ediciones Huracán; 1985. 145 pp.

2373. *El problema negro en Cuba y su solución definitiva.* Pedro Serviat. Havana: Editora Política; 1986. 197 pp.

2374. *Puerto Rico negro.* Jalil Sued Badillo, Angel López Cantos. Río Piedras, P.R.: Editorial Cultural; 1986. 315 pp.

2375. *Race Crossing in Jamaica.* Charles Benedict Davenport [et al.]. Westport, CT: Negro Universities Press; 1970. 516 pp. Reprint of the 1929 ed.

2376. *Rebel Destiny [Among the Bush Negroes of Dutch Guiana].* Melville Jean Herskovits, Frances Shapiro Herskovits. Freeport, NY: Books for Libraries Press; 1971. 366 pp. Reprint of the 1934 ed.

2377. *Saramaka Social Structure: Analysis of a Maroon Society in Surinam.* Richard Price. Río Piedras, P.R.: Institute of Caribbean Studies, University of Puerto Rico; 1975. 177 pp.

2378. *The Sun and the Drum: African Roots in Jamaican Folk Tradition.* Leonard E. Barrett. Kingston: Sangster's; 1976. 128 pp.

cc. Others (Asian Caribbeans, Jews, etc.)

2379. *De betovering verbroken: de migratie van Javanen naar Suriname en het Rapport Van Vleuten (1909) [The Broken Magic Spell: The Migration of Javanese to Suriname and the Van Vleuten Report (1909)].* Rosemarijn Hoefte. Leiden: Caraïbische Afdeling, Koninklijk Instituut voor Taal-, Land- en Volkenkunde; 1990. 131 pp.

2380. *Calcutta to Caroni: [The East Indians of Trinidad and Tobago].* John Gaffar La Guerre, ed. 2d rev. ed. St. Augustine, Trinidad/Tobago: Extra-Mural Studies Unit, University of the West Indies; 1985. 208 pp.

2381. *Caribbean Asians: Chinese, Indian, and Japanese Experiences in Trinidad and the Dominican Republic.* Roger Sanjek, ed. Flushing, NY: Asian/American Center, Queens College, City University of New York; 1990. 126 pp.

2382. *Centenary History of the East Indians in British Guiana, 1838–1938.* Peter Ruhomon. Georgetown: East Indians 150th Anniversary Committee; 1988. 312 pp. Reprint of the 1947 ed.

2383. *The Chinese in British Guiana.* Cecil Clementi. Georgetown: Argosy; 1915. 416 pp.

2384. *Los chinos en la historia de Cuba, 1847–1930.* Juan Jiménez Pastrana. [2a ed.]. Havana: Editorial de Ciencias Sociales; 1983. 225 pp. Rev. ed. of *Los chinos en las luchas por la liberación cubana.*

2385. *La colonia española en la economía cubana.* José M. Alvarez Acevedo. Havana: Ucar, García; 1936. 260 pp.

2386. *The East Indian Indenture in Trinidad.* Judith Ann Weller. Río Piedras, P.R.: Institute of Caribbean Studies, University of Puerto Rico; 1968. 172 pp.

2387. *East Indians and Black Power in the Caribbean: The Case for Trinidad.* Mahin Gosine. New York, NY: Africana Research Publications; 1986. 269 pp.

2388. *East Indians in the West Indies.* Arthur Niehoff, Juanita Niehoff. Milwaukee, WI: Milwaukee Public Museum; 1960. 192 pp.

2389. *East Indians in the Caribbean: Colonialism and the Struggle for Identity—Papers.* Symposium on East Indians in the Caribbean (1975, University of the West Indies, Saint Augustine, Trinidad); V. S. Naipaul [et al.]. Millwood, NY: Kraus International; 1982. 159 pp.

2390. *East Indians in Trinidad: A Study in Minority Politics.* Yogendra K. Malik. New York, NY: Oxford University Press; 1971. 199 pp.

2391. *East Indians in Trinidad: A Study of Cultural Persistence.* Morton Klass. Prospect Heights, IL: Waveland Press; 1988. 265 pp. Reprint of the 1961 ed.

2392. *La formación del pueblo puertorriqueño.* Estela Cifre de Loubriel. San Juan [etc.]: Instituto de Cultura Puertorriqueña [etc.]; 1975–1988. 2 vols. Vol. 1. *La contribución de los catalanes, baleáricos y valencianos;* vol. 2. *La contribución de los gallegos, asturianos y santanderinos.*

2393. *Hindu Trinidad: Religion, Ethnicity and Socio-Economic Change.* Steven Vertovec. London: Macmillan Caribbean; 1992. 272 pp.

2394. *A History of Indians in Guyana.* Dwarka Nath. 2d rev. ed. London: D. Nath; 1970. 281 pp. First ed. has title *A History of Indians in British Guiana.*

2395. *History of the Jews of the Netherlands Antilles.* Isaac Samuel Emmanuel, Suzanne A. Emmanuel. Cincinnati, OH: American Jewish Archives; 1970. 2 vols.

2396. *Idéologie et ethnicité: les chinois macao à Cuba, 1847–1886.* Denise Helly. Montreal: Presses de l'Université de Montréal; 1979. 345 pp.

2397. *Indenture and Exile: The Indo-Caribbean Experience.* Frank Birbalsingh, ed. Toronto: TSAR; 1989. 264 pp.

2398. *India in the Caribbean.* David Dabydeen, Brinsley Samaroo, eds. London: Hansib Publishing; 1987. 326 pp.

2399. *Indian Village in Guyana: A Study of Cultural Change and Ethnic Identity.* Mohammad Abdur Rauf. Leiden: Brill; 1974. 121 pp.

2400. *Indians in the Caribbean.* I. J. Bahadur Singh, ed. New Delhi: Sterling Publishers; 1987. 428 pp.

2401. *Les indiens de la Caraïbe.* Singaravélou. Paris: L'Harmattan; 1987. 3 vols.

2402. *La inmigración haitiana.* Frank Marino Hernández. Santo Domingo: Ediciones Sargazo; 1973. 98 pp.

2403. *The Javanese of Surinam: Segment of a Plural Society.* Annemarie De Waal Malefijt. Assen: Van Gorcum; 1963. 206 pp.

2404. *The Jewish Nation in Surinam: Historical Essays.* Robert Cohen, ed. Amsterdam: Emmering; 1982. 103 pp.

2405. *Migración y relaciones internacionales: el caso haitiano-dominicano.* Suzy Castor. Ed. rev. Santo Domingo: Editora Universitaria, Universidad Autónoma de Santo Domingo; 1987. 186 pp. Rev. ed. of *Migraciones y relaciones internacionales* (1983).

2406. *Minorities and Power in a Black Society: The Jewish Community of Jamaica.* Carol S. Holzberg. Lanham, MD: North-South; 1987. 259 pp.

2407. *A Record of the Jews in Jamaica from the English Conquest to the Present Times.* Jacob A. P. M. Andrade; Basil Parks, ed. Kingston: Jamaica Times; 1941. 282 pp.

2408. *Scenes from the History of the Portuguese in Guyana.* Mary Noel Menezes. London: M. N. Menezes; 1986. 175 pp.

2409. *The Sephardics of Curaçao: A Study of Socio-Cultural Patterns in Flux.* Frances P. Karner. Assen: Van Gorcum; 1970. 94 pp.

2410. *Singing with Sai Baba: The Politics of Revitalization in Trinidad.* Morton Klass. Boulder, CO: Westview Press; 1991. 187 pp.

2411. *Sojourners in the Sun: Scottish Migrants in Jamaica and the Chesapeake, 1740–1800.* Alan L. Karras. Ithaca, NY: Cornell University Press; 1992. 231 pp.

2412. *Sosúa: una colonia hebrea en la República Dominicana.* Josef David Eichen. Santiago, D.R.: Universidad Católica Madre y Maestra; 1980. 126 pp.

2413. *A Study of the Chinese in Cuba, 1847–1947.* Duvon Clough Corbitt. Wilmore, KY: Ashbury College Press; 1971. 142 pp.

7. MASS MEDIA

2414. *Children of Colonial Despotism: Press, Politics, and Culture in Cuba, 1790–1840.* Larry R. Jensen. Tampa, FL: University Presses of Florida; 1988. 211 pp.

2415. *The Grenada File: The Media, Law and Politics.* Ramesh Deosaran, ed. St. Augustine, Trinidad/Tobago: Extra-Mural Studies Unit, University of the West Indies; 1989. 246 pp.

2416. *La imprenta y los primeros periódicos de Santo Domingo.* Emilio Rodríguez Demorizi. Santo Domingo: Editora Taller; 1973. 255 pp. Reprint of the 1941 ed.

2417. *Mass Communications Services: Puerto Rican Government Radio, Television, and Community Education.* Consuelo Rivera de Otero. Río Piedras, P.R.: University of Puerto Rico Press; 1976. 153 pp.

2418. *Mass Communications in the Caribbean.* John A. Lent. Ames, IA: Iowa State University Press; 1990. 398 pp.

2419. *Mass Media and the Caribbean.* Stuart H. Surlin, Walter C. Soderlund, eds. New York, NY: Gordon and Breach; 1990. 471 pp.

2420. *Media in Latin America and the Caribbean: Domestic and International Perspectives—Proceedings.* Ontario Cooperative Program in Latin American and Caribbean Studies, Conference (1984, University of Windsor); Walter C. Soderlund, Stuart H. Surlin, eds. Windsor, Ont.: OCPLACS; 1985. 272 pp.

2421. *Panorama del periodismo puertorriqueño.* José A. Romeu. Río Piedras, P.R.: Universidad de Puerto Rico; 1985. 225 pp.

2422. *El periodismo en Puerto Rico.* Antonio Salvador Pedreira. Río Piedras, P.R.: Editorial Edil; 1982. 358 pp. Reprint of the 1969 (2d) ed.

2423. *Power and Television in Latin America: The Dominican Case.* Antonio V. Menéndez Alarcón. Westport, CT: Praeger; 1992. 199 pp.

2424. *La prensa en República Dominicana: ideología, información y noticia.* Alberto Malagón. Santo Domingo: Universidad Autónoma de Santo Domingo; 1986. 468 pp.

2425. *Prensa y política en la República Dominicana.* Frank Moya Pons, ed. Santo Domingo: Editora Amigo del Hogar; 1984. 173 pp.

2426. *The Press and the Law in the Caribbean.* Dorcas White. Bridgetown: Cedar Press; 1977. 70 pp.

2427. *La publicidad en Puerto Rico: cómo fué, cómo es, cómo se hace.* Rafael H. Benítez. Río Piedras, P.R.: Universidad de Puerto Rico; 1985. 275 pp.

2428. *The Puerto Rican Press Reaction to the United States, 1888–1898.* Paul Nelson Chiles. New York, NY: Arno Press; 1975. 109 pp.

2429. *The Selling of Fidel Castro: The Media and the Cuban Revolution [Papers].* Conference, "The Media and the Cuban Revolution" (1984, Washington, DC); William E. Ratliff, ed. New Brunswick, NJ: Transaction Books; 1987. 197 pp.

2430. *Talking with Whom?* Aggrey Brown, Roderick Sanatan. Mona, Jamaica: Caribbean Institute of Mass Communication, University of the West Indies; 1987. 274 pp.

2431. *Third World Mass Media and Their Search for Modernity: The Case of Commonwealth Caribbean, 1717–1976.* John A. Lent. Lewisburg, PA: Bucknell University Press; 1977. 405 pp.

8. PUBLIC HEALTH AND MEDICINE

2432. *Apothekers en chirurgijns: gezondheidszorg op de Benedenwindse eilanden van de Nederlandse Antillen in de negentiende eeuw [Pharmacists and Surgeons: Health Care on the Leeward Islands of the Netherlands Antilles in the Nineteenth Century].* Alfons Martinus Gerardus Rutten. Assen: Van Gorcum; 1989. 329 pp.

2433. *Apuntes para la historia de la medicina de la isla de Santo Domingo.* Francisco E. Moscoso Puello. Ed. rev. San Pedro de Macorís, D.R.: Universidad Central del Este; 1983–1985. 6 vols.

2434. *The Caribbean: Its Health Problems.* Conference on the Caribbean (Fifteenth, 1964, University of Florida); Alva Curtis Wilgus, ed. Gainesville, FL: University of Florida Press; 1965. 273 pp.

2435. *Colonial Madness: Mental Health in the Barbadian Social Order.* Lawrence E. Fisher. New Brunswick, NJ: Rutgers University Press; 1985. 275 pp.

2436. *Constructive Mental Hygiene in the Caribbean: Proceedings.* Caribbean Conference on Mental Health (First, 1957, Aruba). Assen: Van Gorcum; 1957. 176 pp.

2437. *Cuban Medicine.* Ross Danielson. New Brunswick, NJ: Transaction Books; 1979. 247 pp.

2438. *Cultural Aspects of Delusion: A Psychiatric Study of the Virgin Islands.* Edwin Alexander Weinstein. New York, NY: Free Press of Glencoe; 1962. 215 pp.

2439. *Disease and Economic Development: The Impact of Parasitic Diseases in St. Lucia.* Burton Allen Weisbrod [et al.]. Madison, WI: University of Wisconsin Press; 1973. 218 pp.

2440. *The Elderly in the Caribbean: Proceedings.* CME Conference on the Elderly (1984, Kingston); Gerald A. C. Grell, ed. Kingston: University of the West Indies; 1987. 205 pp.

2441. *L'état de mal en Haïti: sous-développement, dominantes pathologiques, pratiques et perspectives médicales, avec des études sur le SIDA, le vaudou et la médecine traditionelle.* Yves Saint-Gérard. Toulouse: Eché; 1984. 126 pp.

2442. *Farmacodependencia y narcotráfico en República Dominicana: factores culturales, sociales y económicos.* Eusebio Henríquez. Santo Domingo: Editora Taller; 1990. 93 pp.

2443. *For the People, for a Change: Bringing Health to the Families of Haiti.* Ary Bordes, Andrea Couture. Boston, MA: Beacon Press; 1978. 299 pp.

2444. *Four Decades of Advances in Health in the Commonwealth Caribbean: Proceedings of a Symposium, Bridgetown, Barbados, West Indies, 14–16 September 1977.* Kenneth L. Standard, José R. Teruel, eds. Washington, DC: Pan American Health Organization; 1979. 159 pp.

2445. *Health Care for the Poor in Latin America and the Caribbean.* Carmelo Mesa-Lago. Washington, DC: Pan American Health Organization; 1992. 234 pp.

2446. *Health in Grenada: A Social and Historical Account.* David Francis Clyde. London: Vade-Mecum; 1985. 415 pp.

2447. *The Health Revolution in Cuba.* Sergio Díaz-Briquets. Austin, TX: University of Texas Press; 1983. 227 pp.

2448. *Herbal Medicine and Home Remedies: A Pot Pourri in Bahamian Culture.* Portia Brown Jordan. Nassau: Nassau Guardian; 1986. 172 pp.

2449. *Historia de la medicina en Cuba: hospitales y centros benéficos en Cuba colonial.* César A. Mena, Armando F. Cobelo. Miami, FL: Ediciones Universal; 1992. 717 pp.

2450. *History of Haitian Medicine.* Robert Percival Parsons. New York, NY: Hoeber; 1930. 196 pp.

2451. *Hypertension and Culture Change: Acculturation and Disease in the West Indies.* William Wymer Dressler. South Salem, NY: Redgrave; 1982. 158 pp.

2452. *La lucha por la salud en Cuba.* Leopoldo Aráujo Bernal, José Lloréns Figueroa, eds. Mexico City: Siglo XXI Editores; 1985. 382 pp.

2453. *Les maladies en Haïti.* Rulx Léon. Port-au-Prince: Impr. de l'Etat; 1954. 345 pp.

2454. *Población y salud en la República Dominicana.* Nelson Ramírez. Santo Domingo: Instituto de Estudios de Población y Desarrollo de Profamilia; 1987. 158 pp.

2455. *The Politics of Psychiatry in Revolutionary Cuba.* Charles J. Brown, Armando M. Lago. Washington, DC: Freedom House of Human Rights; 1991. 217 pp.

2456. *Regionalization of Health Services: The Puerto Rican Experience.* Guillermo Arbona, Annette B. Ramírez de Arellano. New York, NY: Oxford University Press; 1978. 96 pp.

2457. *La sanidad en Puerto Rico hasta 1898.* Salvador Arana Soto. San Juan: Academia Puertorriqueña de la Historia; 1978. 347 pp.

2458. *Society and Health in Guyana: The Sociology of Health Care in a Developing Nation.* Marcel Fredericks [et al.]. Durham, NC: Carolina Academic Press; 1986. 173 pp.

9. RELIGION

a. General Works

2459. *Between God and the Party: Religion and Politics in Revolutionary Cuba.* John M. Kirk. Tampa, FL: University of South Florida Press; 1989. 231 pp.

2460. *Christ for Jamaica: A Symposium of Religious Activities.* Jamaica Christian Council; J. A. Crabb, ed. Kingston: Pioneer Press; 1951. 102 pp.

2461. *Christ's Witchdoctor: From Savage Sorcerer to Jungle Missionary.* Homer E. Dowdy. Grands Rapids, MI: Zondervan; 1973. 239 pp. Reprint of the 1963 ed.

2462. *Christianity and Revolution: The Lesson of Cuba.* Leslie Dewart. New York, NY: Herder and Herder; 1963. 320 pp.

2463. *The Churches of the Dominican Republic in the Light of History: A Study of the Root Causes of Current Problems.* William Louis Wipfler. Cuernavaca, Mex.: Centro Intercultural de Documentación; 1966. 210 pp.

2464. *Decolonizing Theology: A Caribbean Perspective.* Noel Leo Erskine. Maryknoll, NY: Orbis Books; 1981. 130 pp.

2465. *Emancipation Still Comin': Explorations in Caribbean Emancipatory Theology.* Kortright Davis. Maryknoll, NY: Orbis Books; 1990. 164 pp.

2466. *From Shore to Shore: Soundings in Caribbean Theology.* William Watty. Kingston: [s.n.]; 1981. 96 pp.

2467. *Histoire religieuse des Antilles françaises des origines à 1914: d'après des documents inédits.* Joseph Rennard. Paris: Société de l'histoire des colonies françaises; 1954. 448 pp.

2468. *A History of Christianity in Belize, 1776–1838*. Wallace R. Johnson. Lanham, MD: University Press of America; 1985. 300 pp.

2469. *A History of Religions in the Caribbean*. Dale A. Bisnauth. Kingston: Kingston Publishers; 1989. 225 pp.

2470. *Obeah, Christ, and Rastaman: Jamaica and Its Religion*. Ivor Morrish. Cambridge: J. Clarke; 1982. 122 pp.

2471. *Real Roots and Potted Plants: Reflections on the Caribbean Church*. Ashley A. Smith. Williamsfield, Jamaica: Mandeville; 1984. 91 pp.

2472. *Religion and Politics in Haiti: Two Essays*. Harold Courlander, Rémy Bastien. Washington, DC: Institute for Cross-Cultural Research; 1966. 81 pp.

2473. *Understanding the Religious Background of the Puerto Rican*. Jerry Fenton. Cuernavaca, Mex.: Centro Intercultural de Documentación; 1969. 72 pp.

b. Roman Catholic Church

2474. *The Catholic Church in Colonial Puerto Rico, 1898–1964*. Elisa Julián de Nieves. Río Piedras, P.R.: Editorial Edil; 1982. 266 pp.

2475. *The Catholic Church in Haiti, 1704–1785: Selected Letters, Memoirs and Documents*. George Breathett, ed. Salisbury, NC: Documentary Publications; 1982. 202 pp.

2476. *The Catholic Church in Montserrat, West Indies, 1756–1980*. Antoine Demets. Plymouth, Montserrat: [s.n.]; 1980. 92 pp.

2477. *Catholic Church in Trinidad, 1797–1820*. Vincent Leahy. Arima, Trinidad/Tobago: St. Dominic Press; 1980. 218 pp.

2478. *The Church and Socialism in Cuba*. Raúl Gómez Treto; Phillip Berryman, tr. Maryknoll, NY: Orbis Books; 1988. 151 pp. Translation of *La Iglesia Católica durante la construcción del socialismo en Cuba*.

2479. *Descubrir a Dios en el Caribe: ensayos sobre la historia de la Iglesia*. Armando Lampe. San José, C.R.: Editorial DEI; 1991. 83 pp.

2480. *¿Estos no son hombres? lectura actual del proyecto apostólico de la primera comunidad de dominicos en el Nuevo Mundo*. Juan Manuel Pérez. 2a ed. Santo Domingo: Fundación García-Arévalo; 1988. 175 pp.

2481. *Heterodoxia e inquisición en Santo Domingo, 1492–1822*. Carlos Esteban Deive. Santo Domingo: Editora Taller; 1983. 400 pp.

2482. *Historia de la Iglesia en Puerto Rico, 1511–1802*. Cristina Campo Lacasa. San Juan: Instituto de Cultura Puertorriqueña; 1977. 326 pp.

2483. *Historia eclesiástica de Cuba*. Ismael Testé. Burgos: Editorial "El Monte Carmelo"; 1969– [vols. 1–4+].

2484. *A History of the Catholic Church in Belize*. Richard O. Buhler. Belize City: Belize Institute for Social Research and Action (BISRA); 1976. 96 pp.

2485. *History of the Catholic Church in Jamaica.* Francis J. Osborne. [New ed.]. Chicago, IL: Loyola University Press; 1988. 532 pp.

2486. *In Bloody Terms: The Betrayal of the Church in Marxist Grenada.* Andrew J. Zwerneman. South Bend, IN: Greenlawn Press; 1986. 113 pp.

2487. *La isla Española: cuna de la evangelización de América.* Juan Antonio Flores Santana. Santo Domingo: Amigo del Hogar; 1986. 242 pp.

2488. *Poder, influencia e impotencia: la Iglesia como factor socio-político en República Dominicana.* William Louis Wipfler; Samuel E. James, tr. Santo Domingo: Ediciones CEPAE; 1980. 314 pp.

2489. *Religious Repression in Cuba.* Juan M. Clark. Coral Gables, FL: North-South Center, Institute of Interamerican Studies, University of Miami; 1986. 115 pp.

2490. *Upon These Rocks: Catholics in the Bahamas.* Colman James Barry. Collegeville, MN: St. John's Abbey Press; 1973. 582 pp.

c. Protestant Denominations

2491. *Apuntes para una historia del presbiterianismo en Cuba.* Rafael Cepeda [et al.]. Havana: Ediciones Su Voz; 1986. 332 pp.

2492. *Baptists in the Bahamas: An Historical Review.* Michael Carrington Symonette, Antonia Canzoneri. El Paso, TX: Baptist Spanish Publishing House; 1977. 79 pp.

2493. *The Baptists of Jamaica.* Inez Knibb Sibley. Kingston: Jamaica Baptist Union; 1965. 91 pp.

2494. *Caribbean Quakers.* Harriet Frorer Durham. Hollywood, FL: Dukane Press; 1972. 133 pp.

2495. *Codrington Chronicle: An Experiment in Anglican Altruism on a Barbados Plantation, 1710–1834.* Frank Joseph Klingberg. Millwood, NY: Kraus Reprint; 1974. 157 pp. Reprint of the 1949 ed.

2496. *Cross and Crown in Barbados: Caribbean Political Religion in the Late Nineteenth Century.* Kortright Davis. New York, NY: P. Lang; 1983. 187 pp.

2497. *The Cuban Church in a Sugar Economy: A Study of the Economic and Social Basis of the Evangelical Church in Cuba.* John Merle Davis. New York, NY: International Missionary Council; 1942. 144 pp.

2498. *Daybreak in Jamaica.* Frederick Pilkington. London: Epworth Press; 1950. 220 pp. About the Methodist Church.

2499. *La herencia misionera en Cuba: consulta.* Herencia Misionera en las Iglesias Cubanas (1984, Matanzas, Cuba); Rafael Cepeda, ed. San José, C.R.: Editorial DEI; 1986. 244 pp.

2500. *A History of the Lutheran Church in Guyana.* Paul B. Beatty. Skeldon, Guyana: [s.n.]; 1970. 134 pp.

2501. *A History of the Moravian Church, Eastern West Indies Province*. G. Oliver Maynard. Port of Spain: Yuille's Printerie; 1968. 175 pp.

2502. *Marchin' the Pilgrims Home: A Study of the Spiritual Baptists of Trinidad*. Stephen D. Glazier. Salem, WI: Sheffield; 1991. 165 pp. Reprint of the 1983 ed. published under title *Marchin' the Pilgrims Home: Leadership and Decision-Making in an Afro-Caribbean Faith*.

2503. *Methodism in the West Indies*. Henry Adams. London: R. Culley; 1908. 128 pp.

2504. *Methodism's First Fifty Years in Cuba*. Sterling Augustus Neblett. Wilmore, KY: Asbury Press; 1976. 303 pp.

2505. *Methodism: Two Hundred Years in Barbados*. Francis Blackman. Bridgetown: Caribbean Contact; 1988. 160 pp.

2506. *Methodism: Two Hundred Years in British Virgin Islands*. Francis Blackman. [S.l.]: Methodist Church in the British Virgin Islands; 1989. 151 pp.

2507. *Panorama del protestantismo en Cuba: la presencia de los protestantes o evangélicos en la historia de Cuba desde la colonización española hasta la revolución*. Marcos Antonio Ramos. San José, C.R.: Editoral Caribe; 1986. 668 pp.

2508. *Perspectives on Pentecostalism: Case Studies from the Caribbean and Latin America*. Stephen D. Glazier, ed. Washington, DC: University Press of America; 1980. 197 pp.

2509. *Presbyterian Missions to Trinidad and Puerto Rico*. Graeme Stewart Mount. Hantsport, N.S.: Lancelot Press; 1983. 356 pp.

2510. *Protestantism and Revolution in Cuba*. Marcos Antonio Ramos. Coral Gables, FL: University of Miami; 1989. 168 pp.

2511. *Le protestantisme dans la société haïtienne: contribution à l'étude sociologique d'une religion*. Charles-Poisset Romain. Port-au-Prince: H. Deschamps; 1986. 380 pp.

2512. *El protestantismo en Dominicana*. George A. Lockward. Santo Domingo: Editora Educativa Dominicana; 1982. 462 pp. Reprint of the 1976 ed.

2513. *Les protestants aux Antilles françaises du Vent sous l'Ancien Régime*. Gérald Lafleur. Basse-Terre: Société d'histoire de la Guadeloupe; 1988. 308 pp.

2514. *Seedtime and Harvest: A Brief History of the Moravian Church in Jamaica, 1754–1979*. Selvin U. Hastings, Basil LaTrobe MacLeavy. Kingston: Moravian Church Corp.; 1979. 264 pp.

2515. *A Short History of Baptist Missionary Work in British Honduras, 1822–1939*. Robert Cleghorn. London: Kingsgate Press; 1939. 71 pp.

2516. *Tortola: A Quaker Experiment of Long Ago in the Tropics*. Charles Francis Jenkins. London: Friends' Bookshop; 1923. 106 pp.

d. Afro-Caribbean Religions/Cults

2517. *Black Paradise: The Rastafarian Movement.* Peter Bernard Clarke. San Bernardino, CA: Borgo Press; 1988. 112 pp.

2518. *The Cult That Died: The Tragedy of Jim Jones and the Peoples Temple.* George Klineman, Sherman Butler, David Conn. New York, NY: Putnam; 1980. 372 pp.

2519. *Dieu dans le vaudou haïtien.* Laënnec Hurbon. Port-au-Prince: Deschamps; 1987. 268 pp. Reprint of the 1972 ed.

2520. *Divine Horsemen: The Living Gods of Haiti.* Maya Deren. New Paltz, NY: McPherson; 1983. 350 pp. Also published under title *Divine Horsemen: Voodoo Gods of Haiti;* reprint of the 1953 ed.

2521. *Dread: The Rastafarians of Jamaica.* Joseph Owens. Exeter, NH: Heinemann Educational; 1982. 282 pp. Reprint of the 1976 ed.

2522. *Evolving Culture: A Cross-Cultural Study of Suriname, West Africa, and the Caribbean.* Charles J. Wooding. Washington, DC: University Press of America; 1981. 329 pp.

2523. *The Faces of the Gods: Vodou and Roman Catholicism in Haiti.* Leslie Gérald Desmangles. Chapel Hill, NC: University of North Carolina Press; 1992. 218 pp.

2524. *"Gather with the Saints at the River": The Jonestown Guyana Holocaust of 1978—A Descriptive and Interpretative Essay on Its Ultimate Meaning from a Caribbean Viewpoint.* Gordon K. Lewis. Río Piedras, P.R.: Institute of Caribbean Studies, University of Puerto Rico; 1979. 50 pp.

2525. *The Great Father and the Danger: Religious Cults, Material Forces, and Collective Fantasies in the World of the Surinamese Maroons.* H. U. E. Thoden van Velzen, Wilhelmina van Wetering. Leiden: Caraïbische Afdeling, Koninklijk Instituut voor Taal-, Land- en Volkenkunde; 1991. 451 pp. Reprint of the 1988 ed.

2526. *Inside Voodoo.* Marcus Bach. New York, NY: New American Library; 1968. 176 pp. Reprint of the 1952 ed. published under title *Strange Altars.*

2527. *The Invisibles: Voodoo Gods in Haiti.* Francis Huxley. New York, NY: McGraw-Hill; 1969. 247 pp.

2528. *The Jombee Dance of Montserrat: A Study of Trance Ritual in the West Indies.* Jay D. Dobbin. Columbus, OH: Ohio State University Press; 1986. 202 pp.

2529. *Journey to Nowhere: A New World Tragedy.* Shiva Naipaul. New York, NY: Penguin; 1982. 336 pp. Also published under title *Black and White;* about the Peoples Temple, Jonestown, Guyana.

2530. *The Magic Island.* William Seabrook. New York, NY: Paragon House; 1989. 336 pp. Reprint of the 1929 ed.; about Haiti.

2531. *El monte: igbo, finda, ewe orisha, vititi nfinda—notas sobre las religiones, la magia, las supersticiones y el folklore de los negros criollos y el pueblo de Cuba.* Lydia Cabrera. Miami, FL: Ediciones Universal; 1992. 564 pp. Reprint of the 1975 (4th) ed.

2532. *Passage of Darkness: The Ethnobiology of the Haitian Zombie.* Wade Davis. Chapel Hill, NC: University of North Carolina Press; 1988. 344 pp.

2533. *Psychic Phenomena of Jamaica.* Joseph John Williams. Westport, CT: Greenwood Press; 1979. 309 pp. Reprint of the 1934 ed.

2534. *Rasta and Resistance: From Marcus Garvey to Walter Rodney.* Horace Campbell. Trenton, NJ: Africa World Press; 1987. 234 pp.

2535. *Rastafari: A Way of Life.* Tracy Nicholas; Bill Sparrow [ill.]. Garden City, NY: Anchor Books; 1979. 92 pp.

2536. *The Rastafarians: Sounds of Cultural Dissonance.* Leonard E. Barrett. Rev. and updated ed. Boston, MA: Beacon Press; 1988. 302 pp. Earlier ed. also published under title *The Rastafarians: The Dreadlocks of Jamaica.*

2537. *Religious Cults of the Caribbean: Trinidad, Jamaica, and Haiti.* George Eaton Simpson. 3d, enl., ed. Río Piedras, P.R.: Institute of Caribbean Studies, University of Puerto Rico; 1980. 346 pp. First ed. has title *The Shango Cult in Trinidad.*

2538. *Santería: A Practical Guide to Afro-Caribbean Magic.* Luis Manuel Núñez. Dallas, TX: Spring Publications; 1992. 163 pp.

2539. *Santería: An African Religion in America.* Joseph M. Murphy. Boston, MA: Beacon Press; 1988. 189 pp.

2540. *Secrets of Voodoo.* Milo Rigaud; Robert B. Cross, tr. San Francisco, CA: City Lights Books; 1985. 219 pp. Translation of *La tradition voudoo et le voudoo haïtien;* reprint of the 1969 ed.

2541. *Spirits of the Night: The Vaudun Gods of Haiti.* Selden Rodman, Carole Cleaver. Dallas, TX: Spring Publications; 1992. 144 pp.

2542. *Tell My Horse: Voodoo and Life in Haiti and Jamaica.* Zora Neale Hurston. New York, NY: Perennial Library; 1990. 311 pp. Reprint of the 1938 ed.

2543. *Ten, Ten, the Bible Ten: Obeah in the Bahamas.* Timothy O. McCartney. Nassau: Timpaul; 1976. 192 pp.

2544. *Theology in Folk Culture: The Theological Significance of Haitian Folk Religion.* George MacDonald Mulrain. New York, NY: P. Lang; 1984. 413 pp.

2545. *Vaudou, sorciers, empoisonneurs: de Saint-Domingue à Haiti.* Pierre Pluchon. Paris: Karthala; 1987. 320 pp.

2546. *El vodú en Cuba.* Joel James Figarola, José Millet, Alexis Alarcón. Santo Domingo: Ediciones CEDEE; 1992. 348 pp.

2547. *Vodú y magia en Santo Domingo.* Carlos Esteban Deive. Santo Domingo: Fundación Cultural Dominicana; 1992. 427 pp. Reprint of the 1975 ed.

2548. *Voodoo and Magic Practices.* Jean Kerboull; John Shaw, tr. London: Barrie and Jenkins; 1978. 192 pp. Translation of *Vaudou et pratiques magiques.*

2549. *Voodoo and Politics in Haiti.* Michel S. Laguerre. New York, NY: St. Martin's Press; 1989. 152 pp.

2550. *Voodoo Heritage.* Michel S. Laguerre. Beverly Hills, CA: Sage; 1980. 231 pp.

2551. *Voodoo in Haiti.* Alfred Métraux; Hugo Charteris, tr. New York, NY: Schocken Books; 1989. 426 pp. Translation of *Le vaudou haïtien;* reprint of the 1959 ed.

2552. *Voodoos and Obeahs: Phases of West Indian Witchcraft.* Joseph John Williams. New York, NY: AMS Press; 1970. 257 pp. Reprint of the 1932 ed.

2553. *Voudoun Fire: The Living Reality of Mystical Religion.* Melita Denning, Osborne Phillips. St. Paul, MN: Llewellyn; 1979. 161 pp.

2554. *Winti: Afro-Surinaamse religie en magische rituelen in Suriname en Nederland [Winti: Afro-Surinamese Religion and Magic Rituals in Surinam and the Netherlands].* Henri J. M. Stephen. Amsterdam: Karnak; 1985. 131 pp.

10. SOCIAL CONDITIONS (URBAN AND RURAL)

a. General Works

2555. *Afro-Caribbean Villages in Historical Perspective.* Charles V. Carnegie, ed. Kingston: African-Caribbean Institute of Jamaica; 1987. 133 pp.

2556. *Aliénation et sociétés post-esclavagistes aux Antilles.* Henri Bangou. [S.l.]: Francaribes; 1981. 141 pp.

2557. *Azúcar y política en la República Dominicana.* André Corten [et al.]. Santo Domingo: Editora Taller; 1981. 234 pp. First ed. has title *Imperialismo y clases sociales en el Caribe;* reprint of the 1976 (2d) ed.

2558. *Behind the Planter's Back: Lower Class Responses to Marginality in Bequia Island, St. Vincent.* Neil Price. London: Macmillan Caribbean; 1988. 272 pp.

2558a. *The Caribbean: One and Divisible.* Jean Casimir. Santiago, Chile: Economic Commission for Latin America and the Caribbean, United Nations; 1992. 207 pp.

2559. *Caribbean Social Relations.* Colin G. Clarke, ed. Liverpool: Centre for Latin-American Studies, University of Liverpool; 1978. 95 pp.

2560. *Caribbean Social Science: An Assessment.* Glenn Sankatsing. Caracas: UNESCO; 1989. 190 pp.

2561. *Caribbean Societies [Collected Seminar Papers]*. University of London, Institute of Commonwealth Studies. London: The Institute; 1982– [vols. 1–2+].

2562. *Caribbean Studies: A Symposium*. Vera D. Rubin, ed. New York, NY: AMS Press; 1988. 124 pp. Reprint of the 1957 ed.

2563. *Caribbean Transformations*. Sidney Wilfred Mintz. New York, NY: Columbia University Press; 1989. 355 pp. Reprint of the 1974 ed.

2564. *Children of Che: Childcare and Education in Cuba*. Karen Wald. Palo Alto, CA: Ramparts Press; 1978. 399 pp.

2565. *Clases sociales en la República Dominicana*. Juan Bosch. Santo Domingo: Editora Corripio; 1989. 259 pp. Reprint of the 1982 ed.

2566. *Class, Race, and Political Behaviour in Urban Jamaica*. Carl Stone. Mona, Jamaica: Institute of Social and Economic Research, University of the West Indies; 1987. 188 pp. Reprint of the 1973 ed.

2567. *Color, Class, and Politics in Jamaica*. Aggrey Brown. New Brunswick, NJ: Transaction Books; 1979. 172 pp.

2568. *Conflict and Solidarity in a Guianese Plantation*. Chandra Jayawardena. London: University of London; 1963. 159 pp.

2569. *Consequences of Class and Color: West Indian Perspectives*. David Lowenthal, Lambros Comitas, eds. Garden City, NY: Anchor Books; 1973. 334 pp.

2570. *Contemporary Caribbean: A Sociological Reader*. Susan Craig, ed. Port of Spain: College Press; 1981–1982. 2 vols.

2571. *Contradictory Omens: Cultural Diversity and Integration in the Caribbean*. Edward Kamau Brathwaite. Mona, Jamaica: Savacou; 1974. 80 pp.

2572. *Culture, Race, and Class in the Commonwealth Caribbean*. Michael Garfield Smith. Mona, Jamaica: School of Continuing Studies, University of the West Indies; 1990. 163 pp. Reprint of the 1984 ed.

2573. *Curaçao*. René A. Römer. San Juan: Association of Caribbean Universities and Research Institutes (UNICA); 1981. 244 pp. Translation of *Een volk op weg*.

2574. *Désengagement paysan et sous-production alimentaire: Martinique, Marie-Galante, Barbade*. Romain Paquette. Montreal: Presses de l'Université de Montréal; 1982. 212 pp.

2575. *The Development of Creole Society in Jamaica, 1770–1820*. Edward Kamau Brathwaite. Oxford: Clarendon Press; 1978. 374 pp. Reprint of the 1971 ed.

2576. *Diagnóstico de Puerto Rico*. Luis Nieves-Falcón. 2a ed. Río Piedras, P.R.: Editorial Edil; 1972. 288 pp.

2577. *The Dominican People, 1850–1900: Notes for a Historical Sociology*. Harmannus Hoetink; Stephen K. Ault, tr. Baltimore, MD: Johns Hopkins University Press; 1982. 243 pp. Translation of *El pueblo dominicano*.

2578. *East and West Indians Rescue Trinidad.* Carlton Robert Ottley. Diego Martin, Trinidad/Tobago: Crusoe; 1975. 121 pp.

2579. *Educated to Emigrate: The Social Organization of Saba.* Julia G. Crane. Assen: Van Gorcum; 1971. 269 pp.

2580. *The Emergence of a Multiracial Society: The Sociology of Multiracism with Reference to Guyana.* Iris Devika Sukdeo. Smithtown, NY: Exposition Press; 1982. 224 pp.

2581. *Environmental Planning and Development in the Caribbean.* Charles A. Frankenhoff [et al.]. Río Piedras, P.R.: Editorial Universitaria, Universidad de Puerto Rico; 1977. 51 pp.

2582. *Frontier Society: A Social Analysis of the History of Surinam.* Rudolf Asveer Jacob van Lier; Maria J. L. van Yperen, tr. Boston, MA: M. Nijhoff; 1971. 441 pp. Translation of *Samenleving in een grensgebied.*

2583. *Grassroots Development in Latin America and the Caribbean: Oral Histories of Social Change.* Robert Wasserstrom, ed. New York, NY: Praeger; 1985. 197 pp.

2584. *The Growth of the Modern West Indies.* Gordon K. Lewis. New York, NY: Monthly Review Press; 1968. 506 pp.

2585. *Haïti: paysage et société.* André-Marcel d'Ans. Paris: Karthala; 1987. 337 pp.

2586. *Histoire de la société guyanaise: les années cruciales, 1846–1946.* Serge Mam-Lam-Fouck. Paris: Editions caribéennes; 1987. 253 pp.

2587. *Inside Cuba.* Joe Nicholson. New York, NY: Sheed and Ward; 1974. 235 pp.

2588. *Island Adrift: The Social Organization of a Small Caribbean Community—The Case of St. Eustatius.* Wout van den Bor; S. Murk Jansen, tr. Leiden: Caraïbische Afdeling, Koninklijk Instituut voor Taal-, Land- en Volkenkunde; 1981. 439 pp. Translation of *Eiland op drift.*

2589. *The Jamaican People, 1880–1902: Race, Class and Social Control.* Patrick E. Bryan. London: Macmillan Caribbean; 1991. 300 pp.

2590. *A Just and Moral Society.* Selwyn Reginald Cudjoe. Ithaca, NY: Cataloux; 1984. 142 pp. About Trinidad and Tobago and Grenada.

2591. *Land Tenure, Income, and Employment in Rural Haiti: A Survey.* Clarence Zuvekas. Rev. ed. Washington, DC: Rural Development Division, Bureau for Latin America, Agency for International Development; 1978. 123 pp.

2592. *Little England: Plantation Society and Anglo-Barbadian Politics, 1627–1700.* Gary A. Puckrein. New York, NY: New York University Press; 1984. 235 pp.

2593. *Living in the Changing Caribbean.* Ellis Gladwin. New York, NY: Macmillan; 1970. 299 pp.

2594. *Living the Revolution: An Oral History of Contemporary Cuba.* Oscar Lewis, Ruth M. Lewis, Susan M. Rigdon. Urbana, IL: University of Illinois Press; 1977–1978. 3 vols. Vol. 1. *Four Men;* vol. 2. *Four Women;* vol. 3. *Neighbors.*

2595. *Local Organization and Participation in Integrated Rural Development in Jamaica.* Arthur Austin Goldsmith, Harvey S. Blustain. Ithaca, NY: Rural Development Committee, Center for International Studies, Cornell University; 1980. 144 pp.

2596. *Lords of the Mountain: Social Banditry and Peasant Protest in Cuba, 1878–1918.* Louis A. Pérez. Pittsburgh, PA: University of Pittsburgh Press; 1989. 267 pp.

2597. *Modern Bahamian Society.* Dean Walter Collinwood, Steve Dodge, eds. Parkersburg, IA: Caribbean Books; 1989. 278 pp.

2598. *Nuevos vientos sobre el Caribe.* Arturo Guerrero. Bogotá: Centro de Investigación y Educación Popular (CINEP); 1982. 91 pp.

2599. *La opinión pública y las aspiraciones de los puertorriqueños.* Luis Nieves-Falcón. Río Piedras, P.R.: Centro de Investigaciones Sociales, Universidad de Puerto Rico; 1978. 198 pp. Reprint of the 1970 ed.

2600. *Patricios y plebeyos: burgueses, hacendados, artesanos y obreros—las relaciones de clase en el Puerto Rico de cambio de siglo.* Angel Guillermo Quintero Rivera. Río Piedras, P.R.: Ediciones Huracán; 1988. 332 pp.

2601. *Het patroon van de oude Curaçaose samenleving: een sociologische studie [The Pattern of the Old Curaçaoan Community: A Sociological Study].* Harmannus Hoetink. 5e druk. Amsterdam: Emmering; 1987. 187 pp.

2602. *Le pays en dehors: essai sur l'univers rural haïtien.* Gérard Barthélemy. 2e éd. Port-au-Prince: H. Deschamps; 1989. 189 pp.

2603. *Le paysan haïtien: étude sur la vie rurale en Haïti.* Paul Moral. Port-au-Prince: Editions Fardin; 1978. 375 pp. Reprint of the 1961 ed.

2604. *The People of Puerto Rico: A Study in Social Anthropology.* Julian Haynes Steward [et al.]. Urbana, IL: University of Illinois Press; 1966. 540 pp. Reprint of the 1956 ed.

2605. *Personality and Conflict in Jamaica.* Madeline Kerr. London: Collins; 1963. 220 pp. Reprint of the 1952 ed.

2606. *Philanthropy and Social Welfare in Jamaica: An Historical Survey.* Patrick E. Bryan. Mona, Jamaica: Institute of Social and Economic Research, University of the West Indies; 1990. 96 pp.

2607. *Planificación social en América Latina y el Caribe.* Rolando Franco, ed. Santiago, Chile: ILPES-UNICEF; 1981. 589 pp.

2608. *The Plural Society in the British West Indies.* Michael Garfield Smith. Berkeley, CA: University of California Press; 1974. 359 pp. Reprint of the 1965 ed.

2609. *Política y sociología en Haití y la República Dominicana.* Coloquio Dominico-Haitiano de Ciencias Sociales (1971, Mexico City); Suzy Castor [et al.]. Mexico City: Instituto de Investigaciones Sociales, Universidad Nacional Autónoma de México; 1974. 169 pp.

2610. *Politics, Race, and Youth in Guyana.* Madan M. Gopal. San Francisco, CA: Mellen Research University Press; 1992. 289 pp.

2611. *Problemas de desigualdad social en Puerto Rico.* Rafael L. Ramírez, Barry B. Levine, Carlos Buitrago Ortiz, eds. Río Piedras, P.R.: Librería Internacional; 1972. 176 pp.

2612. *Problems of the New Cuba.* Raymond Leslie Buell [et al.]. New York, NY: Commission on Cuban Affairs, Foreign Policy Association; 1935. 523 pp.

2613. *Puerto Rico and Puerto Ricans: Studies in History and Society.* Adalberto López, James Petras, eds. Cambridge, MA: Schenkman; 1974. 499 pp.

2614. *The Quality of Life in Barbados.* Graham Dann. London: Macmillan Caribbean; 1984. 290 pp.

2615. *La question créole: essai de sociologie sur la Guyane française.* Marie-José Jolivet. Paris: Office de la recherche scientifique et technique outre-mer (ORSTOM); 1982. 503 pp.

2616. *Race, Power, and Social Segmentation in Colonial Society: Guyana After Slavery, 1838–1891.* Brian L. Moore. New York, NY: Gordon and Breach; 1987. 310 pp.

2617. *Radicalism and Social Change in Jamaica, 1960–1972.* Obika Gray. Knoxville, TN: University of Tennessee Press; 1991. 289 pp.

2618. *Readings on the Sociology of the Caribbean.* Jerold Heiss, ed. New York, NY: MSS Educational Publishing; 1970. 322 pp.

2619. *Rich People and Rice: Factional Politics in Rural Guyana.* Marilyn Silverman. Leiden: Brill; 1980. 240 pp.

2620. *Rural Cuba.* Lowry Nelson. New York, NY: Octagon Books; 1970. 285 pp. Reprint of the 1950 ed.

2621. *Rural Development in the Caribbean.* P. I. Gomes, ed. New York, NY: St. Martin's Press; 1985. 246 pp.

2622. *Slaves, Sugar and Colonial Society: Travel Accounts of Cuba, 1801–1899.* Louis A. Pérez, ed. Wilmington, DE: Scholarly Resources; 1992. 259 pp.

2623. *Slums, Projects, and People: Social Psychological Problems of Relocation in Puerto Rico.* Kurt W. Back. Westport, CT: Greenwood Press; 1974. 123 pp. Reprint of the 1962 ed.

2624. *Social and Occupational Stratification in Contemporary Trinidad and Tobago.* Selwyn D. Ryan, ed. St. Augustine, Trinidad/Tobago: Institute of Social and Economic Research, University of the West Indies; 1991. 474 pp.

2625. *Social Change and Images of the Future: A Study of the Pursuit of Progress in Jamaica.* James A. Mau. Cambridge, MA: Schenkman; 1968. 145 pp.

2626. *Social Change and Personality in a Puerto Rican Agrarian Reform Community.* Eduardo Seda Bonilla. Evanston, IL: Northwestern University Press; 1973. 187 pp. Translation of *Interacción social y personalidad en una comunidad de Puerto Rico.*

2627. *Social Class and Social Change in Puerto Rico.* Melvin Marvin Tumin. 2d ed. Indianapolis, IN: Bobbs-Merrill; 1971. 549 pp.

2628. *Social Groups and Institutions in the History of the Caribbean: Papers.* Association of Caribbean Historians, Conference (Sixth, 1974, Puerto Rico); Guillermo A. Baralt [et al.]. Mayagüez, P.R.: Association of Caribbean Historians; 1975. 119 pp.

2629. *Social Movements, Violence, and Change: The May Movement in Curaçao.* William Averette Anderson, Russell Rowe Dynes. Columbus, OH: Ohio State University Press; 1975. 175 pp.

2630. *Social Problems in Porto Rico.* Fred K. Fleagle. New York, NY: Arno Press; 1975. 139 pp. Reprint of the 1917 ed.

2631. *Social Stratification in Trinidad: A Preliminary Analysis.* Lloyd Braithwaite. Mona, Jamaica: Institute of Social and Economic Research, University of the West Indies; 1975. 170 pp.

2632. *The Social Structure of the British Caribbean.* George Edward Cumper. Millwood, NY: Kraus Reprint; 1978. 131 pp. Reprint of the 1949 ed.

2633. *The Social Structure of a Region.* Joseph Lisowski, ed. New Brunswick, NJ: Transaction Publishers; 1991. 214 pp.

2634. *Les sociétés antillaises: études anthropologiques.* Jean Benoist, ed. 4e éd. revue et augm. Fonds St-Jacques, Martinique: Centre de recherches caraïbes, Université de Montréal; 1975. 176 pp.

2635. *Sociología de la colonia y neocolonia cubana, 1510–1959.* Francisco López Segrera. Havana: Editoral de Ciencias Sociales; 1989. 206 pp.

2636. *Stratification in Grenada.* Michael Garfield Smith. Berkeley, CA: University of California Press; 1965. 271 pp.

2637. *Street Life: Afro-American Culture in Urban Trinidad.* Michael Lieber. Boston, MA: G. K. Hall; 1981. 118 pp.

2638. *Studies in Post-Colonial Society: Guyana.* Aubrey B. Armstrong [et al.], eds. Nashville, TN: African World Press; 1975. 321 pp.

2639. *Towns and Villages of Trinidad and Tobago.* Michael Anthony. St. James, Trinidad/Tobago: Circle Press; 1988. 342 pp.

2640. *The Transformation of Political Culture in Cuba.* Richard R. Fagen. Stanford, CA: Stanford University Press; 1969. 271 pp.

2641. *Two Jamaicas: The Role of Ideas in a Tropical Colony, 1830–1865.* Philip D. Curtin. New York, NY: Greenwood Press; 1968. 270 pp. Reprint of the 1955 ed.

2642. *Urban and Regional Planning in the Caribbean: Proceedings of the UNICA Workshops on Caribbean Urbanism.* Gustavo A. Antonini, ed. and tr. Kingston: Association of Caribbean Universities and Research Institutes; 1976. 106 pp.

2643. *Urban Life in the Caribbean: A Study of a Haitian Urban Community.* Michel S. Laguerre. Cambridge, MA: Schenkman; 1982. 214 pp.

2644. *The Urban Poor of Puerto Rico: A Study in Development and Inequality.* Helen Icken Safa. New York, NY: Holt, Rinehart, and Winston; 1974. 116 pp.

2645. *Urban Poverty in the Caribbean: French Martinique as a Social Laboratory.* Michel S. Laguerre. New York, NY: St. Martin's Press; 1990. 181 pp.

2646. *Urban Reform in Revolutionary Cuba.* Maruja Acosta, Jorge Enrique Hardoy; Mal Bochner, tr. New Haven, CT: Antilles Research Program, Yale University; 1973. 111 pp. Translation of *Reforma urbana en Cuba revolucionaria.*

2647. *Urbanization and Urban Growth in the Caribbean: An Essay on Social Change in Dependent Societies.* Malcolm Cross. New York, NY: Cambridge University Press; 1979. 174 pp.

2648. *Urbanization in the Commonwealth Caribbean.* Kempe Ronald Hope. Boulder, CO: Westview Press; 1986. 129 pp.

2649. *Urbanization, Planning, and Development in the Caribbean.* Robert B. Potter, ed. New York, NY: Mansell; 1989. 327 pp.

2650. *Violence, famille, magie, religion, musique, criminels: Guadeloupe, Haïti, Grands Fonds.* Centre antillais de recherches et d'études (CARE). Paris: Editions caribéennes; 1988. 139 pp.

2651. *Welfare and Planning in the West Indies.* Thomas Spensley Simey. Oxford: Clarendon Press; 1946. 267 pp.

2652. *West Indian Societies.* David Lowenthal. New York, NY: Oxford University Press; 1972. 385 pp.

2653. *The West Indies and Their Future.* Daniel Guérin; Austryn Wainhouse, tr. London: D. Dobson; 1961. 191 pp.

2654. *Working Papers in Haitian Society and Culture.* Elizabeth L. Saxe [et al.]; Sidney Wilfred Mintz, ed. New Haven, CT: Antilles Research Program, Yale University; 1975. 290 pp.

b. Family, Kinship, and Sexual Values

2655. *The Andros Islanders: A Study of Family Organization in the Bahamas.* Keith F. Otterbein. Lawrence, KS: University of Kansas Press; 1966. 152 pp.

2656. *The Barbadian Male: Sexual Attitudes and Practice.* Graham Dann. London: Macmillan Caribbean; 1987. 228 pp.

2657. *The Caribbean Family: Legitimacy in Martinique.* Miriam Slater. New York, NY: St. Martin's Press; 1977. 264 pp.

2658. *Crisis of the West Indian Family: A Sample Study.* Basil Matthews. Westport, CT: Greenwood Press; 1971. 117 pp. Reprint of the 1953 ed.

2659. *English Rustics in Black Skin: A Study of Modern Family Forms in a Pre-Industrialized Society.* Sidney M. Greenfield. New Haven, CT: College and University Press; 1966. 208 pp. About Barbados.

2660. *Famille et nuptialité dans la Caraïbe.* Yves Charbit. Paris: Presses universitaires de France; 1987. 412 pp.

2661. *Family and Colour in Jamaica.* Fernando Henriques. Kingston: Sangster's Book Stores; 1976. 208 pp. Reprint of the 1968 (2d) ed.

2662. *Family and Fertility in Puerto Rico: A Study of the Lower Income Group.* J. Mayone Stycos. Westport, CT: Greenwood Press; 1973. 332 pp. Reprint of the 1955 ed.

2663. *Family and Kinship in Middle America and the Caribbean: Proceedings of the Fourteenth Seminar of the Committee on Family Research of the International Sociological Association, Curaçao, Sept. 1975.* Arnaud F. Marks, René A. Römer, eds. Willemstad: Institute of Higher Studies in Curaçao; 1978. 672 pp.

2664. *The Family in the Caribbean: Proceedings.* Conference on the Family in the Caribbean (First, 1968, St. Thomas, V.I.); Stanford Neil Gerber, ed. Río Piedras, P.R.: Institute of Caribbean Studies, University of Puerto Rico; 1968. 147 pp.

2665. *The Family in the Caribbean: Proceedings.* Conference on the Family in the Caribbean (Second, 1969, Aruba); Stanford Neil Gerber, ed. Río Piedras, P.R.: Institute of Caribbean Studies, University of Puerto Rico; 1973. 167 pp.

2666. *Family Structure in Jamaica: The Social Context of Reproduction.* Judith Blake, J. Mayone Stycos, Kingsley Davis. New York, NY: Free Press of Glencoe; 1980. 262 pp. Reprint of the 1961 ed.

2667. *Female Fertility and Family Planning in Trinidad and Tobago.* Jack Harewood. Mona, Jamaica: Institute of Social and Economic Research, University of the West Indies; 1978. 377 pp.

2668. *Gays Under the Cuban Revolution.* Allen Young. San Francisco, CA: Grey Fox Press; 1981. 112 pp.

2669. *L'inceste focal dans la famille noire antillaise: crimes, conflits, structure.* Jacques André. Paris: Presses universitaires de France; 1987. 396 pp.

2670. *IPPF/WHR Caribbean Contraceptive Prevalence Surveys.* Tirbani P. Jagdeo, ed. New York, NY: International Planned Parenthood Federation, Western Hemisphere Region; 1985– [vols. 1–9+].

2671. *Kinship and Class in the West Indies: A Genealogical Study of Jamaica and Guyana.* Raymond Thomas Smith. New York, NY: Cambridge University Press; 1988. 205 pp.

2672. *Lower-Class Families: The Culture of Poverty in Negro Trinidad.* Hyman Rodman. New York, NY: Oxford University Press; 1971. 242 pp.

2673. *Male and Female and the Afro-Curaçaoan Household.* Arnaud F. Marks; Maria J. L. van Yperen, tr. Boston, MA: M. Nijhoff; 1976. 355 pp. Translation of *Man, vrouw en huishoudgroep.*

2674. *Marriage, Class, and Colour in Nineteenth-Century Cuba: A Study of Racial Attitudes and Sexual Values in a Slave Society.* Verena Stolcke. Ann Arbor, MI: University of Michigan Press; 1989. 202 pp. Reprint of the 1974 ed.

2675. *My Mother Who Fathered Me: A Study of the Family in Three Selected Communities in Jamaica*. Edith Clarke. London: Allen and Unwin; 1972. 228 pp. Reprint of the 1966 (2d) ed.

2676. *The Negro Family in British Guiana: Family Structure and Social Status in the Villages*. Raymond Thomas Smith. New York, NY: Humanities Press; 1971. 282 pp. Reprint of the 1956 ed.

2677. *On the Corner: Male Social Life in a Paramaribo Creole Neighborhood*. Gary Brana-Shute. Prospect Heights, IL: Waveland Press; 1989. 123 pp. Reprint of the 1979 ed.

2678. *Sex, Contraception, and Motherhood in Jamaica*. Eugene B. Brody. Cambridge, MA: Harvard University Press; 1981. 278 pp.

2679. *We Wish to Be Looked Upon: A Study of the Aspirations of Youth in a Developing Society*. Vera D. Rubin, Marisa Zavalloni. New York, NY: Teachers College Press; 1969. 257 pp. About Trinidad.

2680. *West Indian Family Structure*. Michael Garfield Smith. Seattle, WA: University of Washington Press; 1962. 311 pp.

2681. *Youth and Development in the Caribbean: Report*. Commonwealth Caribbean Regional Youth Seminar (1970, Port of Spain). London: Commonwealth Secretariat; 1970. 257 pp.

c. Crime and Drug Abuse

2682. *Crime and Punishment in the Caribbean*. Rosemary Brana-Shute, Gary Brana-Shute, eds. Gainesville, FL: Center for Latin American Studies, University of Florida; 1980. 146 pp.

2683. *Crime in Trinidad: Conflict and Control in a Plantation Society, 1838–1900*. David Vincent Trotman. Knoxville, TN: University of Tennessee Press; 1986. 345 pp.

2684. *Crime, Race, and Culture: A Study in a Developing Country*. Howard Jones. New York, NY: Wiley; 1981. 184 pp. About Guyana.

2685. *Drug Abuse in the Caribbean: Report of the Drug Seminar Held in Trinidad, November 26–28, 1986*. Bustamante Institute of Public and International Affairs. Kingston: The Institute; 1987. 52 pp.

2686. *Ganja in Jamaica: The Effects of Marijuana Use*. Vera D. Rubin, Lambros Comitas. Garden City, NY: Anchor; 1976. 217 pp. European ed. has title *Ganja in Jamaica: A Medical Anthropological Study of Chronic Marihuana Use.*

2687. *Improving Prison Conditions in the Caribbean: Report and Papers*. Conference on Improving Prison Conditions in the Caribbean (1991, Port of Spain). St. Michael, Barbados: Caribbean Rights; 1991. 144 pp.

2688. *La mala vida: delincuencia y picaresca en la colonia española de Santo Domingo*. Carlos Esteban Deive. Santo Domingo: Fundación Cultural Dominicana; 1988. 270 pp.

2689. *Masters of Paradise: Organized Crime and the Internal Revenue Service in the Bahamas*. Alan A. Block. New Brunswick, NJ: Transaction Publishers; 1991. 319 pp.

2690. *Patrones de criminalidad en Puerto Rico: apreciación socio-histórica, 1898–1980.* Pedro A. Vales, Astrid A. Ortiz, Noel E. Mattei. Río Piedras, P.R.: Centro de Investigaciones Sociales, Universidad de Puerto Rico; 1982. 213 pp.

2691. *Social Control and Deviance in Cuba.* Luis Salas. New York, NY: Praeger; 1979. 398 pp.

2692. *Violencia y criminalidad en Puerto Rico, 1898–1973: apuntes para un estudio de historia social.* Blanca G. Silvestrini. Río Piedras, P.R.: Editorial Universitaria, Universidad de Puerto Rico; 1980. 146 pp.

2693. *Working Men and Ganja: Marihuana Use in Rural Jamaica.* Melanie Creagan Dreher. Philadelphia, PA: Institute for the Study of Human Issues; 1982. 216 pp.

11. SOCIAL LIFE AND CUSTOMS

2694. *Alternative Cultures in the Caribbean.* Society of Caribbean Research, International Conference (First, 1988, Berlin); Thomas Bremer, Ulrich Fleischmann, eds. Frankfurt am Main: Vervuert; 1992. 299 pp.

2695. *L'archipel inachevé: culture et société aux Antilles françaises.* Jean Benoist, ed. Montreal: Presses de l'Université de Montréal; 1972. 354 pp.

2696. *Bahamian Society After Emancipation: Essays in Nineteenth and Early Twentieth Century Bahamian History.* Gail Saunders. Nassau: [s.n.]; 1990. 209 pp.

2697. *Black Clubs in Bermuda: Ethnography of a Play World.* Frank E. Manning. Ithaca, NY: Cornell University Press; 1973. 277 pp.

2698. *Caribbean Cricketers: From the Pioneers to Packer.* Clayton Goodwin. London: Harrap; 1980. 260 pp.

2699. *Caribbean Essays: An Anthology.* Andrew Salkey, ed. London: Evans; 1973. 131 pp.

2700. *Caribbean Festival Arts: Each and Every Bit of Difference.* John Wallace Nunley, Judith Bettelheim. Seattle, WA: University of Washington Press; 1988. 218 pp.

2701. *Caribbean Foodways.* Versada Campbell. Kingston: Caribbean Food and Nutrition Institute; 1988. 122 pp.

2702. *Christmas Sports in St. Kitts-Nevis: Our Neglected Cultural Tradition.* Frank L. Mills, Simon B. Jones-Hendrickson, Bertram Eugene. Frederiksted, V.I.: Eastern Caribbean Institute; 1984. 66 pp.

2703. *De tierra morena vengo: imágenes del hombre dominicano y su cultura.* Wifredo García [et al.]. Santo Domingo: Sociedad Industrial Dominicana; 1987. 231 pp.

2704. *Los deportes en Puerto Rico.* Emilio Enrique Huyke. Sharon, CT: Troutman Press; 1991. 586 pp. Reprint of the 1968 ed.

2705. *The Development of the Puerto Rican Jibaro and His Present Attitude Towards Society.* José Colomban Rosario. New York, NY: Arno Press; 1975. 116 pp. Reprint of the 1935 ed.

2706. *Everyday Life in Barbados: A Sociological Perspective.* Graham Dann, ed. Leiden: Caraïbische Afdeling, Koninklijk Instituut voor Taal-, Land- en Volkenkunde; 1976. 190 pp.

2707. *El gíbaro en su origen y su manifestación humana y costumbrista.* Ernesto Juan Fonfrías. Santurce, P.R.: Jay-Ce Printing; 1987. 140 pp.

2708. *Grass Roots Commitment: Basketball and Society in Trinidad and Tobago.* Jay R. Mandle, Joan D. Mandle. Parkersburg, IA: Caribbean Books; 1988. 75 pp.

2709. *The Haitian People.* James Graham Leyburn. Westport, CT: Greenwood Press; 1980. 342 pp. Reprint of the 1966 (rev.) ed.

2710. *A History of West Indies Cricket.* Michael Manley. Rev. ed. London: Pan; 1990. 574 pp.

2711. *In the Fist of the Revolution: Life in a Cuban Country Town.* José Yglesias. New York, NY: Pantheon Books; 1968. 307 pp.

2712. *Island Possessed.* Katherine Dunham. Garden City, NY: Doubleday; 1969. 280 pp. About Haiti.

2713. *Jamaica Farewell.* Morris Cargill. Secaucus, NJ: L. Stuart; 1978. 224 pp.

2714. *Kinship and Community in Carriacou.* Michael Garfield Smith. New Haven, CT: Yale University Press; 1962. 347 pp.

2715. *The Land of Look Behind: A Study of Jamaica.* Mona Macmillan. London: Faber and Faber; 1957. 224 pp.

2716. *Life and Food in the Caribbean.* Christine MacKie. New York, NY: New Amsterdam Books; 1991. 190 pp.

2717. *Life in a Haitian Valley.* Melville Jean Herskovits. New York, NY: Octagon Books; 1975. 350 pp. Reprint of the 1937 ed.

2718. *Living in the D.R.: Transcultural Handbook to Life in the Dominican Republic.* Rosendo Alvarez [et al.]. Santo Domingo: ASIEX; 1990. 153 p. Cover title *Living in the Dominican Republic.*

2719. *McGill Studies in Caribbean Anthropology.* Frances Henry, ed. Montreal: Centre for Developing-Area Studies, McGill University; 1969. 109 pp.

2720. *Notes of a Crucian Son.* Richard A. Schrader. [Frederiksted, V.I.]: Schrader; 1989. 90 pp. About St. Croix, V.I.

2721. *A Puritan in Voodoo-land.* Edna Taft. Detroit, MI: Tower Books; 1971. 407 pp. Reprint of the 1938 ed.

2722. *Retablo de costumbres dominicanas.* Aida Bonnelly de Díaz. Santiago, R.D.: Pontificia Universidad Católica Madre y Maestra; 1991. 173 pp.

2723. *Saba Silhouettes: Life Stories from a Caribbean Island.* Julia G. Crane, ed. New York, NY: Vantage Press; 1987. 515 pp.

2724. *Saint-Domingue: la société et la vie créoles sous l'Ancien Régime, 1629–1789.* Pierre de Vaissière. Paris: Perrin; 1909. 384 pp.

2725. *Social Life in the Caribbean, 1838–1938.* Bridget Brereton. Exeter, NH: Heinemann Educational; 1985. 65 pp.

2726. *Some Trinidad Yesterdays.* Phillip Emmett Taaffe O'Connor. Port of Spain: Inprint Caribbean; 1978. 109 pp.

2727. *Spanish Trinidad: An Account of Life in Trinidad, 1498–1797.* Carlton Robert Ottley. Port of Spain: Longman Caribbean; 1971. 131 pp. Reprint of the 1955 ed. published under title *An Account of Life in Spanish Trinidad.*

2728. *St. John Backtime: Eyewitness Accounts from 1718 to 1956.* Ruth Hull Low, Rafael Valls, eds. St. John, V.I.: Eden Hill Press; 1985. 93 pp.

2729. *St. Lucia Diary: A Caribbean Memoir.* Hazel Eggleston. Old Greenwich, CT: Devin-Adair; 1977. 168 pp.

2730. *Sugar and Slaves: The Rise of the Planter Class in the English West Indies, 1624–1713.* Richard S. Dunn. Chapel Hill, NC: University of North Carolina Press; 1972. 359 pp.

2731. *The Trinidad Callaloo: Life in Trinidad from 1851 to 1900.* Carleton Robert Ottley. Diego Martin, Trinidad/Tobago: Crusoe; 1978. 152 pp.

2732. *The Trinidad Carnival: Mandate for a National Theatre.* Errol Hill. Austin, TX: University of Texas Press; 1972. 139 pp.

2733. *The Tropic of Baseball: Baseball in the Dominican Republic.* Rob Ruck. Westport, CT: Meckler; 1991. 205 pp.

2734. *Tryin' to Make It: Adapting to the Bahamas.* John Bregenzer. Lanham, MD: University Press of America; 1982. 88 pp.

2735. *La vida escandolosa en Santo Domingo en los siglos XVII y XVIII.* Frank Moya Pons, ed. Santiago, D.R.: Universidad Católica Madre y Maestra; 1976. 166 pp.

2736. *La vie quotidienne de la société créole: Saint-Domingue au XVIIIe siècle.* François Girod. Paris: Editions Hachette; 1972. 238 pp.

2737. *West Indians at the Wicket.* Clayton Goodwin. London: Macmillan Caribbean; 1986. 200 pp. About cricket.

12. SPECIAL TOPIC: WOMEN

2738. *The Agricultural Traders of St. Vincent and the Grenadines, Grenada, Dominica and St. Lucia.* Monique Lagro, Donna Plotkin. Port of Spain: Economic Commission for Latin America and the Caribbean, United Nations; 1990. 75 pp.

2739. *L'autre moitié du développement: à propos du travail des femmes en Haïti.* Mireille Neptune Anglade. Pétion-Ville: Editions des Alizès; 1986. 261 pp.

2740. *Blaze a Fire: Significant Contributions of Caribbean Women.* Nesha Z. Haniff. Toronto: Sister Vision; 1988. 220 pp.

2741. *Caribbean Women: Their History and Habits.* Gabriel Kingsley Osei. London: African Publication Society; 1979. 191 pp.

2742. *Co-Wives and Calabashes.* Sally Price. Ann Arbor, MI: University of Michigan Press; 1984. 224 pp. About the Saramacca of Suriname.

2743. *Cuban Women Now: Interviews with Cuban Women.* Margaret Randall. Toronto: Women's Press; 1974. 375 pp. Translation of *La mujer cubana ahora.*

2744. *Cuban Women: Changing Roles and Population Trends.* Sonia Catasús Cervera [et al.]. Geneva: International Labour Office; 1988. 125 pp.

2745. *Dames des Iles du temps jadis: récits historiques.* Auguste Joyau. Morne-Rouge [France]: Editions des Horizons caraïbes; 1976. 234 pp. Reprint of the 1948 ed.; about Martinique.

2746. *Debate sobre la mujer en América Latina y el Caribe: discusión acerca de la unidad producción—reproducción.* Magdalena León de Leal, ed. Bogotá: Asociación Colombiana para el Estudio de la Población; 1982. 3 vols.

2747. *The Decade for Women in Latin America and the Caribbean: Background and Prospects.* United Nations, Economic Commission for Latin America and the Caribbean, Social Development Division. Santiago, Chile: ECLAC; 1988. 215 pp.

2748. *The Developing Legal Status of Women in Trinidad and Tobago.* Stephanie Daly. Port of Spain: National Commission on the Status of Women; 1982. 136 pp.

2749. *Femme martiniquaise: mythes et réalités.* Germaine Louilot, Danielle Crusol-Baillard. Fort-de-France: Editions caribéennes; 1987. 138 pp.

2750. *Les femmes antillaises.* Claudie Beauvue-Fougeyrollas. 2e éd. Paris: L'Harmattan; 1985. 150 pp.

2751. *Femmes: livre d'or de la femme créole.* Antoine Abou [et al.]. Pointe-à-Pitre: Raphy; 1988. 6 vols.

2752. *From Adam's Rib to Women's Lib.* Basil Cooper. Nassau: [s.n.]; 1973. 204 pp. About the Bahamas.

2753. *From the House to the Streets: The Cuban Woman's Movement for Legal Reform, 1898–1940.* K. Lynn Stoner. Durham, NC: Duke University Press; 1991. 242 pp.

2754. *Gender in Caribbean Development: Papers.* University of the West Indies (St. Augustine, Trinidad/Tobago), Women and Development Studies

Project, Seminar (First, 1986, St. Augustine, Trinidad/Tobago); Patricia Mohammed, Catherine Shepherd, eds. Mona, Jamaica: Women and Development Studies Project, University of the West Indies; 1988. 372 pp.

2755. *Haïti et ses femmes: une étude d'évolution culturelle.* Madeleine G. Sylvain Bouchereau. Port-au-Prince: Presses libres; 1957. 253 pp.

2756. *L'haïtienne face à l'histoire.* Marcelle Désinor. Port-au-Prince: Hibiscus; 1980?– [vol. 1–].

2757. *Historia del feminismo en la República Dominicana: su origen y su proyección social.* Ramón Alberto Ferreras. Santo Domingo: Editora Cosmos; 1976. 206 pp.

2758. *Incriminación a la violencia contra la mujer.* Melania Rondón, ed. Santo Domingo: Centro de Servicios Legales para la Mujer (CENSEL); 1991. 169 pp. About the Dominican Republic.

2759. *Labour Force Participation and Fertility in Three Caribbean Countries.* Norma Abdulah, Susheela Singh. St. Augustine, Trinidad/Tobago: Institute of Social and Economic Research, University of the West Indies; 1984. 210 pp. About Guyana, Jamaica, Trinidad and Tobago.

2760. *Midlife and Older Women in Latin America and the Caribbean.* American Association of Retired Persons [and] Pan American Health Organization. Washington, DC: AARP; 1989. 424 pp.

2761. *Muchachas No More: Household Workers in Latin America and the Caribbean.* Elsa M. Chaney, Mary Garcia Castro, eds. Philadelphia, PA: Temple University Press; 1989. 486 pp.

2762. *La mujer cubana en el quehacer de la historia.* Laurette Séjourné, Tatiana Coll. Mexico City: Siglo XXI Editores; 1980. 413 pp.

2763. *La mujer dominicana.* Tomás Báez Díaz. Santo Domingo: Editora Educativa Dominicana; 1980. 110 pp.

2764. *La mujer en Cuba: discursos, entrevistas, documentos.* Vilma Espín Guillois. Havana: Impr. Central de las Fuerzas Armadas Revolucionarias [etc.], 1990. 2 vols. Vol. 1. Familia y sociedad.—vol. 2. Historia.

2765. *La mujer en el sector popular urbano: América Latina y el Caribe.* United Nations, Economic Commission for Latin America and the Caribbean. Santiago, Chile: ECLAC; 1984. 349 pp.

2766. *La mujer en Puerto Rico: ensayos de investigación.* Yamila Azize, ed. Río Piedras, P.R.: Ediciones Huracán; 1987. 238 pp.

2767. *Mujeres sobresalientes en la historia dominicana.* Museo Nacional de Historia y Geografía [y] Dirección General de Promoción de la Mujer. Santo Domingo: Dirección de Información, Publicidad y Prensa de la Presidencia; 1983– [vol. 1–].

2768. *The Ninety Most Prominent Women in Trinidad and Tobago.* Suzanne Lopez [et al.]. Port of Spain: Trinidad Express Newspapers; 1991. 80 pp.

2769. *Participación de la mujer en el desarrollo de América Latina y el Caribe.* Querubina Henríquez de Paredes, Maritza Izaguirre P., Inés Vargas Delaunoy. New York, NY: UNICEF; 1975. 177 pp.

2770. *Perceptions of Caribbean Women: Towards a Documentation of Stereotypes.* Erna Brodber. Cave Hill, Barbados: Institute of Social and Economic Research (Eastern Caribbean), University of the West Indies; 1982. 62 pp.

2771. *Planning for Women in Rural Development: A Source Book for the Caribbean.* Population Council [and] University of the West Indies, Women and Development Unit. Cave Hill, Barbados: A. Zephirin; 1985. 112 pp.

2772. *Población y condición de la mujer en República Dominicana.* Isis Duarte [et al.]. Santo Domingo: Instituto de Estudios de Población y Desarrollo; 1989. 170 pp.

2773. *Política sexual en Puerto Rico.* Margarita Ostolaza Bey. Río Piedras, P.R.: Ediciones Huracán; 1989. 203 pp.

2774. *The Psychosocial Development of Puerto Rican Women.* Cynthia T. García Coll, María de Lourdes Mattei, eds. New York, NY: Praeger; 1989. 272 pp.

2775. *The Puerto Rican Woman: Her Life and Evolution Throughout History.* Federico Ribes Tovar; Anthony Rawlings, tr. New York, NY: Plus Ultra; 1972. 253 pp. Translation of *La mujer puertorriqueña.*

2776. *The Puerto Rican Woman: Perspectives on Culture, History, and Society.* Edna Acosta-Belén, ed. 2d ed. New York, NY: Praeger; 1986. 212 pp.

2777. *The Role of Women in Caribbean Development: Report on Ecumenical Consultation, July 19–23, 1971.* Marlene Cuthbert, ed. Bridgetown: Christian Action for Development in the Eastern Caribbean; 1971. 56 pp.

2778. *Trinidad Women Speak.* Bori S. Clark, ed. Redlands, CA: Libros Latinos; 1981. 71 pp.

2779. *Women and Education .* University of the West Indies, Institute of Social and Economic Research. Cave Hill, Barbados: The Institute; 1982. 77 pp.

2780. *Women and Politics in Barbados, 1948–1981.* Neville C. Duncan, Kenneth O'Brien. Cave Hill, Barbados: Institute of Social and Economic Research (Eastern Caribbean), University of the West Indies; 1983. 68 pp.

2781. *Women and Social Production in the Caribbean: Final Report of a Seminar [held in] San Juan, Puerto Rico, June 23–July 24, 1980.* Kate Young, Marcia Rivera Quintero, eds. Río Piedras, P.R.: Centro de Estudios de la Realidad Puertorriqueña (CEREP); 1982. 143 pp.

2782. *Women and the Ancestors: Black Carib Kinship and Ritual.* Virginia Kerns. Urbana, IL: University of Illinois Press; 1989. 229 pp. Reprint of the 1983 ed.

2783. *Women and the Cuban Revolution: Speeches and Documents.* Fidel Castro, Vilma Espín Guillois [et al.]; Elizabeth Kathryn Stone, ed. New York, NY: Pathfinder Press; 1981. 156 pp.

2784. *Women and the Family.* University of the West Indies, Institute of Social and Economic Research. Cave Hill, Barbados: The Institute; 1982. 162 pp.

2785. *Women and the Law.* Norma Monica Forde. Cave Hill, Barbados: Institute of Social and Economic Research (Eastern Caribbean), University of the West Indies; 1981. 125 pp.

2786. *Women and the Sexual Division of Labour in the Caribbean.* Keith Hart, ed. Kingston: Consortium Graduate School of Social Sciences; 1989. 141 pp.

2787. *Women as Heads of Households in the Caribbean: Family Structure and Feminine Status.* Joycelin Massiah. Paris: UNESCO; 1983. 69 pp.

2788. *Women in Cuba: Twenty Years Later.* Margaret Randall. New York, NY: Smyrna Press; 1981. 167 pp.

2789. *Women in Jamaica: Patterns of Reproduction and Family.* George W. Roberts, Sonja A. Sinclair. Millwood, NY: KTO Press; 1978. 346 pp.

2790. *Women in the Caribbean: A Record of Career Women in the Caribbean, Their Background, Services, and Achievements.* Henry A. Guy, ed. Port of Spain: [s.n.]; 1968. 173 pp.

2791. *The Women of Azua: Work and Family in the Rural Dominican Republic.* Barbara Finlay. New York, NY: Praeger; 1989. 190 pp.

2792. *Women of Barbados: Amerindian Era to Mid-Twentieth Century.* Jill Hamilton. Bridgetown: J. Hamilton; 1981. 91 pp.

2793. *Women of Cuba.* Inger Holt-Seeland; Elizabeth Hamilton Lacoste, Mirtha Quintanales, José Vigo, trs. Westport, CT: L. Hill; 1982. 109 pp. Translation of *Con las puertas abiertas.*

2794. *Women of the Caribbean.* Pat Ellis, ed. Atlantic Highlands, NJ: Zed Books; 1986. 165 pp.

2795. *Women's Power and Social Revolution: Fertility Transition in the West Indies.* W. Penn Handwerker. Newbury Park, CA: Sage; 1989. 254 pp. About Barbados.

2796. *Women, Work, and Development.* Margaret Gill, Joycelin Massiah. Cave Hill, Barbados: Institute of Social and Economic Research (Eastern Caribbean), University of the West Indies; 1984. 129 pp.

C. Biography

1. GENERAL WORKS

2797. *Alexander Bustamante and Modern Jamaica.* George E. Eaton. Kingston: Kingston Publishers; 1975. 276 pp.

2798. *Antonio Maceo: The "Bronze Titan" of Cuba's Struggle for Independence.* Philip Sheldon Foner. New York, NY: Monthly Review Press; 1977. 340 pp.

2799. *Bermuda Settlers of the Seventeenth Century: Genealogical Notes from Bermuda.* Julia E. Mercer. Baltimore, MD: Genealogical Publishing Co.; 1982. 276 pp. Reprinted from *Tyler's Quarterly Historical and Genealogical Magazine,* vols. 23–29 (1942–1947).

2800. *Biografía de Luis Muñoz Marín.* José A. Toro Sugrañes. Río Piedras, P.R.: Editora Edil; 1989. 94 pp.

2801. *Biografías puertorriqueñas: perfil histórico de un pueblo.* Cesáreo Rosa-Nieves, Esther Melón de Díaz. 9a ed. Sharon, CT: Troutman Press; 1991. 660 pp.

2802. *The Black Jacobins: Toussaint L'Ouverture and the San Domingo Revolution.* Cyril Lionel Robert James. New York, NY: Vintage Books; 1989. 426 pp. Reprint of the 1963 (2d) ed.

2803. *Black Liberator: The Life of Toussaint Louverture.* Stéphen Alexis; William Stirling, tr. New York, NY: Macmillan; 1949. 227 pp. Abridged translation of *Toussaint Louverture, libérateur d'Haïti.*

2804. *Black Majesty: The Life of Christophe, King of Haiti.* John Womack Vandercook. New York, NY: Scholastic Book Services; 1966. 207 pp. Reprint of the 1928 ed.

2805. *Black Moses: The Story of Marcus Garvey and the Universal Negro Improvement Association.* Edmund David Cronon. Madison, WI: University of Wisconsin Press; 1987. 278 pp. Reprint of the 1955 ed.

2806. *Black Power and the Garvey Movement.* Theodore G. Vincent; Omali Yeshitela, ed. 2d ed. Oakland, CA: Nzinga; 1988. 302 pp.

2807. *Blood in the Streets: The Life and Rule of Trujillo.* Albert C. Hicks. New York, NY: Creative Age Press; 1946. 230 pp.

2808. *Caribbean Power.* Colin Rickards. London: D. Dobson; 1963. 247 pp.

2809. *Castro, the Blacks, and Africa.* Carlos Moore. Los Angeles, CA: Center for Afro-American Studies, University of California; 1988. 472 pp.

2810. *Castro.* Sebastian Balfour. New York, NY: Longman; 1990. 184 pp.

2811. *Cien dominicanos célebres.* Víctor Fleury [et al.]. Santo Domingo: Publicaciones América; 1973. 331 pp.

2812. *Citizen Toussaint.* Ralph Korngold. Westport, CT: Greenwood Press; 1979. 358 pp. Reprint of the 1944 ed.

2813. *El Cristo de la Libertad: vida de Juan Pablo Duarte.* Joaquín Balaguer. Ed. especial. Santo Domingo: Editora Corripio; 1989. 248 pp.

2814. *Cuban Leadership After Castro: Biographies of Cuba's Top Commanders.* Rafael Fermoselle. 2d ed. Coral Gables, FL: North-South Center, University of Miami; 1992. 203 pp. First ed. has title *Cuban Leadership After Castro: Biographies of Cuba's Top Generals.*

2815. *Cudjoe of Jamaica: Pioneer for Black Freedom in the New World.* Milton C. McFarlane. Short Hills, NJ: R. Enslow; 1977. 144 pp. British ed. has title *Cudjoe the Maroon.*

2816. *Las doctrinas educativas y políticas de Martí.* Roberto Daniel Agramonte y Pichardo. Río Piedras, P.R.: Editorial de la Universidad de Puerto Rico; 1991. 663 pp.

2817. *The Early Fidel: Roots of Castro's Communism.* Lionel Martin. Secaucus, NJ: L. Stuart; 1978. 272 pp.

2818. *An Encounter with Fidel: An Interview.* Fidel Castro, Gianni Minà; Mary Todd, tr. Melbourne, Vic.: Ocean Press; 1991. 273 pp. Rev. translation of *Un encuentro con Fidel.*

2819. *The Era of Trujillo: Dominican Dictator.* Jesús de Galíndez; Russell Humke Fitzgibbon, ed. Tucson, AZ: University of Arizona Press; 1973. 298 pp. Translation of *La era de Trujillo.*

2820. *Eric Williams: The Man, His Ideas, and His Politics.* Ramesh Deosaran. Port of Spain: Signum; 1981. 194 pp.

2821. *Eric Williams: The Man and the Leader.* Ken I. Boodhoo, ed. Lanham, MD: University Press of America; 1986. 143 pp.

2822. *Eugenio María de Hostos: Philosophical System and Methodology—Cultural Fusion.* Joann Borda de Sainz. New York, NY: Senda Nueva de Ediciones; 1989. 240 pp.

2823. *Eugenio María de Hostos: Promoter of Pan Americanism—A Collection of Writings and a Bibliography.* Eugenio Carlos de Hostos, ed. Madrid: J. Bravo; 1954. 311 pp.

2824. *Familias dominicanas.* Carlos Larrazábal Blanco. Santo Domingo: Academia Dominicana de la Historia; 1967–1980. 9 vols.

2825. *Family Portrait with Fidel: A Memoir.* Carlos Franqui; Alfred MacAdam, tr. New York, NY: Random House; 1984. 262 pp. Translation of *Retrato de familia con Fidel.*

2826. *Fidel and Religion: Castro Talks on Revolution and Religion with Frei Betto.* Fidel Castro, Frei Betto; Cuban Center for Translation and Interpretation, tr. New York, NY: Simon and Schuster; 1987. 314 pp. Translation of *Fidel e a religião.*

2827. *Fidel Castro's Political Programs from Reformism to Marxism-Leninism.* Loree A. R. Wilkerson. Gainesville, FL: University of Florida Press; 1965. 100 pp.

2828. *Fidel Castro.* Herbert Lionel Matthews. New York, NY: Simon and Schuster; 1969. 382 pp.

2829. *Fidel Castro: el final del camino.* Santiago Aroca. Barcelona: Editorial Planeta; 1992. 324 pp.

2830. *Fidel Castro: Rebel−Liberator or Dictator?* Jules Dubois. Indianapolis, IN: Bobbs-Merrill; 1959. 391 pp.

2831. *Fidel: A Biography of Fidel Castro.* Peter G. Bourne. New York, NY: Dodd, Mead; 1986. 332 pp. British ed. has title *Castro: A Biography of Fidel Castro.*

2832. *Fidel: A Critical Portrait.* Tad Szulc. New York, NY: Morrow; 1986. 703 pp.

2833. *Figuras cubanas del siglo XIX.* Salvador Bueno. Havana: Unión de Escritores y Artistas de Cuba; 1980. 311 pp. Updates his *Figuras cubanas: breves biografías de grandes cubanos del siglo XIX* [#2834].

2834. *Figuras cubanas: breves biografías de grandes cubanos del siglo XIX.* Salvador Bueno. Havana: Comisión Nacional Cubano de de la UNESCO; 1964. 390 pp. Updated by his *Figuras cubanas del siglo XIX* [#2833].

2835. *From We Were Boys: The Story of the Magnificent Cousins, the Rt. Excellent Sir William Alexander Bustamante and the Rt. Excellent Norman Washington Manley.* Jackie Ranston. Kingston: Bustamante Institute of Public and International Affairs; 1989. 201 pp.

2836. *Galería de dominicanos ilustres: Juan Pablo Duarte y sus descendientes.* Luis Padilla d'Onis. Santo Domingo: [s.n.]; 1992. 237 pp.

2837. *Garvey and Garveyism.* Amy Jacques Garvey. New York, NY: Octagon Books; 1986. 336 pp. Reprint of the 1970 ed.

2838. *Garvey's Children: The Legacy of Marcus Garvey.* Tony Sewell. Trenton, NJ: Africa World Press; 1990. 125 pp.

2839. *Garvey: His Work and Impact.* Rupert Lewis, Patrick E. Bryan, eds. Trenton, NJ: Africa World Press; 1991. 334 pp.

2840. *Garvey: The Story of a Pioneer Black Nationalist.* Elton C. Fax. New York, NY: Dodd, Mead; 1972. 305 pp.

126

Bibliography

2841. *Genealogies of Barbados Families: From Caribbeana and the Journal of the Barbados Museum and Historical Society.* James C. Brandow, ed. Baltimore, MD: Genealogical Publishing Co.; 1983. 753 pp.

2842. *Geneaología, heráldica e historia de nuestras familias.* Fernando de Castro y de Cárdenas. Miami, FL: Ediciones Universal; 1989. 179 pp. About Cuba.

2843. *Grantley Adams and the Social Revolution: The Story of the Movement That Changed the Pattern of West Indian Society.* F. A. Hoyos. London: Macmillan Caribbean; 1988. 280 pp. Reprint of the 1974 ed.

2844. *Guerrilla Prince: The Untold Story of Fidel Castro.* Georgie Anne Geyer. Boston, MA: Little, Brown; 1991. 445 pp.

2845. *¡Hablamos! Puerto Ricans Speak.* Henrietta Yurchenco; Julia Singer [ill.]. New York, NY: Praeger; 1971. 136 pp.

2846. *The Hero and the Crowd in a Colonial Polity.* A. W. Singham. New Haven, CT: Yale University Press; 1968. 389 pp. About Grenada's Eric Matthew Gairy.

2847. *Heroes of the People of Trinidad and Tobago.* Michael Anthony. Port of Spain: Circle Press; 1986. 194 pp.

2848. *Historia de familias cubanas.* Francisco Xavier de Santa Cruz y Mallén, conde de San Juan de Jaruco. Havana [etc]: Editorial Hercules [etc.]; 1940– [vols. 1–9+].

2849. *Hombres dominicanos.* Rufino Martínez. Santo Domingo: Sociedad Dominicana de Bibliófilos; 1985. 2 vols. in 1. Reprint of the 1936–1943 ed.

2850. *The Horses of the Morning: About the Rt. Excellent N. W. Manley, Q.C., M.M., National Hero of Jamaica.* Victor Stafford Reid. Kingston: Caribbean Authors; 1985. 548 pp.

2851. *Hostos: ciudadano de América.* Antonio Salvador Pedreira. Río Piedras, P.R.: Editorial Edil; 1976. 222 pp. Reprint of the 1964 (rev.) ed.

2852. *Hostos: el sembrador.* Juan Bosch. Santo Domingo: Editora Alfa y Omega; 1985. 207 pp. Reprint of the 1976 (rev.) ed.

2853. *Inward Hunger: The Education of a Prime Minister.* Eric Eustace Williams. Chicago, IL: University of Chicago Press; 1971. 352 pp. Reprint of the 1969 ed.

2854. *Jamaica's National Heroes.* Sylvia Wynter. Kingston: Jamaica National Trust Commission; 1971. 55 pp.

2855. *José Martí: A Biography in Photographs and Documents/José Martí: una biografía en fotos y documentos.* Carlos Ripoll. Coral Gables, FL: Senda Nueva de Ediciones; 1992. 141 pp.

2856. *José Martí, the United States, and the Marxist Interpretation of Cuban History.* Carlos Ripoll. New Brunswick, NJ: Transaction Books; 1984. 80 pp.

2857. *José Martí: antimperialista.* Centro de Estudios Martianos, ed. Havana: Editorial de Ciencias Sociales; 1989. 548 pp.

2858. *José Martí: Architect of Cuba's Freedom.* Peter Turton. Atlantic Highlands, NJ: Zed Books; 1986. 157 pp.

2859. *José Martí: Cuban Patriot.* Richard Butler Gray. Gainesville, FL: University of Florida Press; 1962. 307 pp.

2860. *José Martí: Mentor of the Cuban Nation.* John M. Kirk. Tampa, FL: University Presses of Florida; 1983. 201 pp.

2861. *José Martí: Revolutionary Democrat.* Christopher Abel, Nissa Torrents, eds. Durham, NC: Duke University Press; 1986. 238 pp.

2862. *Juan Bosch: el comienzo de la historia.* Víctor Grimaldi. Santo Domingo: Editora Alfa y Omega; 1990. 109 pp.

2863. *Liberators and Heroes of the West Indian Islands.* Marion Florence Lansing. Boston, MA: L. C. Page; 1953. 294 pp.

2864. *Luis Muñoz Marín: juicios sobre su significado histórico.* Carmelo Rosario Natal, ed. San Juan: Fundación Luis Muñoz Marín; 1990. 110 pp.

2865. *Luis Muñoz Rivera: savia y sangre de Puerto Rico.* Salvador Arana Soto. San Juan: [s.n.]; 1968–1975. 4 vols.

2866. *Marcus Garvey and the Vision of Africa.* John Henrik Clarke, Amy Jacques Garvey, eds. New York, NY: Vintage Books; 1974. 496 pp.

2867. *Marcus Garvey: Anti-Colonial Champion.* Rupert Lewis. Trenton, NJ: Africa World Press; 1988. 301 pp.

2868. *Martí y Hostos.* José Ferrer Canales. Río Piedras, P.R.: Instituto de Estudios Hostosianos, Universidad de Puerto Rico; 1990. 197 pp.

2869. *Martí y su concepción del mundo.* Roberto Daniel Agramonte y Pichardo. Río Piedras, P.R.: Editorial Universitaria, Universidad de Puerto Rico; 1971. 815 pp.

2870. *Martí: Apostle of Freedom.* Jorge Mañach; Coley Taylor, tr. New York, NY: Devin-Adair; 1950. 363 pp. Translation of *Martí, el apóstol.*

2871. *Martí: Martyr of Cuban Independence.* Félix Lizaso; Esther Elise Shuler, tr. Westport, CT: Greenwood Press; 1974. 260 pp. Translation of *Martí, místico del deber;* reprint of the 1953 ed.

2872. *Michael Manley: The Making of a Leader.* Darrell E. Levi. Athens, GA: University of Georgia Press; 1990. 349 pp.

2873. *Military Biography of Generalissimo Rafael Leonidas Trujillo Molina, Commander in Chief of the Armed Forces.* Ernesto Vega i Pagán; Ida Es-

paillat, tr. Ciudad Trujillo: Editorial Atenas; 1956. 199 pp. Translation of *Biografía militar del generalísimo doctor Rafael Leónidas Trujillo Molina*.

2874. *Papa Doc: Haiti and Its Dictator*. Bernard Diederich, Al Burt. Maplewood, NJ: Waterfront Press; 1991. 424 pp. Reprint of the 1970 ed. originally published under title *Papa Doc: The Truth About Haiti Today*.

2875. *Pioneers in Nation-Building in a Caribbean Mini-State*. Rupert John. New York, NY: United Nations Institute for Training and Research; 1979. 193 pp. About St. Vincent.

2876. *Profiles of Outstanding Virgin Islanders*. Ruth Molenaar. 3d ed. Charlotte Amalie, V.I.: Dept. of Education, Government of the U.S. Virgin Islands; 1992. 238 pp. Previous ed. by the Department.

2877. *Puertorriqueños ilustres [primera y segunda selección]*. Cayetano Coll y Toste; Isabel Cuchí Coll, ed. New York, NY [etc.]: Las Américas [etc.]; 1957–1978. 2 vols.

2878. *¿Quién es . . . ? biografías puertorriqueñas*. Lucas Morán Arce, Sarah Díez de Morán. San Juan: Librotex; 1986. 202 pp.

2879. *Race First: The Ideological and Organizational Struggles of Marcus Garvey and the Universal Negro Improvement Association*. Tony Martin. Dover, MA: Majority Press; 1986. 421 pp. Reprint of the 1976 ed.

2880. *The Rhetorical Uses of the Authorizing Figure: Fidel Castro and José Martí*. Donald E. Rice. New York, NY: Praeger; 1992. 163 pp.

2881. *Rise of West Indian Democracy: The Life and Times of Sir Grantley Adams*. F. A. Hoyos. Bridgetown: Advocate Press; 1963. 228 pp.

2882. *Sealy's Caribbean Leaders*. Theodore Sealy. Kingston: Eagle Merchant Bank of Jamaica; 1991. 207 pp.

2883. *A Sergeant Named Batista*. Edmund A. Chester. New York, NY: Holt; 1954. 276 pp.

2884. *Six Great Jamaicans: Biographical Sketches*. Walter Adolphe Roberts. 2d ed. Kingston: Pioneer Press; 1957. 117 pp.

2885. *The Tiger and the Children: Fidel Castro and the Judgment of History*. Roberto Luque Escalona; Manuel A. Tellechea, tr. New Brunswick, NJ: Transaction Publishers; 1992. 212 pp. Translation of *Fidel, el juicio de la historia*.

2886. *Toussaint L'Ouverture*. George F. Tyson, ed. Englewood Cliffs, NJ: Prentice-Hall; 1973. 185 pp.

2887. *Toussaint Louverture: la Révolution française et le problème colonial*. Aimé Césaire. Ed. rev., corr. et augm. Paris: Présence africaine; 1981. 345 pp.

2888. *Toussaint Louverture; ou, La vocation de la liberté.* Roger Dorsinville. Montreal: Editions du CIDIHCA; 1987. 269 pp. Reprint of the 1965 ed.

2889. *Toussaint Louverture: un révolutionnaire noir d'Ancien Régime.* Pierre Pluchon. Paris: Fayard; 1989. 654 pp.

2890. *Trials and Triumphs of Marcus Garvey.* Len S. Nembhard. Millwood, NY: Kraus Reprint; 1978. 249 pp. Reprint of the 1940 ed.

2891. *Trujillo: causas de una tiranía sin ejemplo.* Juan Bosch. 5a ed. Santo Domingo: Editora Alfa y Omega; 1991. 206 pp.

2892. *Trujillo: Little Caesar of the Caribbean.* Germán E. Ornes. New York, NY: T. Nelson; 1958. 338 pp.

2893. *Trujillo: The Biography of a Great Leader.* Abelardo René Nanita. New York, NY: Vantage Press; 1957. 222 pp. Translation of *Trujillo de cuerpo entero.*

2894. *Trujillo: The Death of the Goat.* Bernard Diederich. Maplewood, NJ: Waterfront Press; 1990. 264 pp. Cover title *Trujillo: The Death of the Dictator;* reprint of the 1978 ed.

2895. *Trujillo: The Last Caesar.* Arturo R. Espaillat. Chicago, IL: H. Regnery; 1963. 192 pp.

2896. *Trujillo: The Life and Times of a Caribbean Dictator.* Robert D. Crassweller. New York, NY: Macmillan; 1966. 468 pp.

2897. *Trujillo: un estudio del fenómeno dictatorial.* Jacinto Gimbernard. Santo Domingo: Publicaciones América; 1986. 223 pp. Reprint of the 1976 ed.

2898. *Valores de Puerto Rico.* Vicente Geigel Polanco. New York, NY: Arno Press; 1975. 169 pp. Reprint of the 1943 ed.

2899. *Vivir a Hostos: ensayos.* Josemilio González. San Juan: Comité Pro Celebración Sesquicentenario del Natalicio de Eugenio María de Hostos; 1989. 165 pp.

2. MEMOIRS, COLLECTED SPEECHES, AND WORKS

2900. *A Destiny to Mould: Selected Speeches by the Prime Minister of Guyana.* Forbes Burnham; C. A. Nascimento, Reynold A. Burrowes, eds. New York, NY: Africana; 1970. 275 pp. British ed. has title *A Destiny to Mould: Selected Discourses by the Prime Minister of Guyana.*

2901. *The Diario of Christopher Columbus's First Voyage to America, 1492–1493.* Christopher Columbus; Oliver Charles Dunn, James Edward Kelley, eds. Norman, OK: University of Oklahoma Press; 1989. 491 pp.

2902. *Diario.* Eugenio María de Hostos; Julio César López, Vivian Quiles Calderín, eds. San Juan: Instituto de Cultura Puertorriqueña; 1990– [vol. 1–]. Vol. 1. *1866–1869.*

2903. *Eugenio María de Hostos.* Eugenio María de Hostos; Angel López Cantos, ed. Madrid: Instituto de Cooperación Iberoamericana; 1990. 187 pp.

2904. *Fidel Castro Speeches.* Fidel Castro; Michael Taber, ed. New York, NY: Pathfinder Press; 1981– [vols. 1–3+]. Vol. 1. *Cuba's Internationalist Foreign Policy, 1975–80;* vol. 2. *Our Power Is That of the Working People;* vol. 3. *War and Crisis in the Americas.*

2905. *Forged from the Love of Liberty: Selected Speeches.* Eric Eustace Williams. Paul K. Sutton, ed. Port of Spain: Longman Caribbean; 1981. 473 pp.

2906. *Forward Ever! Three Years of the Grenadian Revolution—Speeches.* Maurice Bishop. New York, NY: Pathfinder Press; 1982. 287 pp.

2907. *In Defense of Socialism: Four Speeches on the Thirtieth Anniversary of the Cuban Revolution.* Fidel Castro; Mary-Alice Waters, ed. New York, NY: Pathfinder Press; 1989. 142 pp.

2908. *In Nobody's Backyard: Maurice Bishop's Speeches, 1979–1983—A Memorial Volume.* Maurice Bishop; Chris Searle, ed. Atlantic Highlands, NJ: Zed Books; 1984. 260 pp.

2909. *In the Parish of the Poor: Writings from Haiti.* Jean-Bertrand Aristide; Amy Wilenz, tr. Maryknoll, NY: Orbis Books; 1990. 112 pp.

2910. *Maurice Bishop Speaks: The Grenada Revolution, 1979–83.* Maurice Bishop; Bruce Marcus, Michael Taber, eds. New York, NY: Pathfinder Press; 1983. 352 pp.

2911. *Mémoires d'un leader du Tiers Monde: mes négotiations avec le Saint-Siège; ou, Une tranche d'histoire.* François Duvalier. Paris: Hachette; 1969. 383 pp.

2912. *Norman Washington Manley and the New Jamaica: Selected Speeches and Writings, 1938–68.* Norman Washington Manley; Rex M. Nettleford, ed. New York, NY: Africana; 1971. 393 pp.

2913. *Our America: Writings on Latin America and the Struggle for Cuban Independence.* José Martí; Elinor Randall [et al.], trs.; Philip Sheldon Foner, ed. New York, NY: Monthly Review Press; 1977. 448 pp.

2914. *Philosophy and Opinions of Marcus Garvey.* Marcus Garvey; Amy Jacques Garvey, ed. New York, NY: Atheneum; 1992. 412 pp. Reprint of the 1923–1925 ed.

2915. *The Search for Solutions: Selections from the Speeches and Writings of Michael Manley.* Michael Manley; John Hearne, ed. Oshawa, Ont.: Maple House; 1976. 322 pp.

2916. *The West on Trial: The Fight for Guyana's Freedom.* Cheddi Jagan. Rev. ed. Berlin: Seven Seas; 1980. 463 pp.

D. Economics

1. AGRICULTURE AND AGRICULTURAL ECONOMICS

2917. *Agrarian Reform Policy in the Dominican Republic: Local Organization and Beneficiary Investment Strategies.* Ana Teresa Gutiérrez de San Martín. Lanham, MD: University Press of America; 1988. 280 pp.

2918. *Agricultural Diversification in a Small Economy: The Case for Dominica.* John-Baptiste McCarthy Marie. Cave Hill, Barbados: Institute of Social and Economic Research (Eastern Caribbean), University of the West Indies; 1979. 119 pp.

2919. *Agricultural Policy and Collective Self-Reliance in the Caribbean.* W. Andrew Axline. Boulder, CO: Westview Press; 1986. 134 pp.

2920. *Agriculture and Trade of the Caribbean Region: Bermuda, the Bahamas, the Guianas, and British Honduras.* Wilbur Francis Buck. Washington, DC: Economic Research Service, U.S. Dept. of Agriculture; 1971. 102 pp.

2921. *Agriculture in Haiti: With Special Reference to Rural Economy and Agricultural Education.* Marc Aurele Holly. New York, NY: Vantage Press; 1955. 513 pp.

2922. *Agriculture in Surinam, 1650–1950: An Inquiry into the Causes of Its Decline.* Radjnarain Mohanpersad Nannan Panday. Amsterdam: H. J. Paris; 1959. 226 pp.

2923. *Coffee and the Growth of Agrarian Capitalism in Nineteenth-Century Puerto Rico.* Laird W. Bergad. Princeton, NJ: Princeton University Press; 1983. 242 pp.

2924. *The Ecology of Malnutrition in the Caribbean: The Bahamas, Cuba, Jamaica, Hispaniola (Haiti and the Dominican Republic), Puerto Rico, the Lesser Antilles and Trinidad and Tobago.* Jacques Mayer May, Donna L. McLellan. New York, NY: Hafner Press; 1973. 490 pp.

2925. *Family Land and Development in St. Lucia.* Christine Barrow. Cave Hill, Barbados: Institute of Social and Economic Research (Eastern Caribbean), University of the West Indies; 1992. 83 pp.

2926. *Food and Nutrition Profile of the English-Speaking Caribbean Countries and Suriname: A Basis for the Scientific and Technical Approaches to the Work of CFNI.* Caribbean Food and Nutrition Institute. Kingston: The Institute; 1984. 212 pp.

2927. *Green Gold: Bananas and Dependency in the Eastern Caribbean.* Robert Thomson [et al.]. London: Latin American Bureau; 1987. 93 pp.

2928. *Land and Development in the Caribbean*. Jean Besson, Janet Momsen, eds. London: Macmillan Caribbean; 1987. 228 pp.

2929. *Land in Belize, 1765–1871*. O. Nigel Bolland, Assad Shoman. Mona, Jamaica: Institute of Social and Economic Research, University of the West Indies; 1977. 142 pp.

2930. *Man and Land in the Haitian Economy*. Maurice De Young. Millwood, NY: Kraus Reprint; 1972. 73 pp. Reprint of the 1958 ed.

2931. *Markets, Prices and Nutrition: Experiences from Antigua and Barbuda and St. Vincent and the Grenadines*. Curtis E. McIntosh. Kingston: Caribbean Food and Nutrition Institute; 1986. 122 pp.

2932. *Migration, Smallholder Agriculture, and Food Consumption in Jamaica and Saint Lucia*. Elsa M. Chaney. Washington, DC: Hemispheric Migration Project, Georgetown University; 1988. 74 pp.

2933. *No Free Lunch: Food and Revolution in Cuba Today*. Medea Benjamin, Joseph Collins, Michael Scott. 3d ed. San Francisco, CA: Institute for Food and Development Policy; 1989. 242 pp.

2934. *Panorama histórico de la agricultura en Puerto Rico*. Juana Gil-Bermejo García. Seville: Escuela de Estudios Hispano-Americanos; 1970. 385 pp.

2935. *Peasants and Capital: Dominica in the World Economy*. Michel-Rolph Trouillot. Baltimore, MD: Johns Hopkins University Press; 1988. 344 pp.

2936. *Peasants and Poverty: A Study of Haiti*. Mats Lundahl. New York, NY: St. Martin's Press; 1979. 699 pp.

2937. *Peasants in Distress: Poverty and Unemployment in the Dominican Republic*. Rosemary Vargas-Lundius. Boulder, CO: Westview Press; 1991. 387 pp.

2938. *Peasants, Plantations and Rural Communities in the Caribbean*. Caribbean Colloquium (Third, 1977, Leiden); Malcolm Cross, Arnaud F. Marks, eds. Leiden: Caraïbische Afdeling, Koninklijk Instituut voor Taal, Land- en Volkenkunde; 1979. 304 pp.

2939. *The Problem of Freedom: Race, Labor, and Politics in Jamaica and Britain, 1832–1938*. Thomas Cleveland Holt. Baltimore, MD: Johns Hopkins University Press; 1992. 517 pp.

2940. *La reforma agraria, la Iglesia Católica, las fuerzas armadas y los campesinos*. Marcos Rivera Cuesta. Santo Domingo: Amigo del Hogar; 1991. 224 pp. About the Dominican Republic.

2941. *Regional Food and Nutrition Strategy*. Caribbean Community. Georgetown: The Community; 1980? 5 vols.

2942. *Revolution and Economic Development in Cuba*. Arthur MacEwan. New York, NY: St. Martin's Press; 1981. 265 pp.

2943. *The Role of Agriculture in the Economy of Haiti: Perspectives for a Better Development.* Raymond Myrthil. Flushing, NY: Haitian Book Centre; 1988. 94 pp.

2944. *Roosenburg en Mon Bijou: twee Surinaamse plantages, 1720–1870 [Roosenburg and Mon Bijou: Two Surinamese Plantations, 1720–1870].* Gert Oostindie. Leiden: Caraïbische Afdeling, Koninklijk Instituut voor Taal-, Land- en Volkenkunde; 1989. 548 pp.

2945. *Rural Santo Domingo: Settled, Unsettled, and Resettled.* Marlin D. Clausner. Philadelphia, PA: Temple University Press; 1973. 323 pp.

2946. *Secondary Agrobased Industries: ECCM and Barbados.* Jeffrey W. Dellimore, Judy A. Whitehead. Mona, Jamaica: Institute of Social and Economic Research, University of the West Indies; 1984. 296 pp.

2947. *Small Farming and Peasant Resources in the Caribbean.* John S. Brierley, Hymie Rubenstein, eds. Winnipeg, Man.: Dept. of Geography, University of Manitoba; 1988. 134 pp.

2948. *Small Farming in the Less Developed Countries of the Commonwealth Caribbean: Grenada, St. Vincent, St. Lucia, Dominica, St. Kitts, Nevis, Montserrat, Antigua, Belize.* Weir's Agricultural Consulting Services (Jamaica); Compton Bourne [et al.], associate consultants. Kingston: Caribbean Development Bank; 1980. 335 pp.

2949. *The Structure of Plantation Agriculture in Jamaica.* Phillips Wayne Foster, Peter Creyke. College Park, MD: Agricultural Experiment Station, University of Maryland; 1968. 102 pp.

2950. *Systèmes de production agricole caribéens et alternatives de développement/Caribbean Farming Systems and Alternatives for Development: actes du colloque 9–11 mai 1985.* Université Antilles-Guyane, Développement agricole caraïbe. Pointe-à-Pitre: La Université; 1985. 736 pp.

2951. *Trade, Exchange Rate, and Agricultural Pricing Policies in the Dominican Republic.* Duty D. Greene, Terry L. Roe. Washington, DC.: World Bank; 1989. 2 vols.

2. ECONOMIC CONDITIONS, INTEGRATION, AND POLICY

2952. *Aiding Migration: The Impact of International Development Assistance on Haiti.* Josh DeWind, David H. Kinley. Boulder, CO: Westview Press; 1988. 196 pp.

2953. *Antigua and Barbuda: Economic Report.* World Bank. Washington, DC: The Bank; 1985. 90 pp.

2954. *Les Antilles françaises.* Jean Pouquet. Paris: Presses universitaires de France; 1976. 126 pp. Reprint of the 1952 ed.

134 Bibliography

2955. *Apertura y reformas estructurales: el desafío dominicano.* Fernando Pellerano, ed. Santo Domingo: Centro de Investigación y Economía Aplicada; 1991. 372 pp.

2956. *The Asian Development Model and the Caribbean Basin Initiative [Conference Papers].* John Tessitore, Susan Woolfson, Constance Carpenter, eds. New York, NY: Council on Religion and International Affairs; 1985. 244 pp.

2957. *Avenir des Antilles-Guyane: des solutions existent, projet économique et politique.* Guy Numa. Paris: L'Harmattan; 1986. 183 pp.

2958. *The Bahamas: Economic Report.* World Bank. Washington, DC: The Bank; 1986. 117 pp.

2959. *Belize: Economic Report.* World Bank. Washington, DC: The Bank; 1984. 111 pp.

2960. *Capital transnacional y trabajo en el Caribe.* Gérard Pierre-Charles, ed. Mexico City: Instituto de Investigaciones Sociales, Universidad Nacional Autónoma de México; 1988. 281 pp.

2961. *Capitalism and Socialism in Cuba: A Study of Dependency, Development, and Underdevelopment.* Patricia Ruffin. New York, NY: St. Martin's Press; 1990. 212 pp.

2962. *La Caraïbe et la Martinique: faits et décisions économiques.* Fred Celimène, François Vellas. Paris: Economica; 1990. 344 pp.

2963. *The Caribbean Basin and the Changing World Economic Structure.* Henk E. Chin, ed. Groningen: Wolters-Noordhoff; 1986. 194 pp.

2964. *The Caribbean Basin to the Year 2000: Demographic, Economic, and Resource-Use Trends in Seventeen Countries—A Compendium of Statistics and Projections.* Norman A. Graham, Keith L. Edwards. Boulder, CO: Westview Press; 1984. 166 pp.

2965. *Caribbean Countries: Economic Situation, Regional Issues, and Capital Flows.* World Bank. Washington, DC: The Bank; 1988. 78 pp.

2966. *Caribbean Development to the Year 2000: Challenges, Prospects and Policies.* Compton Bourne [et al.]. Georgetown: Caribbean Community Secretariat; 1988. 218 pp.

2967. *Caribbean Economy: Dependence and Backwardness.* George L. Beckford, ed. Mona, Jamaica: Institute of Social and Economic Research, University of the West Indies; 1975. 181 pp.

2968. *The Caribbean in Transition: Papers on Social, Political, and Economic Development.* Caribbean Scholars' Conference (Second, 1964, Mona, Jamaica); Fuat M. Andic, Thomas G. Mathews, eds. Río Piedras, P.R.: Institute of Caribbean Studies, University of Puerto Rico; 1965. 353 pp.

2969. *Caribbean Integration: Papers on Social, Political, and Economic Integration.* Caribbean Scholars' Conference (Third, 1966, Georgetown);

Sybil Farrell Lewis, Thomas G. Mathews, eds. Río Piedras, P.R.: Institute of Caribbean Studies, University of Puerto Rico; 1967. 258 pp.

2970. *The Caribbean Issues of Emergence: Socio-Economic and Political Perspectives.* Vincent R. McDonald, ed. Washington, DC: University Press of America; 1980. 356 pp.

2971. *Caribbean Patterns: A Political and Economic Study of the Contemporary Caribbean.* Harold Paton Mitchell. 2d ed. New York, NY: Wiley; 1972. 583 pp.

2972. *Caribbean Regionalism: Challenges and Options.* Alister McIntyre, Shridath S. Ramphal, William G. Demas. St. Augustine, Trinidad/Tobago: Institute of International Relations, University of the West Indies; 1987. 88 pp.

2973. *The Caribbean: Its Economy.* Conference on the Caribbean (Fourth, 1953, University of Florida); Alva Curtis Wilgus, ed. Gainesville, FL: University of Florida Press; 1954. 286 pp.

2974. *The Caribbean: The Genesis of a Fragmented Nationalism.* Franklin W. Knight. 2d ed. New York, NY: Oxford University Press; 1990. 389 pp.

2975. *El Caribe 1990: elementos para análisis político.* José Rodríguez Iturbe. Caracas: Centro de Estudios de Política Internacional; 1990. 103 pp.

2976. *The Challenge of Structural Adjustment in the Commonwealth Caribbean.* Ramesh F. Ramsaran. New York, NY: Praeger; 1992. 206 pp.

2977. *Change and Renewal in the Caribbean.* William G. Demas. Bridgetown: CCC Publishing House; 1975. 60 pp.

2978. *Changer la Martinique: initiation à l'économie des Antilles.* Jean Crusol. Paris: Editions caribéennes; 1986. 91 pp.

2979. *The Changing Face of the Caribbean.* Irene Hawkins. Bridgetown: Cedar Press; 1976. 271 pp.

2980. *Changing Jamaica.* Adam Kuper. Boston, MA: Routledge and K. Paul; 1976. 163 pp.

2981. *La colaboración y la integración económicas en el Caribe.* Armando López Coll. Havana: Editorial de Ciencias Sociales; 1983. 383 pp.

2982. *Colonialism and Underdevelopment: Processes of Political Economic Change in British Honduras.* Norman Ashcraft. New York, NY: Teachers College Press, Columbia University; 1973. 180 pp.

2983. *Commercialization of Technology and Dependence in the Caribbean.* Maurice A. Odle, Owen S. Arthur. Mona, Jamaica: Institute of Economic and Social Research, University of the West Indies; 1985. 225 pp.

2984. *The Commonwealth Caribbean: The Integration Experience—Report of a Mission Sent to the Commonwealth Caribbean by the World Bank.* Sidney E. Chernick. Baltimore, MD: Johns Hopkins University Press; 1978. 521 pp.

2985. *The Commonwealth Caribbean in the World Economy.* Ramesh F. Ramsaran. London: Macmillan; 1989. 288 pp.

2986. *Condiciones socioeconómicas de la mujer trabajadora en la República Dominicana.* Frank Moya Pons, ed. Santo Domingo: FORUM; 1986. 150 pp.

2987. *Contemporary Politics and Economics in the Caribbean.* Harold Paton Mitchell. Athens, OH: Ohio University Press; 1968. 520 pp.

2988. *Coping with Poverty: Adaptive Strategies in a Caribbean Village.* Hymie Rubenstein. Boulder, CO: Westview Press; 1987. 389 pp. About St. Vincent and the Grenadines.

2989. *Crecimiento económico y acumulación de capital: consideraciones teóricas y empíricas en la República Dominicana.* Miguel Ceara Hatton. Santo Domingo: Universidad Iberoamericana; 1990. 187 pp.

2990. *Crises in the Caribbean Basin.* Richard Tardanico, ed. Newbury Park, CA: Sage; 1987. 263 pp.

2991. *Cuba in Transition: Papers and Proceedings.* Association for the Study of the Cuban Economy, Meeting (First, 1991, Miami). Miami, FL: Latin American and Caribbean Center, Florida International University; 1992. 321 pp.

2992. *Cuba's Socialist Economy Toward the 1990's.* Andrew S. Zimbalist, ed. Boulder, CO: L. Rienner; 1987. 188 pp.

2993. *Cuba: economía y sociedad.* Leví Marrero. Río Piedras, P.R. [etc.]: Editorial San Juan [etc.]; 1972– [vols. 1–15+].

2994. *Cuba: Socialism and Development.* René Dumont; Helen R. Lane, tr. New York, NY: Grove Press; 1970. 240 pp. Translation of *Cuba: socialisme et développement.*

2995. *Cuba: The Economic and Social Revolution.* Dudley Seers [et al.]; Dudley Seers, ed. Westport, CT: Greenwood Press; 1975. 432 pp. Reprint of the 1964 ed.

2996. *Cuban Communism.* Irving Louis Horowitz, ed. 7th ed. New Brunswick, NJ: Transaction Publishers; 1989. 854 pp.

2997. *The Cuban Economy: Dependency and Development.* Antonio Jorge, Jaime Suchlicki, eds. Coral Gables, FL: Institute of Interamerican Studies, University of Miami; 1989. 120 pp.

2998. *The Cuban Economy: Measurement and Analysis of Socialist Performance.* Andrew S. Zimbalist, Claes Brundenius. Baltimore, MD: Johns Hopkins University Press; 1989. 220 pp.

2999. *Cuban Political Economy: Controversies in Cubanology.* Andrew S. Zimbalist, ed. Boulder, CO: Westview Press; 1988. 240 pp.

3000. *Democracy by Default: Dependency and Clientelism in Jamaica.* Carlene J. Edie. Boulder, CO: L. Rienner; 1991. 170 pp.

3001. *Les départements français d'Amérique: Guadeloupe, Guyane, Martinique, face aux schémas d'intégration économique de la Caraïbe et de l'Amérique latine.* Louis Dupont. Paris: L'Harmattan; 1988. 303 pp.

3002. *Dependency Under Challenge: The Political Economy of the Commonwealth Caribbean.* Anthony Payne, Paul K. Sutton, eds. Dover, NH: Manchester University Press; 1984. 295 pp.

3003. *El desarrollo económico de Cuba, 1959–1988.* José Luis Rodríguez. Mexico City: Editorial Nuestro Tiempo; 1990. 223 pp.

3004. *Después de Colón: trabajo, sociedad y política en la economía del oro.* Frank Moya Pons. [Nueva ed.]. Madrid: Alianza Editorial; 1987. 195 pp. Rev. ed. of *La Española en el siglo XVI, 1493–1520* (1971).

3005. *Development in Suspense: Selected Papers and Proceedings.* Conference of Caribbean Economists (First, 1987, Kingston); Norman Girvan, George L. Beckford, eds. Kingston: Friedrich Ebert Stiftung; 1989. 366 pp.

3006. *The Development of the British West Indies, 1700–1763.* Frank Wesley Pitman. Hamden, CT: Archon Books; 1967. 495 pp. Reprint of the 1917 ed.

3007. *The Development of the Plantations to 1750: An Era of West Indian Prosperity, 1750–1775.* Richard B. Sheridan. Bridgetown: Caribbean Universities Press; 1970. 120 pp.

3008. *Development Policy in Guyana: Planning, Finance, and Administration.* Kempe Ronald Hope. Boulder, CO: Westview Press; 1979. 260 pp.

3009. *Development Strategies as Ideology: Puerto Rico's Export-Led Industrialization Experience.* Emilio Pantojas-García. Boulder, CO: L. Rienner; 1990. 205 pp.

3010. *Developmental Issues in Small Island Economies.* David L. McKee, Clement Allan Tisdell. New York, NY: Praeger; 1990. 196 pp.

3011. *Dominica: Priorities and Prospects for Development.* World Bank. Washington, DC: The Bank; 1985. 105 pp.

3012. *Dominican Republic: Economic Prospects and Policies to Renew Growth.* World Bank. Washington, DC: The Bank; 1985. 174 pp.

3013. *Dual Legacies in the Contemporary Caribbean: Continuing Aspects of British and French Dominion.* Paul K. Sutton, ed. Totowa, NJ: Cass; 1986. 266 pp.

3014. *The Dynamics of West Indian Economic Integration.* Havelock Brewster, Clive Yolande Thomas. Kingston: Institute of Social and Economic Research, University of the West Indies; 1967. 335 pp.

3015. *The Ecology of Development Administration in Jamaica, Trinidad and Tobago, and Barbados.* Jean Claude García Zamor. Washington, DC: Program of Development Financing, Organization of American States; 1977. 122 pp.

3016. *Economia e sociedade em áreas coloniais periféricas: Guiana Francesa e Pará, 1750–1817.* Ciro Flamarion Santana Cardoso. Rio de Janeiro: Graal; 1984. 201 pp.

3017. *Economía política de Puerto Rico.* Antonio J. González. San Juan: Editorial Cordillera; 1971. 168 pp. Reprint of the 1967 ed.

3018. *Economía, población y territorio en Cuba, 1899–1983.* José Luis Luzón. Madrid: Ediciones Cultura Hispánica; 1987. 341 pp.

3019. *Economic Adjustment Policies for Small Nations: Theory and Experience in the English-Speaking Caribbean.* DeLisle Worrell, Compton Bourne, eds. New York, NY: Praeger; 1989. 180 pp.

3020. *Economic and Political Change in the Leeward and Windward Islands.* Carleen O'Loughlin. New Haven, CT: Yale University Press; 1968. 260 pp.

3021. *The Economic Development of Jamaica: Report by a Mission.* World Bank. Baltimore, MD: Johns Hopkins University Press; 1952. 288 pp.

3022. *The Economic Development of British Guiana: Report of a Mission.* World Bank. Baltimore, MD: Johns Hopkins University Press; 1953. 366 pp.

3023. *The Economic Development of Revolutionary Cuba: Strategy and Performance.* Archibald R. M. Ritter. New York, NY: Praeger; 1974. 372 pp.

3024. *Economic Development in the Caribbean.* Kempe Ronald Hope. New York, NY: Praeger; 1986. 215 pp.

3025. *The Economic Geography of Barbados: A Study of the Relationships Between Environmental Variations and Economic Development.* Otis Paul Starkey. Westport, CT: Negro Universities Press; 1971. 228 pp. Reprint of the 1939 ed.

3026. *Economic History of Cuba.* Julio Le Riverend; María Juana Cazabón, Homero León, trs. Havana: Ensayo Book Institute; 1967. 277 pp. Translation of *Historia económica de Cuba.*

3027. *An Economic History of the Bahamas.* Anthony A. Thompson. Nassau: Commonwealth Publications; 1979. 292 pp.

3028. *Economic History of Puerto Rico: Institutional Change and Capitalist Development.* James L. Dietz. Princeton, NJ: Princeton University Press; 1986. 337 pp.

3029. *Economic Management, Income Distribution, and Poverty in Jamaica.* Derick Boyd. New York, NY: Praeger; 1988. 164 pp.

3030. *Economic Structure and Demographic Performance in Jamaica, 1891–1935.* Richard A. Lobdell. New York, NY: Garland; 1987. 259 pp.

3031. *Economic Study of Puerto Rico.* United States, Dept. of Commerce. Washington, DC: The Department; 1979. 2 vols.

3032. *The Economic Transformation of Cuba: A First-Hand Account.* Edward Boorstein. New York, NY: Monthly Review Press; 1968. 303 pp.

3033. *The Economics of Development in Small Countries: With Special Reference to the Caribbean.* William G. Demas. Montreal: McGill University Press; 1965. 150 pp.

3034. *Economie antillaise.* René Acheen [et al.]. Fort-de-France: Désormeaux; 1973. 416 pp.

3035. *Economies insulaires de la Caraïbe: aspects théoriques et pratiques du développement; Guadeloupe, Martinique, Barbade, Trinidad, Jamaïque, Puerto-Rico.* Jean Crusol. Paris: Editions caribéennes; 1980. 339 pp.

3036. *The Economy of Barbados, 1946–1980.* DeLisle Worrell, ed. Bridgetown: Central Bank of Barbados; 1982. 199 pp.

3037. *The Economy of Socialist Cuba: A Two-Decade Appraisal.* Carmelo Mesa-Lago. Albuquerque, NM: University of New Mexico Press; 1981. 235 pp.

3038. *The Economy of the West Indies.* George Edward Cumper, ed. New York, NY: Greenwood Press; 1974. 273 pp. Reprint of the 1960 ed.

3039. *Erradicación de la pobreza en Cuba.* José Luis Rodríguez, George Carriazo Moreno. 2a ed. Havana: Editorial de Ciencias Sociales; 1990. 207 pp.

3040. *Essays on Caribbean Integration and Development.* William G. Demas. Kingston: Institute of Social and Economic Research, University of the West Indies; 1976. 159 pp.

3041. *Essays on Power and Change in Jamaica.* Carl Stone, Aggrey Brown, eds. Kingston: Jamaica Publishing House; 1977. 207 pp.

3042. *Estudio de las implicaciones de la incorporación de la República Dominicana a la Comunidad del Caribe.* Bernardo Vega. Santo Domingo: Fondo para el Avance de las Ciencias Sociales; 1978. 247 pp.

3043. *Factories and Food Stamps: The Puerto Rico Model of Development.* Richard Weisskoff. Baltimore, MD: Johns Hopkins University Press; 1985. 190 pp.

3044. *The Fall of the Planter Class in the British Caribbean, 1763–1833: A Study in Social and Economic History.* Lowell Joseph Ragatz. New York, NY: Octagon Books; 1971. 520 pp. Reprint of the 1928 ed.

3045. *Far from Paradise: An Introduction to Caribbean Development.* James Ferguson. New York, NY: Monthly Review Press; 1990. 64 pp.

3046. *Financing Development in the Commonwealth Caribbean.* DeLisle Worrell, Compton Bourne, Dinesh Dodhia, eds. London: Macmillan Caribbean; 1991. 321 pp.

3047. *Five of the Leewards, 1834–1870: The Major Problems of the Post-Emancipation Period in Antigua, Barbuda, Montserrat, Nevis, and St. Kitts.*

Douglas Hall. St. Lawrence, Barbados: Caribbean Universities Press; 1971. 210 pp.

3048. *FMI, agricultura y pobreza.* Adriano Sánchez Roa. Santo Domingo: Editora Corripio; 1991. 112 pp. About the International Monetary Fund and the Dominican Republic.

3049. *La formación del sistema agroexportador en el Caribe: República Dominicana-Cuba, 1515–1898.* Franc Báez Evertsz. Santo Domingo: Universidad Autónoma de Santo Domingo; 1986. 253 pp.

3050. *The Formation of a Colonial Society: Belize, from Conquest to Crown Colony.* O. Nigel Bolland. Baltimore. MD: Johns Hopkins University Press; 1977. 240 pp.

3051. *Free Jamaica, 1838–1865: An Economic History.* Douglas Hall. St. Michael, Barbados: Caribbean Universities Press; 1976. 290 pp. Reprint of the 1959 ed.

3052. *Grenada: Economic Report.* World Bank. Washington, DC: The Bank; 1985. 90 pp.

3053. *Grenada: Politics, Economics, and Society.* Tony Thorndike. Boulder, CO: L. Rienner; 1985. 206 pp.

3054. *Haiti in the World Economy: Class, Race, and Underdevelopment Since 1700.* Alex Dupuy. Boulder, CO: Westview Press; 1989. 245 pp.

3055. *Haiti: Its Stagnant Society and Shackled Economy—A Survey.* O. Ernest Moore. New York, NY: Exposition Press; 1972. 281 pp.

3056. *Haiti: Land of Poverty.* Robert J. Tata. Washington, DC: University Press of America; 1982. 127 pp.

3057. *The Haitian Economy: Man, Land, and Markets.* Mats Lundahl. New York, NY: St. Martin's Press; 1983. 290 pp.

3058. *Histoire économique de la Guadeloupe et de la Martinique: du XVIIe siècle à nos jours.* Alain Philippe Blérald. Paris: Karthala; 1986. 336 pp.

3059. *Historia económica de Cuba.* Leví Marrrero. Havana: Instituto Superior de Estudios e Investigaciones Económicas, Universidad de La Habana; 1956– [vol. 1–].

3060. *Historia económica de Cuba.* Heinrich Friedländer. Havana: Editorial de Ciencias Sociales; 1978. 2 vols. Reprint of the 1944 ed.

3061. *In the Shadows of the Sun: Caribbean Development Alternatives and U.S. Policy.* Peggy Antrobus [et al.]; Carmen Diana Deere, ed. Boulder, CO: Westview Press; 1990. 246 pp.

3062. *Inequality in a Post-Colonial Society: Trinidad and Tobago, 1956–1981.* Jack Harewood, Ralph Henry. St. Augustine, Trinidad/Tobago: Institute of Social and Economic Research, University of the West Indies; 1985. 97 pp.

3063. *Inmigración y cambio socio-económico en Trinidad, 1783–1797.* María Rosario Sevilla Soler. Seville: Escuela de Estudios Hispano-Americanos; 1988. 238 pp.

3064. *Integration and Participatory Development: Selected Papers and Proceedings.* Conference of Caribbean Economists (Second, 1990, Bridgetown); Judith Wedderburn, ed. Kingston: Friederich Ebert Stiftung; 1990. 191 pp.

3065. *The Inter-Virgin Islands Conference: A Study of a Microstate International Organization.* Norwell Harrigan. Gainesville, FL: Center for Latin American Studies, University of Florida; 1980. 88 pp.

3066. *Jamaica, 1830–1930: A Study in Economic Growth.* Gisela Eisner. Westport, CT: Greenwood Press; 1974. 399 pp. Reprint of the 1961 ed.

3067. *The Jamaican Economy.* Ransford W. Palmer. New York, NY: Praeger; 1968. 185 pp.

3068. *Karibische Klein- und Mikrostaaten: wirtschaftliche Aussenabhängigkeit und Integrationsbestrebungen.* Hans-Dieter Haas, Udo Bader, Jörg Grumptmann. Tübingen: Attempto; 1985. 200 pp.

3069. *De laatste kolonie, de Nederlandse Antillen: afhankelijkheid, belastingprofijt en geheime winsten [The Last Colony, the Netherlands Antilles: Dependence, Tax Advantages and Hidden Profits].* Rudie Kagie. Bussum: Wereldvenster; 1982. 125 pp.

3070. *A Macroeconomic Assessment of the Economy of Guyana.* Kenneth P. Jameson, Frank J. Bonello. Washington, DC: Rural Development Division, Bureau for Latin America and the Caribbean, Agency for International Development; 1978. 84 pp.

3071. *Macroeconomic Modeling and Policy Analysis for Less Developed Countries.* Mohammed F. Khayum. Boulder, CO: Westview Press; 1991. 203 pp. About Guyana.

3072. *Mammon vs. History: American Paradise or Virgin Islands Home.* Mario C. Moorhead. Frederiksted, V.I.: United People Party; 1973. 253 pp.

3073. *Man and Socialism in Cuba: The Great Debate.* Bertram Silverman, ed. New York, NY: Atheneum; 1971. 382 pp.

3074. *La Martinique: une isle à paradoxes.* Louis Ouensanga. Fort-de-France: Désormeaux; 1985. 253 pp.

3075. *Measuring Cuban Economic Performance.* Jorge F. Pérez-López. Austin, TX: University of Texas Press; 1987. 202 pp.

3076. *The Mechanics of Independence: Patterns of Political and Economic Transformation in Trinidad and Tobago.* Arthur Napoleon Raymond Robinson. Cambridge, MA: MIT Press; 1971. 200 pp.

3077. *Nederlandse Antillen en Aruba [Netherlands Antilles and Aruba].* Mark W. de Jong, Henk ten Napel. Amsterdam: Koninklijk Instituut voor de Tropen; 1988. 72 pp.

3078. *Olie als water: de Curaçaose economie in de eerste helft van de twintig-ste eeuw [Oil as Water: The Curaçaoan Economy in the First Half of the Twentieth Century].* Jaap van Soest. Zutphen: Walburg Pers; 1977. 766 pp.

3079. *The Pattern of a Dependent Economy: The National Income of British Honduras.* N. S. Carey Jones. Westport, CT: Greenwood Press; 1972. 162 pp. Reprint of the 1953 ed.

3080. *Patterns of Caribbean Development: An Interpretive Essay on Economic Change.* Jay R. Mandle. New York, NY: Gordon and Breach; 1982. 156 pp.

3081. *Patterns of Living in Puerto Rican Families.* Lydia Jane Roberts, Rosa Luisa Stefani. New York, NY: Arno Press; 1975. 411 pp. Reprint of the 1949 ed.

3082. *Peripheral Capitalism and Underdevelopment in Antigua.* Paget Henry. New Brunswick, NJ: Transaction Books; 1985. 220 pp.

3083. *Les Petites Antilles: étude sur leur évolution économique, 1820–1908.* Paul Chemin Dupontès. [Nouv. éd.]. Paris: L'Harmattan; 1979. 318 pp.

3084. *The Plantation Economy: Population and Economic Change in Guyana, 1838–1960.* Jay R. Mandle. Philadelphia, PA: Temple University Press; 1973. 170 pp.

3085. *Political Economy in Haiti: The Drama of Survival.* Simon M. Fass. New Brunswick, NJ: Transaction Books; 1988. 369 pp.

3086. *Politics and Economics in the Caribbean.* Thomas G. Mathews, Fuat M. Andic, eds. 2d ed., rev. Río Piedras, P.R.: Institute of Caribbean Studies, University of Puerto Rico; 1971. 284 pp.

3087. *The Politics of Caribbean Economic Integration.* Aaron Segal. Río Piedras, P.R.: Institute of Caribbean Studies, University of Puerto Rico; 1968. 156 pp.

3088. *The Politics of the Caribbean Community, 1961–79: Regional Integration Among New States.* Anthony Payne. New York, NY: St. Martin's Press; 1980. 299 pp.

3089. *The Poor and the Powerless: Economic Policy and Change in the Caribbean.* Clive Yolande Thomas. New York, NY: Monthly Review Press; 1988. 396 pp.

3090. *A Post-Emanicipation History of the West Indies.* Isaac Dookhan. London: Collins; 1975. 191 pp. Continues his *A Pre-Emancipation History of the West Indies* [#3097].

3091. *The Post-War Economic Development of Jamaica.* Owen Jefferson. Mona, Jamaica: Institute of Social and Economic Research, University of the West Indies; 1972. 302 pp.

3092. *Poverty and Basic Needs: Evidence from Guyana and the Philippines.* Guy Standing, Richard Szal. Geneva: International Labour Office; 1979. 154 pp.

3093. *Poverty and Progress in the Caribbean, 1800–1960.* J. R. Ward. London: Macmillan; 1985. 82 pp.

3094. *Poverty in Jamaica.* Michael Garfield Smith. Mona, Jamaica: Institute of Social and Economic Research, University of the West Indies; 1989. 167 pp.

3095. *Power and Economic Change: The Response to Emancipation in Jamaica and British Guiana, 1840–1865.* Philip J. McLewin. New York, NY: Garland; 1987. 271 pp.

3096. *Power in the Caribbean Basin: A Comparative Study of Political Economy.* Carl Stone. Philadelphia, PA: Institute for the Study of Human Issues; 1986. 159 pp.

3097. *A Pre-Emancipation History of the West Indies.* Isaac Dookhan. San Juan, Trinidad/Tobago: Longman Caribbean; 1988. 160 pp. Continued by his *A Post-Emancipation History of the West Indies* [#3090]; reprint of the 1971 ed.

3098. *Premisas geográficas de la integración socioeconómica del Caribe.* Instituto de Geografía (Academia de Ciencias de Cuba), Depto. de Geografía Económica. Havana: Editorial Científico-Técnica; 1979. 187 pp.

3099. *Problems of Development in Beautiful Countries: Perspectives on the Caribbean.* Ransford W. Palmer. Lanham, MD: North-South Publishing Co.; 1984. 91 pp.

3100. *Public Finance and Economic Development: Spotlight on Jamaica.* Hugh N. Dawes. Washington, DC: University Press of America; 1982. 147 pp.

3101. *The Puerto Rican Dilemma.* Sakari Sariola. Port Washington, NY: Kennikat Press; 1979. 200 pp.

3102. *The Puerto Rican Economy and United States Economic Fluctuations.* Werner Baer. Río Piedras, P.R.: Social Science Research Center, University of Puerto Rico; 1962. 155 pp.

3103. *Puerto Rico's Economic Future.* Harvey S. Perloff. New York, NY: Arno Press; 1975. 435 pp. Reprint of the 1950 ed.

3104. *Puerto Rico: Development by Integration to the U.S.* Eliezer Curet. Río Piedras, P.R.: Editorial Cultural; 1986. 257 pp.

3105. *Raíces de la nacionalidad cubana.* Fernando Fernández Escobio. Miami, FL: Laurenty [etc.]; 1987–1992. 2 vols.

3106. *Rape of the American Virgins.* Edward A. O'Neill. New York, NY: Praeger; 1972. 216 pp.

3107. *Readings in the Political Economy of the Caribbean: A Collection of Reprints of Articles on Caribbean Political Economy with Suggested Fur-*

ther Reading. Norman Girvan, Owen Jefferson, eds. Kingston: New World Group; 1977. 287 pp. Reprint of the 1971 ed.

3108. *Recent Performance and Trends in the Caribbean Economy: A Study of Selected Caribbean Countries.* Kempe Ronald Hope. St. Augustine, Trinidad/Tobago: Institute of Social and Economic Research, University of the West Indies; 1980. 118 pp.

3109. *The "Redlegs" of Barbados: Their Origins and History.* Jill Sheppard. Millwood, NY: KTO Press; 1977. 147 pp.

3110. *Reflexiones acerca de la economía dominicana.* Hugo Guiliani Cury. Santo Domingo: Editora Alfa y Omega; 1980. 411 pp.

3111. *Regionalism and the Commonwealth Caribbean: Papers.* Seminar on the Foreign Policies of Caribbean States (1968, University of the West Indies); Roy Preiswerk, ed. St. Augustine, Trinidad/Tobago: Institute of International Relations, University of the West Indies; 1969. 273 pp.

3112. *Reorientación política, económica y social dominicana.* Marcio Mejía-Ricart Guzmán. Santo Domingo: Editora Corripio; 1986. 247 pp.

3113. *Report on Cuba: Findings and Recommendations.* Economic and Technical Mission to Cuba; Francis Adams Truslow, Chief of Mission. Baltimore, MD: Johns Hopkins University Press; 1951. 1,049 pp.

3114. *Rethinking Caribbean Development.* George W. Schuyler, Henry Veltmeyer, eds. Halifax, N.S.: International Education Centre; 1988. 196 pp.

3115. *Revolutionary Change in Cuba.* Carmelo Mesa-Lago, ed. Pittsburgh, PA: University of Pittsburgh Press; 1971. 544 pp.

3116. *Revolutionary Cuba: The Challenge of Economic Growth with Equity.* Claes Brundenius. Boulder, CO: Westview Press; 1984. 224 pp.

3117. *Revolutionary Grenada: A Study in Political Economy.* Fredric L. Pryor. New York, NY: Praeger; 1986. 395 pp.

3118. *Seize the Time: Towards OECS Political Union.* William G. Demas. St. Michael, Barbados: Caribbean Development Bank; 1987. 57 pp.

3119. *Small Garden—Bitter Weed: The Political Economy of Struggle and Change in Jamaica.* George L. Beckford, Michael Witter. 2d ed. London: Zed Press; 1982. 167 pp.

3120. *Small Island Economies: Structure and Performance in the English-Speaking Caribbean Since 1970.* DeLisle Worrell. New York, NY: Praeger; 1987. 289 pp.

3121. *Spotlight on the Caribbean: A Microcosm of the Third World.* Edmund H. Dale. Regina, Sask.: Dept. of Geography, University of Regina; 1977. 95 pp.

3122. *St. Christopher and Nevis: Economic Report.* World Bank. Washington, DC: The Bank; 1985. 82 pp.

3123. *St. Lucia: Economic Performance and Prospects.* World Bank. Washington, DC: The Bank; 1985. 99 pp.

3124. *St. Vincent and the Grenadines: Economic Situation and Selected Development Issues.* World Bank. Washington, DC: The Bank; 1985. 108 pp.

3125. *The State in Caribbean Society.* Omar Davies, ed. New ed. Mona, Jamaica: Dept. of Economics, University of the West Indies; 1986. 157 pp.

3126. *Storm Signals: Structural Adjustment and Development Alternatives in the Caribbean.* Kathy McAfee. Boston, MA: South End Press; 1991. 259 pp.

3127. *A Strategy for Caribbean Economic Integration.* Roland I. Perusse. San Juan: North-South Press; 1971. 212 pp.

3128. *Structural Changes in Puerto Rico's Economy, 1947–1976.* Robert J. Tata. Athens, OH: Center for International Studies, Ohio University; 1980. 104 pp.

3129. *La structure économique et sociale d'Haïti.* Edouard Francisque. Port-au-Prince: H. Deschamps; 1986. 255 pp.

3130. *A Study of Cuba's Material Product System: Its Conversion to the System of National Accounts and Estimation of Gross Domestic Product per Capita and Growth Rates.* Carmelo Mesa-Lago, Jorge F. Pérez-López. Washington, DC: World Bank; 1985. 104 pp.

3131. *A Study on Cuba: The Colonial and Republican Periods, the Socialist Experiment, Economic Structure, Institutional Development, Socialism and Collectivization.* Grupo Cubano de Investigaciones Económicas. Coral Gables, FL: University of Miami Press; 1965. 774 pp.

3132. *Sugar and Slavery: An Economic History of the British West Indies, 1623–1775.* Richard B. Sheridan. Baltimore, MD: Johns Hopkins University Press; 1974. 529 pp.

3133. *Sugar Without Slaves: The Political Economy of British Guiana, 1838–1904.* Alan H. Adamson. New Haven, CT: Yale University Press; 1972. 315 pp.

3134. *Suriname: ontwikkelingsland in het Caraïbisch gebied [Surinam: Developing Country in the Caribbean].* Anna Maria Janssen. Amsterdam: Socialistiese Uitgeverij Amsterdam (SUA); 1986. 176 pp.

3135. *A Survey of Economic Potential, Fiscal Structure, and Capital Requirements of the British Virgin Islands.* Carleen O'Loughlin. Mona, Jamaica: Institute of Social and Economic Research, University of the West Indies; 1962. 60 pp.

3136. *A Survey of Economic Potential and Capital Needs of the Leeward Islands, Windward Islands, and Barbados.* Carleen O'Loughlin. London: HMSO; 1963. 184 pp.

3137. *Le système économique haïtien.* Gérard Pierre-Charles. Port-au-Prince: Centre de recherche et de formation économique et société pour le développement; 1989– [vol. 1–].

3138. *Technology Transfer and Capability in Selected Sectors: Case Studies from the Caribbean.* Steve De Castro [et al.]. Kingston: Institute of Social and Economic Research, University of the West Indies; 1985. 249 pp.

3139. *Ten Years of CARICOM: Papers.* Seminar on Economic Integration in the Caribbean (1983, Bridgetown). Washington, DC: Inter-American Development Bank; 1984. 351 pp.

3140. *A Theory of Economic Integration for Developing Countries: Illustrated by Caribbean Countries.* Fuat M. Andic, Suphan Andic, Douglas Dosser. London: Allen and Unwin; 1971. 176 pp.

3141. *Towards Sustained Development in Latin America and the Caribbean: Restrictions and Requisites.* United Nations, Economic Commission for Latin America and the Caribbean. Santiago, Chile: ECLAC; 1989. 93 pp.

3142. *Trinidad and Tobago: A Program for Policy Reform and Renewed Growth.* World Bank. Washington, DC: The Bank; 1988. 158 pp.

3143. *Up the Down Escalator: Development and the International Economy— A Jamaican Case Study.* Michael Manley. Washington, DC: Howard University Press; 1987. 332 pp.

3144. *Warning from the West Indies: A Tract for Africa and the Empire.* William M. Macmillan. Freeport, NY: Books for Libraries Press; 1971. 213 pp. Reprint of the 1936 ed.

3145. *West Indian Nationhood and Caribbean Integration.* William G. Demas. Bridgetown: CCC Publishing House; 1974. 74 pp.

3146. *The West Indies: Patterns of Development, Culture, and Environmental Change Since 1492.* David Watts. New York, NY: Cambridge University Press; 1987. 609 pp.

3. FOREIGN ECONOMIC RELATIONS, COMMERCE, AND TRADE

3147. *The American Struggle for the British West India Carrying Trade, 1815–1830.* Frank Lee Benns. Clifton, NJ: A. M. Kelley; 1972. 207 pp. Reprint of the 1923 ed.

3148. *Barbados: A Study of North American-West Indian Relations, 1739– 1789.* David H. Makinson. London: Mouton; 1964. 142 pp.

3149. *A Brief History of the West India Committee.* Douglas Hall. St. Lawrence, Barbados: Caribbean Universities Press; 1971. 60 pp.

3150. *The British West Indies During the American Revolution.* Selwyn H. H. Carrington. Leiden: Caraïbische Afdeling, Koninklijk Instituut voor Taal-, Land- en Volkenkunde; 1988. 222 pp.

3151. *Canada-West Indies Economic Relations.* Kari Levitt, Alister McIntyre. Montreal: Centre for Developing-Area Studies, McGill University; 1967. 181 pp.

3152. *Canadian Development Assistance to Haiti: An Independent Study.* Edward Philip English. Ottawa: North-South Institute; 1984. 167 pp.

3153. *Caribbean Backgrounds and Prospects.* Chester Lloyd Jones. Port Washington, NY: Kennikat Press; 1971. 354 pp. Reprint of the 1931 ed.

3154. *The Caribbean Basin Initiative: Genuine or Deceptive? An Early Assessment.* Glenn O. Phillips, Talbert O. Shaw, eds. Baltimore, MD: Morgan State University Press; 1987. 143 pp.

3155. *Caribbean Cases in Marketing Management.* George H. Wadinambiaratchi. Kingston: Caribbean Authors; 1989. 530 pp.

3156. *The Caribbean Connection.* Robert Chodos. Toronto: J. Lorimer; 1977. 269 pp. About Canada-Caribbean relations.

3157. *Caribbean Dependence on the United States Economy.* Ransford W. Palmer. New York, NY: Praeger; 1979. 173 pp.

3158. *Caribbean Interests of the United States.* Chester Lloyd Jones. New York, NY: Arno Press; 1970. 379 pp. Reprint of the 1916 ed.

3159. *The Caribbean: Export Preferences and Performance.* World Bank. Washington, DC: The Bank; 1988. 75 pp.

3160. *Colbert's West India Policy.* Stewart Lea Mims. New York, NY: Octagon Books; 1977. 385 pp. Reprint of the 1912 ed.

3161. *Le commerce aux Antilles.* Joseph Rennard. Fort-de-France: Impr. du Service de l'information; 1946. 76 pp.

3162. *Le commerce entre la Nouvelle-France et les Antilles au XVIIIe siècle.* Jacques Mathieu. Montreal: Fides; 1981. 276 pp.

3163. *Europe 1992: The Single Market and Its Implications for Labour—Report of a Conference (May 20–22, 1990).* Bustamante Institute of Public and International Affairs [and] Joint Trade Unions Research Centre (Jamaica) [and] Caribbean Congress of Labour. Kingston: The Institute; 1990. 122 pp.

3164. *Las exportaciones intrarregionales y la integración latinoamericana y del Caribe en perspectiva.* Francisco E. Thoumi. Washington, DC: Inter-American Development Bank; 1989. 90 pp.

3165. *The Free Port System in the British West Indies: A Study in Commercial Policy, 1766–1822.* Frances Armytage. New York, NY: Longmans, Green; 1953. 176 pp.

3166. *Haiti and the Caribbean Community: Profile of an Applicant and the Problematique of Widening the Integration Movement.* Mirlande Hippolyte-Manigat; Keith Warner, tr. Mona, Jamaica: Institute of Social and Economic Research, University of the West Indies; 1980. 256 pp.

3167. *Impacto económico de las zonas francas industriales de exportación en la República Dominicana.* Andrés Dauhajre [et al.]. Santo Domingo: Fundación Economía y Desarrollo; 1989. 360 pp.

3168. *Increasing the International Competitiveness of Exports from Caribbean Countries: Collected Papers from an EDI Policy Seminar Held in Bridgetown, Barbados, May 22–24, 1989.* Yin-Kann Wen, Jayshree Sengupta, eds. Washington, DC: World Bank; 1991. 114 pp.

3169. *La Ley Foraker: raíces de la política colonial de los Estados Unidos.* Lyman Jay Gould; Jorge Luis Morales, tr. 2a. ed. Río Piedras, P.R.: Editorial Universitaria, Universidad de Puerto Rico; 1975. 284 pp.

3170. *Marketing Efficiency in Puerto Rico.* John Kenneth Galbraith, Richard Henry Holton [et al.]. Cambridge, MA: Harvard University Press; 1955. 204 pp.

3171. *Marketing Strategy for Economic Development: The Puerto Rican Experience.* Gordon A. DiPaolo. New York, NY: Dunellen; 1976. 144 pp.

3172. *Merchants and Jews: The Struggle for British West Indian Commerce, 1650–1750.* Stephen Alexander Fortune. Gainesville, FL: University Presses of Florida; 1984. 244 pp.

3173. *The New Europe: The New World Order; Jamaica and the Caribbean.* Don Mills. Kingston: Grace, Kennedy Foundation; 1991. 88 pp.

3174. *Politics, Foreign Trade, and Economic Development: A Study of the Dominican Republic.* Claudio Vedovato. New York, NY: St. Martin's Press; 1986. 224 pp.

3175. *Problems of Caribbean Development: Regional Interaction, International Relations, and the Constraints of Small Size—Proceedings.* Arbeitsgemeinschaft Deutsche Lateinamerika-Forschung, Symposium (1980, Hamburg); Ulrich Fanger [et al.], eds. Munich: W. Fink; 1982. 271 pp.

3176. *Promoting Investment and Exports in the Caribbean Basin: Papers and Proceedings.* Seminar on Promoting Investment and Exports in the Caribbean Basin (1988, Miami); George P. Montalván, ed. Washington, DC: General Secretariat, Organization of American States; 1989. 297 pp.

3177. *Puerto Rico en la economía política del Caribe.* Carmen Gautier Mayoral, Angel I. Rivera Ortiz, Idsa E. Alegría Ortega, eds. Río Piedras, P.R.: Ediciones Huracán; 1990. 204 pp.

3178. *Relaciones económicas de Colombia con los países del Caribe insular.* Juan José Echavarría S., Alfredo L. Fuentes H. Bogotá: Banco de la República; 1981. 224 pp. Reprint of the 1977 ed.

3179. *The Spanish Caribbean: Trade and Plunder, 1530–1630.* Kenneth R. Andrews. New Haven, CT: Yale University Press; 1978. 267 pp.

3180. *Struggle Against Dependence: Nontraditional Export Growth in Central America and the Caribbean.* Eva Paus, ed. Boulder, CO: Westview Press; 1988. 225 pp.

3181. *The Suitcase Traders in the Free Zone of Curaçao.* Monique Lagro, Donna Plotkin. Port of Spain: Economic Commission for Latin America and the Caribbean, United Nations; 1990. 83 pp.

3182. *Trade and Underdevelopment: A Study of the Small Caribbean Countries and Large Multinational Corporations.* Iserdeo Jainarain. Georgetown: Institute of Development Studies, University of Guyana; 1976. 390 pp.

3183. *Trade, Government, and Society in Caribbean History, 1700–1920: Essays Presented to Douglas Hall.* B. W. Higman, ed. Kingston: Heinemann Educational Books Caribbean; 1983. 172 pp.

3184. *De West-Indische Compagnie [The West-India Company].* W. R. Menkman. Amsterdam: Van Kampen; 1947. 186 pp.

3185. *Yankees and Creoles: The Trade Between North America and the West Indies Before the American Revolution.* Richard Pares. Hamden, CT: Archon Books; 1968. 168 pp. Reprint of the 1956 ed.

4. LABOR, EMPLOYMENT, AND TRADE UNIONS

3186. *"Alas, Alas, Kongo": A Social History of Indentured African Immigration into Jamaica, 1841–1865.* Monica Schuler. Baltimore, MD: Johns Hopkins University Press; 1980. 186 pp.

3187. *Arise Ye Starvelings: The Jamaican Labour Rebellion of 1938 and Its Aftermath.* Ken Post. Boston, MA: M. Nijhoff; 1978. 502 pp.

3188. *Aspects of Caribbean Labour Relations Law.* Roop Lal Chaudhary, R. M. Castagne. Bridgetown: Coles Printery; 1979. 187 pp.

3189. *The Availability and Utilization of Skills in Guyana.* Norma Abdulah. St. Augustine, Trinidad/Tobago: Institute of Social and Economic Research, University of the West Indies; 1981. 104 pp.

3190. *Braceros haitianos en la República Dominicana.* Franc Báez Evertsz. 2a ed. Santo Domingo: Instituto Dominicano de Investigaciones Sociales; 1986. 354 pp.

3191. *Cuba: el movimiento obrero y su retorno socio-político, 1865–1983.* Rodolfo Riesgo. Miami, FL: Saeta Ediciones; 1985. 251 pp.

3192. *Desafío y solidaridad: breve historia del movimiento obrero puertorriqueño.* Gervasio Luis García, Angel Guillermo Quintero Rivera. Río Piedras, P.R.: Ediciones Huracán; 1982. 172 pp.

3193. *Employment in Trinidad and Tobago.* Sidney E. Chernick [et al.]. Washington, DC: International Bank for Reconstruction and Development; 1973. 150 pp.

3194. *Environment and Labor in the Caribbean.* Joseph Lisowski, ed. New Brunswick, NJ: Transaction Books; 1992. 148 pp.

3195. *Factor Proportions, Technology Transmission, and Unemployment in Puerto Rico.* Elías R. Gutiérrez. Río Piedras, P.R.: University of Puerto Rico Press; 1977. 112 pp.

3196. *Historial obrero cubano, 1574–1965.* Mario Riera Hernández. Miami, FL: Rema Press; 1965. 303 pp.

3197. *A History of the Guyanese Working People, 1881–1905.* Walter Rodney. Baltimore, MD: Johns Hopkins University Press; 1981. 282 pp.

3198. *The History of the Working-Class in the Twentieth Century, 1919–1956: The Trinidad and Tobago Experience.* Bukka Rennie. Toronto: New Beginning Movement; 1973. 167 pp.

3199. *A History of Trade Unionism in Guyana, 1900 to 1961.* Ashton Chase. Ruimveldt, Guyana: New Guyana; 1966. 327 pp.

3200. *Human Resources in the Commonwealth Caribbean: Report.* Human Resources Seminar (1970, University of the West Indies); Jack Harewood, ed. St. Augustine, Trinidad/Tobago: Institute of Social and Economic Research, University of the West Indies; 1970. 1 vol. (unpaged).

3201. *The Impact of Brain Drain on Development: A Case-Study of Guyana.* Martin Jagdeo Boodhoo, Ahamad Baksh. Kuala Lampur, Malaysia: Percetakan Intisari; 1981. 235 pp.

3202. *In the Spirit of Butler: Trade Unionism in Free Grenada.* Rev. ed. St. George's, Grenada: Fedon; 1982. 104 pp.

3203. *Jamaica and Voluntary Laborers from Africa, 1840–1865.* Mary Elizabeth Thomas. Gainesville, FL: University Presses of Florida; 1974. 211 pp.

3204. *Jamaican Labor Migration: White Capital and Black Labor, 1850–1930.* Elizabeth McLean Petras. Boulder, CO: Westview Press; 1988. 297 pp.

3205. *The Labor Force, Employment, Unemployment, and Underemployment in Cuba, 1899–1970.* Carmelo Mesa-Lago. Beverly Hills, CA: Sage; 1972. 71 pp.

3206. *Labor Migration Under Capitalism: The Puerto Rican Experience.* Centro de Estudios Puertorriqueños (New York, NY). New York, NY: Monthly Review Press; 1979. 287 pp.

3207. *The Labor Sector and Socialist Distribution in Cuba.* Carmelo Mesa-Lago. New York, NY: Praeger; 1968. 250 pp.

3208. *Labour and Development in Rural Cuba.* Dharam P. Ghai, Cristóbal Kay, Peter Peek. New York, NY: St. Martin's Press; 1988. 141 pp.

3209. *Labour in the Caribbean: From Emancipation to Independence.* Malcolm Cross, Gad J. Heuman, eds. London: Macmillan Caribbean; 1988. 329 pp.

3210. *Labour in the West Indies: The Birth of a Workers' Movement.* William Arthur Lewis, Susan Craig. London: New Beacon Books; 1977. 104 pp. Reprint, with additions, of the 1939 ed.

3211. *Labour Relations and Industrial Conflict in Commonwealth Caribbean Countries.* Zin Henry. Port of Spain: Columbus Publishers; 1972. 283 pp.

3212. *Labour Relations in the Caribbean Region [Proceedings and Documents].* Caribbean Regional Seminar on Labour Relations (1973, Port of Spain). Geneva: International Labour Office; 1974. 205 pp.

3213. *Managing Socialism: From Old Cadres to New Professionals in Revolutionary Cuba.* Frank T. Fitzgerald. New York, NY: Praeger; 1990. 161 pp.

3214. *Migration and Development in the West Indies.* Edwin Pierce Reubens. Mona, Jamaica: Institute of Social and Economic Research, University College of the West Indies; 1961. 84 pp.

3215. *Mineworkers of Guyana: The Making of a Working Class.* Odida T. Quamina. Atlantic Highlands, NJ: Zed Books; 1987. 118 pp.

3216. *Movimiento obrero y lucha socialista en la República Dominicana: desde los orígenes hasta 1960.* Roberto Cassá. Santo Domingo: Fundación Cultural Dominicana; 1990. 620 pp.

3217. *The Organized Labor Movement in Puerto Rico.* Miles Galvin. Cranbury, NJ: Associated University Presses; 1979. 241 pp.

3218. *Panama Money in Barbados, 1900–1920.* Bonham C. Richardson. Knoxville, TN: University of Tennessee Press; 1985. 283 pp.

3219. *The Politics of the Dispossessed: Politics, Labour, and Social Legislation in the Commonwealth Caribbean.* Winston Murray. Port of Spain: Beacon; 1976. 139 pp.

3220. *Projected Imbalances Between Labor Supply and Labor Demand in the Caribbean Basin: Implications for Future Migration to the United States.* Thomas J. Espenshade. Washington, DC: Urban Institute; 1988. 73 pp.

3221. *Puerto Rico's Present and Prospective Technical, Skilled and Clerical Manpower and Training Needs.* Luz M. Torruelas. Hato Rey, P.R.: University of Puerto Rico; 1972. 387 pp.

3222. *Revolutionary Politics and the Cuban Working Class.* Maurice Zeitlin. New York, NY: Harper and Row; 1970. 307 pp. Reprint of the 1967 ed.

3223. *Rise and Organize: The Birth of the Workers and National Movements in Jamaica, 1936–1939.* Richard Hart. London: Karia Press; 1989. 157 pp.

3224. *Sembraron la no siembra: los cosecheros de tabaco puertorriqueños frente a las corporaciones tabacaleras, 1920–1934.* Juan José Baldrich. Río Piedras, P.R.: Ediciones Huracán; 1988. 194 pp.

3225. *The Struggle and the Conquest.* Novelle H. Richards. St. Johns, Antigua: N. H. Richards; 1964–1981. 2 vols. About Antigua.

3226. *Studies in Caribbean Labour Relations Law.* Roop Lal Chaudhary. 2d ed. Bridgetown: Cole Printery; 1984. 234 pp.

3227. *Tobacco on the Periphery: A Case Study in Cuban Labour History, 1860–1958.* Jean Stubbs. New York, NY: Cambridge University Press; 1985. 203 pp.

3228. *El trabajador cubano en el estado de obreros y campesinos.* Efrén Córdova. Miami, FL: Ediciones Universal; 1990. 219 pp.

3229. *Trabajadores urbanos: ensayos sobre fuerza laboral en República Dominicana.* Isis Duarte, André Corten, Francis Pou. Santo Domingo: Universidad Autónoma de Santo Domingo; 1986. 314 pp.

3230. *Trade Union Foreign Policy: A Study of British and American Trade Union Activities in Jamaica.* Jeffrey Harrod. Garden City, NY: Doubleday; 1972. 485 pp.

3231. *Trade Union Law in the Caribbean.* Ashton Chase. Georgetown: A. Chase; 1976. 250 pp.

3232. *Trade Unionism and Industrial Relations in the Commonwealth Caribbean: History, Contemporary Practice, and Prospect.* Lawrence A. Nurse. Westport, CT: Greenwood Press; 1992. 157 pp.

3233. *Trade Unions and Democracy.* Seminar on Trade Unions and Democracy (First, 1986, Kingston). Kingston: Bustamante Institute of Public and International Affairs; 1986. 52 pp.

3234. *Trends in Labour Legislation in the Caribbean.* J. Burns Bonadie, ed. Bridgetown: Caribbean Labour Economics Research Training Program; 1977. 585 pp.

3235. *Unemployment and Social Life: A Sociological Study of the Unemployed in Trinidad.* Farley Brathwaite. Bridgetown: Antilles Publications; 1983. 165 pp.

3236. *A Voice at the Workplace: Reflections on Colonialism and the Jamaican Worker.* Michael Manley. Washington, DC: Howard University Press; 1991. 253 pp. Reprint of the 1975 ed.

3237. *Wage Determination in English-Speaking Caribbean Countries: Proceedings and Documents.* Regional Seminar on Wage Determination for English-Speaking Caribbean Countries (1978, Kingston). Geneva: International Labour Office; 1979. 121 pp.

3238. *Wage-Policy Issues in an Underdeveloped Economy: Trinidad and Tobago.* Havelock Brewster. Mona, Jamaica: Institute of Social and Economic Research, University of the West Indies; 1969. 101 pp.

3239. *Wages, Productivity, and Industrialization in Puerto Rico.* Lloyd George Reynolds, Peter Gregory. Homewood, IL: R. D. Irwin; 1965. 357 pp.

3240. *Work and Family Life: West Indian Perspectives.* Lambros Comitas, David Lowenthal, eds. Garden City, NY: Anchor Books; 1973. 422 pp.

3241. *Worker in the Cane: A Puerto Rican Life History.* Sidney Wilfred Mintz. Westport, CT: Greenwood Press; 1974. 288 pp. Reprint of the 1960 ed.

3242. *Workers' Struggle in Puerto Rico: A Documentary History.* Angel Guillermo Quintero Rivera, ed.; Cedric Belfrage, tr. New York, NY: Monthly Review Press; 1976. 236 pp. Translation of *Lucha obrera en Puerto Rico.*

5. INDUSTRY, BUSINESS, AND MULTINATIONAL CORPORATIONS

3243. *Bermuda's Energy Future: Proceedings.* Conference on Bermuda's Energy Future (1981, Bermuda Biological Station); Wolfgang Sterrer, Jonathan Sands, Gary C. Barbour, eds. Ferry Reach, Bermuda: Bermuda Biological Station for Research; 1982. 210 pp.

3244. *Caribbean Cases in Small Business.* George H. Wadinambiaratchi. Mona, Jamaica: Institute of Social and Economic Research, University of the West Indies; 1981. 448 pp.

3245. *The Caribbean Region.* United Nations Industrial Development Organization. Vienna: UNIDO; 1987. 291 pp.

3246. *The Coffee Industry of Jamaica: Growth, Structure, and Performance.* Randolph Lambert Williams. Mona, Jamaica: Institute of Social and Economic Research, University of the West Indies; 1975. 82 pp.

3247. *Conflicts Between Multinational Corporations and Less Developed Countries: The Case of Bauxite Mining in the Caribbean, with Special Reference to Guyana.* Thakoor Persaud. New York, NY: Arno Press; 1980. 270 pp.

3248. *Empresarios en conflicto: políticas de industrialización y sustitución de importaciones en la República Dominicana.* Frank Moya Pons. Santo Domingo: Fondo para el Avance de las Ciencias Sociales; 1992. 433 pp.

3249. *Historia económica del comercio y la industria en Puerto Rico.* Gilberto R. Cabrera. Hato Rey, P.R.: Fundación Socio-Económica de Puerto Rico; 1982. 465 pp.

3250. *Industrial Development of Puerto Rico and the Virgin Islands of the United States: Report.* Thomas S. Hibben, Rafael Picó. Port of Spain: Caribbean Commission; 1948. 300 pp.

3251. *Industrial Development of Dominica.* Randolph Lambert Williams. Mona, Jamaica: Institute of Social and Economic Research, University of the West Indies; 1971. 100 pp.

3252. *Die industrieräumliche Entwicklung der Dominikanischen Republik: unter besonderer Berücksichtigung des informellen Sektors und der Möglichkeiten von angepassten Technologien.* Thorsten Sagawe. Munich: W. Fink; 1987. 280 pp.

3253. *Jamaica in the World Aluminum Industry, 1938–1973.* Carlton E. Davis. Kingston: Jamaica Bauxite Institute; 1989. 412 pp.

3254. *Multinational Corporations and Black Power.* Harry G. Matthews. Cambridge, MA: Schenkman; 1976. 124 pp. About Barbados, Trinidad, and Tobago.

3255. *The Nutmeg Industry of Grenada.* J. M. Mayers. Kingston: Institute of Social and Economic Research, University of the West Indies; 1974. 50 pp.

3256. *The Oil Industry and Nationalization: Who Benefits?* Paul Nehru Tennassee. Willemstad: Caribbean Institute of Social Formation; 1986. 52 pp. About Curaçao.

3257. *L'or de Guyane: son histoire, ses hommes.* Jean Petot. Paris: Editions caribéennes; 1986. 248 pp.

3258. *An Overview of Public Enterprise in the Commonwealth Caribbean.* University of Guyana, Institute of Development Studies [and] University of the West Indies, Institute of Social and Economic Research. Mona, Jamaica: Institute of Social and Economic Research, University of the West Indies; 1983. 216 pp.

3259. *Le sang de l'arbre: le roucou dans l'économie de la Guyane et des Antilles du XVIIe siècle à nos jours.* José M. Saint-Martin. Paris: Editions caribéennes; 1989. 255 pp.

3260. *Sharks and Sardines: Blacks in Business in Trinidad and Tobago.* Selwyn D. Ryan, Lou Anne Barclay. St. Augustine, Trinidad/Tobago: Institute of Social and Economic Research, University of the West Indies; 1992. 217 pp.

3261. *Tabaco y sociedad: la organización del poder en el ecomercado de tabaco dominicano.* Fernando I. Ferrán. Santo Domingo: Fondo para el Avance de las Ciencias Sociales, Centro de Investigación y Acción Social; 1976. 209 pp.

3262. *Transnational Corporations and Caribbean Inequalities.* David Kowalewski. New York, NY: Praeger; 1982. 235 pp.

6. MONETARY ISSUES, FINANCE, AND BANKING

3263. *Análisis de la economía dominicana.* Carlos Massad [et al.]. Santo Domingo: Banco Central de la República Dominicana; 1985. 73 pp.

3264. *Banking Growth in Puerto Rico.* Biagio Di Venuti. Baltimore, MD: Waverly Press; 1955. 161 pp. Updates his *Money and Banking in Puerto Rico* (1950).

3265. *The Banks of Canada in the Commonwealth Caribbean: Economic Nationalism and Multinational Enterprises of a Medium Power.* Daniel Jay Baum. New York, NY: Praeger; 1974. 158 pp.

3266. *Central Banking in a Developing Economy: A Study of Trinidad and Tobago, 1964–1989.* Terrence W. Farrell. Mona, Jamaica: Institute of Social and Economic Research, University of the West Indies; 1990. 150 pp.

3267. *Corporate Taxation in the Netherlands Antilles.* F. Damian Leo, Antonio A. Amador. Deventer: Kluwer; 1978. 95 pp.

3268. *Crédito, moneda y bancos en Puerto Rico durante el siglo XIX.* Annie Santiago de Curet. Río Piedras, P.R.: Editorial de la Universidad de Puerto Rico; 1989. 238 pp.

3269. *The Cuban Nationalizations: The Demise of Foreign Private Property.* Michael W. Gordon. Buffalo, NY: W. S. Hein; 1976. 239 pp.

3270. *The Debt Problem of Small Peripheral Economies: Case Studies from the Caribbean and Central America.* Norman Girvan [et al.]. Kingston: Association of Caribbean Economists; 1990. 71 pp.

3271. *Development Finance and the Development Process: A Case Study of Selected Caribbean Countries.* Kempe Ronald Hope. New York, NY: Greenwood Press; 1987. 100 pp.

3272. *The Economics of the Caribbean Basin.* Michael Bahaamonde Connolly, John McDermott, eds. New York, NY: Praeger; 1985. 355 pp.

3273. *The Evolution of Public Expenditure: The Case of a Structurally Dependent Economy, Guyana.* Maurice A. Odle. Kingston: Institute of Social and Economic Research, University of the West Indies; 1976. 271 pp.

3274. *Fiscal Survey of the French Caribbean.* Fuat M. Andic, Suphan Andic. Río Piedras, P.R.: Institute of Caribbean Studies, University of Puerto Rico; 1965. 108 pp.

3275. *Foreign Capital and Economic Underdevelopment in Jamaica.* Norman Girvan. Kingston: Institute of Social and Economic Research, University of the West Indies; 1971. 282 pp.

3276. *Government Finance and Planned Development: Fiscal Surveys of Surinam and the Netherlands Antilles.* Fuat M. Andic, Suphan Andic. Río Piedras, P.R.: Institute of Caribbean Studies, University of Puerto Rico; 1968. 395 pp.

3277. *Haiti: Public Expenditure Review.* World Bank. Washington, DC: The Bank; 1987. 254 pp.

3278. *The IMF Threat to Trinidad and Tobago and the Caribbean.* Kasala Kamara. Rev. ed. Belmont, Trinidad/Tobago: Pegasus Publishing; 1988. 107 pp.

3279. *Impacto de la deuda externa de las pequeñas economías de la Cuenca del Caribe.* Saúl Osorio Paz. Mexico City: Instituto de Investigaciones Económicas, Universidad Nacional Autónoma de México; 1987. 172 pp.

3280. *El impacto distributivo de la gestión fiscal en la República Dominicana.* Isidoro Santana, Magdalena Rathe. Santo Domingo: Fundación Siglo 21; 1992. 268 pp.

3281. *Inflation in the Caribbean.* Compton Bourne, ed. Mona, Jamaica: Institute of Social and Economic Research, University of the West Indes; 1977. 166 pp.

3282. *Investing in the Caribbean.* Caribbean Economic Development Corporation. San Juan: The Corporation; 1970. 3 vols.

3283. *Jamaica's Financial System: Its Historical Development.* Gail Lue Lim. Kingston: Bank of Jamaica; 1991. 54 pp.

3284. *Labour Banks in Latin America and the Caribbean.* Jürgen Lewerenz. Frankfurt am Main: Europäische Verlagsanstalt; 1979. 60 pp. Translation of *Die Arbeiterbanken in Lateinamerika und in der Karibik.*

3285. *Managing Financial Institutions in a Changing Environment: A Caribbean Perspective.* Stanley D. Reid, ed. Cave Hill, Barbados: Centre for Management Development, University of the West Indies; 1991. 111 pp.

3286. *The Monetary and Financial System of the Bahamas: Growth, Structure, and Operation.* Ramesh F. Ramsaran. Mona, Jamaica: Institute of Social and Economic Research, University of the West Indies; 1984. 409 pp.

3287. *Monetary Problems of an Export Economy: The Cuban Experience, 1914–1947.* Henry Christopher Wallich. New York, NY: Arno Press; 1979. 357 pp. Reprint of the 1950 ed.

3288. *Money and Finance in Trinidad and Tobago.* Compton Bourne, Ramesh F. Ramsaran. Mona, Jamaica: Institute of Social and Economic Research, University of the West Indies; 1988. 348 pp.

3289. *Monnaie et crédit en économie coloniale: contribution à l'histoire économique de la Guadeloupe, 1635–1919.* Alain Buffon. Basse-Terre: Sociéte d'histoire de la Guadeloupe; 1979. 388 pp.

3290. *The Other Side of Paradise: Foreign Control in the Caribbean.* Tom Barry, Beth Wood, Deb Preusch. New York, NY: Grove Press; 1984. 405 pp.

3291. *Pension Funds in Labour Surplus Economies: An Analysis of the Developmental Role of Pension Plans in the Caribbean.* Maurice A. Odle. Kingston: Institute of Social and Economic Research, University of the West Indies; 1974. 150 pp.

3292. *Public Finance and Fiscal Issues in Barbados and the O.E.C.S.* Neville C. Duncan, ed. Cave Hill, Barbados: Faculty of Social Sciences, University of the West Indies; 1989. 112 pp.

3293. *Public Finance and Monetary Policy in Open Economies: A Caribbean Perspective.* Simon B. Jones-Hendrickson. Mona, Jamaica: Institute of Social and Economic Research, University of the West Indies; 1985. 172 pp.

3294. *Public Finance in Small Open Economies: The Caribbean Experience.* Michael Howard. Westport, CT: Praeger; 1992. 187 pp.

3295. *Readings in Caribbean Public Sector Economics.* Fuat M. Andic, Simon B. Jones-Hendrickson, eds. Kingston: Institute of Social and Economic Research, University of the West Indies; 1981. 290 pp.

3296. *La Real Hacienda en Puerto Rico: administración, política y grupos de presión, 1815–1868.* Birgit Sonesson. Madrid: Instituto de Cooperación Iberoamericana; 1990. 418 pp.

3297. *The Role of the Financial Sector in the Economic Development of Puerto Rico.* Rita M. Maldonado. New York, NY: Federal Deposit Insurance Corp.; 1970. 152 pp.

3298. *The Significance of Non-Bank Financial Intermediaries in the Caribbean: An Analysis of Patterns of Financial Structure and Development.* Maurice A. Odle. Mona, Jamaica: Institute of Social and Economic Research, University of the West Indies; 1972. 212 pp.

3299. *El sistema tributario dominicano: propuesta de reforma.* Andrés Dauhajre. Santo Domingo: Fundación Economía y Desarrollo; 1989. 161 pp.

3300. *Southern Exposure: Canadian Promoters in Latin America and the Caribbean, 1896–1930.* Christopher Armstrong, H. V. Nelles. Buffalo, NY: University of Toronto Press; 1988. 375 pp.

3301. *The Structure, Performance, and Prospects of Central Banking in the Caribbean.* Clive Yolande Thomas. Mona, Jamaica: Institute of Social and Economic Research, University of the West Indies; 1972. 77 pp.

3302. *Studies in Foreign Investment in the Commonwealth Caribbean.* Alister McIntyre, Beverly Watson. Mona, Jamaica: Institute of Social and Economic Research, University of the West Indies; 1970– [vol. 1–].

3303. *Survey of Off-Shore Finance Sectors in the Caribbean Dependent Territories: Report.* Rodney Gallagher. London: Coopers and Lybrand; 1990. 155 pp.

3304. *Trustee of the Netherlands Antilles: A History of Money, Banking, and the Economy, with Special Reference to the Central Bank van de Nederlandse Antillen, 1828–6 February–1978.* Jaap van Soest. Zutphen: Walburg Pers; 1978. 422 pp.

3305. *U.S. Investment in Latin America and the Caribbean: Trends and Issues.* Ramesh F. Ramsaran. New York, NY: St. Martin's Press; 1985. 196 pp.

7. SPECIAL TOPIC: THE SUGAR COMPLEX

3306. *Las antillas: colonización, azúcar e imperialismo.* José A. Benítez. Havana: Casa de las Américas; 1977. 332 pp

3307. *Azúcar e inmigración, 1900–1940.* Rolando Alvarez Estévez. Havana: Editorial de Ciencias Sociales; 1988. 290 pp. About Cuba.

3308. *Azúcar y haitianos en la República Dominicana.* José Manuel Madruga. Santo Domingo: Ediciones MSC; 1986. 202 pp.

3309. *El batey: estudio socioeconómico de los bateyes del Consejo Estatal del Azúcar.* Frank Moya Pons [et al.]. Santo Domingo: Fondo para el Avance de las Ciencias Sociales; 1986. 636 pp.

3310. *Bitter Cuban Sugar: Monoculture and Economic Dependence from 1825 to 1899.* Félix Goizueta-Mimó. New York, NY: Garland; 1987. 287 pp. Reprint of the 1972 ed. published under title *Effects of Sugar Monoculture Upon Colonial Cuba.*

3311. *Bitter Sugar: Slaves Today in the Caribbean.* Maurice Lemoine; Andrea Johnston, tr. Chicago, IL: Banner Press; 1985. 308 pp. Translation of *Sucre amer;* reprint of the 1981 ed.

3312. *The British West Indies Sugar Industry in the Late Nineteenth Century.* R. W. Beachey. Westport, CT: Greenwood Press; 1978. 189 pp. Reprint of the 1957 ed.

3313. *Capitalism in Colonial Puerto Rico: Central San Vicente in the Late Nineteenth Century.* Teresita Martínez Vergne. Gainesville, FL: University Press of Florida; 1992. 189 pp.

3314. *Capitalism, Socialism, and Technology: A Comparative Study of Cuba and Jamaica.* Charles Edquist. Atlantic Highlands, NJ: Zed Books; 1985. 182 pp.

3315. *The Caribbean Sugar Industries: Constraints and Opportunities.* G. B. Hagelberg. New Haven, CT: Antilles Research Program, Yale University; 1974. 173 pp.

3316. *Class, Politics, and Sugar in Colonial Cuba.* Anton Allahar. Lewiston, NY: E. Mellen Press; 1990. 217 pp.

3317. *Cuando reinaba su majestad el azúcar: estudio histórico-sociológico de una tragedia latinoamericana.* Roland T. Ely. Buenos Aires: Editorial Sudamericana; 1963. 875 pp.

3318. *Cuba y la economía azucarera mundial.* Marcelo Fernández Font. Havana: Instituto Superior de Relaciones Internacionales "Raúl Roa García"; 1986. 213 pp.

3319. *Cuban Counterpoint: Tobacco and Sugar.* Fernando Ortiz; Harriet de Onís, tr. New York, NY: Vintage Books; 1970. 312 pp. Translation of *Contrapunteo cubano del tabaco y el azúcar;* reprint of the 1947 ed.

3320. *Cuban Sugar Policy from 1963 to 1970.* Heinrich Brunner; Marguerite Borchardt, H. F. Broch de Rothermann, trs. Pittsburgh, PA: University of Pittsburgh Press; 1977. 163 pp.

3321. *The Economics of Cuban Sugar.* Jorge F. Pérez-López. Pittsburgh, PA: University of Pittsburgh Press; 1991. 313 pp.

3322. *Guyanese Sugar Plantations in the Late Nineteenth Century: A Contemporary Description from the "Argosy."* Walter Rodney, ed. Georgetown: Release Publishers; 1979. 97 pp.

3323. *Histoire de l'industrie sucrière en Guadeloupe aux XIXe et XXe siècles.* Christian Schnakenbourg. Paris: L'Harmattan; 1980– [vol. 1–].

3324. *La industria azucarera de Cuba: su importancia nacional, su organización, sus mercados, su situación actual.* Ramiro Guerra. Havana: Cultural; 1940. 304 pp.

3325. *Jamaica and the Sugar Worker Cooperatives: The Politics of Reform.* Carl Henry Feuer. Boulder, CO: Westview Press; 1984. 220 pp.

3326. *Labour Displacement in a Labour-Surplus Economy: The Sugar Industry of British Guiana.* Edwin Pierce Reubens, Beatrice G. Reubens. Mona, Jamaica: Institute of Social and Economic Research, University of the West Indies; 1962. 105 pp.

3327. *Noncapitalist Development: The Struggle to Nationalize the Guyanese Sugar Industry.* Paulette Pierce. Totowa, NJ: Rowman and Allanheld; 1984. 200 pp.

3328. *Our Cuban Colony: A Study in Sugar.* Leland Hamilton Jenks. St. Clair Shores, MI: Scholarly Press; 1972. 341 pp. Reprint of the 1928 ed.

3329. *Plantations, Peasants, and State: A Study of the Mode of Sugar Production in Guyana.* Clive Yolande Thomas. Los Angeles, CA: Center for Afro-American Studies, University of California; 1984. 214 pp.

3330. *The Politics of the Caribbean Basin Sugar Trade.* Scott B. MacDonald, Georges A. Fauriol, eds. New York, NY: Praeger; 1991. 164 pp.

3331. *Sugar and Jamaica.* Ian Sangster. London: Nelson; 1973. 60 pp.

3332. *Sugar and Modern Slavery: A Tale of Two Countries.* Roger Plant. Atlantic Highlands, NJ: Zed Books; 1987. 177 pp. About the Dominican Republic and Haiti.

3333. *Sugar and Slavery in Puerto Rico: The Plantation Economy of Ponce, 1800–1850.* Francisco Antonio Scarano. Madison, WI: University of Wisconsin Press; 1984. 242 pp.

3334. *Sugar and Society in the Caribbean: An Economic History of Cuban Agriculture.* Ramiro Guerra; Marjory M. Urquidi, tr. New Haven, CT: Yale University Press; 1964. 218 pp. Translation of *Azúcar y población en las Antillas.*

3335. *Sugar and the Cuban Economy: An Assessment.* Jorge F. Pérez-López. Coral Gables, FL: Research Institute for Cuban Studies, University of Miami; 1987. 112 pp.

3336. *The Sugar Economy of Puerto Rico.* Arthur David Gayer, Paul Thomas Homan, Earle K. James. New York, NY: Columbia University Press; 1938. 326 pp.

3337. *The Sugar Industry of the Caribbean.* Gustave Burmeister, ed. Washington, DC: Committee on Agriculture, Nutrition, Fisheries and Forestry, Caribbean Research Council; 1947. 343 pp.

3338. *The Sugarmill: The Socioeconomic Complex of Sugar in Cuba, 1760–1860*. Manuel Moreno Fraginals; Cedric Belfrage, tr. New York, NY: Monthly Review Press; 1976. 182 pp. Translation of *El ingenio*.

3339. *A West-India Fortune*. Richard Pares. Hamden, CT: Archon Books; 1968. 374 pp. Reprint of the 1950 ed.; about the Pinney family of Nevis.

E. History

1. GENERAL WORKS

3340. *Abaco: The History of an Out Island and Its Cays*. Steve Dodge. Decatur, IL: White Sound Press; 1987. 172 pp. Reprint of the 1983 ed.

3341. *America's Virgin Islands: A History of Human Rights and Wrongs*. William W. Boyer. Durham, NC: Carolina Academic Press; 1983. 418 pp.

3342. *The American Mediterranean*. Stephen Bonsal. New York, NY: Moffat, Yard; 1912. 488 pp.

3343. *Les Antilles décolonisées*. Daniel Guérin. Paris: Présence africaine; 1986. 188 pp. Reprint of the 1956 ed.

3344. *Les Antilles*. Eugène Revert. Paris: A. Colin; 1954. 220 pp.

3345. *Antilliaans verhaal: geschiedenis van Aruba, Bonaire, Curaçao, Saba, St. Eustatius en St. Maarten [Antillean Story: History of Aruba, Bonaire, Curaçao, Saba, St. Eustatius and St. Maarten]*. Luis H. Daal, Ted Schouten. Zutphen: Walburg Pers; 1988. 160 pp.

3346. *Avonturen aan de Wilde Kust: de geschiedenis van Suriname met zijn buurlanden [Adventures on the Wild Coast: The History of Surinam with Its Neighbors]*. Albert Helman. Alphen a/d Rijn: A. W. Sijthoff; 1982. 208 pp.

3347. *Background to Revolution: The Development of Modern Cuba*. Robert Freeman Smith, ed. Huntington, NY: R. E. Krieger; 1979. 244 pp. Reprint of the 1966 ed.

3348. *The Bahamas Between Worlds*. Dean Walter Collinwood. Decatur, IL: White Sound Press; 1989. 119 pp.

3349. *The Bahamas in Slavery and Freedom*. Howard Johnson. Kingston: Randle; 1991. 184 pp.

3350. *Barbados: A History from the Amerindians to Independence*. F. A. Hoyos. London: Macmillan; 1978. 293 pp.

3351. *Belize: A New Nation in Central America*. O. Nigel Bolland. Boulder, CO: Westview Press; 1986. 157 pp.

3352. *Bermuda*. John J. Jackson. Newton Abbot: David and Charles; 1988. 208 pp.

3353. *Bermuda.* Roger Bruns, Haldon K. Richardson. Edgemont, PA: Chelsea House; 1986. 96 pp.

3354. *Bermuda: Today and Yesterday, 1503–1980s.* Terry Tucker. 3d ed. London: R. Hale; 1983. 223 pp.

3355. *Biografía del Caribe.* Germán Arciniegas. [Nueva ed.]. San José, C.R.: Libro Libre; 1986. 501 pp.

3356. *Black Democracy: The Story of Haiti.* Harold Palmer Davis. New York, NY: Biblio and Tannen; 1967. 360 pp. Reprint of the 1936 (rev.) ed.

3357. *Black Haiti: A Biography of Africa's Eldest Daughter.* Blair Niles. New York, NY: Putnam's; 1926. 325 pp.

3358. *The Book of Trinidad.* Gérard A. Besson, Bridget Brereton. Port of Spain: Paria; 1991. 421 pp.

3359. *A Brief History of the Caribbean: From the Arawak and the Carib to the Present.* Jan Rogozínski. New York, NY: Facts on File; 1992. 324 pp.

3360. *Britain and the West Indies.* Agnes Mary Whitson, Lucy Frances Horsfall. New York, NY: Longmans, Green; 1948. 87 pp.

3361. *British Guiana.* Raymond Thomas Smith. Westport, CT: Greenwood Press; 1980. 218 pp. Reprint of the 1962 ed.

3362. *British Historians and the West Indies.* Eric Eustace Williams. New York, NY: Africana; 1972. 238 pp. Reprint of the 1964 ed.

3363. *British Honduras Past and Present.* Stephen Langrish Caiger. London: Allen and Unwin; 1951. 240 pp.

3364. *British Honduras.* Algar Robert Gregg. London: HMSO; 1968. 158 pp.

3365. *British Honduras: A Historical and Contemporary Survey.* David Alan Gilmour Waddell. Westport, CT: Greenwood Press; 1981. 151 pp. Reprint of the 1961 ed.

3366. *The British in the Caribbean.* Cyril Hamshere. Cambridge, MA: Harvard University Press; 1972. 240 pp.

3367. *The British West Indies.* William Laurence Burn. Westport, CT: Greenwood Press; 1975. 196 pp. Reprint of the 1951 ed.

3368. *The British West Indies: Their History, Resources and Progress.* Algernon Edward Aspinall. London: Pitman; 1912. 434 pp.

3369. *Caraïbes en construction: espace, colonisation, résistance.* Oruno D. Lara. Epinay-sur-Seine: Centre de recherches Caraïbes-Amériques (CERCAM); 1992. 2 vols.

3370. *The Caribbean Area.* Seminar Conference on Hispanic American Affairs (1933, George Washington University); Alva Curtis Wilgus, ed. Washington, DC: George Washington University; 1934. 604 pp.

3371. *The Caribbean Experience: An Historical Survey, 1450–1960.* Douglas Hall. Kingston: Heinemann Educational Books Caribbean; 1982. 146 pp.

3372. *Caribbean History in Maps*. Peter Ashdown. London: Longman Caribbean; 1979. 84 pp.

3373. *Caribbean Story*. William Claypole, John Robottom. 2d ed. London: Longman Caribbean; 1989. 2 vols.

3374. *Caribbean Visions: Ten Presidential Addresses of Ten Presidents of the Caribbean Studies Association*. Simon B. Jones-Hendrickson, ed. Frederiksted, V.I.: Eastern Caribbean Institute; 1990. 257 pp.

3375. *The Caribbean*. Selden Rodman. New York, NY: Hawthorn Books; 1968. 320 pp.

3376. *The Caribbean: British, Dutch, French, United States*. Conference on the Caribbean (Eighth, 1957, University of Florida); Alva Curtis Wilgus, ed. Gainesville, FL: University of Florida Press; 1958. 331 pp.

3377. *Caribbean: Sea of the New World*. Germán Arciniegas; Harriet de Onís, tr. New York, NY: Knopf; 1946. 464 pp. Translation of *Mar del nuevo mundo*.

3378. *The Caribbean: The Central American Area*. Conference on the Caribbean (Eleventh, 1960, University of Florida); Alva Curtis Wilgus, ed. Gainesville, FL: University of Florida Press; 1961. 383 pp.

3379. *Caribbeana: Being Miscellaneous Papers Relating to the History, Genealogy, Topography, and Antiquities of the British West Indies*. Vere Langford Oliver, ed. London: Mitchell, Hughes and Clarke; 1909–1919. 6 vols.

3380. *El Caribe*. Antonio Lot Helgueras, Manuel Lucena Salmoral. Madrid: Sociedad Estatal para la Ejecución de Programas del Quinto Centenario; 1989. 127 pp.

3381. *Colonialism and Resistance in Belize: Essays in Historical Sociology*. O. Nigel Bolland. Benque Viejo del Carmen, Belize: Cubola Productions; 1988. 218 pp.

3382. *A Concise History of the British Virgin Islands*. Vernon W. Pickering. New York, NY: Falcon; 1987. 159 pp.

3383. *A Continent of Islands: Searching for the Caribbean Destiny*. Mark Kurlansky. Reading, MA: Addison-Wesley; 1992. 324 pp.

3384. *Crónicas de Puerto Rico: desde la conquista hasta nuestros días, 1493–1955*. Eugenio Fernández Méndez, ed. Río Piedras, P.R.: Editorial de la Universidad de Puerto Rico; 1981. 694 pp. Reprint of the 1969 (2d) ed.

3385. *Cuba Old and New*. Albert Gardner Robinson. Westport, CT: Negro Universities Press; 1970. 264 pp. Reprint of the 1915 ed.

3386. *The Cuba Reader: The Making of a Revolutionary Society*. Philip Brenner [et al.], eds. New York, NY: Grove Press; 1989. 564 pp.

3387. *Cuba y su destino histórico: reflexiones sobre su historia y destino*. Ernesto Ardura. Miami, FL: Ediciones Universal; 1989. 291 pp.

3388. *Cuba, Haiti, and the Dominican Republic.* John Edwin Fagg. Englewood Cliffs, NJ: Prentice-Hall; 1965. 181 pp.

3389. *Cuba.* Herbert Lionel Matthews. New York, NY: Macmillan; 1964. 134 pp.

3390. *Cuba: Between Reform and Revolution.* Louis A. Pérez. New York, NY: Oxford University Press; 1988. 504 pp.

3391. *Cuba: From Columbus to Castro.* Jaime Suchlicki. 3d ed., rev. Washington, DC: Brassey's (U.S.); 1990. 246 pp.

3392. *Cuba: Prophetic Island.* Waldo David Frank. New York, NY: Marzani and Munsell; 1961. 191 pp.

3393. *Cuba: The Pursuit of Freedom.* Hugh Thomas. New York, NY: Harper and Row; 1971. 1,696 pp.

3394. *Curaçao: Short History.* Johannes Hartog; Virginia Gideon Oenes, tr. 4th, enl., ed. Oranjestad: De Wit; 1979. 79 pp.

3395. *De Cristóbal Colón a Fidel Castro: el Caribe, frontera imperial.* Juan Bosch. Santo Domingo: Editora Alfa y Omega; 1988. 740 pp. Reprint of the 1970 ed.

3396. *Democracy and Empire in the Caribbean: A Contemporary Review.* Paul Blanshard. New York, NY: Macmillan; 1947. 379 pp.

3397. *The Diplomatic History of British Honduras, 1638–1901.* Robert Arthur Humphreys. Westport, CT: Greenwood Press; 1981. 196 pp. Reprint of the 1961 ed.

3398. *Documentos para la historia de la República Dominicana.* Emilio Rodríguez Demorizi, ed. Santo Domingo: Editora del Caribe; 1981– [vol. 4–]. Vols. 1–3 published by the Archivo General de la Nación in 1944, 1947, and 1959.

3399. *Documentos para la historia de Cuba.* Hortensia Pichardo, ed. 4a ed. rev. Havana: Editorial de Ciencias Sociales; 1980– [vols. 1–4+].

3400. *Documents of West Indian History.* Eric Eustace Williams, ed. Port of Spain: PNM Publishing Co.; 1963– [vol. 1–].

3401. *Dominica.* Basil E. Cracknell. Harrisburg, PA: Stackpole Books; 1973. 198 pp.

3402. *A Dominican Chronicle: History of Hispaniola/Dominican Republic.* Carleton Alexander Rood. 2d ed. Santo Domingo: Editora Corripio; 1986. 210 pp.

3403. *The Dominican Republic.* Ian Bell. Boulder, CO: Westview Press; 1981. 392 pp.

3404. *The Dominican Republic: Nation in Transition.* Howard John Wiarda. New York, NY: Praeger; 1969. 249 pp.

3405. *The Dominican Republic: A Caribbean Crucible*. Howard John Wiarda, Michael J. Kryzanek. 2d ed. Boulder, CO: Westview Press; 1992. 167 pp.

3406. *Dutch Authors on West Indian History: A Historiographical Selection*. Marie Antoinette Petronella Meilink-Roelofsz, ed.; Maria J. L. van Yperen, tr. Boston, MA: M. Nijhoff; 1982. 384 pp.

3407. *A Family of Islands: A History of the West Indies from 1492 to 1898, with an Epilogue Sketching Events from the Spanish-American War to the 1960's*. Alec Waugh. Garden City, NY: Doubleday; 1964. 348 pp.

3408. *Formerly British Honduras: A Profile of the New Nation of Belize*. William David Setzekorn. Rev. ed. Athens, OH: Ohio University Press; 1981. 299 pp.

3409. *The French in the West Indies*. Walter Adolphe Roberts. New York, NY: Cooper Square Publishers; 1971. 335 pp. Reprint of the 1942 ed.

3410. *From Columbus to Castro: The History of the Caribbean, 1492–1969*. Eric Eustace Williams. New York, NY: Vintage Books; 1984. 576 pp. Reprint of the 1970 ed.

3411. *From Dessalines to Duvalier: Race, Colour and National Independence in Haiti*. David Nicholls. London: Macmillan Caribbean; 1988. 357 pp. Reprint of the 1979 ed.

3412. *The Golden Antilles*. Timothy Severin. New York, NY: Knopf; 1970. 336 pp.

3413. *Grenada: Island of Conflict—From Amerindians to People's Revolution, 1498–1979*. George I. Brizan. Atlantic Highlands, NJ: Zed Books; 1984. 381 pp.

3414. *La Guadeloupe dans l'histoire*. Oruno Lara. Nouv. éd. Paris: L'Harmattan; 1979. 340 pp. First ed. has title *La Guadeloupe, physique, économique, agricole, commerciale, financière, politique et sociale de la découverte à nos jours*.

3415. *La Guadeloupe*. Henri Bangou. Paris: L'Harmattan; 1987. 3 vols.

3416. *Guiana: British, Dutch, and French*. James Rodway. London: Unwin; 1921. 318 pp. Reprint of the 1912 ed.

3417. *Guyana: A Composite Monograph*. Brian Irving, ed. Hato Rey, P.R.: Inter American University Press; 1972. 87 pp.

3418. *La Guyane française: son histoire, 1604–1946*. Arthur Henry. Nouv. éd. Cayenne: Mayouri; 1981. 265 pp.

3419. *Haiti and the Dominican Republic*. Rayford Whittingham Logan. New York, NY: Oxford University Press; 1968. 220 pp.

3420. *Haiti—Today and Tomorrow: An Interdisciplinary Study*. Charles Robert Foster, Albert Valdman, eds. Lanham, MD: University Press of America; 1984. 389 pp.

3421. *Haiti: Her History and Her Detractors.* Jacques Nicolas Léger. Westport, CT: Negro Universities Press; 1970. 372 pp. Originally published in French under title *Haïti: son histoire et ses détracteurs;* reprint of the 1907 ed.

3422. *Haiti: Political Failures, Cultural Successes.* Brian Weinstein, Aaron Segal. New York, NY: Praeger; 1984. 175 pp.

3423. *Haiti: The Black Republic—The Complete Story and Guide.* Selden Rodman. 6th rev. ed. Old Greenwich, CT: Devin-Adair; 1984. 217 pp.

3424. *The Haitian Potential: Research and Resources of Haiti.* Conference on Research and Resources of Haiti (1967, New York); Vera D. Rubin, Richard P. Schaedel, eds. New York, NY: Teachers College Press; 1975. 284 pp.

3425. *A Handbook History of Anguilla.* Colville L. Petty. Anguilla: Anguilla Printers; 1991. 68 pp.

3426. *Histoire des Antilles et de la Guyane.* Lucien-René Abénon [et al.]; Pierre Pluchon, ed. Toulouse: Privat; 1982. 480 pp.

3427. *Historia cultural de Puerto Rico, 1493–1968.* Eugenio Fernández Méndez. Río Piedras, P.R.: Editorial Universitaria, Universidad de Puerto Rico; 1980. 369 pp. Reprint of the 1975 (4th) ed.

3428. *Historia de Cuba.* Fernando Portuondo. Havana: Editorial Minerva; 1965. 602 pp. First ed. has title *Curso de historia de Cuba;* reprint of the 1957 (6th) ed.

3429. *Historia de Cuba: desde Colón hasta Castro.* Carlos Márquez Sterling. New York, NY: Las Américas; 1963. 496 pp.

3430. *Historia de Cuba: la lucha de un pueblo por cumplir su destino histórico y su vocación de libertad.* Calixto Masó Vázquez. 2a ed. Miami, FL: Ediciones Universal; 1976. 587 pp.

3431. *Historia de la nación puertorriqueña.* Juan Angel Silén. 2a ed., rev. y anotada. Río Piedras, P.R.: Editora Edil; 1980. 547 pp.

3432. *Historia de Puerto Rico.* Ricardo E. Alegría [et al.]; Lucas Morán Arce, ed. 2a ed., rev. y aum. San Juan: Librotex; 1986. 411 pp.

3433. *Historia de Puerto Rico: trayectoria de un pueblo.* Blanca G. Silvestrini, María Dolores Luque de Sánchez. San Juan: Ediciones Cultural Panamericana; 1991. 605 pp. Reprint of the 1987 ed.

3435. *Historia de Santo Domingo.* Jacinto Gimbernard. 7a ed., rev. Madrid: M. Fernández; 1978. 398 pp.

3436. *Historia general de Puerto Rico.* Fernando Picó. 3a ed., rev. y aum. Río Piedras, P.R.: Ediciones Huracán; 1986. 300 pp.

3437. *Historia ilustrada de un pueblo: la evolución puertorriqueña.* Eugenio Fernández Méndez. [Ed. corregida]. Sharon, CT: Troutman Press; 1991. 546 pp.

3438. *Historia, economía y sociedad en los pueblos de habla inglesa del Caribe.* Mario G. del Cueto. Havana: Editorial de Ciencias Sociales; 1982. 106 pp.

3439. *The Historical Geography of St. Kitts and Nevis, the West Indies.* Gordon Clark Merrill. Mexico City: Instituto Panamericano de Geografía e Historia; 1958. 145 pp.

3440. *Historiografía de Cuba.* José Manuel Pérez Cabrera. Mexico City: Instituto Panamericano de Geografía e Historia; 1962. 394 pp.

3441. *Historiographie d'Haïti.* Catts Pressoir, Ernst Trouillot, Hénock Trouillot. Mexico City: Instituto Panamericano de Geografía e Historia; 1953. 298 pp.

3442. *History of Alliouagana: A Short History of Montserrat.* Howard A. Fergus. Rev. ed. Plymouth: Montserrat Printery; 1985. 64 pp.

3443. *A History of Barbados.* Ronald Tree; E. L. Cozier, ed. London: Grafton Books; 1986. 116 pp. Reprint of the 1977 (2d) ed.

3444. *A History of Barbados: From Amerindian Settlement to Nation-State.* Hilary Beckles. New York, NY: Cambridge University Press; 1990. 224 pp.

3445. *A History of Belize.* Narda Dobson. Port of Spain: Longman Caribbean; 1973. 362 pp.

3446. *A History of British Honduras.* William Arlington Donohoe. New York, NY: Colorite Offset Publishing; 1946. 118 pp.

3448. *The History of Jamaica.* Clinton Vane de Brosse Black. Harlow [Eng.]: Longman; 1988. 176 pp. Reprint of the 1983 (rev.) ed.

3449. *A History of Modern Trinidad, 1783–1962.* Bridget Brereton. Exeter, NH: Heinemann; 1981. 262 pp.

3450. *A History of the Bahamas.* Michael Craton. 3d ed. Waterloo, Ont.: San Salvador Press; 1986. 332 pp.

3451. *History of the British West Indies.* Alan Cuthbert Burns. 2d rev. ed. New York, NY: Barnes and Noble; 1965. 849 pp.

3452. *A History of the British Virgin Islands, 1672 to 1970.* Isaac Dookhan. Epping, Eng.: Caribbean Universities Press; 1975. 255 pp.

3453. *A History of the Cayman Islands.* Neville Williams. Grand Cayman: Government of the Cayman Islands; 1970. 94 pp.

3454. *A History of the Cuban Nation.* Ramiro Guerra [et al.], eds.; James J. O'-Mailia, tr. Havana: Editorial Historia de la Nación Cubana; 1958– [vols. 1–6+]. Translation of *Historia de la nación cubana.*

3455. *History of the Netherlands Antilles.* Johannes Hartog. Oranjestad: De Wit; 1961– [vol. 1–]. Translation of *Geschiedenis van de Nederlandse Antillen.*

3456. *History of the People of Trinidad and Tobago.* Eric Eustace Williams. London: Deutsch; 1982. 292 pp. Reprint of the 1962 ed.

3457. *A History of the Turks and Caicos Islands.* Hosay Smith, ed. Hamilton, Bermuda: H. Smith; 1968. 77 pp.

3458. *A History of the Virgin Islands of the United States.* Isaac Dookhan. Epping, Eng.: Caribbean Universities Press; 1974. 321 pp.

3459. *The History of the West Indian Islands of Trinidad and Tobago, 1498–1900.* Gertrude Carmichael. London: A. Redman; 1961. 463 pp.

3460. *Islanders in the Stream: A History of the Bahamian People.* Michael Craton, Gail Saunders. Athens, GA: University of Georgia Press; 1992– [vol. 1–].

3461. *Jamaica: A Historical Portrait.* Samuel Justin Hurwitz, Edith F. Hurwitz. New York, NY: Praeger; 1971. 273 pp.

3462. *Jamaica: The Blessed Island.* Sydney Haldane Olivier. New York, NY: Russell and Russell; 1971. 466 pp. Reprint of the 1936 ed.

3463. *The Loss of El Dorado: A History.* V. S. Naipaul. New York, NY: Vintage Books; 1984. 394 pp. Reprint of the 1969 ed.

3464. *The Making of the West Indies.* Fitzroy Richard Augier [et al.]. London: Longman Caribbean; 1976. 310 pp. Reprint of the 1960 ed.

3465. *Manual de historia de Cuba.* Ramiro Guerra. Havana: Editorial de Ciencias Sociales; 1980. 720 pp. Reprint of the 1962 (2d) ed.

3466. *Manual de historia dominicana.* Frank Moya Pons. 9a ed. Santo Domingo: Caribbean Publishers; 1992. 723 pp.

3467. *La Martinique: carrefour du monde caraïbe.* Auguste Joyau. Fort-de-France: Editions des Horizons caraïbes; 1977. 172 pp. Reprint of the 1967 ed.

3468. *The Modern Caribbean.* Franklin W. Knight, Colin A. Palmer, eds. Chapel Hill, NC: University of North Carolina Press; 1989. 382 pp.

3469. *My Paradise Is Hell: The Story of the Caribbean.* Albert Balink. New York, NY: Vista; 1948. 331 pp.

3470. *La nación haitiana.* Dantès Bellegarde; Lissette Vega de Purcell, tr. Santo Domingo: Sociedad Dominicana de Bibliófilos; 1984. 429 pp. Translation of *La nation haïtienne.*

3471. *De Nederlanders in het Caraïbische Zeegebied: waarin vervat de geschiedenis der Nederlandse Antillen [The Dutch in the Caribbean: Including the History of the Netherlands Antilles].* W. R. Menkman. Amsterdam: Van Kampen; 1942. 291 pp.

3472. *De Nederlanders op de West-Indische Eilanden [The Dutch on the West Indian Islands].* J. H. J. Hamelberg. Amsterdam: Emmering; 1979. 3 vols. in 1. Reprint of the 1901–1903 ed.

3473. *Notes on the History of the Cayman Islands.* George S. S. Hirst. Grand Cayman: Caribbean Colour; 1967. 5 vols. in 3. Reprint of the 1910 ed.

3474. *Outlines of St. Lucia's History.* Charles Jesse. 4th ed. Castries: St. Lucia Archaeological and Historical Society; 1986. 99 pp.

3475. *Perspectives on Caribbean Regional Identity.* Elizabeth M. Thomas-Hope, ed. Liverpool, Eng.: Centre for Latin American Studies, University of Liverpool; 1984. 134 pp.

3476. *Politics, Society, and Culture in the Caribbean: Selected Papers.* Conference of Caribbean Historians (Fourteenth, 1982); Blanca G. Silvestrini, ed. San Juan: University of Puerto Rico; 1983. 273 pp.

3477. *Porto Rico and Its Problems.* Victor Selden Clark [et al.]. New York, NY: Arno Press; 1975. 707 pp. Reprint of the 1930 ed.

3478. *Porto Rico, Past and Present.* José Enamorado-Cuesta. New York, NY: Arno Press; 1975. 170 pp. Reprint of the 1929 ed.

3479. *Portrait of Puerto Rico.* Louise Cripps Samoiloff. New York, NY: Cornwall Books; 1984. 215 pp.

3480. *The Prodigious Caribbean: Columbus to Roosevelt.* Rosita Torr Forbes. London: Cassell; 1940. 314 pp.

3481. *Profile Trinidad: A Historical Survey from the Discovery to 1900.* Michael Anthony. London: Macmillan Caribbean; 1975. 198 pp.

3482. *Prospects for Latin America and the Caribbean to the Year 2000: Proceedings.* Consultative Symposium on Canadian Relations with Latin America (1989, Carleton University); Archibald R. M. Ritter, ed. Ottawa: Canadian Association for Latin American and Caribbean Studies; 1990. 453 pp.

3483. *The Puerto Ricans, 1493–1973: A Chronology and Fact Book.* Francesco Cordasco, Eugene Bucchioni. Dobbs Ferry, NY: Oceana Publications; 1973. 137 pp.

3484. *The Puerto Ricans: A Documentary History.* Kal Wagenheim, Olga Jiménez de Wagenheim, eds. Maplewood, NJ: Waterfront Press; 1988. 332 pp. Reprint of the 1973 ed.

3485. *The Puerto Ricans: Their History, Culture, and Society.* Adalberto López, ed. Cambridge, MA: Schenkman; 1980. 490 pp.

3486. *Puerto Rico: A Political and Cultural History.* María Teresa Babín [et al.]; Arturo Morales Carrión, ed. New York, NY: W. W. Norton; 1983. 384 pp.

3487. *Puerto Rico: A Profile.* Kal Wagenheim. 2d ed. New York, NY: Praeger; 1975. 294 pp.

3488. *Puerto Rico: A Socio-Historic Interpretation.* Manuel Maldonado-Denis; Elena Vialo, tr. New York, NY: Random House; 1972. 336 pp. Translation of *Puerto Rico, una interpretación histórico-social.*

3489. *Puerto Rico: tierra adentro y mar afuera—historia y cultura de los puertorriqueños.* Fernando Picó, Carmen Rivera Izcoa. Río Piedras, P.R.: Ediciones Huracán; 1991. 304 pp.

3490. *Quisqueya: A History of the Dominican Republic.* Selden Rodman. Seattle, WA: University of Washington Press; 1964. 202 pp.

3491. *Readings in Belizean History.* John Maher, ed. Belize City: Belize Institute for Social Research and Action (BISRA); 1978– [vol. 1–].

3492. *Readings in Caribbean History and Economics: An Introduction to the Region.* Roberta Marx Delson, ed. New York, NY: Gordon and Breach; 1981. 336 pp.

3493. *Resistance and Rebellion in Suriname: Old and New.* Gary Brana-Shute, ed. Williamsburg, VA: Dept. of Anthropology, College of William and Mary; 1990. 310 pp.

3494. *Sainte-Lucie: fille de la Martinique.* Eugène Bruneau-Latouche, Raymond Bruneau-Latouche. Paris: Impr. Pierron; 1989. 332 pp.

3495. *Santo Domingo frente al destino.* Luis Julián Pérez. 2a ed. Santo Domingo: Fundación Universitaria Dominicana; 1990. 293 pp.

3496. *Santo Domingo: A Country with a Future.* Otto Schoenrich. New York, NY: Macmillan; 1918. 418 pp.

3497. *The Serpent and the Rainbow.* Wade Davis. New York, NY: Simon and Schuster; 1985. 297 pp. About Haiti.

3498. *A Short History of Puerto Rico.* Morton J. Golding. New York, NY: New American Library; 1973. 174 pp.

3499. *A Short History of the British West Indies.* Herbert Victor Wiseman. London: University of London Press; 1950. 159 pp.

3500. *A Short History of the Guyanese People.* Vere T. Daly. London: Macmillan; 1975. 326 pp. Reprint of the 1966 ed.

3501. *A Short History of the Netherlands Antilles and Surinam.* Cornelis Christiaan Goslinga. Boston, MA: M. Nijhoff; 1979. 198 pp.

3502. *A Short History of the West Indies.* John Horace Parry, Philip Manderson Sherlock, Anthony P. Maingot. 4th ed. New York, NY: St. Martin's Press; 1987. 333 pp.

3503. *Sources of West Indian History.* Fitzroy Richard Augier, Shirley C. Gordon, eds. London: Longman Caribbean; 1973. 308 pp. Reprint of the 1962 ed.

3504. *The Spanish Caribbean: From Columbus to Castro.* Louise Cripps Samoiloff. Boston, MA: G. K. Hall; 1979. 251 pp.

3505. *St. Croix Under Seven Flags: Being a "Cruzan" Cavalcade of the Island of St. Croix in the Virgens.* Florence Lewisohn. Hollywood, FL: Dukane Press; 1970. 432 pp.

3506. *St. Eustatius: A Short History of the Island and Its Monuments.* Ypie Attema. Zutphen: Walburg Pers; 1976. 87 pp.

170 Bibliography



3507. *The Story of Bermuda and Her People.* William S. Zuill. 2d rev. ed. London: Macmillan Caribbean; 1987. 240 pp.

3508. *The Story of the Bahamas.* Paul Albury. London: Macmillan Caribbean; 1990. 294 pp. Reprint of the 1975 ed.

3509. *The Story of Tobago: Robinson Crusoe's Island in the Caribbean.* Carlton Robert Ottley. [New ed.] Port of Spain: Longman Caribbean; 1973. 114 pp. First ed. has title *Tobago, Robinson Crusoe's Island in the West Indies.*

3510. *A Study on the Historiography of the British West Indies to the End of the Nineteenth Century.* Elsa V. Goveia. Washington, DC: Howard University Press; 1980. 181 pp. Reprint of the 1956 ed.

3511. *Suriname.* J. Moerland. Amsterdam: Koninklijk Instituut voor de Tropen; 1984. 80 pp.

3512. *Tobago, "Melancholy Isle."* Douglas Archibald. Port of Spain: Westindiana; 1987– [vol. 1–].

3513. *Tobago.* David L. Niddrie. Gainesville, FL: Litho Press; 1980. 243 pp.

3514. *Trailing the Conquistadores.* Samuel Guy Inman. New York, NY: Friendship Press; 1930. 236 pp.

3515. *The U.S. Virgins and the Eastern Caribbean.* Darwin D. Creque. Philadelphia, PA: Whitmore; 1968. 266 pp.

3516. *Under an English Heaven.* Donald E. Westlake. New York, NY: Simon and Schuster; 1972. 278 pp. About Anguilla.

3517. *The Virgin Islands of the United States of America: Historical and Descriptive, Commercial and Industrial Facts, Figures and Resources.* Luther Kimbell Zabriskie. Stonington, ME: Mainspring Press; 1985. 339 pp. Reprint of the 1918 ed.

3518. *Virgin Islands Story.* Jens Peter Mouritz Larsen. Philadelphia, PA: Fortress Press; 1950. 256 pp.

3519. *The Virgin Islands: A Caribbean Lilliput.* Gordon K. Lewis. Evanston, IL: Northwestern University Press; 1972. 382 pp.

3520. *The Virgin Islands: Our New Possessions and the British Islands.* Theodoor Hendrik Nikolaas de Booy, John Thomson Faris. Westport, CT: Negro Universities Press; 1970. 292 pp. Reprint of the 1918 ed.

3521. *The Virgins: A Descriptive and Historical Profile.* Pearl Varlack, Norwell Harrigan. Charlotte Amalie, V.I.: Caribbean Research Institute, College of the Virgin Islands; 1977. 72 pp.

3522. *Visión general de la historia dominicana.* Valentina Peguero, Danilo de los Santos. Santiago, D.R.: Universidad Católica Madre y Maestra; 1988. 462 pp. Reprint of the 1981 (4th) ed.

3523. *The West Indian Heritage: A History of the West Indies.* Jack Brierley Watson. London: J. Murray; 1979. 210 pp.

3524. *West Indian Nations: A New History.* Philip Manderson Sherlock. New York, NY: St. Martin's Press; 1973. 362 pp.

3525. *The West Indian Scene.* George Etzel Pearcy. Princeton, NJ: Van Nostrand; 1965. 136 pp.

3526. *West Indian Tales of Old.* Algernon Edward Aspinall. Westport, CT: Negro Universities Press; 1969. 259 pp. Reprint of the 1915 ed.

3527. *The West Indies and the Guianas.* David Alan Gilmour Waddell. Englewood Cliffs, NJ: Prentice-Hall; 1967. 149 pp.

3528. *Whither Bound, St. Kitts-Nevis?* Probyn Inniss. St. Johns, Antigua: Antigua Printing and Publishing; 1983. 99 pp.

3529. *Written in Blood: The Story of the Haitian People, 1492–1971.* Robert Debs Heinl, Nancy Gordon Heinl. Boston, MA: Houghton Mifflin; 1978. 785 pp.

2. PREHISTORY AND ANTIQUITIES

3530. *Los aborígenes de las Antillas.* Felipe Pichardo Moya. Mexico City: Fondo de Cultura Económica; 1956. 140 pp.

3531. *Aboriginal and Spanish Colonial Trinidad: A Study in Culture Contact.* Linda A. Newson. New York, NY: Academic Press; 1976. 344 pp.

3532. *Aboriginal Indian Pottery of the Dominican Republic.* Herbert William Krieger. Washington, DC: GPO; 1931. 165 pp.

3533. *Ancient Guyana.* Denis Williams. Georgetown: Dept. of Culture; 1985. 94 pp.

3534. *Apuntes en torno a la mitología de los indios taínos de las Antillas Mayores y sus orígenes suramericanos.* Ricardo E. Alegría. Santo Domingo: Centro de Estudios Avanzados de Puerto Rico y el Caribe; 1986. 178 pp. Reprint of the 1978 ed.

3535. *Archaeological Investigations in British Guiana.* Clifford Evans, Betty Jane Meggers. Washington, DC: GPO; 1960. 418 pp.

3536. *The Archaeology of Grenada, West Indies.* Ripley P. Bullen. Gainesville, FL: University of Florida; 1964. 67 pp.

3537. *Archéologie antillaise: Arawaks et Caraïbes.* Maurice Barbotin. Pointe-à-Pitre: Parc naturel de Guadeloupe; 1987. 119 pp.

3538. *Arqueología de Cuba: métodos y sistemas.* José M. Guarch Delmonte. Havana: Editorial de Ciencias Sociales; 1987. 103 pp.

3539. *Art and Mythology of the Taino Indians of the Greater West Indies.* Eugenio Fernández Méndez. San Juan: Ediciones CEMI; 1972. 95 pp.

3540. *Artifacts of the Spanish Colonies of Florida and the Caribbean, 1500–1800.* Kathleen Deagan. Washington, DC: Smithsonian Institution Press; 1987– [vol. 1–].

3541. *Ball Courts and Ceremonial Plazas in the West Indies.* Ricardo E. Alegría. New Haven, CT: Dept. of Anthropology, Yale University; 1983. 185 pp.

3542. *The Caribbean as Columbus Saw It.* Samuel Eliot Morison, Mauricio Obregón. Boston, MA: Little, Brown; 1964. 252 pp.

3543. *Los caribes: realidad o fábula; ensayo de rectificación histórica.* Jalil Sued Badillo. Río Piedras, P.R.: Editorial Antillana; 1978. 187 pp.

3544. *Cave of the Jagua: The Mythological World of the Taínos.* Antonio M. Stevens Arroyo. Albuquerque, NM: University of New Mexico Press; 1988. 282 pp.

3545. *Central American and West Indian Archeology: Being an Introduction to the Archaeology of the States of Nicaragua, Costa Rica, Panama, and the West Indies.* Thomas Athol Joyce. Freeport, NY: Books for Libraries Press; 1971. 270 pp. Reprint of the 1916 ed.

3546. *Civilisations précolombiennes de la Caraïbe: actes du colloque du Marin, août 1989.* André Lucrèce, ed. Paris: L'Harmattan; 1991. 286 pp.

3547. *Columbus and the Golden World of the Island Arawaks: The Story of the First Americans and Their Caribbean Environment.* Donald James Riddell Walker. Kingston: I. Randle; 1992. 320 pp.

3548. *Cuba Before Columbus.* Mark Raymond Harrington. New York, NY: AMS Press; 1979. 2 vols. Reprint of the 1921 ed.

3549. *La cultura taína.* Seminario sobre la Situación de la Investigación de la Cultura Taína (First, 1983, Madrid); [organizado por la] Comisión Nacional del Quinto Centenario del Descubrimiento de América (Spain). Madrid: Turner; 1989. 182 pp.

3550. *Culturas indígenas de Puerto Rico.* Labor Gómez Acevedo, Manuel Ballesteros Gaibrois. Río Piedras, P.R.: Editorial Cultural; 1978. 229 pp. Reprint of the 1975 ed.

3551. *Descubrimiento, conquista y colonización de América: mito y realidad; conferencia internacional de reflexión crítica sobre el pasado, el presente y el futuro de los pueblos aborígenes y afroamericanos.* Centro para la Investigación y Acción Social en el Caribe. Santo Domingo: CIASCA; 1992. 294 pp.

3552. *Early Ceramic Population Lifeways and Adaptive Strategies in the Caribbean.* Peter E. Siegel, ed. Oxford: B.A.R.; 1989. 418 pp.

3553. *Estudio de las hachas antillanas: creación de índices axiales para las petaloides.* René Herrera Fritot. Havana: Depto. de Antropología, Comisión Nacional de la Academia de Ciencias; 1964. 146 pp.

3554. *From Spaniard to Creole: The Archaeology of Cultural Formation at Puerto Real, Haiti.* Charles Robin Ewen. Tuscaloosa, AL: University of Alabama Press; 1991. 155 pp.

3555. *Hispaniola: Caribbean Chiefdoms in the Age of Columbus.* Samuel M. Wilson. Tuscaloosa, AL: University of Alabama Press; 1990. 170 pp.

3556. *Los indios caribes: estudio sobre el origen del mito de la antropofagia.* Julio C. Salas. Madrid: Editorial América; 1920. 235 pp.

3557. *Los inicios de la colonización en América: la arqueología como historia.* José G. Guerrero, Marcio Veloz Maggiolo. San Pedro de Macorís, D.R.: Universidad Central del Este; 1988. 117 pp.

3558. *La Isabela y la arqueología en la ruta de Colón.* Elpidio Ortega. San Pedro de Macorís, D.R.: Universidad Central del Este; 1988. 100 pp.

3559. *Lubaantun: A Classic Maya Realm.* Norman Hammond. Cambridge, MA: Peabody Musuem of Archaeology and Ethnology, Harvard University; 1975. 428 pp.

3560. *The Maya Indians of Southern Yucatán and Northern British Honduras.* Thomas William Francis Gann. Washington, DC: GPO; 1918. 146 pp.

3561. *Maya Settlement in Northwestern Belize: The 1988 and 1990 Seasons of the Río Bravo Archaeological Project.* Thomas H. Guderjan, ed. San Antonio, TX: Maya Research Program; 1991. 119 pp.

3562. *Mitología y artes prehispánicas de las Antillas.* José Juan Arrom. 2a ed., corr. y ampliada. Mexico City: Siglo XXI Editores; 1989. 125 pp.

3563. *On the Trail of the Arawaks.* Fred Olsen. Norman, OK: University of Oklahoma Press; 1974. 408 pp.

3564. *Origins of the Tainan Culture, West Indies.* Sven Lovén. New York: AMS Press; 1979. 696 pp. Originally published under title *Über die Wurzeln der tainischen Kultur;* reprint of the 1935 (2d rev.) ed.

3565. *The People Who Discovered Columbus: The Prehistory of the Bahamas.* William F. Keegan. Gainesville, FL: University Press of Florida; 1992. 279 pp.

3566. *Les Petites Antilles avant Christophe Colomb: vie quotidienne des Indiens de la Guadeloupe.* Christian Montbrun. Paris: Karthala; 1984. 172 pp.

3567. *Prehistoria de Cuba.* Ernesto E. Tabío, Estrella Rey. Havana: Editorial de Ciencias Sociales; 1985. 234 pp. Reprint of the 1979 (2d) ed.

3568. *Prehistoria de Puerto Rico.* Cayetano Coll y Toste. San Juan: [s.n.]; 1979. 261 pp. Reprint of the 1967 (2d) ed.

3569. *Prehistoric Maya Settlements in the Belize Valley.* Gordon Randolph Willey [et al.]. Cambridge, MA: Peabody Museum, Harvard University; 1965. 589 pp.

3570. *Prehistory in Haiti.* Irving Rouse. New Haven, CT: Human Relations Area Files Press; 1964. 202 pp. Reprint of the 1939 ed.

3571. *Pulltrouser Swamp: Ancient Maya Habitat, Agriculture, and Settlement in Northern Belize.* Billie Lee Turner, Peter D. Harrison, eds. Austin, TX: University of Texas Press; 1983. 310 pp.

3572. *Relación acerca de las antigüedades de los indios.* Ramón Pané; José Juan Arrom, ed. Havana: Editorial de Ciencias Sociales; 1990. 148 pp. Reprint, with additions, of the 1988 ed.

3573. *South American and Caribbean Petroglyphs.* C. N. Dubelaar. Leiden: Caraïbische Afdeling, Koninklijk Instituut voor Taal-, Land- en Volkenkunde; 1986. 249 pp.

3574. *Los taínos de La Española.* Roberto Cassá. 3a ed. Santo Domingo: Editora Búho; 1990. 229 pp.

3575. *The Tainos: Rise and Decline of the People Who Greeted Columbus.* Irving Rouse. New Haven, CT: Yale University Press; 1992. 211 pp.

3576. *Tribus y clases en el Caribe antiguo.* Francisco Moscoso. San Pedro de Macorís, D.R.: Universidad Central del Este; 1986. 518 pp.

3577. *Vers une préhistoire des Petites Antilles.* Louis Allaire. St.-Jacques, Que.: Centre de recherches caraïbes; 1973. 51 pp.

3578. *Wild Majesty: Encounters with Caribs from Columbus to the Present Day; An Anthology.* Peter Hulme, Neil L. Whitehead, eds. New York, NY: Oxford University Press; 1992. 369 pp.

3. 16TH–19TH CENTURIES

3579. *Admirals of the Caribbean.* Francis Russell Hart. Freeport, NY: Books for Libraries Press; 1971. 203 pp. Reprint of the 1922 ed.

3580. *The Adventurers of Bermuda: A History of the Island from Its Discovery Until the Dissolution of the Somers Island Company in 1684.* Henry Campbell Wilkinson. 2d ed. New York, NY: Oxford University Press; 1958. 421 pp. Continued by his *Bermuda in the Old Empire* [#3589].

3581. *Las Antillas y la independencia de la América española, 1808–1826.* María Rosario Sevilla Soler. Seville: Escuela de Estudios Hispano-Americanos; 1986. 183 pp.

3582. *Les Antilles britaniques: de l'époque coloniale aux indépendances.* Jean-Paul Barbiche. Paris: L'Harmattan; 1989. 303 pp.

3583. *Antilles, Guyanes, la mer des Caraïbes: de 1492 à 1789.* Michel Devèze. Paris: SEDES; 1977. 382 pp.

3584. *Bahamian Loyalists and Their Slaves.* Gail Saunders. London: Macmillan Caribbean; 1983. 81 pp.

3585. *Barbados Records.* Joanne Mcree Sanders, ed. Houston, TX: Sanders Historical Publications; 1979–[1984]. 3 vols. in 6. Vol. 1. *Wills and administration* [1639–1725] (3 pts.); vol. 2. *Marriages* [1643–1800] (2 pts.); vol. 3. *Baptisms* [1637–1800]. Compiled from copies of parochial registers in the Barbados Dept. of Archives.

3586. *The Beginning of British Honduras, 1506–1765.* E. O. Winzerling. New York, NY: North River Press; 1946. 90 pp.

3587. *Belice, 1663(?)–1821: historia de los establecimientos británicos del Río Valis hasta la independencia de Hispano-América.* José Antonio Calderón Quijano. Seville: Escuela de Estudios Hispano-Americanos; 1944. 503 pp.

3588. *Bermuda from Sail to Steam: The History of the Island from 1784 to 1901.* Henry Campbell Wilkinson. New York, NY: Oxford University Press; 1973. 2 vols. Continues his *Bermuda in the Old Empire* [#3589].

3589. *Bermuda in the Old Empire: A History of the Island from the Dissolution of the Somers Island Company Until the End of the American Revolutionary War, 1684–1784.* Henry Campbell Wilkinson. New York, NY: Oxford University Press; 1950. 457 pp. Continues his *The Adventurers of Bermuda* [#3580]; continued by his *Bermuda from Sail to Steam* [#3588].

3590. *Bolívar y las Antillas hispanas.* Emeterio Santiago Santovenia y Echaide. Madrid: Espasa-Calpe; 1935. 276 pp.

3591. *The Boni Maroon Wars in Suriname.* Wim S. M. Hoogbergen. New York, NY: Brill; 1990. 254 pp.

3592. *A Brief History of Trinidad Under the Spanish Crown.* Alfred Claud Hollis. Port of Spain: A. L. Rhodes; 1941. 108 pp.

3593. *British Honduras: Colonial Dead End, 1859–1900.* Wayne M. Clegern. Baton Rouge, LA: Louisiana State University Press; 1967. 214 pp.

3594. *The Buccaneers in the West Indies in the Seventeenth Century.* Clarence Henry Haring. Hamden, CT: Archon Books; 1966. 298 pp. Reprint of the 1910 ed.

3595. *Cannibal Encounters: Europeans and Island Caribs, 1492–1763.* Philip P. Boucher. Baltimore, MD: Johns Hopkins University Press; 1992. 217 pp.

3596. *Les Caraïbes au temps des flibustiers, XVIe–XVIIe siècles.* Paul Butel. Paris: Aubier Montaigne; 1982. 299 pp.

3597. *Caribbean Pirates.* Warren Alleyne. London: Macmillan Caribbean; 1986. 113 pp.

3598. *The Caribbean: The Story of Our Sea of Destiny.* Walter Adolphe Roberts. New York, NY: Negro Universities Press; 1969. 361 pp. Reprint of the 1940 ed.

3599. *The Caribbee Islands Under the Proprietary Patents.* James Alexander Williamson. London: Oxford University Press; 1926. 234 pp.

3600. *Christopher Columbus: The Voyage of Discovery, 1492.* Samuel Eliot Morison. Greenwich, CT: Brompton Books; 1991. 128 pp.

3601. *Colonial Encounters: Europe and the Native Caribbean, 1492–1797.* Peter Hulme. New York, NY: Routledge; 1992. 348 pp. Reprint of the 1986 ed.

3602. *Colonialism and Science: Saint Domingue in the Old Regime.* James Edward McClellan. Baltimore, MD: Johns Hopkins University Press; 1992. 393 pp.

3603. *Colonialism and Underdevelopment in Guyana, 1580–1803.* Alvin O. Thompson. Bridgetown: Carib Research and Publications; 1987. 299 pp.

3604. *Colonising Expeditions to the West Indies and Guiana, 1623–1667.* Vincent Todd Harlow, ed. Millwood, NY: Kraus Reprint; 1967. 262 pp. Reprint of the 1925 ed.

3605. *La colonización danesa en las Islas Vírgenes: estudio histórico-jurídico.* Manuel Gutiérrez de Arce. Seville: Escuela de Estudios Hispano-Americanos; 1945. 151 pp.

3606. *La colonización de Puerto Rico: desde el decubrimiento de la isla hasta la reversión a la corona española de los privilegios de Colón.* Salvador Brau. San Juan: Instituto de Cultura Puertorriqueña; 1981. 639 pp. Reprint of the 1966 (3d) ed.

3607. *The Columbus Dynasty in the Caribbean, 1492–1526.* Troy S. Floyd. Albuquerque, NM: University of New Mexico Press; 1973. 294 pp.

3608. *Conquest of Eden, 1493–1515: Other Voyages of Columbus—Guadeloupe, Puerto Rico, Hispaniola, Virgin Islands.* Michael Paiewonsky. Rome: MAPes MONDe Editore; 1990. 176 pp.

3609. *Crónicas francesas de los indios caribes.* Manuel Cárdenas Ruiz, ed. and tr. Río Piedras, P.R.: Editorial de la Universidad de Puerto Rico; 1981. 624 pp.

3610. *Crossroads of the Buccaneers.* Hendrik De Leeuw. New York, NY: Arco; 1957. 404 pp. Reprint of the 1937 ed.

3611. *Cuba Between Empires, 1878–1902.* Louis A. Pérez. Pittsburgh, PA: University of Pittsburgh Press; 1983. 490 pp.

3612. *Cuba y su evolución colonial.* Francisco Figueras. Havana: Isla; 1959. 441 pp. Reprint of the 1907 ed.

3613. *Cuba, 1753–1815: Crown, Military, and Society.* Allan J. Kuethe. Knoxville, TN: University of Tennessee Press; 1986. 213 pp.

3614. *Curazao hispánico: antagonismo flamenco-español*. Carlos Felice Cardot. Caracas: Ediciones de la Presidencia de la República; 1982. 552 pp. Reprint of the 1973 ed.

3615. *The Development of the Leeward Islands Under the Restoration, 1660–1688: A Study of the Foundations of the Old Colonial System*. Charles Strachan Sanders Higham. New York, NY: Cambridge University Press; 1921. 266 pp.

3616. *Discovery, Conquest, and Colonization of Puerto Rico, 1493–1599*. Ricardo E. Alegría. San Juan: [s.n.]; 1971. 165 pp. Spanish ed. has title *Descubrimiento, conquista y colonización de Puerto Rico*.

3617. *Distinction, Death, and Disgrace: Governorship of the Leeward Islands in the Early Eighteenth Century*. William Laws. Kingston: Jamaica Historical Society; 1976. 100 pp.

3618. *Documentos para la historia colonial de Cuba: siglos XVI, XVII, XVIII, XIX*. César García del Pino, Alicia Melis Cappa, eds. Havana: Editorial de Ciencias Sociales; 1988. 348 pp.

3619. *Documents d'histoire antillaise et guyanaise, 1814–1914*. Jacques Adélaïde-Merlande, ed. Noyon [France]: Finet; 1979. 323 pp.

3620. *Los domínicos y las encomiendas de indios de la Isla Española*. Emilio Rodríguez Demorizi. Santo Domingo: Editora del Caribe; 1971. 399 pp.

3621. *Doña Licha's Island: Modern Colonialism in Puerto Rico*. Alfredo López. Boston, MA: South End Press; 1987. 178 pp.

3622. *The Dutch in the Caribbean and on the Wild Coast, 1580–1680*. Cornelis Christiaan Goslinga. Gainesville, FL: University of Florida Press; 1971. 647 pp.

3623. *The Dutch in the Caribbean and in the Guianas, 1680–1791*. Cornelis Christiaan Goslinga; Maria J. L. van Yperen, ed. Assen: Van Gorcum; 1985. 712 pp.

3624. *The Dutch in the Caribbean and in Surinam, 1791/5–1942*. Cornelis Christiaan Goslinga. Assen: Van Gorcum; 1990. 812 pp.

3625. *Earliest Hispanic/Native American Interactions in the Caribbean*. William F. Keegan, ed. New York, NY: Garland; 1991. 383 pp.

3626. *The Early History of Cuba, 1492–1586*. Irene Aloha Wright. New York, NY: Octagon Books; 1970. 390 pp. Reprint of the 1916 ed.

3627. *Early History of the British Virgin Islands: From Columbus to Emancipation*. Vernon W. Pickering. [S.l.]: Falcon Publications International; 1983. 248 pp.

3628. *The Early Settlers of the Bahamas and Colonists of North America*. Arnold Talbot Bethell. Baltimore, MD: Genealogical Publishing Co.; 1992. 218 pp. Reprint of the 1937 (3d) ed.

3629. *The Early Spanish Main.* Carl Ortwin Sauer. Berkeley, CA: University of California Press; 1992. 306 pp. Reprint of the 1966 ed.

3630. *Les engagés pour les Antilles, 1634–1715.* Gabriel Debien. Paris: Société de l'histoire des colonies françaises; 1952. 277 pp.

3631. *English Colonies in Guiana and on the Amazon, 1604–1668.* James Alexander Williamson. Oxford: Clarendon Press; 1923. 191 pp.

3632. *English Privateering Voyages to the West Indies, 1588–1595: Documents Relating to English Voyages to the West Indies from the Defeat of the Armada to the Last Voyage of Sir Francis Drake.* Kenneth R. Andrews, ed. Millwood, NY: Kraus Reprint; 1986. 421 pp. Reprint of the 1959 ed.

3633. *Un eslabón perdido en la historia: piratería en el Caribe, siglos XVI y XVII.* Martha de Jármy Chapa. Mexico City: Centro Coordinador y Difusor de Estudios Latinoamericanos, Universidad Nacional Autónoma de México; 1983. 291 pp.

3634. *Esprit colon et esprit d'autonomie à Saint-Domingue au VIIIe siècle.* Gabriel Debien. 2e éd. Paris: Larose; 1954. 55 pp.

3635. *Estudio histórico de la Guyana Británica: del descubrimiento a la formación del movimiento independentista, 1499–1949.* Rita Giacalone de Romero. Mérida, Venezuela: Corpoandes; 1982. 156 pp.

3636. *Etre patriotique sous les tropiques: la Guadeloupe, la colonisation et la Révolution, 1789–1794.* Anne Pérotin-Dumon. Basse-Terre: Société d'histoire de la Guadeloupe; 1985. 339 pp.

3637. *Etudes antillaises, XVIIIe siècle.* Gabriel Debien. Paris: A. Colin; 1956. 186 pp.

3638. *The European Nations in the West Indies, 1493–1688.* Arthur Percival Newton. New York, NY: Barnes and Noble; 1967. 356 pp. Reprint of the 1933 ed.

3639. *Filibusters and Buccaneers.* Alfred Sternbeck; Elizabeth Hill, Doris Mudie, trs. Freeport, NY: Books for Libraries Press; 1972. 272 pp. Translation of *Flibustier und Bukaniere;* reprint of the 1930 ed.

3640. *First Encounters: Spanish Explorations in the Caribbean and the United States, 1492–1570.* Jerald T. Milanich, Susan Milbrath, eds. Gainesville, FL: University of Florida Press; 1989. 222 pp.

3641. *French Pioneers in the West Indies, 1624–1664.* Nellis Maynard Crouse. New York, NY: Octagon Books; 1977. 294 pp. Reprint of the 1940 ed.

3642. *The French Revolution in San Domingo.* Lothrop Stoddard. Westport, CT: Negro Universities Press; 1970. 410 pp. Reprint of the 1914 ed.

3643. *The French Struggle for the West Indies, 1665–1713.* Nellis Maynard Crouse. New York, NY: Octagon Books; 1966. 324 pp. Reprint of the 1943 ed.

3644. *The Funnel of Gold.* Mendel Peterson. Boston, MA: Little, Brown; 1975. 481 pp. About pirates.

3645. *Geschiedenis van de Bovenwindsche Eilanden in de 18de eeuw [History of the Windward Islands in the Eighteenth Century].* Laurentius Knappert. Amsterdam: Emmering; 1979. 308 pp. Reprint of the 1932 ed.

3646. *The Great Days of Piracy in the West Indies.* George Woodbury. New York, NY: Norton; 1951. 232 pp.

3647. *La Guadeloupe de 1671 à 1759: étude politique, économique et sociale.* Lucien-René Abénon. Paris: L'Harmattan; 1987. 2 vols.

3648. *The Haitian Revolution, 1789–1804.* Thomas O. Ott. Knoxville, TN: University of Tennessee Press; 1973. 232 pp.

3649. *Histoire politique, économique et sociale de la Martinique sous l'Ancien Régime, 1635–1789.* Cabuzel Andréa Banbuck. Fort-de-France: Société de distribution et de culture; 1972. 335 pp. Reprint of the 1935 ed.

3650. *Historia colonial de Santo Domingo.* Frank Moya Pons. 2a ed. Santiago, D.R.: Universidad Católica Madre y Maestra; 1976. 488 pp.

3651. *Historia de Puerto Rico, 1537–1700.* Salvador Perea. San Juan: Instituto de Cultura Puertorriqueña; 1972. 242 pp.

3652. *Historia de Puerto Rico, 1600–1650.* Enriqueta Vila Vilar. Seville: Escuela de Estudios Hispano-Americanos; 1974. 279 pp.

3653. *Historia de Puerto Rico, 1650–1700.* Angel López Cantos. Seville: Escuela de Estudios Hispano-Americanos; 1975. 426 pp.

3654. *Historia de Puerto Rico, siglo XIX.* Lidio Cruz Monclova. Río Piedras, P.R.: Editorial Universitaria, Universidad de Puerto Rico; 1979. 3 vols. in 6. Reprint of the 1952–1962 ed.

3655. *A History of Barbados, 1625–1685.* Vincent Todd Harlow. New York, NY: Negro Universities Press; 1969. 347 pp. Reprint of the 1926 ed.

3656. *The History of Puerto Rico.* Rudolph Adams Van Middeldyk. New York, NY: Arno Press; 1975. 318 pp. Reprint of the 1903 ed.

3657. *History of Puerto Rico from the Beginning to 1892.* Loida Figueroa. New York, NY: L. A. Publishers; 1978. 474 pp. Translation of vols. 1 and 2 of *Breve historia de Puerto Rico.*

3658. *A History of the Island of Grenada, 1498–1796: With Some Notes and Comments on Carriacou and Events of Later Years.* Raymund P. Devas. 2d ed. St. George's, Grenada: Carenage Press; 1974. 261 pp.

3660. *History of the Puerto Rican Independence Movement.* Harold J. Lidin. Hato Rey, P.R.: [s.n.]; 1981– [vol. 1–].

3661. *In the Wake of Columbus: Islands and Controversy.* Louis De Vorsey, John Parker, eds. New ed. Detroit, MI: Wayne University Press; 1985. 231 pp.

3662. *La independencia de Cuba.* Luis Navarro García. Madrid: Editorial MAPFRE; 1992. 413 pp.

3663. *Jamaica española.* Francisco Morales Padrón. Seville: Escuela de Estudios Hispano-Americanos; 1952. 497 pp.

3664. *Jamaica Under the Spaniards: Abstracted from the Archives of Seville.* Frank Cundall, Joseph Luckert Pietersz. Kingston: Institute of Jamaica; 1919. 115 pp.

3665. *Jamaican Blood and Victorian Conscience: The Governor Eyre Controversy.* Bernard Semmel. Westport, CT: Greenwood Press; 1976. 188 pp. Reprint of the 1962 ed. published under title *The Governor Eyre Controversy.*

3666. *Jews in the Caribbean: Evidence on the History of the Jews in the Caribbean Zone in Colonial Times.* Zvi Loker. Jerusalem: Misgav Yerushalayim; 1991. 411 pp.

3667. *Lawless Liberators: Political Banditry and Cuban Independence.* Rosalie Schwartz. Durham, NC: Duke University Press; 1989. 297 pp.

3668. *The Legacy of the American Revolution to the British West Indies and Bahamas: A Chapter Out of the History of the American Loyalists.* Wilbur Henry Siebert. Boston, MA: Gregg Press; 1972. 50 pp. Reprint of the 1913 ed.

3669. *Liberty: The Story of Cuba.* Horatio Seymour Rubens. New York, NY: Arno Press; 1970. 447 pp. Reprint of the 1932 ed.

3670. *Lords of the Tiger Spirit: A History of the Caribs in Colonial Venezuela and Guyana, 1498–1820.* Neil L. Whitehead. Leiden: Caraïbische Afdeling, Koninklijk Instituut voor Taal-, Land- en Volkenkunde; 1988. 250 pp.

3671. *The Making of Haiti: The Saint Domingue Revolution from Below.* Carolyn E. Fick. Knoxville, TN: University of Tennessee Press; 1990. 355 pp.

3672. *The Maroons of Jamaica, 1655–1796: A History of Resistance, Collaboration and Betrayal.* Mavis Christine Campbell. Granby, MA: Bergin and Garvey; 1988. 296 pp.

3673. *1898: la guerra después de la guerra.* Fernando Picó. Río Piedras, P.R.: Ediciones Huracán; 1987. 215 pp. About Puerto Rico.

3674. *My Odyssey: Experiences of a Young Refugee from Two Revolutions.* A Creole of Saint Domingue; Althea de Puech Parham, ed. and tr. Baton Rouge, LA: Louisiana State University Press; 1959. 204 pp.

3675. *Nederlandsche zeevaarders op de eilanden in de Caraïbische Zee en aan de kust van Columbia en Venezuela gedurende de jaren 1621–1648(9): documenten hoofdzakelijk uit het Archivo General de Indias te Sevilla [Dutch Seafarers to the Islands in the Caribbean Sea and to the Coast of Colombia and Venezuela During the Years 1621–1648(9): Documents*

Mainly from the Archivo General de Indias in Seville]. Irene Aloha Wright, ed. Utrecht: Kemink; 1934–1935. 2 vols.

3676. *No Peace Beyond the Line: The English in the Caribbean, 1624–1690.* Carl Bridenbaugh, Roberta Bridenbaugh. New York, NY: Oxford University Press; 1972. 440 pp.

3677. *Panorámica colonial de la isla Hispaniola: siglos XV–XVI.* Lorenzo Rodríguez. Santo Domingo: Taller; 1989. 492 pp.

3678. *Pérdida de la isla de Trinidad.* Josefina Pérez Aparicio. Seville: Escuela de Estudios Hispano-Americanos; 1966. 229 pp.

3679. *Pirates and Privateers of the Caribbean.* Jenifer Marx. Malabar, FL: Krieger; 1992. 310 pp.

3680. *Pirates of the West Indies.* Clinton Vane de Brosse Black. New York, NY: Cambridge University Press; 1989. 136 pp.

3681. *Powder, Profits and Privateers: A Documentary History of the Virgin Islands During the Era of the American Revolution.* George F. Tyson, ed. Charlotte Amalie, V.I.: Dept. of Conservation and Cultural Affairs, Bureau of Libraries, Museums and Archeological Services; 1977. 114 pp.

3682. *Proceso histórico de la conquista de Puerto Rico, 1508–1640.* Eugenio Fernández Méndez. San Juan: Instituto de Cultura Puertorriqueña; 1970. 92 pp.

3683. *Puerto Rico and the Non Hispanic Caribbean: A Study in the Decline of Spanish Exclusivism.* Arturo Morales Carrión. Río Piedras, P.R.: University of Puerto Rico; 1974. 160 pp. Reprint of the 1952 ed.

3684. *Puerto Rico y la crisis de la guerra hispano-americana, 1895–1898.* Carmelo Rosario Natal. Río Piedras, P.R.: Editora Edil; 1989. 336 pp. Reprint of 1975 ed.

3685. *Puerto Rico's Revolt for Independence: el Grito de Lares.* Olga Jiménez de Wagenheim. Boulder, CO: Westview Press; 1985. 127 pp.

3686. *Quand les Français cherchaient fortune aux Caraïbes.* Louis Doucet. Paris: Fayard; 1981. 294 pp.

3687. *Queen Anne's Navy in the West Indies.* Ruth Bourne. New Haven, CT: Yale University Press; 1939. 334 pp.

3688. *Ralegh's Last Voyage.* Vincent Todd Harlow, ed. New York, NY: Da Capo Press; 1971. 379 pp. About Raleigh's 1617 voyage to Guyana; reprint of the 1932 ed.

3689. *Les révoltes blanches à Saint-Domingue aux XVIIe et XVIIIe siècles: Haïti avant 1789.* Charles Frostin. Paris: L'Ecole; 1989. 407 pp. Reprint of the 1975 ed.

3690. *La revolución haitiana y Santo Domingo.* Emilio Cordero Michel. Santo Domingo: Universidad Autónoma de Santo Domingo; 1989. 116 pp. Reprint of the 1968 ed.

3691. *The Rich Papers—Letters from Bermuda, 1615–1646: Eye-Witness Accounts Sent by the Early Colonists to Sir Nathaniel Rich.* Vernon Arthur Ives, ed. Buffalo, NY: University of Toronto Press; 1984. 413 pp.

3692. *The Rise of British Guiana.* Laurens Storm van 's Gravesande; Charles Alexander Harris, John Abraham Jacob De Villiers, eds. Millwood, NY: Kraus Reprint; 1967. 2 vols. Extracts from despatches written to the Directors of the Zeeland Chamber of the Dutch West India Company, 1738–1772; reprint of the 1911 ed.

3693. *The Scourge of the Indies: Buccaneers, Corsairs, and Filibusters.* Maurice Besson; Everard Thornton, tr. New York, NY: Random House; 1929. 330 pp. Translation of *Les Frères de la coste.*

3694. *Seventeenth Century Montserrat: An Environmental Impact Statement.* Lydia Mihelic Pulsipher. Norwich, Eng.: Geo Books; 1986. 96 pp.

3695. *Slavery, War, and Revolution: The British Occupation of Saint Domingue, 1793–1798.* David Patrick Geggus. Oxford: Clarendon Press; 1982. 492 pp.

3696. *Slaves in Red Coats: The British West India Regiments, 1795–1815.* Roger Norman Buckley. New Haven, CT: Yale University Press; 1979. 210 pp.

3697. *Society and Politics in Colonial Trinidad.* James Millette. 2d ed. Atlantic Highlands, NJ: Zed Books; 1985. 295 pp. First ed. has title *The Genesis of Crown Colony Government.*

3698. *Sodomy and the Perception of Evil: English Sea Rovers in the Seventeenth-Century Caribbean.* Barry Richard Burg. New York, NY: New York University Press; 1983. 215 pp.

3699. *Soldiers, Sugar, and Seapower: The British Expeditions to the West Indies and the War against Revolutionary France.* Michael Duffy. New York, NY: Oxford University Press; 1987. 420 pp.

3700. *The Spanish Crown and the Defense of the Caribbean, 1535–1585: Precedent, Patrimonialism, and Royal Parsimony.* Paul E. Hoffman. Baton Rouge, LA: Louisiana State University Press; 1980. 312 pp.

3701. *Spanish Documents Concerning English Voyages to the Caribbean, 1527–1568: Selected from the Archives of the Indies at Seville.* Irene Aloha Wright, ed. Millwood, NY: Kraus Reprint; 1967. 167 pp. Reprint of the 1929 ed.

3702. *The Spanish-Cuban-American War and the Birth of American Imperialism, 1895–1902.* Philip Sheldon Foner. New York, NY: Monthly Review Press; 1972. 2 vols.

3703. *To Slay the Hydra: Dutch Colonial Perspectives on the Saramaka Wars.* Richard Price. Ann Arbor, MI: Karoma Publishers; 1983. 247 pp. About Suriname.

3704. *Trinidad: provincia de Venezuela; historia de la administración española de Trinidad.* Jesse A. Noel. Caracas: Academia Nacional de la Historia; 1972. 270 pp.

3705. *Two Worlds: The Indian Encounter with the European, 1492–1509.* Samuel Lyman Tyler. Salt Lake City, UT: University of Utah Press; 1988. 258 pp.

3706. *War and Trade in the West Indies, 1739–1763.* Richard Pares. Totowa, NJ: Cass; 1963. 631 pp. Reprint of the 1936 ed.

3707. *The West Indies and Central America to 1898.* Bruce B. Solnick. New York, NY: Knopf; 1970. 206 pp.

3708. *The Western Design: An Account of Cromwell's Expedition to the Caribbean.* Stanley Arthur Goodwin Taylor. 2d ed. London: Solstice Productions; 1969. 243 pp.

4. THE 20TH CENTURY

3709. *American Intervention in Grenada: The Implications of Operation "Urgent Fury."* Peter M. Dunn, Bruce W. Watson, eds. Boulder, CO: Westview Press; 1985. 185 pp.

3710. *Barrios in Arms: Revolution in Santo Domingo.* José Antonio Moreno. Pittsburgh, PA: University of Pittsburgh Press; 1970. 226 pp.

3711. *Bay of Pigs: A Firsthand Account of the Mission by a U.S. Pilot in Support of the Cuban Invasion Force in 1961.* Albert C. Persons. Jefferson, NC: McFarland; 1990. 162 pp.

3712. *Bay of Pigs: The Untold Story.* Peter Wyden. New York, NY: Simon and Schuster; 1979. 352 pp.

3713. *The Caribbean at Mid-Century.* Conference on the Caribbean (First, 1950, University of Florida); Alva Curtis Wilgus, ed. Gainesville, FL: University of Florida Press; 1951. 284 pp.

3714. *The Caribbean: Contemporary Trends.* Conference on the Caribbean (Third, 1952, University of Florida); Alva Curtis Wilgus. ed. Gainesville, FL: University of Florida Press; 1953. 292 pp.

3715. *Castro's Cuba, Cuba's Fidel.* Lee Lockwood. Rev. ed. Boulder, CO: Westview Press; 1990. 379 pp.

3716. *Castro's Revolution: Myths and Realities.* Theodore Draper. New York, NY: Praeger; 1962. 211 pp.

3717. *Castroism: Theory and Practice.* Theodore Draper. New York, NY: Praeger; 1965. 263 pp.

3718. *The Conquest of Grenada: Sovereignty in the Periphery.* Mohammed Shahabuddeen. Georgetown: University of Guyana; 1986. 266 pp.

3719. *The Crime of Cuba.* Carleton Beals. New York, NY: Arno Press; 1970. 441 pp. Reprint of the 1933 ed.

3720. *Cuba 1933: Prologue to Revolution.* Luis E. Aguilar. New York, NY: Norton; 1974. 256 pp. Reprint of the 1972 ed.

3721. *Cuba After Thirty Years: Rectification and the Revolution.* Richard Gillespie, ed. Savage, MD: Cass; 1990. 188 pp.

3722. *Cuba in Revolution.* Rolando E. Bonachea, Nelson P. Valdés, eds. Garden City, NY: Anchor Books; 1972. 544 pp.

3723. *Cuba libre: Breaking the Chains?* Peter H. Marshall. Boston, MA: Faber and Faber; 1987. 300 pp.

3724. *Cuba Under Castro: The Limits of Charisma.* Edward Gonzalez. Boston, MA: Houghton Mifflin; 1974. 241 pp.

3725. *Cuba, Castro, and the Caribbean: The Cuban Revolution and the Crisis in Western Conscience.* Carlos Alberto Montaner; Nelson Duran, tr. New Brunswick, NJ: Transaction Books; 1985. 116 pp.

3726. *Cuba: An American Tragedy.* Robert Scheer, Maurice Zeitlin. Rev. ed. Harmondsworth, Eng.: Penguin; 1964. 368 pp. Previous ed. has title *Cuba: Tragedy in Our Hemisphere.*

3727. *Cuba: Anatomy of a Revolution.* Leo Huberman, Paul Marlor Sweezy. New York, NY: Monthly Review Press; 1968. 208 pp. Reprint of the 1961 (2d) ed.

3728. *Cuba: Castroism and Communism, 1959–1966.* Andrés Suárez; Joel Carmichael, Ernst Halperin, trs. Cambridge, MA: MIT Press; 1967. 266 pp.

3729. *Cuba: Internal and International Affairs.* Jorge I. Domínguez, ed. Beverly Hills, CA: Sage; 1982. 230 pp.

3730. *Cuba: The Making of a Revolution.* Ramón Eduardo Ruiz. Amherst, MA: University of Massachusetts Press; 1968. 190 pp.

3731. *Cuba: The Measure of a Revolution.* Lowry Nelson. Minneapolis, MN: University of Minnesota Press; 1972. 242 pp.

3732. *The Cuban Insurrection, 1952–1959.* Ramón L. Bonachea, Marta San Martín. New Brunswick, NJ: Transaction Books; 1974. 451 pp.

3733. *The Cuban Revolution and Latin America.* Boris Goldenberg. New York, NY: Praeger; 1965. 376 pp. English version of *Lateinamerika und die kubanische Revolution* brought up to date.

3734. *The Cuban Revolution: Twenty-five Years Later.* Hugh Thomas, Georges A. Fauriol, Juan Carlos Weiss. Boulder, CO: Westview Press; 1984. 69 pp.

3735. *The Cuban Story.* Herbert Lionel Matthews. New York, NY: G. Braziller; 1961. 318 pp.

3736. *Cuban Studies Since the Revolution.* Damián J. Fernández, ed. Gainesville, FL: University Press of Florida; 1992. 318 pp.

3737. *Diary of the Cuban Revolution.* Carlos Franqui; Georgette Felix [et al.], trs. New York, NY: Viking Press; 1980. 546 pp. Translation of *Diario de la revolución cubana.*

3738. *The Dominican Crisis: The 1965 Constitutionalist Revolt and American Intervention.* Piero Gleijeses; Lawrence Lipson, tr. Baltimore, MD: Johns Hopkins University Press; 1978. 460 pp.

3739. *Dominican Diary.* Tad Szulc. New York, NY: Delacorte Press; 1965. 306 pp.

3740. *La era de Trujillo.* Franklin J. Franco. Santo Domingo: Fundación Cultural Dominicana; 1992. 198 pp.

3741. *Eye on Cuba.* Edwin Tetlow. New York, NY: Harcourt, Brace and World; 1966. 291 pp.

3742. *Fidel Castro and the Cuban Revolution: Age, Position, Character, Destiny, Personality, and Ambition.* Carlos Alberto Montaner. New Brunswick, NJ: Transaction Publishers; 1989. 214 pp. Rev. ed. of *Secret Report on the Cuban Revolution;* translation of *Informe secreto sobre la Revolución Cubana.*

3743. *Fidel Castro's Personal Revolution in Cuba, 1959–1973.* James Nelson Goodsell, ed. New York, NY: Knopf; 1975. 349 pp.

3744. *From the Palm Tree: Voices of the Cuban Revolution.* Jane McManus, ed. and tr. Secaucus, NJ: L. Stuart; 1983. 206 pp.

3745. *Grenada and Soviet/Cuban Policy: Internal Crisis and U.S./OECS Intervention.* Jiri Valenta, Herbert J. Ellison, eds. Boulder, CO: Westview Press; 1986. 512 pp.

3746. *The Grenada Documents: Window on Totalitarianism.* Nicholas Dujmovíc. Cambridge, MA: Institute for Foreign Policy Analysis; 1988. 94 pp.

3747. *The Grenada Intervention: Analysis and Documentation.* William C. Gilmore. New York, NY: Facts on File; 1984. 116 pp.

3748. *The Grenada Papers.* Paul Seabury, Walter A. McDougall, eds. San Francisco, CA: Institute for Contemporary Studies; 1984. 346 pp.

3749. *Grenada: A Study in Politics and the Limits of International Law.* Scott Davidson. Brookfield, VT: Gower; 1987. 196 pp.

3750. *Grenada: An Eyewitness Account of the U.S. Invasion and the Caribbean History That Provoked It.* Hugh O'Shaughnessy. New York, NY: Dodd, Mead; 1984. 261 pp. British ed. has title *Grenada: Revolution, Invasion, and Aftermath.*

3751. *Grenada: Revolution and Invasion.* Anthony Payne, Paul K. Sutton, Tony Thorndike. New York, NY: St. Martin's Press; 1984. 233 pp.

3752. *Grenada: The Jewel Despoiled.* Gordon K. Lewis. Baltimore, MD: Johns Hopkins University Press; 1987. 239 pp.

3753. *Guerrillas in Power: The Course of the Cuban Revolution.* K. S. Karol; Arnold Pomerans, tr. New York, NY: Hill and Wang; 1970. 624 pp. Translation of *Les Guérilleros au pouvoir.*

3754. *Haïti de 1804 à nos jours.* Jacques Barros. Paris: L'Harmattan; 1984. 2 vols.

3755. *Haiti in Caribbean Context: Ethnicity, Economy, and Revolt.* David Nicholls. New York, NY: St. Martin's Press; 1985. 282 pp.

3756. *Haiti Under American Control, 1915–1930.* Arthur Chester Millspaugh. Westport, CT: Negro Universities Press; 1970. 253 pp. Reprint of the 1931 ed.

3757. *Haiti: The Breached Citadel.* Patrick Bellegarde-Smith. Boulder, CO: Westview Press; 1990. 217 pp.

3758. *Haiti: The Politics of Squalor.* Robert I. Rotberg, Christopher K. Clague. Boston, MA: Houghton Mifflin; 1971. 456 pp.

3759. *The Haitians: Class and Color Politics.* Lyonel Paquin. Brooklyn, NY: Multi-Type; 1983. 271 pp.

3760. *A History of the Cuban Republic: A Study in Hispanic American Politics.* Charles Edward Chapman. Westport, CT: Greenwood Press; 1971. 685 pp. Reprint of the 1927 ed.

3761. *Ideology and Class Conflict in Jamaica: The Politics of Rebellion.* Abigail Bess Bakan. Montreal: McGill-Queen's University Press; 1990. 183 pp.

3762. *The Impact of Intervention: The Dominican Republic During the U.S. Occupation of 1916–1924.* Bruce J. Calder. Austin, TX: University of Texas Press; 1984. 334 pp.

3763. *Jamaica in Independence: Essays on the Early Years.* Rex M. Nettleford, ed. Kingston: Heinemann Caribbean; 1989. 364 pp.

3764. *Listen Yankee: The Revolution in Cuba.* Charles Wright Mills. New York, NY: McGraw-Hill; 1960. 192 pp.

3765. *M-26: Biography of a Revolution.* Robert Taber. New York, NY: L. Stuart; 1961. 348 pp.

3766. *Magoon in Cuba: A History of the Second Intervention, 1906–1909.* David Alexander Lockmiller. New York, NY: Greenwood Press; 1969. 252 pp. Reprint of the 1938 ed.

3767. *Marines in the Dominican Republic, 1916–1924.* Stephen M. Fuller, Graham A. Cosmas. Washington, DC: History and Museums Division, Headquarters, U.S. Marine Corps, 1974. 109 pp.

3768. *Naboth's Vineyard: The Dominican Republic, 1844–1924*. Sumner Welles. New York, NY: Arno Press; 1972. 2 vols. in 1. Reprint of the 1928 ed.

3769. *Nueva historia de la República de Cuba, 1898–1979*. Herminio Portell-Vilá. Miami, FL: Moderna Poesía; 1986. 874 pp.

3770. *Occupied Haiti*. Emily Greene Balch, ed. New York, NY: Garland; 1972. 186 pp. Reprint of the 1927 ed.

3771. *Operation Zapata: The "Ultrasensitive" Report and Testimony of the Board of Inquiry on the Bay of Pigs*. Luis E. Aguilar, ed. Frederick, MD: University Publications of America; 1981. 367 pp.

3772. *Overtaken by Events: The Dominican Crisis from the Fall of Trujillo to the Civil War*. John Bartlow Martin. Garden City, NY: Doubleday; 1966. 821 pp.

3773. *Papa Doc, Baby Doc: Haiti and the Duvaliers*. James Ferguson. Rev. ed. New York, NY: B. Blackwell; 1988. 204 pp.

3774. *The Politics of Intervention: The Military Occupation of Cuba, 1906–1909*. Allan Reed Millett. Columbus, OH: Ohio State University Press; 1968. 306 pp.

3775. *Puerto Rico: Island of Promise*. Ruth Gruber. New York, NY: Hill and Wang; 1960. 216 pp.

3776. *The Purchase of the Danish West Indies*. Charles Callan Tansill. New York, NY: Greenwood Press; 1968. 548 pp. Reprint of the 1932 ed.

3777. *Les racines historiques de l'état duvaliérien*. Michel-Rolph Trouillot. Port-au-Prince: Editions Deschamps; 1986. 255 pp.

3778. *A Rebel in Cuba: An American's Memoir*. Neill Macaulay. Chicago, IL: Quadrangle Books; 1970. 199 pp.

3779. *Reminiscences of the Cuban Revolutionary War*. Ernesto Guevara; Victoria Ortiz, tr. New York, NY: Grove Press; 1968. 287 pp. Rev. and enl. translation of *Pasajes de la Guerra Revolucionaria*.

3780. *Revolution and Rescue in Grenada: An Account of the U.S.-Caribbean Invasion*. Reynold A. Burrowes. New York, NY: Greenwood Press; 1988. 180 pp.

3781. *Revolution in Cuba: An Essay in Understanding*. Herbert Lionel Matthews. New York, NY: Scribner; 1975. 468 pp.

3782. *The Rise and Decline of Fidel Castro: An Essay in Contemporary History*. Maurice Halperin. Berkeley, CA: University of California Press; 1972. 380 pp. Continued by his *The Taming of Fidel Castro* [#3785].

3783. *Scrap Book of Anguilla's Revolution*. Ronald Webster. Anguilla, W.I.: Seabreakers; 1987. 160 pp.

3784. *St. Croix at the Twentieth Century: A Chapter in Its History*. D. C. Canegata. New York, NY: Carlton Press; 1968. 161 pp.

3785. *The Taming of Fidel Castro*. Maurice Halperin. Berkeley, CA: University of California Press; 1981. 345 pp. Continues his *The Rise and Decline of Fidel Castro* [#3782].

3786. *Through Caribbean Eyes: Reflections on an Era of Independence*. Clement B. G. London. New York, NY: ECA Associates; 1989. 493 pp. About Trinidad and Tobago.

3787. *Trinidad in Transition: The Years After Slavery*. Donald Wood. New York, NY: Oxford University Press; 1986. 318 pp. Reprint of the 1968 ed.

3788. *The United States Occupation of Haiti, 1915–1934*. Hans Schmidt. New Brunswick, NJ: Rutgers University Press; 1971. 303 pp.

3789. *The Unsuspected Revolution: The Birth and Rise of Castroism*. Mario Llerena. Ithaca, NY: Cornell University Press; 1978. 324 pp.

3790. *Urgent Fury: The Battle for Grenada*. Mark Adkin. Lexington, MA: Lexington Books; 1989. 391 pp.

3791. *War, Cooperation, and Conflict: The European Possessions in the Caribbean, 1939–1945*. Fitzroy André Baptiste. New York, NY: Greenwood Press; 1988. 351 pp.

3792. *The West Indies Today: A Thesis on the Forces, Struggles, Frustrations and People of the West Indies*. D. Sinclair DaBreo. St. George's, Grenada: [s.n.]; 1971. 117 pp.

3793. *The Winds of December*. John Dorschner, Roberto Fabricio. New York, NY: Coward, McCann and Geoghegan; 1980. 552 pp. About Cuba.

5. SPECIAL TOPIC: SLAVERY

3794. *La abolición de la esclavitud en Cuba*. Enrique Pérez-Cisneros. San José, C.R.: LIL; 1985. 177 pp.

3795. *L'abolition de l'esclavage à la Martinique*. Léo Elisabeth. Fort-de-France: Société d'histoire de la Martinique; 1983. 155 pp.

3796. *Africa in America: Slave Acculturation and Resistance in the American South and the British Caribbean, 1736–1831*. Michael Mullin. Urbana, IL: University of Illinois Press; 1992. 412 pp.

3797. *African Slavery in Latin America and the Caribbean*. Herbert S. Klein. New York, NY: Oxford University Press; 1986. 311 pp.

3798. *Afro-Caribbean Women and Resistance to Slavery in Barbados*. Hilary Beckles. London: Karnak House; 1988. 96 pp. Spine title *Afro-Caribbean Women in Resistance to Slavery in Barbados*.

3799. *After Africa: Extracts from British Travel Accounts and Journals of the Seventeenth, Eighteenth, and Nineteenth Centuries Concerning the Slaves, Their Manners, and Customs in the British West Indies*. Roger D. Abra-

hams, John F. Szwed, eds. New Haven, CT: Yale University Press; 1983. 444 pp.

3800. *Am I Not a Man and a Brother? British Missions and the Abolition of the Slave Trade and Slavery in West Africa and the West Indies, 1786–1838.* Stiv Jakobsson. Lund, Sweden: Gleerup; 1972. 661 pp.

3801. *Auge y decadencia de la trata negrera en Puerto Rico, 1820–1860.* Arturo Morales Carrión. San Juan: Centro de Estudios Avanzados de Puerto Rico y el Caribe, Instituto de Cultura Puertorriqueña; 1978. 259 pp.

3802. *The Autobiography of a Runaway Slave.* Esteban Montejo; Miguel Barnet, ed.; Jocasta Innes, tr. New York, NY: Vintage Books; 1973. 223 pp. Translation of *Biografía de un cimarrón;* reprint of the 1968 ed.

3803. *Azúcar y abolición.* Raúl Cepero Bonilla. [Nueva ed.]. Havana: Editorial de Ciencias Sociales; 1971. 276 pp. About Cuba.

3804. *El barracón: esclavitud y capitalismo en Cuba.* Juan Pérez de la Riva. Barcelona: Crítica; 1978. 185 pp.

3805. *Between Slavery and Free Labor: The Spanish-Speaking Caribbean in the Nineteenth Century.* Manuel Moreno Fraginals, Frank Moya Pons, Stanley L. Engerman, eds. Baltimore, MD: Johns Hopkins University Press; 1985. 294 pp.

3806. *Black Rebellion in Barbados: The Struggle Against Slavery, 1627–1838.* Hilary Beckles. Bridgetown: Carib Research and Publications; 1987. 164 pp. Reprint of the 1984 ed.

3807. *The Black Saturnalia: Conflict and Its Ritual Expression on British West Indian Slave Plantations.* Robert Dirks. Gainesville, FL: University Presses of Florida; 1987. 228 pp.

3808. *Blacks in Colonial Cuba, 1774–1899.* Kenneth F. Kiple. Gainesville, FL: University Presses of Florida; 1976. 115 pp.

3809. *Bondmen and Rebels: A Study of Master-Slave Relations in Antigua, with Implications for Colonial British America.* David Barry Gaspar. Baltimore, MD: Johns Hopkins University Press; 1985. 338 pp.

3810. *De bosnegers zijn gekomen!: slavernij en rebellie in Suriname [The Maroons Have Come: Slavery and Rebellion in Suriname].* Wim S. M. Hoogbergen. Amsterdam: Prometheus; 1992. 349 pp.

3811. *British Capitalism and Caribbean Slavery: The Legacy of Eric Williams.* Barbara Lewis Solow, Stanley L. Engerman, eds. New York, NY: Cambridge University Press; 1987. 345 pp.

3812. *British Slave Emancipation, 1838–1849.* William Law Mathieson. New York, NY: Octagon Books; 1967. 243 pp. Continues his *British Slavery and Its Abolition, 1823–1838* [#3814]; reprint of the 1932 ed.

3813. *British Slave Emancipation: The Sugar Colonies and the Great Experiment, 1830–1865.* William A. Green. New York, NY: Clarendon Press; 1991. 449 pp. Reprint of the 1976 ed.

3814. *British Slavery and Its Abolition, 1823–1838.* William Law Mathieson. New York, NY: Octagon Books; 1967. 318 pp. Continued by his *British Slave Emancipation, 1838–1849* [#3812]; reprint of the 1926 ed.

3815. *British West Indian Slavery, 1750–1834: The Process of Amelioration.* J. R. Ward. New York, NY: Oxford University Press; 1988. 320 pp.

3816. *British West Indies at Westminster, 1789–1823: Extracts from the Debates in Parliament.* Eric Ernest Williams, ed. Westport, CT: Negro Universities Press; 1970. 136 pp. Reprint of the 1954 ed.

3817. *Caribbean Slave Society and Economy.* Hilary Beckles, Verene Shepherd, eds. New York, NY: New Press; 1991. 480 pp.

3818. *The Caribbean Slave: A Biological History.* Kenneth F. Kiple. New York, NY: Cambridge University Press; 1984. 274 pp.

3819. *The Colthurst Journal: Journal of a Special Magistrate in the Islands of Barbados and St. Vincent, July 1835–September 1838.* John Bowen Colthurst; Woodville K. Marshall, ed. Millwood, NY: KTO Press; 1977. 255 pp.

3820. *Cultural Adaptation and Resistance on St. John: Three Centuries of Afro-Caribbean Life.* Karen Fog Olwig. Gainesville, FL: University of Florida Press; 1985. 226 pp.

3821. *The Danish Virgin Islands: A Socio-Historical Analysis of the Emancipation of 1848 and the Labor Revolt of 1878.* Clifton E. Marsh. Bristol, IN: Wyndham Hall Press; 1985. 96 pp.

3822. *Doctors and Slaves: A Medical and Demographic History of Slavery in the British West Indies, 1680–1834.* Richard B. Sheridan. New York, NY: Cambridge University Press; 1985. 420 pp.

3823. *The Dynamics of Change in a Slave Society: A Sociopolitical History of the Free Coloreds of Jamaica, 1800–1865.* Mavis Christine Campbell. Rutherford, NJ: Fairleigh Dickinson University Press; 1976. 393 pp.

3824. *Econocide: British Slavery in the Era of Abolition.* Seymour Drescher. Pittsburgh, PA: University of Pittsburgh Press; 1977. 279 pp.

3825. *Emancipatie en emancipator: de geschiedenis van de slavernij op de Benedenwindse eilanden en van het werk der bevrijding [Emancipation and Emancipator: The History of Slavery in the Netherlands Antilles and of the Struggle for Freedom].* Cornelis Christiaan Goslinga. Assen: Van Gorcum; 1956. 187 pp.

3826. *Emancipation and Apprenticeship in the British West Indies.* William Laurence Burn. New York, NY: Johnson Reprint; 1970. 398 pp. Reprint of the 1937 ed.

3827. *Emancipation, Sugar, and Federalism: Barbados and the West Indies, 1833–1876.* Claude Levy. Gainesville, FL: University Presses of Florida; 1980. 206 pp.

3828. *Emancipation: A Series of Lectures to Commemorate the 150th Anniversary of Emancipation.* Alvin O. Thompson, Woodville K. Marshall, eds. Cave Hill, Barbados: History Dept., University of the West Indies; 1986–1987. 2 vols. About Barbados.

3829. *L'esclavage aux Antilles françaises (XVIIe-XIXe siècle): contribution au problème de l'esclavage.* Antoine Gisler. Nouv. éd., rev. et corr. Paris: Karthala; 1981. 228 pp.

3830. *Esclavage et colonisation.* Victor Schoelcher; Emile Tersen, ed. Paris: Presses universitaires de France; 1948. 218 pp.

3831. *Esclavage, assimilation et guyanité.* Neuville Doriac. Paris: Anthropos; 1985. 261 pp. About French Guiana.

3832. *Les esclaves aux Antilles françaises, XVIIe-XVIIIe siècles.* Gabriel Debien. Basse-Terre: Société d'histoire de la Guadeloupe; 1974. 529 pp.

3833. *La esclavitud del negro en Santo Domingo, 1492–1844.* Carlos Esteban Deive. Santo Domingo: Museo del Hombre Dominicano; 1980. 2 vols.

3834. *Esclavitud y sociedad: notas y documentos para la historia de la esclavitud negra en Cuba.* Eduardo Torres-Cuevas, Eusebio Reyes. Havana: Editorial de Ciencias Sociales; 1986. 280 pp.

3835. *Esclavos prófugos y cimarrones: Puerto Rico, 1770–1870.* Benjamín Nistal Moret. Río Piedras, P.R.: Editorial de la Universidad de Puerto Rico; 1984. 287 pp.

3836. *Esclavos rebeldes: conspiraciones y sublevaciones de esclavos en Puerto Rico, 1795–1873.* Guillermo A. Baralt. Río Piedras, P.R.: Ediciones Huracán; 1989. 183 pp. Reprint of the 1982 ed.

3837. *Eyewitness Accounts of Slavery in the Danish West Indies: Also Graphic Tales of Other Slave Happenings on Ships and Plantations.* Isidor Paiewonsky. New York, NY: Fordham University Press; 1989. 166 pp. Reprint of the 1987 ed.

3838. *The Folk Culture of the Slaves in Jamaica.* Edward Kamau Brathwaite. Rev. ed. London: New Beacon Books; 1981. 56 pp.

3839. *Free Coloreds in the Slave Societies of St. Kitts and Grenada, 1763–1833.* Edward L. Cox. Knoxville, TN: University of Tennessee Press; 1984. 197 pp.

3840. *Freedom to Be: The Abolition of Slavery in Jamaica and Its Aftermath.* National Library of Jamaica [and] Urban Development Corporation (Jamaica). Kingston: The Library; 1984. 94 pp.

3841. *The Great White Lie: Slavery, Emancipation, and Changing Racial Attitudes.* Jack Gratus. New York, NY: Monthly Review Press; 1973. 324 pp.

3842. *Los guerrilleros negros: esclavos fugitivos y cimarrones en Santo Domingo.* Carlos Esteban Deive. Santo Domingo: Fundación Cultural Dominicana; 1989. 307 pp.

3843. *The Haitian Maroons: Liberty or Death.* Jean Fouchard; A. Faulkner Watts, tr. New York, NY: E. W. Blyden Press; 1981. 386 pp. Translation of *Les marrons de la liberté.*

3844. *Histoire de l'esclavage dans les colonies françaises.* Gaston Martin. Brionne, France: G. Montfort; 1978. 318 pp. Reprint of the 1948 ed.

3845. *Historia de la esclavitud en Puerto Rico.* Cayetano Coll y Toste; Isabel Cuchí Coll, ed. San Juan: Litografía Metropolitana; 1977. 267 pp. Reprint of the 1972 (2d) ed.

3846. *Historia de la esclavitud negra en Puerto Rico.* Luis M. Díaz Soler. Río Piedras, P.R.: Editorial Universitaria, Universidad de Puerto Rico; 1981. 439 pp. Reprint of the 1965 (2d) ed.

3847. *A History of Slavery in Cuba, 1511–1868.* Hubert Hillary Suffern Aimes. Totowa, NJ: Cass; 1972. 298 pp. Reprint of the 1907 ed.

3848. *In Miserable Slavery: Thomas Thistlewood in Jamaica, 1750–86.* Thomas Thistlewood; Douglas Hall, ed. London: Macmillan; 1989. 322 pp.

3849. *El Machete de Ogún: las luchas de los esclavos en Puerto Rico, siglo XIX.* Guillermo A. Baralt [et al.]. San Juan: Centro de Estudios de la Realidad Puertorriqueña (CEREP); 1990. 113 pp.

3850. *Moral Imperium: Afro-Caribbeans and the Transformation of British Rule, 1776–1838.* Ronald Kent Richardson. Westport, CT: Greenwood Press; 1987. 211 pp.

3851. *Natural Rebels: A Social History of Enslaved Black Women in Barbados.* Hilary Beckles. New Brunswick, NJ: Rutgers University Press; 1989. 197 pp.

3852. *Los negros esclavos.* Fernando Ortiz. Havana: Editorial de Ciencias Sociales; 1988. 525 pp. Reprint of the 1975 ed. originally published under title *Hampa afro-cubana.*

3853. *Odious Commerce: Britain, Spain, and the Abolition of the Cuban Slave Trade.* David R. Murray. New York, NY: Cambridge University Press; 1980. 423 pp.

3854. *Out of Slavery: Abolition and After.* Jack Ernest Shalom Hayward, ed. Totowa, NJ: Cass; 1985. 200 pp. Lectures and conference papers given at the University of Hull (Eng.), 1983.

3855. *Plantation Slavery in Barbados: An Archaeological and Historical Investigation.* Jerome S. Handler, Frederick W. Lange, Robert V. Riordan. Cambridge, MA: Harvard University Press; 1978. 368 pp.

3856. *The Plantation Slaves of Trinidad, 1783–1816: A Mathematical and Demographic Enquiry.* A. Meredith John. New York, NY: Cambridge University Press; 1988. 259 pp.

3857. *Plantations et esclaves à Saint-Domingue.* Gabriel Debien. Dakar: Université de Dakar; 1962. 184 pp.

3858. *Las rebeliones negras de La Española [y] La isla dividida.* Sócrates Barinas Coiscou. Santo Domingo: Impresos de Calidad; 1988. 264 pp.

3859. *Searching for a Slave Cemetery in Barbados, West Indies: A Bioarcheological and Ethnohistorical Investigation.* Jerome S. Handler, Michael D. Conner, Keith P. Jacobi. Carbondale, IL: Center for Archaeological Investigations, Southern Illinois University; 1989. 125 pp.

3860. *Searching for the Invisible Man: Slaves and Plantation Life in Jamaica.* Michael Craton, Garry Greenland. Cambridge, MA: Harvard University Press; 1978. 439 pp.

3861. *Seven Slaves and Slavery: Trinidad, 1777–1838.* Anthony De Verteuil. Port of Spain: [s.n.]; 1992. 427 pp.

3862. *Slave Emancipation in Cuba: The Transition to Free Labor, 1860–1899.* Rebecca J. Scott. Princeton, NJ: Princeton University Press; 1985. 319 pp.

3863. *Slave Population and Economy in Jamaica, 1807–1834.* B. W. Higman. New York, NY: Cambridge University Press; 1976. 327 pp.

3864. *Slave Populations of the British Caribbean, 1807–1834.* B. W. Higman. Baltimore, MD: Johns Hopkins University Press; 1984. 781 pp.

3865. *Slave Society in Cuba During the Nineteenth Century.* Franklin W. Knight. Madison, WI: University of Wisconsin Press; 1977. 228 pp. Reprint of the 1970 ed.

3866. *Slave Society in the British Leeward Islands at the End of the Eighteenth Century.* Elsa V. Goveia. Westport, CT: Greenwood Press; 1980. 370 pp. Reprint of the 1965 ed.

3867. *Slave Society in the Danish West Indies: St. Thomas, St. John, and St. Croix.* Neville A. T. Hall; B. W. Higman, ed. Baltimore, MD: Johns Hopkins University Press; 1992. 287 pp.

3868. *Slave Women in Caribbean Society, 1650–1838.* Barbara Bush. Bloomington, IN: Indiana University Press; 1990. 190 pp.

3869. *Slave Women in the New World: Gender Stratification in the Caribbean.* Marietta Morrissey. Lawrence, KS: University Press of Kansas; 1989. 202 pp.

3870. *Slavery in the Americas: A Comparative Study of Virginia and Cuba.* Herbert S. Klein. Chicago, IL: Elephant Paperbacks; 1989. 270 pp. Reprint of the 1967 ed.

3871. *Slavery in the Bahamas, 1648–1838.* Gail Saunders. Nassau: [s.n.]; 1985. 249 pp.

3872. *Slavery in the Circuit of Sugar: Martinique and the World Economy, 1830–1848.* Dale W. Tomich. Baltimore, MD: Johns Hopkins University Press; 1990. 353 pp.

3873. *Slaves and Missionaries: The Disintegration of Jamaican Slave Society, 1787–1834.* Mary Turner. Urbana, IL: University of Illinois Press; 1982. 223 pp.

3874. *Slaves Who Abolished Slavery.* Richard Hart. Mona, Jamaica: Institute of Social and Economic Research, University of the West Indies; 1980–1985. 2 vols. About Jamaica.

3875. *Slaves, Free Men, Citizens: West Indian Perspectives.* Lambros Comitas, David Lowenthal, eds. Garden City, NY: Anchor Books; 1973. 340 pp.

3876. *Social Control in Slave Plantation Societies: A Comparison of St. Domingue and Cuba.* Gwendolyn Midlo Hall. Baltimore, MD: Johns Hopkins University Press; 1971. 166 pp.

3877. *The Sociology of Slavery: An Analysis of the Origins, Development, and Structure of Negro Slave Society in Jamaica.* Orlando Patterson. Rutherford, NJ: Fairleigh Dickinson University Press; 1969. 310 pp.

3878. *Les soeurs de solitude: la condition féminine dans l'esclavage aux Antilles du XVIIe au XIXe siècle.* Arlette Gautier. Paris: Editions caribéennes; 1985. 284 pp.

3879. *Spain and the Abolition of Slavery in Cuba, 1817–1886.* Arthur F. Corwin. Austin, TX: University of Texas Press; 1967. 373 pp.

3880. *Sugar Is Made with Blood: The Conspiracy of La Escalera and the Conflict Between Empires over Slavery in Cuba.* Robert L. Paquette. Middletown, CT: Wesleyan University Press; 1988. 346 pp.

3881. *Testing the Chains: Resistance to Slavery in the British West Indies.* Michael Craton. Ithaca, NY: Cornell University Press; 1982. 389 pp.

3882. *The Unappropriated People: Freedmen in the Slave Society of Barbados.* Jerome S. Handler. Baltimore, MD: Johns Hopkins University Press; 1974. 225 pp.

3883. *The West Indian Slave Laws of the Eighteenth Century.* Elsa V. Goveia. Bridgetown: Caribbean Universities Press; 1970. 105 pp.

3884. *White Servitude and Black Slavery in Barbados, 1627–1715.* Hilary Beckles. Knoxville, TN: University of Tennessee Press; 1989. 218 pp.

F. Language and Literature

1. LANGUAGES AND DIALECTS

3885. *Acts of Identity: Creole-Based Approaches to Language and Ethnicity.* Robert Brock Le Page, Andrée Tabouret-Keller. New York, NY: Cambridge University Press; 1985. 275 pp.

3886. *Anagó, vocabulario lucumí: el yoruba que se habla en Cuba.* Lydia Cabrera. Miami, FL: Ediciones Universal; 1986. 326 pp. Reprint of the 1957 ed.

3887. *El bilingüismo en Puerto Rico: actitudes socio-lingüísticas del maestro.* María M. López Laguerre. Río Piedras, P.R.: M. M. López Laguerre; 1989. 279 pp.

3888. *"Black Talk": Being Notes on Negro Dialect in British Guiana with (Inevitably) a Chapter on the Vernacular of Barbados.* J. Graham Cruickshank. Demerara: Argosy; 1916. 76 pp.

3889. *The Carib Language: Phonology, Morphonology, Morphology, Texts and Word Index.* B. J. Hoff. Leiden: Caraïbische Afdeling, Koninklijk Instituut voor Taal-, Land- en Volkenkunde; 1968. 441 pp.

3890. *Caribbean and African Languages: Social History, Language, Literature, and Education.* Morgan Dalphinis. London: Karia Press; 1985. 288 pp.

3891. *Contribution à l'étude comparée du créole et du français à partir du créole haïtien.* Pradel Pompilus. Port-au-Prince: Editions Caraïbes; 1973–1976. 2 vols.

3892. *Corrientes actuales en la dialectología del Caribe hispánico: actas de un simposio.* Humberto López Morales, ed. Río Piedras, P.R.: Editorial Universitaria, Universidad de Puerto Rico; 1978. 247 pp.

3893. *Le créole de la Guadeloupe: nègres-marrons.* Gérard Lauriette. Pointe-à-Pitre: [s.n.]; 1981. 84 pp.

3894. *Le créole haïtien: morphologie et syntaxe.* Suzanne Comhaire-Sylvain. Geneva: Slatkine Reprints; 1979. 180 pp. Reprint of the 1936 ed.

3895. *Creole Talk of Trinidad and Tobago.* Carlton Robert Ottley. 4th ed., enl. Diego Martin, Trinidad/Tobago: Crusoe; 1981. 100 pp. First ed. has title *Trinibagianese.*

3896. *La cuestión del origen y de la formación del Papiamento.* Orlando Ferrol. Leiden: Caraïbische Afdeling, Koninklijk Instituut voor Taal-, Land- en Volkenkunde; 1982. 93 pp.

3897. *De la lengua de Isabel la Católica a la taína del cacique Argueybana: origen y desarrollo del habla hispano-antillana.* Ernesto Juan Fonfrías. San Juan: Editorial Club de la Prensa; 1969. 125 pp.

3898. *De lo popular y lo vulgar en el habla cubana.* Carlos Paz Pérez. Havana: Editorial de Ciencias Sociales; 1988. 228 pp.

3899. *Del vocabulario dominicano.* Emilio Rodríguez Demorizi. Santo Domingo: Editora Taller; 1983. 297 pp.

3900. *Des baragouins à la langue antillaise: analyse historique et sociolinguistique du discours sur le créole.* Lambert-Félix Prudent. Paris: Editions caribéennes; 1980. 211 pp.

3901. *Dimensions of a Creole Continuum: History, Texts, and Linguistic Analysis of Guyanese Creole.* John R. Rickford. Palo Alto, CA: Stanford University Press; 1987. 340 pp.

3902. *Dynamics of a Creole System.* Derek Bickerton. New York, NY: Cambridge University Press; 1975. 224 pp. About Guyanese Creole.

3903. *El elemento afronegroide en el español de Puerto Rico: contribución al estudio del negro en América.* Manuel Alvarez Nazario. 2a ed., rev. y aum. San Juan: Instituto de Cultura Puertorriqueña; 1974. 489 pp.

3904. *Eléments de grammaire du créole martiniquais.* Robert Damoiseau. Fort-de-France: Hatier Antilles; 1984. 127 pp.

3905. *El español en Puerto Rico: contribución a la geografía lingüística hispanoamericana.* Tomás Navarro Tomás. Río Piedras, P.R.: Editorial Universitaria, Universidad de Puerto Rico; 1974. 346 pp. Reprint of the 1948 ed.

3906. *El español en Santo Domingo.* Pedro Henríquez Ureña. Santo Domingo: Editora Taller; 1987. 301 pp. Reprint of the 1940 ed.

3907. *Estudio lingüístico de Santo Domingo: aportación a la geografía lingüística del Caribe e Hispano América.* Elercia Jorge Morel. Santo Domingo: Editora Taller; 1978. 217 pp. Reprint of the 1974 ed.

3908. *Estudios sobre el español de Cuba.* Humberto López Morales. Long Island City, NY: Las Américas; 1971. 188 pp.

3909. *Estudios sobre el español dominicano.* Orlando Alba. Santiago, D.R.: Pontificia Universidad Católica Madre y Maestra; 1990. 223 pp.

3910. *A Festival of Guyanese Words.* John R. Rickford. 2d ed. Georgetown: University of Guyana; 1978. 272 pp.

3911. *Focus on the Caribbean.* Manfred Görlach, John A. Holm, eds. Philadelphia, PA: J. Benjamins; 1986. 209 pp.

3912. *The Forsaken Lover: White Words and Black People.* Chris Searle. Boston, MA: Routledge and K. Paul; 1972. 108 pp.

3913. *Das Französisch-Kreolische in der Karibik: zur Funktion von Sprache im sozialen und geographischen Raum.* Ulrich Fleischmann. Tübingen: Narr; 1986. 326 pp.

3914. *Grammaire créole/Fondas kréyol-la: éléments de base des créoles de la zone américano-caraïbe.* Jean Bernabé. Paris: L'Harmattan; 1987. 205 pp.

3915. *El habla campesina del país: orígenes y desarrollo del español en Puerto Rico.* Manuel Alvarez Nazario. Río Piedras, P.R.: Editorial de la Universidad de Puerto Rico; 1990. 594 pp.

3916. *El habla popular cubana de hoy : una tonga de cubichismos que le of a mi pueblo.* Argelio Santiesteban. Havana: Editorial de Ciencias Sociales; 1982. 366 pp.

3917. *El habla popular de Puerto Rico.* Washington Lloréns. 3a ed. aum. Río Piedras, P.R.: Editorial Edil; 1981. 220 pp.

3918. *Haitian Creole: Grammar, Texts, Vocabulary.* Robert Anderson Hall [et al.]. Millwood, NY: Kraus Reprint; 1979. 309 pp. Reprint of the 1953 ed.

3919. *El idioma de Puerto Rico y el idioma escolar de Puerto Rico.* Epifanio Fernández Vanga. New York, NY: Arno Press; 1975. 301 pp. Reprint of the 1931 ed.

3920. *El influjo indígena en el español de Puerto Rico.* Manuel Alvarez Nazario. Río Piedras, P.R.: Editorial Universitaria, Universidad de Puerto Rico; 1977. 191 pp.

3921. *Une introduction au créole guadeloupéen.* Marie-Josée Cérol. [S.l.]: Jasor; 1991. 115 pp.

3922. *Jamaica Talk: Three Hundred Years of the English Language in Jamaica.* Frederic Gomes Cassidy. New York, NY: Macmillan Education; 1982. 468 pp. Reprint of the 1961 ed.

3923. *Jamaican Creole Syntax: A Transformational Approach.* Beryl Loftman Bailey. New York, NY: Cambridge University Press; 1966. 164 pp.

3924. *Jamaican Creole: An Historical Introduction to Jamaican Creole.* Robert Brock Le Page. New York, NY: St. Martin's Press; 1960. 182 pp.

3925. *Language and Communication in the Caribbean.* Marlene Cuthbert, Michael W. Pidgeon, eds. 3d ed. Bridgetown: Cedar Press; 1981. 169 pp.

3926. *Language and Liberation: Creole Language Politics in the Caribbean.* Hubert Devonish. London: Karia Press; 1986. 157 pp.

3927. *Language in Exile: Three Hundred Years of Jamaican Creole.* Barbara Lalla, Jean D'Costa. Tuscaloosa, AL: University of Alabama Press; 1990. 253 pp.

3928. *Languages of the West Indies.* Douglas MacRae Taylor. Baltimore, MD: Johns Hopkins University Press; 1977. 278 pp.

3929. *La langue créole, force jugulée: étude socio-linguistique des rapports de force entre le créole et le français aux Antilles.* Dany Bébel-Gisler. Paris: L'Harmattan; 1976. 255 pp.

3930. *Langue et littérature des aborigènes d'Ayti.* Jean Fouchard. [Nouv. éd.]. Port-au-Prince: H. Deschamps; 1988. 112 pp.

3931. *La langue française en Haïti.* Pradel Pompilus. Paris: Institut des hautes études de l'Amérique Latine; 1981. 278 pp. Reprint of the 1961 ed.

3932. *Lengua mayor: ensayos sobre el español de aquí y de allá.* Salvador Tío. Río Piedras, P.R.: Plaza Mayor; 1991. 188 pp. About Puerto Rico.

3933. *Manuscript of the Belizean Lingo.* George McKesey. Belize City: National Printers; 1974. 106 pp.

198 Bibliography

3934. *Notes for a Glossary of Words and Phrases of Barbadian Dialect.* Frank Collymore. Bridgetown: Barbados National Trust; 1992. 122 pp. Cover title *Barbadian Dialect;* reprint of the 1965 (3d) ed.

3935. *Papiamentu: Problems and Possibilities/Papiamentu: problema i posibilidad—Papers Presented at a Conference, 4–6 June 1981.* Universiteit van de Nederlandse Antillen [and] Instituto pa Promoshon i Estudio di Papiamentu. Zutphen: Walburg Pers; 1983. 96 pp.

3936. *Philologie créole: études historiques et étymologiques sur la langue créole d'Haïti.* Jules Faine. Geneva: Slatkine Reprints; 1981. 303 pp. Reprint of the 1936 ed.

3937. *Saying and Meaning in Puerto Rico: Some Problems in the Ethnography of Discourse.* Marshall Morris. New York, NY: Pergamon Press; 1981. 152 pp.

3938. *Smoky Joe Says: A Volume in Bahamian Dialect.* Eugene Dupuch. Nassau: Nassau Daily Tribune; 1936. 130 pp.

3939. *Sranan Syntax.* Jan Voorhoeve. Amsterdam: North-Holland Publishing Co.; 1962. 91 pp.

3940. *St. Lucian Creole: A Descriptive Analysis of Its Phonology and Morpho-Syntax.* Lawrence D. Carrington. Hamburg: H. Buske; 1984. 180 pp.

3941. *Studies in Caribbean Language.* Lawrence D. Carrington, Dennis R. Craig, Ramón Todd-Dandaré, eds. St. Augustine, Trinidad/Tobago: Society for Caribbean Linguistics; 1983. 338 pp.

3942. *Transculturación e interferencia lingüística en el Puerto Rico contemporáneo, 1898–1968.* Germán de Granda Gutiérrez. Río Piedras, P.R.: Editorial Edil; 1980. 226 pp. Reprint of the 1968 ed.

3943. *La vocabulaire du parler créole de la Martinique.* Anne Marie Louise Jourdain. Paris: C. Klinkcsieck; 1956. 303 pp.

3944. *Voices in Exile: Jamaican Texts of the Eighteenth and Nineteenth Centuries.* Jean D'Costa, Barbara Lalla, eds. Tuscaloosa, AL: University of Alabama Press; 1989. 157 pp.

3945. *West Indians and Their Language.* Peter A. Roberts. New York, NY: Cambridge University Press; 1988. 215 pp.

3946. *Words Unchained: Language and Revolution in Grenada.* Chris Searle. Atlantic Highlands, NJ: Zed Books; 1984. 260 pp.

2. LITERATURE

a. Anthologies

3947. *Anthologie de la littérature française d'Haïti.* Maurice A. Van Zeebroeck, ed. Port-au-Prince: Editions du Soleil; 1985. 392 pp.

3948. *Antología de la literatura dominicana.* José Alcántara Almánzar. Santo Domingo: Editora Taller; 1988. 439 pp. Reprint of the 1972 ed.

3949. *Antología de la poesía de la mujer puertorriqueña.* Theresa Ortiz de Hadjopoulos, ed. New York, NY: Peninsula; 1981. 248 pp.

3950. *Una antología de poesía cubana.* Mariano Brull [et al.]; Diego García Elío, ed. Mexico City: Editorial Oasis; 1984. 235 pp.

3951. *Antología del cuento cubano contemporáneo.* Ambrosio Fornet, ed. Mexico City: Ediciones Era; 1979. 241 pp. Reprint of the 1967 ed.

3952. *Antología general de la literatura puertorriqueña: prosa, verso, teatro.* Josefina Rivera de Alvarez, Manuel Alvarez Nazario. Madrid: Ediciones Partenón; 1982– [vol. 1–].

3953. *Antología literaria dominicana.* Margarita Vallejo de Paredes [et al.], eds. Santo Domingo: Instituto Tecnológico de Santo Domingo; 1981. 5 vols.

3954. *Apalabramiento: diez cuentistas puertorriqueños de hoy.* Efraín Barradas, ed. Hanover, NH: Ediciones del Norte; 1983. 250 pp.

3955. *Aquí cuentan las mujeres: muestra y estudio de cinco narradoras puertorriqueñas.* Rosario Ferré [et al.]; María Magdalena Solá, ed. Río Piedras, P.R.: Ediciones Huracán; 1990. 177 pp.

3956. *Bahamian Anthology.* College of the Bahamas, ed. London: Macmillan Caribbean; 1983. 172 pp.

3957. *Borinquen: An Anthology of Puerto Rican Literature.* María Teresa Babín, Stan Steiner, eds. New York, NY: Knopf; 1974. 515 pp.

3958. *Breaking the Silences: An Anthology of Twentieth-Century Poetry by Cuban Women.* Margaret Randall, ed. and tr. Vancouver: Pulp Press; 1982. 293 pp.

3959. *Breaklight: The Poetry of the Caribbean.* Andrew Salkey, ed. Garden City, NY: Doubleday; 1972. 265 pp.

3960. *Caribbean Literature: an Anthology.* George Robert Coulthard, ed. London: University of London Press; 1966. 127 pp.

3961. *Caribbean Narrative: An Anthology of West Indian Writing.* O. R. Dathorne, ed. Portsmouth, NH: Heinemann Educational; 1966. 247 pp.

3962. *Caribbean New Wave: Contemporary Short Stories.* Stewart Brown, ed. Portsmouth, NH: Heinemann International; 1990. 181 pp.

3963. *Caribbean Plays for Playing.* Keith Noel, ed. Portsmouth, NH: Heinemann International; 1985. 163 pp.

3964. *Caribbean Poetry Now.* Stewart Brown, ed. 2d ed. New York, NY: E. Arnold; 1992. 212 pp.

3965. *Caribbean Rhythms: The Emerging English Literature of the West Indies.* James T. Livingston, ed. New York, NY: Washington Square Press; 1974. 379 pp.

3966. *Caribbean Stories/Cuentos del Caribe.* Blanca Acosta, Samuel Goldberg, Ileana Sanz, eds. Havana: Casa de las Américas; 1977. 274 pp.

3967. *Caribbean Verse: An Anthology.* O. R. Dathorne, ed. Portsmouth, NH: Heinemann Educational; 1979. 131 pp. Reprint of the 1967 ed.

3968. *Caribbean Voices: An Anthology of West Indian Poetry.* John J. Figueroa, ed. 2d ed. London: Evans; 1982– [vols. 1–2+].

3969. *The Caribbean Writer.* Caribbean Research Institute. Frederiksted, V.I.: The Institute; 1987– [vol. 1–]. Annual.

3970. *Combatidas, combativas y combatientes: antología de cuentos escritos por mujeres dominicanas.* Daisy Cocco-DeFillipis, ed. Santo Domingo: Editora Taller; 1992. 446 pp.

3971. *Con Cuba: An Anthology of Cuban Poetry of the Last Sixty Years.* Nathaniel Tarn, ed.; Elinor Randall [et al.], trs. London: Cape Goliard; 1969. 142 pp.

3972. *Creation Fire: A CAFRA Anthology of Caribbean Women's Poetry.* Ramabai Espinet, ed. Toronto: Sister Vision; 1990. 371 pp.

3973. *Creole Drum: An Anthology of Creole Literature in Surinam.* Jan Voorhoeve, Ursy M. Lichtveld, eds.; Vernie A. February, tr. New Haven, CT: Yale University Press; 1975. 308 pp.

3974. *Cuban Consciousness in Literature, 1923–1974: A Critical Anthology of Cuban Culture.* José R. de Armas, Charles W. Steele. Miami, FL: Ediciones Universal; 1978. 243 pp.

3975. *Cuentos del Caribe.* Leonardo Fernández Marcané, ed. Madrid: Playor; 1978. 280 pp.

3976. *Cuentos puertorriqueños de hoy.* Abelardo Milton Díaz Alfaro [et al.]; René Marqués, ed. Río Piedras, P.R.: Editorial Cultural; 1990. 287 pp. Reprint of the 1959 (3d) ed.

3977. *Cuentos: An Anthology of Short Stories from Puerto Rico.* Kal Wagenheim, ed. New York, NY: Schocken Books; 1978. 170 pp.

3978. *Dark Against the Sky: An Anthology of Poems and Short Stories from Montserrat.* Howard A. Fergus, Larry Rowdon, eds. Montserrat: School of Continuing Studies, University of the West Indies; 1990. 96 pp.

3979. *Del silencio al estallido: narrativa femenina puertorriqueña.* Ramón Luis Acevedo, ed. Río Piedras, P.R.: Editorial Cultural; 1991. 259 pp.

3980. *Los dispositivos en la flor: Cuba, literatura desde la Revolución.* Edmundo Desnoes, William Luis, eds. Hanover, NH: Ediciones del Norte; 1981. 557 pp.

3981. *The Faber Book of Contemporary Caribbean Short Stories.* Mervyn Morris, ed. Boston, MA: Faber and Faber; 1990. 275 pp.

3982. *From Our Yard: Jamaican Poetry Since Independence.* Pamela Morde-
cai, ed. Kingston: Institute of Jamaica; 1987. 235 pp.

3983. *From the Green Antilles: Writings of the Caribbean.* Barbara Howes, ed.
London: Panther; 1980. 397 pp. Reprint of the 1966 ed.

3984. *From Trinidad: An Anthology of Early West Indian Writing.* Reinhard
Sander, Peter K. Ayers, eds. New York, NY: Africana; 1978. 310 pp.

3985. *Guianese Poetry: Covering the Hundred Years' Period 1831–1931.* Nor-
man Eustace Cameron, ed. Millwood, NY: Kraus Reprint; 1970. 186 pp.
Reprint of the 1931 ed.

3986. *Her True-True Name: An Anthology of Women's Writing from the
Caribbean.* Pamela Mordecai, Betty Wilson, eds. Portsmouth, NH: Hei-
nemann International; 1989. 202 pp.

3987. *Heritage: A Caribbean Anthology.* Esmor Jones, Wenty Bowen, eds. Lon-
don: Cassell; 1981. 224 pp.

3988. *Hinterland: Caribbean Poetry from the West Indies and Britain.* Edward
Archibald Markham, ed. Newcastle upon Tyne, Eng.: Bloodaxe; 1989.
335 pp.

3989. *Inventing a Word: An Anthology of Twentieth-Century Puerto Rican Po-
etry.* Julio Marzán, ed. New York, NY: Columbia University Press; 1980.
184 pp.

3990. *Jahaji Bhai: An Anthology of Indo-Caribbean Literature.* Frank Birbal-
singh, ed. Toronto: TSAR; 1988. 151 pp.

3991. *Jamaica Woman: An Anthology of Poems.* Pamela Mordecai, Mervyn
Morris, eds. Kingston: Heinemann; 1987. 110 pp. Reprint of the 1980 ed.

3992. *Literatura puertorriqueña: antología general.* Edgar Martínez Masdeu,
Esther Melón de Díaz. Río Piedras, P.R.: Editorial Edil; 1990. 2 vols.
Reprint of the 1972 (2d) ed.

3993. *Naturaleza y alma de Cuba: dos siglos de poesía cubana, 1760–1960.*
Carlos Ripoll, Alfredo E. Figueredo, eds. New York, NY: Las Américas;
1974. 242 pp.

3994. *New Planet: Anthology of Modern Caribbean Writing.* Sebastian Clarke,
ed. London: Caribbean Culture International; 1978. 93 pp.

3995. *New Writing in the Caribbean.* Arthur J. Seymour, ed. Georgetown: [s.n.];
1972. 324 pp.

3996. *News for Babylon: The Chatto Book of Westindian-British Poetry.* James
Berry, ed. London: Chatto and Windus; 1984. 212 pp.

3997. *Panorama de la littérature à la Martinique.* Auguste Joyau, ed. Morne-
Rouge: Editions des Horizons caraïbes; 1974–1977. 2 vols.

3998. *The Penguin Book of Caribbean Verse in English.* Paula Burnett, ed. New
York, NY: Penguin; 1986. 447 pp.

3999. *Poesía afroantillana y negrista: Puerto Rico, República Dominicana, Cuba*. Jorge Luis Morales, ed. Nueva ed., rev. y aum. Río Piedras, P.R.: Editorial Universitaria, Universidad de Puerto Rico; 1981. 456 pp.

4000. *Poesía negra del Caribe y otras áreas*. Hortensia Ruiz del Vizo, ed. Miami, FL: Ediciones Universal; 1972. 164 pp.

4001. *Poesía puertorriqueña*. Carmen Gómez Tejera, Ana María Losada, Jorge Luis Porras. Mexico City: Editorial Orión; 1990. 425 pp. Reprint of the 1956 ed.

4002. *La poésie antillaise*. Maryse Condé, Bernard Lecherbonnier, eds. Paris: F. Nathan; 1977. 96 pp.

4003. *The Poets of Haiti, 1782–1934*. Edna Worthley Underwood, ed. and tr. Portland, ME: Mosher Press; 1934. 159 pp.

4004. *The Puerto Rican Poets/Los poetas puertorriqueños*. Alfredo Matilla Rivas, Iván Silén, eds. New York, NY: Bantam; 1972. 238 pp.

4005. *Le roman antillais*. Maryse Condé, Bernard Lecherbonnier, eds. Paris: F. Nathan; 1977. 2 vols.

4006. *Stories from the Caribbean: An Anthology*. Andrew Salkey, ed. 2d ed. London: Elek; 1972. 257 pp.

4007. *Sun Island Jewels: An Anthology of Virgin Islands Poetry*. Valdemar A. Hill, ed. Charlotte Amalie, V.I.: Val Hill Enterprises; 1975. 64 pp.

4008. *A Treasury of Guyanese Poetry*. Arthur J. Seymour, ed. Georgetown: [s.n.]; 1980. 233 pp.

4009. *A Treasury of Jamaican Poetry*. John Ebenezer Clare McFarlane, ed. London: University of London Press; 1949. 159 pp.

4010. *Voiceprint: An Anthology of Oral and Related Poetry from the Caribbean*. Stewart Brown, Mervyn Morris, Gordon Rohlehr, eds. Harlow, Eng.: Longman Caribbean; 1989. 276 pp.

4011. *West Indian Narrative: An Introductory Anthology*. Kenneth Ramchand, ed. Walton-on-Thames, Eng.: Nelson Caribbean; 1988. 214 pp. Reprint of the 1980 (rev.) ed.

4012. *Writers in the New Cuba: An Anthology*. John Michael Cohen, ed. and tr. Baltimore, MD: Penguin; 1967. 191 pp.

b. History and Criticism

4013. *La africanía en el cuento cubano y puertorriqueño*. María Carmen Zielina. Miami, FL: Ediciones Universal; 1992. 198 pp.

4014. *Anancy in the Great House: Ways of Reading West Indian Fiction*. Joyce Jonas. New York, NY: Greenwood Press; 1990. 149 pp.

4015. *Apuntes sobre poesía popular y poesía negra en las Antillas*. Tomás Rafael Hernández Franco. Santo Domingo: Sociedad Dominicana de Bibliófilos; 1978. 71 pp. Reprint of the 1942 ed.

4016. *The Black Protagonist in the Cuban Novel.* Pedro Barreda; Page Bancroft, tr. Amherst, MA: University of Massachusetts Press; 1979. 179 pp. Translation of *La caracterización del protagonista negro en la novela cubana.*

4017. *Black Time: Fiction of Africa, the Caribbean, and the United States.* Bonnie J. Barthold. New Haven, CT: Yale University Press; 1981. 209 pp.

4018. *Breve historia de la literatura antillana.* Otto Olivera. Mexico City: Ediciones de Andrea; 1957. 222 pp.

4019. *Caraïbales: études sur la littérature antillaise.* Jacques André. Paris: Editions caribéennes; 1981. 169 pp.

4020. *The Caribbean Novel in Comparison.* Conference of Hispanists (Ninth, 1986, University of the West Indies); Ena V. Thomas, ed. St. Augustine, Trinidad/Tobago: Dept. of French and Spanish Literature, University of the West Indies; 1986. 140 pp.

4021. *Caribbean Women Writers: Essays.* International Conference on the Women Writers of the English-Speaking Caribbean (First, 1988, Wellesley College); Selwyn Reginald Cudjoe, ed. Wellesley, MA: Cataloux Publications; 1990. 382 pp.

4022. *Caribbean Writers: Critical Essays.* Ivan Van Sertima. London: New Beacon; 1968. 67 pp.

4023. *The Colonial Legacy in Caribbean Literature.* Amon Saba Saakana. Trenton, NJ: Africa World Press; 1987– [vol. 1–].

4024. *La creación mitopoética: símbolos y arquetipos en la lírica dominicana.* Bruno Rosario Candelier. Santiago, D.R.: Pontificia Universidad Católica Madre y Maestra; 1989. 252 pp.

4025. *Crítica cubana.* Cintio Vitier. Havana: Editorial Letras Cubanas; 1988. 570 pp.

4026. *Critical Issues in West Indian Literature: Selected Papers from West Indian Literature Conferences, 1981–1983.* Erika Smilowitz, Roberta Knowles, eds. Parkersburg, IA: Caribbean Books; 1984. 136 pp.

4027. *Critics on Caribbean Literature: Readings in Literary Criticism.* Edward Baugh, ed. New York, NY: St. Martin's Press; 1978. 164 pp.

4028. *The Cuban Condition: Translation and Identity in Modern Cuban Literature.* Gustavo Pérez Firmat. New York, NY: Cambridge University Press; 1989. 185 pp.

4029. *Dark Ancestor: The Literature of the Black Man in the Caribbean.* O. R. Dathorne. Baton Rouge, LA: Louisiana State University Press; 1981. 288 pp.

4030. *The Docile Puerto Rican: Essays.* René Marqués; Barbara Bockus Aponte, tr. Philadelphia, PA: Temple University Press; 1976. 137 pp. Translation of *Ensayos.*

4031. *Los escritores dominicanos y la cultura.* José Alcántara Almánzar. Santo Domingo: Instituto Tecnológico de Santo Domingo; 1990. 226 pp.

4032. *Esquema histórico de las letras en Cuba, 1548–1902.* José Antonio Fernández de Castro. Havana: Depto. de Intercambio Cultural, Universidad de la Habana; 1949. 145 pp.

4033. *Essays on Haitian Literature.* Léon-François Hoffmann. Washington, DC: Three Continents Press; 1984. 184 pp.

4034. *Haiti and the United States: National Stereotypes and the Literary Imagination.* J. Michael Dash. New York, NY: St. Martin's Press; 1988. 152 pp.

4035. *Haïti: lettres et l'être.* Léon-François Hoffmann. Toronto: Editions du GREF; 1992. 371 pp.

4036. *Histoire de la littérature haïtienne: ou, "L'âme noir".* Duraciné Vaval. 2e éd. Port-au-Prince: Editions Fardin; 1986. 2 vols.

4037. *Historia crítica del teatro dominicano.* José Molinaza. Santo Domingo: Universidad Autónoma de Santo Domingo; 1984– [vols. 1–2+].

4038. *Historia de la literatura cubana.* Juan José Remos y Rubio. Miami, FL: Mnemosyne; 1969. 3 vols. Reprint of the 1945 ed.

4039. *Historia de la literatura dramática cubana.* José Juan Arrom. New York, NY: AMS Press; 1973. 132 pp. Reprint of the 1944 ed.

4040. *Historia de la literatura puertorriqueña.* Francisco Manrique Cabrera. Río Piedras, P.R.: Editorial Cultural; 1986. 384 pp. Reprint of the 1956 ed.

4041. *Historia de la literatura dominicana.* Joaquín Balaguer. Santo Domingo: Editora Corripio; 1988. 370 pp. Reprint of the 1968 (4th, rev.) ed.

4042. *Historia panorámica de la literatura puertorriqueña, 1589–1959.* Cesáreo Rosa-Nieves. San Juan: Editorial Campos; 1963. 2 vols.

4043. *History of the Voice: The Development of Nation Language in Anglophone Caribbean Poetry.* Edward Kamau Brathwaite. London: New Beacon; 1984. 87 pp.

4044. *L'homme et l'identité dans le roman des Antilles et Guyane françaises.* André Ntonfo. Sherbrooke, Que.: Naaman; 1982. 254 pp.

4045. *Humour in Spanish Caribbean Literature.* Conference of Hispanists (Seventh, 1984, University of the West Indies). Cave Hill, Barbados: Dept. of French and Spanish, University of the West Indies; 1986. 117 pp.

4046. *Images and Identities: The Puerto Rican in Two World Contexts.* Asela Rodríguez-Seda de Laguna, ed. New Brunswick, NJ: Transaction Books; 1987. 276 pp.

4047. *An Introduction to the Study of West Indian Literature.* Kenneth Ramchand. Sunbury-on-Thames, Eng.: Nelson Caribbean; 1976. 183 pp.

4048. *An Introduction to the French Caribbean Novel.* Beverley Ormerod. Portsmouth, NH: Heinemann; 1985. 152 pp.

4049. *Island Voices: Stories from the West Indies.* Andrew Salkey, ed. New York, NY: Liveright; 1970. 256 pp.

4050. *The Islands in Between: Essays on West Indian Literature.* Louis James, ed. London: Oxford University Press; 1968. 166 pp.

4051. *Literary Bondage: Slavery in Cuban Narrative.* William Luis. Austin, TX: University of Texas Press; 1990. 312 pp.

4052. *Literatura puertorriqueña: su proceso en el tiempo.* Josefina Rivera de Alvarez. Madrid: Ediciones Partenón; 1983. 953 pp.

4053. *Literatura y sociedad en Puerto Rico: de los cronistas de Indias a la generación del 98.* José Luis González. Mexico City: Fondo de Cultura Económica; 1976. 246 pp.

4054. *Literature and Ideology in Haiti, 1915–1961.* J. Michael Dash. Totowa, NJ: Barnes and Noble; 1981. 213 pp.

4055. *Literatures in Transition: The Many Voices of the Caribbean Area—A Symposium.* Rose S. Minc, ed. Gaithersburg, MD: Hispamérica; 1982. 197 pp.

4056. *La littérature des Antilles-Guyane françaises.* Jack Corzani. Fort-de-France: Désormeaux; 1978. 6 vols.

4057. *Major Cuban Novelists: Innovation and Tradition.* Raymond D. Souza. Columbia, MO: University of Missouri Press; 1976. 120 pp.

4058. *One Master for Another: Populism as Patriarchal Rhetoric in Dominican Novels.* Doris Sommer. Lanham, MD: University Press of America; 1983. 280 pp.

4059. *Les origines sociales de la littérature haïtienne.* Hénock Trouillot. Port-au-Prince: Editions Fardin; 1986. 376 pp. Reprint of the 1962 ed.

4060. *Out of the Kumbla: Caribbean Women and Literature.* Carole Boyce Davies, Elaine Savory Fido, eds. Trenton, NJ: Africa World Press; 1990. 399 pp.

4061. *Panorama histórico de la literatura dominicana.* Max Henríquez Ureña. 2a ed., rev. y ampliada. Santo Domingo: [s.n.]; 1965– [vols. 1–2+].

4062. *Panorama histórico de la literatura cubana.* Max Henríquez Ureña. Havana: Editorial Arte y Literatura; 1978–1979. 2 vols. Reprint of the 1963 ed.

4063. *La parole des femmes: essai sur des romancières des Antilles de langue française.* Maryse Condé. Paris: L'Harmattan; 1979. 136 pp.

4064. *Passion and Exile: Essays in Caribbean Literature.* Frank Birbalsingh. London: Hansib; 1988. 186 pp.

4065. *Plumas estelares en las letras de Puerto Rico.* Cesáreo Rosa-Nieves. Río Piedras, P.R.: Ediciones de la Torre, Universidad de Puerto Rico; 1967–1971. 2 vols.

4066. *La poesía afroantillana.* Leslie N. Wilson. Miami, FL: Ediciones Universal; 1981. 182 pp.

4067. *La poesía en Puerto Rico: historia de los temas poéticos en la literatura puertorriqueña.* Cesáreo Rosa-Nieves. San Juan: Editorial Edil; 1969. 301 pp. Reprint of the 1958 (2d, rev.) ed.

4068. *Poetry of the Spanish-Speaking Caribbean.* Conference of Latin-Americanists (Third, 1980, University of the West Indies). Mona, Jamaica: Dept. of Spanish, University of the West Indies; 1980. 166 pp.

4069. *Prose Fiction of the Cuban Revolution.* Seymour Menton. Austin, TX: University of Texas Press; 1975. 344 pp.

4070. *Race and Colour in Caribbean Literature.* George Robert Coulthard. New York, NY: Oxford University Press; 1962. 152 pp. Translation of *Raza y color en la literatura antillana.*

4071. *A Reader's Guide to West Indian and Black British Literature.* David Dabydeen, Nana Wilson-Tagoe, eds. London: Hansib; 1988. 182 pp.

4072. *Reapropiaciones: cultura y nueva escritura en Puerto Rico.* Julio Ortega. Río Piedras, P.R.: Editorial de la Universidad de Puerto Rico; 1991. 252 pp.

4073. *The Renaissance of Haitian Poetry.* Naomi Mills Garrett. Paris: Présence africaine; 1963. 257 pp.

4074. *Resistance and Caribbean Literature.* Selwyn Reginald Cudjoe. Athens, OH: Ohio University Press; 1980. 319 pp.

4075. *Le roman haïtien: idéologie et structure.* Léon-François Hoffmann. Sherbrooke, Que.: Editions Naaman; 1982. 329 pp.

4076. *Spanish Caribbean Narrative: Proceedings.* Conference of Hispanists (First, 1977, University of the West Indies) [and] Conference of Hispanists (Fourth, 1981, University of the West Indies). Mona, Jamaica: Dept. of Spanish, University of the West Indies; 1983. 258 pp.

4077. *The Theatrical into Theatre: A Study of the Drama and Theatre of the English-Speaking Caribbean.* Kole Omotoso. London: New Beacon; 1982. 173 pp.

4078. *The Trinidad Awakening: West Indian Literature of the Nineteen-Thirties.* Reinhard Sander. New York, NY: Greenwood Press; 1988. 168 pp.

4079. *Van Maria tot Rosy: over Antilliaanse literatuur [From Maria to Rosy: About Antillean Literature].* Harry Theirlynck. Leiden: Caraïbische Afdeling, Koninklijk Instituut voor Taal-, Land- en Volkenkunde; 1986. 107 pp.

4080. *Voices from Under: Black Narrative in Latin America and the Caribbean.* William Luis, ed. Westport, CT: Greenwood Press; 1984. 263 pp.

4081. *West Indian Literature.* Bruce Alvin King, ed. Hamden, CT: Archon Books; 1979. 247 pp.

4082. *West Indian Literature and Its Social Context: Proceedings.* Conference on West Indian Literature (Fourth, 1984, University of the West Indies); Mark A. McWatt, ed. Cave Hill, Barbados: Dept. of English, University of the West Indies; 1985. 163 pp.

4083. *The West Indian Novel and Its Background.* Kenneth Ramchand. 2d ed. Exeter, NH: Heinemann; 1983. 310 pp.

4084. *The West Indian Novel.* Michael Gilkes. Boston, MA: Twayne; 1981. 168 pp.

4085. *West Indian Poetry.* Lloyd Wellesley Brown. 2d ed. Exeter, NH: Heinemann Educational; 1984. 202 pp.

4086. *Whispers from the Caribbean: I Going Away, I Going Home.* Wilfred G. Cartey. Los Angeles, CA: Center for Afro-American Studies, University of California; 1991. 503 pp.

c. Criticism and Interpretation

4087. *Aimé Césaire.* Daniel Delas. Paris: Hachette; 1991. 223 pp.

4088. *Aimé Césaire.* Janis L. Pallister. Boston, MA: Twayne; 1991. 149 pp.

4089. *Aimé Césaire: Black Between Worlds.* Susan Frutkin. Coral Gables, FL: Center for Advanced International Studies, University of Miami; 1973. 66 pp.

4090. *Alejo Carpentier.* Donald Leslie Shaw. Boston, MA: Twayne; 1985. 150 pp.

4091. *El almuerzo en la hierba [Lloréns Torres, Palés Matos, René Marqués].* Arcadio Díaz Quiñones. Río Piedras, P.R.: Ediciones Huracán; 1982. 168 pp.

4092. *Antilia retrouvée: Claude McKay, Luis Palés Matos, Aimé Césaire, poètes noirs antillais.* Jean-Claude Bajeux. Paris: Editions caribéennes; 1983. 431 pp.

4093. *The Art of Derek Walcott.* Stewart Brown, ed. Chester Springs, PA: Dufour Editions; 1991. 231 pp.

4094. *C. L. R. James's Caribbean.* Paget Henry, Paul Buhle, eds. Durham, NC: Duke University Press; 1992. 287 pp.

4095. *C. L. R. James: The Artist as Revolutionary.* Paul Buhle. New York, NY: Verso; 1988. 197 pp.

4096. *Claude McKay: Rebel Sojourner in the Harlem Renaissance—A Biography.* Wayne F. Cooper. Baton Rouge, LA: Louisiana State University Press; 1987. 441 pp.

4097. *La cosmovisión poética de José Lezama Lima en Paradiso y Oppiano Licario.* Alina L. Camacho Rivero de Gingerich. Miami, FL: Ediciones Universal; 1990. 169 pp.

4098. *Critical Perspectives on V. S. Naipaul.* Robert D. Hamner, ed. Washington, DC: Three Continents Press; 1977. 300 pp.

4099. *Cuba's Nicolás Guillén: Poetry and Ideology.* Keith Ellis. Buffalo, NY: University of Toronto Press; 1983. 251 pp.

4100. *Derek Walcott.* Robert D. Hamner. Boston, MA: Twayne; 1981. 175 pp.

4101. *Engagement and the Language of the Subject in the Poetry of Aimé Césaire.* Ronnie Leah Scharfman. Gainesville, FL: University Presses of Florida; 1987. 133 pp.

4102. *Harlem, Haiti, and Havana: A Comparative Critical Study of Langston Hughes, Jacques Roumain, Nicolás Guillén.* Martha K. Cobb. Washington, DC: Three Continents Press; 1978. 250 pp.

4103. *Jean Rhys: Life and Work.* Carole Angier. Boston, MA: Little, Brown; 1991. 762 pp.

4104. *Jean Rhys: The West Indian Novels.* Teresa F. O'Connor. New York, NY: New York University Press; 1986. 247 pp.

4105. *José Lezama Lima's Joyful Vision: A Study of Paradiso and Other Prose Works.* Gustavo Pellón. Austin, TX: University of Texas Press; 1989. 151 pp.

4106. *José Lezama Lima: bases y génesis de un sistema poético.* Enrique Márquez. New York, NY: P. Lang; 1991. 224 pp.

4107. *José Lezama Lima: Poet of the Image.* Emilio Bejel. Gainesville, FL: University of Florida Press; 1990. 178 pp.

4108. *Journey Through Darkness: The Writing of V. S. Naipaul.* Peggy Nightingale. St. Lucia, Australia: University of Queensland Press; 1987. 255 pp.

4109. *A Knot in the Thread: The Life and Work of Jacques Roumain.* Carolyn Fowler. Washington, DC: Howard University Press; 1980. 383 pp.

4110. *Lino Novás Calvo.* Raymond D. Souza. Boston, MA: Twayne; 1981. 146 pp.

4111. *The Literate Imagination: Essays on the Novels of Wilson Harris.* Michael Gilkes, ed. London: Macmillan Caribbean; 1989. 208 pp.

4112. *London Calling: V. S. Naipaul, Postcolonial Mandarin.* Rob Nixon. New York, NY: Oxford University Press; 1992. 229 pp.

4113. *Modernism and Negritude: The Poetry and Poetics of Aimé Césaire.* Albert James Arnold. Cambridge, MA: Harvard University Press; 1981. 318 pp.

4114. *Nicolás Guillén: Popular Poet of the Caribbean.* Ian Smart. Columbia, MO: University of Missouri Press; 1990. 187 pp.

4115. *La obra narrativa de Alejo Carpentier.* Alexis Márquez Rodríguez. Caracas: Universidad Central de Venezuela; 1970. 220 pp.

4116. *Paradoxes of Order: Some Perspectives on the Fiction of V. S. Naipaul.* Robert K. Morris. Columbia, MO: University of Missouri Press; 1975. 105 pp.

4117. *La poesía de Nicolás Guillén: cuatro elementos sustanciales.* Jorge María Ruscalleda Bercedóniz. Río Piedras, P.R.: Editorial Universitaria, Universidad de Puerto Rico; 1975. 310 pp.

4118. *La poesía de Nicolás Guillén: seguido de una antología del poeta.* Ezequiel Martínez Estrada, Horacio Salas. Buenos Aires: Calicanto Editorial; 1977. 151 pp.

4119. *The Poet's Africa: Africanness in the Poetry of Nicolás Guillén and Aimé Césaire.* Josaphat Bekunuru Kubayanda. New York, NY: Greenwood Press; 1990. 176 pp.

4120. *The Poetic Fiction of José Lezama Lima.* Raymond D. Souza. Columbia, MO: University of Missouri Press; 1983. 149 pp.

4121. *René Marqués.* Eleanor J. Martin. Boston, MA: Twayne; 1979. 168 pp.

4122. *René Marqués: A Study of His Fiction.* Charles R. Pilditch. New York, NY: Plus Ultra; 1977. 245 pp.

4123. *Self and Society in the Poetry of Nicolás Guillén.* Lorna V. Williams. Baltimore, MD: Johns Hopkins University Press; 1982. 177 pp.

4124. *Smile Please: An Unfinished Autobiography.* Jean Rhys. New York, NY: Harper and Row; 1979. 151 pp.

4125. *Surinaamse schrijvers en dichters: met honderd schrijversprofielen en een lijst van pseudoniemen [Surinamese Authors and Poets: With a Hundred Profiles and a List of Pseudonyms].* Michiel van Kempen. Amsterdam: Arbeiderspers; 1989. 191 pp.

4126. *La temática novelística de Alejo Carpentier.* José Sánchez-Boudy. Miami, FL: Ediciones Universal; 1969. 208 pp.

4127. *Tribute to a Scholar: Appreciating C. L. R. James.* Bishnu Ragoonath, ed. Kingston: Consortium Graduate School of Social Sciences; 1990. 114 pp.

4128. *V. S. Naipaul and the West Indies.* Dolly Zulakha Hassan. New York, NY: P. Lang; 1989. 376 pp.

4129. *V. S. Naipaul.* Peter Hughes. New York, NY: Routledge; 1988. 114 pp.

4130. *V. S. Naipaul.* Robert D. Hamner. Boston, MA: Twayne; 1973. 181 pp.

4131. *V. S. Naipaul.* William Walsh. New York, NY: Barnes and Noble; 1973. 94 pp.

4132. *V. S. Naipaul: A Materialist Reading.* Selwyn Reginald Cudjoe. Amherst, MA: University of Massachusetts Press; 1988. 287 pp.

4133. *Voices of the Storyteller: Cuba's Lino Novás Calvo.* Lorraine Elena Roses. Westport, CT: Greenwood Press; 1986. 155 pp.

4134. *Wilson Harris.* Hena Maes-Jelinek. Boston, MA: Twayne; 1982. 191 pp.

G. Politics and Government

1. GOVERNMENT AND ADMINISTRATION

4135. *African and Caribbean Politics: From Kwame Nkrumah to the Grenada Revolution.* Manning Marable. London: Verso; 1987. 314 pp. Spine title *African and Caribbean Politics from Kwame Nkrumah to Maurice Bishop.*

4136. *The Aftermath of Sovereignty: West Indian Perspectives.* David Lowenthal, Lambros Comitas, eds. Garden City, NY: Anchor Books; 1973. 422 pp.

4137. *And the Russians Stayed: The Sovietization of Cuba—A Personal Portrait.* Néstor T. Carbonell. New York, NY: Morrow; 1989. 384 pp.

4138. *Approaches to Caribbean Political Integration.* Patrick A. M. Emmanuel. Cave Hill, Barbados: Institute of Social and Economic Research (Eastern Caribbean), University of the West Indies; 1987. 89 pp.

4139. *Arms and Politics in the Dominican Republic.* G. Pope Atkins. Boulder, CO: Westview Press; 1981. 158 pp.

4140. *Belize: Case Study for Democracy in Central America.* Julio A. Fernandez. Brookfield, VT: Avebury; 1989. 112 pp.

4141. *Bermudian Politics in Transition: Race, Voting, and Public Opinion.* Frank E. Manning. Hamilton: Island Press; 1978. 231 pp.

4142. *Big Revolution, Small Country: The Rise and Fall of the Grenada Revolution.* Jay R. Mandle. Lanham, MD: North-South; 1985. 107 pp.

4143. *Black Frenchmen: The Political Integration of the French Antilles.* Arvin Murch. Cambridge, MA: Schenkman; 1972. 156 pp.

4144. *Black Intellectuals and the Dilemmas of Race and Class in Trinidad.* Ivar Oxaal. Cambridge, MA: Schenkman; 1982. 317 pp. Joint reprint, with an updated epilogue, of *Black Intellectuals Come to Power* and *Race and Revolutionary Consciousness.*

4145. *Breakthrough from Colonialism: An Interdisciplinary Study of Statehood.* Grupo de Investigadores Puertorriqueños. Río Piedras, P.R.: Editorial de la Universidad de Puerto Rico; 1984. 2 vols.

4146. *Britain and the United States in the Caribbean: A Comparative Study in Methods of Development.* Mary Macdonald Proudfoot. Westport, CT: Greenwood Press; 1976. 434 pp. Reprint of the 1954 ed.

4747. *The British Caribbean from the Decline of Colonialism to the End of Federation*. Elisabeth Wallace. Buffalo, NY: University of Toronto Press; 1977. 274 pp.

4148. *British Policy Towards the Amerindians in British Guiana, 1803–1873*. Mary Noel Menezes. Oxford: Clarendon Press; 1977. 326 pp.

4149. *The British West Indies: The Search for Self-Government*. Morley Ayearst. New York, NY: New York University Press; 1960. 258 pp.

4150. *Les Caraïbes, des brulots sur la mer: ABC géopolitique du bassin caribéen*. Hector Elisabeth, Jean-Jacques Seymour. Paris: Editions caribéennes; 1981. 195 pp.

4151. *The Caribbean After Grenada: Revolution, Conflict, and Democracy*. Scott B. MacDonald, Harald M. Sandstrom, Paul B. Goodwin, eds. New York, NY: Praeger; 1988. 287 pp.

4152. *The Caribbean and World Politics: Cross Currents and Cleavages*. Jorge Heine, Leslie François Manigat, eds. New York, NY: Holmes and Meier; 1988. 385 pp.

4153. *The Caribbean as a Subordinate State System, 1945–1976*. Paul K. Sutton. Hull, Eng.: Dept. of Politics, University of Hull; 1980– [vol. 1–].

4154. *The Caribbean Community: Changing Societies and U.S. Policy*. Robert D. Crassweller. New York, NY: Praeger; 1972. 470 pp.

4155. *Caribbean Crusade*. James F. Mitchell. Waitsfield, VT: Concepts; 1989. 251 pp.

4156. *Caribbean Geopolitics: Toward Security Through Peace?* Andrés Serbín; Sabeth Ramirez, tr. Boulder, CO.: L. Rienner; 1990. 131 pp. Translation of *El Caribe, ¿zona de paz?*

4157. *The Caribbean Prepares for the Twenty-first Century*. Jorge I. Domínguez, Richard D. Fletcher, Robert A. Pastor. Boston, MA: World Peace Foundation; 1991. 56 pp.

4158. *The Caribbean Revolution*. Cheddi Jagan. Prague: Orbis Press Agency; 1979. 217 pp.

4159. *The Caribbean: Its Political Problems*. Conference on the Caribbean (Sixth, 1955, University of Florida); Alva Curtis Wilgus, ed. Gainesville, FL: University of Florida Press; 1956. 324 pp.

4160. *The Caribbean: Survival, Struggle, and Sovereignty*. Catherine A. Sunshine. 2d ed. Washington, DC: Ecumenical Program on Central America and the Caribbean (EPICA); 1988. 255 pp.

4161. *El Caribe contemporáneo*. Gérard Pierre-Charles. Mexico City: Siglo XXI Editores; 1987. 413 pp. Reprint of the 1981 ed.

4162. *El Caribe: elementos para una reflexión política a fines de los '80*. José Rodríguez Iturbe. Caracas: Ediciones Centauro; 1987. 157 pp.

4163. *Castro's Final Hour: The Secret Story Behind the Coming Downfall of Communist Cuba.* Andrés Oppenheimer. New York, NY: Simon and Schuster; 1992. 461 pp.

4164. *Caymanian Politics: Structure and Style in a Changing Island Society.* Ulf Hannerz. Stockholm: Dept. of Social Anthropology, University of Stockholm; 1974. 198 pp.

4165. *Cedulants and Capitulants: The Politics of the Coloured Opposition in the Slave Society of Trinidad, 1783–1838.* Carl C. Campbell. Port of Spain: Paria; 1992. 429 pp.

4166. *Central America and the Caribbean.* Graham Hovey, Gene Brown, eds. New York, NY: Arno Press; 1980. 412 pp. Articles from the *New York Times.*

4167. *Class, State, and Democracy in Jamaica.* Carl Stone. New York, NY: Praeger; 1986. 198 pp.

4168. *Coalitions of the Oppressed.* Edwin Jones. Mona, Jamaica: Institute of Social and Economic Research, University of the West Indies; 1987. 201 pp. About Jamaica, Guyana, and Trinidad.

4169. *The Colonial Agents of the British West Indies: A Study in Colonial Administration, Mainly in the Eighteenth Century.* Lillian Margery Penson. Totowa, NJ: Cass; 1971. 318 pp. Reprint of the 1924 ed.

4170. *Communism in Central America and the Caribbean.* Robert G. Wesson, ed. Stanford, CA: Hoover Institution Press; 1982. 177 pp.

4171. *Confederation of the British West Indies versus Annexation to the United States of America: A Political Discourse on the West Indies.* Louis S. Meikle. New York, NY: Negro Universities Press; 1969. 279 pp. Reprint of the 1912 ed.

4172. *The Costs of Regime Survival: Racial Mobilization, Elite Domination, and Control of the State in Guyana and Trinidad.* Percy C. Hintzen. New York, NY: Cambridge University Press; 1989. 240 pp.

4173. *Crisis in the Caribbean.* Fitzroy Ambursley, Robin Cohen, eds. New York, NY: Monthly Review Press; 1983. 271 pp.

4174. *Crown Colony Politics in Grenada, 1917–1951.* Patrick A. M. Emmanuel. Cave Hill, Barbados: Institute of Social and Economic Research (Eastern Caribbean), University of the West Indies; 1978. 198 pp.

4175. *Cuba After Communism.* Eliana A. Cardoso, Ann Helwege. Cambridge, MA: MIT Press; 1992. 148 pp.

4176. *Cuba in a Changing World.* Antonio Jorge, Jaime Suchlicki, Adolfo Leyva de Varona, eds. Coral Gables, FL: North-South Center, University of Miami; 1991. 130 pp.

4177. *Cuba in Transition: Crisis and Transformation.* Sandor Halebsky [et al.], eds. Boulder, CO: Westview Press; 1992. 244 pp.

4178. *Cuba Under the Platt Amendment, 1902–1934.* Louis A. Pérez. Pittsburgh, PA: University of Pittsburgh Press; 1986. 410 pp.

4179. *Cuba, Castro, and Revolution.* Jaime Suchlicki, ed. Coral Gables, FL: University of Miami Press; 1972. 250 pp.

4180. *Cuba: A Different America.* Wilber A. Chaffee, Gary Prevost, eds. Rev. ed. Totowa, NJ: Rowman and Littlefield; 1992. 192 pp.

4181. *Cuba: Continuity and Change.* Jaime Suchlicki, Antonio Jorge, Damián J. Fernández, eds. Coral Gables, FL: North-South Center, University of Miami; 1985. 190 pp.

4182. *Cuba: Dilemmas of a Revolution.* Juan M. Del Aguila. 2d, rev. and updated, ed. Boulder, CO: Westview Press; 1988. 228 pp.

4183. *Cuba: las estructuras del poder—la élite.* Manuel Sánchez Pérez. Miami, FL: Ediciones Universal; 1989. 255 pp.

4184. *Cuba: Order and Revolution.* Jorge I. Domínguez. Cambridge, MA: Harvard University Press; 1978. 683 pp.

4185. *Cuba: Politics, Economics, and Society.* Max Azicri. New York, NY: Pinter; 1988. 276 pp.

4186. *Cuba: The Revolution in Peril.* Janette Habel; Jon Barnes, tr. New York, NY: Verso; 1991. 241 pp. Translation of *Ruptures à Cuba.*

4187. *Cuba: The Shaping of Revolutionary Consciousness.* Tzvi Medin; Martha Grenzback, tr. Boulder, CO: L. Rienner; 1990. 191 pp.

4188. *Cuba: The Test of Time.* Jean Stubbs. New York, NY: Monthly Review Press; 1989. 142 pp.

4189. *Cuba: The Unfinished Revolution.* Enrique G. Encinosa. Austin, TX: Eakin Publications; 1988. 215 pp.

4190. *Cuban Politics: The Revolutionary Experiment.* Rhoda Pearl Rabkin. New York, NY: Praeger; 1991. 235 pp.

4191. *The Cuban Revolution into the 1990's: Cuban Perspectives.* Centro de Estudos sobre América, ed. Boulder, CO: Westview Press; 1992. 197 pp.

4192. *The Cubans: Voices of Change.* Lynn Geldof. New York, NY: St. Martin's Press; 1992. 358 pp.

4193. *Decisions of Nationhood: Political and Social Development in the British Caribbean.* Wendell Bell, Ivar Oxaal. Denver, CO: University of Denver; 1964. 99 pp.

4194. *Decolonization and Conflict in the United Nations: Guyana's Struggle for Independence.* Basil A. Ince. Cambridge, MA: Schenkman; 1974. 202 pp.

4195. *Democracies and Tyrannies of the Caribbean.* William Krehm. Westport, CT: L. Hill; 1984. 244 pp. Translation of *Democracia y tiranías en el Caribe.*

4196. *Democracy and Clientelism in Jamaica.* Carl Stone. New Brunswick, NJ: Transaction Books; 1980. 262 pp.

4197. *The Democratic Left in Exile: The Antidictatorial Struggle in the Caribbean, 1945–1959.* Charles D. Ameringer. Coral Gables, FL: University of Miami Press; 1974. 352 pp.

4198. *The Democratic Revolution in the West Indies: Studies in Nationalism, Leadership and the Belief in Progress.* Wendell Bell, ed. Cambridge, MA: Schenkman; 1967. 232 pp.

4199. *Democratic Socialism in Jamaica: The Political Movement and Social Transformation in Dependent Capitalism.* Evelyne Huber Stephens, John D. Stephens. Princeton, NJ: Princeton University Press; 1986. 423 pp.

4200. *The Democratic System in the Eastern Caribbean.* Donald C. Peters. Westport, CT: Greenwood Press; 1992. 242 pp.

4201. *Dependency and Change: Political Status Options for the U.S. Virgin Islands.* Carlyle G. Corbin. Tortola, V.I.: Aaronsrod; 1988. 103 pp.

4202. *Dictatorship and Development: The Methods of Control in Trujillo's Dominican Republic.* Howard John Wiarda. Gainesville, FL: University of Florida Press; 1968. 224 pp.

4203. *Dictatorship, Development and Disintegration: Politics and Social Change in the Dominican Republic.* Howard John Wiarda. Ann Arbor, MI: Xerox University Microfilms; 1975. 3 vols.

4204. *The Difficult Flowering of Surinam: Ethnicity and Politics in a Plural Society.* Edward Dew. Boston, MA: M. Nijhoff; 1978. 234 pp.

4205. *The Disillusioned Electorate: The Politics of Succession in Trinidad and Tobago.* Selwyn D. Ryan. Port of Spain: Inprint Caribbean; 1989. 344 pp.

4206. *Distant Neighbors in the Caribbean: The Dominican Republic and Jamaica in Comparative Perspective.* Richard S. Hillman, Thomas J. D'Agostino. New York, NY: Praeger; 1992. 197 pp.

4207. *Domination and Power in Guyana: A Study of the Police in a Third World Context.* George K. Danns. New Brunswick, NJ: Transaction Books; 1982. 193 pp.

4208. *The Dominican Republic: Rebellion and Repression.* Carlos María Gutiérrez; Richard E. Edwards, tr. New York, NY: Monthly Review Press; 1972. 172 pp.

4209. *The Dominican Republic: Politics and Development in an Unsovereign State.* Jan Knippers Black. Boston, MA: Allen and Unwin; 1986. 164 pp.

4210. *The Dutch Caribbean: Prospects for Democracy.* Betty Nelly Sedoc-Dahlberg, ed. New York, NY: Gordon and Breach; 1990. 333 pp.

4211. *Duvalier, Caribbean Cyclone: The History of Haiti and Its Present Government.* Jean Pierre O. Gingras. New York, NY: Exposition Press; 1967. 136 pp.

4212. *Early West Indian Government: Showing the Progress of Government in Barbados, Jamaica, and the Leeward Islands, 1660–1783.* Frederick G. Spurdle. Palmerston North, New Zealand: [s.n.]; 1962. 275 pp.

4213. *Eighteenth-Century Reforms in the Caribbean: Miguel de Muesas, Governor of Puerto Rico, 1769–76.* Altagracia Ortiz. Rutherford, NJ: Fairleigh Dickinson University Press; 1981. 258 pp.

4214. *Elecciones y partidos políticos de Puerto Rico.* Fernando Bayrón Toro. 4a ed. Mayagüez, P.R.: Editorial Isla; 1989. 364 pp.

4215. *Elections and Ethnicity in French Martinique: A Paradox in Paradise.* William F. S. Miles. New York, NY: Praeger; 1986. 284 pp.

4216. *Elections and Party Systems in the Commonwealth Caribbean, 1944–1991.* Patrick A. M. Emmanuel. St. Michael, Barbados: Caribbean Development Research Services (CADRES); 1992. 111 pp.

4217. *Europe in the Caribbean: The Policies of Great Britain, France and the Netherlands Towards Their West Indian Territories.* Harold Paton Mitchell. New York, NY: Cooper Square Publishers; 1973. 211 pp. Reprint of the 1963 ed.

4218. *Federation of the West Indies.* John Mordecai. Evanston, IL: Northwestern University Press; 1968. 484 pp. British ed. has title *The West Indies: The Federal Negotiations.*

4219. *Fifty Years of the Ballot: A Political History of Trinidad and Tobago.* George John. Port of Spain: Trinidad Express Newspapers; 1991. 80 pp.

4220. *Forbidden Freedom: The Story of British Guiana.* Cheddi Jagan. London: Hansib; 1989. 104 pp. Reprint of the 1954 ed.

4221. *Freedom and Welfare in the Caribbean: A Colonial Dilemma.* Annette Baker Fox. New York, NY: Harcourt, Brace; 1949. 272 pp.

4222. *The French Colonial Question, 1789–1791: Dealings of the Constituent Assembly with Problems Arising from the Revolution in the West Indies.* Mitchell Bennett Garrett. New York, NY: Negro Universities Press; 1970. 167 pp. Reprint of the 1916 ed.

4223. *From Colonialism to Co-operative Republic: Aspects of Political Development in Guyana.* Harold A. Lutchman. Río Piedras, P.R.: Institute of Caribbean Studies, University of Puerto Rico; 1974. 291 pp.

4224. *Geopolitics of the Caribbean: Ministates in a Wider World.* Thomas D. Anderson. New York, NY: Praeger; 1992. 175 pp. Reprint of the 1984 ed.

4225. *Government of the West Indies.* Humphrey Hume Wrong. New York, NY: Negro Universities Press; 1969. 190 pp. Reprint of the 1923 ed.

4226. *Grenada: Revolution in Reverse.* James Ferguson. London: Latin American Bureau; 1990. 138 pp.

4227. *Grenada: The Struggle Against Destabilization.* Chris Searle. New York, NY: W. W. Norton; 1983. 164 pp.

4228. *The Growth and Decline of the Cuban Republic.* Fulgencio Batista y Zaldívar; Blas M. Rocafort, tr. New York, NY: Devin-Adair; 1964. 300 pp. Translation of *Piedras y leyes.*

4229. *Guyana at the Crossroads.* Dennis Watson, Christine Craig, eds. New Brunswick, NJ: Transaction Publishers; 1992. 95 pp.

4230. *Guyana: Fraudulent Revolution.* Latin American Bureau. London: The Bureau; 1984. 106 pp.

4231. *Guyana: Politics and Development in an Emergent Socialist State.* Kempe Ronald Hope. New York, NY: Mosaic Press; 1985. 136 pp.

4232. *Guyana: Politics in a Plantation Society.* Chaitram Singh. New York, NY: Praeger; 1988. 161 pp.

4233. *Guyana: Politics, Economics, and Society—Beyond the Burnham Era.* Henry B. Jeffrey, Colin Baber. Boulder, CO: L. Rienner; 1986. 203 pp.

4234. *La Guyane: les grands problèmes, les solutions possibles.* Elie Castor, Georges Othily. Paris: Editions caribéennes; 1984. 337 pp.

4235. *Haiti and the Great Powers, 1902–1915.* Brenda Gayle Plummer. Baton Rouge, LA: Louisiana State University Press; 1988. 255 pp.

4236. *Haiti's Future: Views of Twelve Haitian Leaders.* Conference on Democracy in Haiti (1986, Wilson Center); Richard McGee Morse, ed. Washington, DC: Wilson Center Press; 1988. 129 pp.

4237. *Haiti, State Against Nation: The Origins and Legacy of Duvalierism.* Michel-Rolph Trouillot. New York, NY: Monthly Review Press; 1990. 282 pp.

4238. *Haiti: Family Business.* Rod Prince, Jean Jacques Honorat. London: Latin American Bureau; 1985. 86 pp.

4239. *Haiti: The Duvaliers and Their Legacy.* Elizabeth Abbott. Rev. ed. New York, NY: Simon and Schuster; 1991. 402 pp.

4240. *Haiti: The Failure of Politics.* Brian Weinstein, Aaron Segal. New York, NY: Praeger; 1992. 203 pp.

4241. *Historia electoral dominicana, 1848–1986.* Julio G. Campillo Pérez. 4a ed. Santo Domingo: Junta Central Electoral; 1986. 627 pp. Rev. ed. of *Elecciones dominicanas;* first ed. has title *El grillo y el ruiseñor* (1966).

4242. *Ideology and Political Development: The Growth and Development of Political Ideas in the Caribbean, 1774–1983.* Denis Benn. Mona, Jamaica: Institute of Social and Economic Research, University of the West Indies; 1987. 233 pp. Spine title *The Growth and Development of Political Ideas in the Caribbean, 1774–1983.*

4243. *In Nobody's Backyard: The Grenada Revolution in Its Own Words.* Tony Martin, Dessima Williams, eds. Dover, MA: Majority Press; 1983–1985. 2 vols.

4244. *In the Caribbean Political Areas.* Enrique Ventura Corominas; L. Charles Foresti, tr. Cambridge, MA: University Press; 1954. 204 pp. Translation of *En las áreas políticas del Caribe.*

4245. *The Independence Papers: Readings on a New Political Status for St. Maarten/St. Martin.* Lasana M. Sekou, Oswald Francis, Napolina Gumbs, eds. Philipsburg: Nehesi; 1990– [vol. 1–].

4246. *The Intellectual Roots of Independence: An Anthology of Puerto Rican Political Essays.* Iris M. Zavala, Rafael Rodríguez, eds. New York, NY: Monthly Review Press; 1980. 376 pp. Translation of *Libertad y crítica en el ensayo político puertorriqueño.*

4247. *Issues and Problems in Caribbean Public Administration.* Selwyn D. Ryan, Deryck R. Brown, eds. 2d ed. St. Augustine, Trinidad/Tobago: Institute of Social and Economic Research, University of the West Indies; 1992. 373 pp.

4248. *Jamaica Under Manley: Dilemmas of Socialism and Democracy.* Michael Kaufman. Westport, CT: L. Hill; 1985. 282 pp.

4249. *Jamaica: Struggle in the Periphery.* Michael Manley. New York, NY: Pilgrim Press; 1982. 259 pp.

4250. *Jamaican Leaders: Political Attitudes in a New Nation.* Wendell Bell. Berkeley, CA: University of California Press; 1964. 229 pp.

4251. *Jamaican Politics: A Marxist Perspective in Transition.* Trevor Munroe. Boulder, CO: L. Rienner; 1990. 322 pp.

4252. *Local Democracy in the Commonwealth Caribbean: A Study of Adaptation and Growth.* Paul G. Singh. Port of Spain: Longman Caribbean; 1972. 146 pp.

4253. *Los Macheteros: The Wells Fargo Robbery and the Violent Struggle for Puerto Rican Independence.* Ronald Fernandez. New York, NY: Prentice Hall; 1987. 272 pp.

4254. *Major Political and Constitutional Documents of the United States Virgin Islands, 1671–1991.* Paul M. Leary, ed. Charlotte Amalie, V.I.: University of the Virgin Islands; 1992. 465 pp. Cover title *United States Virgin Islands Major Political Documents, 1671–1991.*

4255. *The Making of Modern Belize: Politics, Society, and British Colonialism in Central America.* Cedric Hilburn Grant. New York, NY: Cambridge University Press; 1976. 400 pp.

4256. *The Modernization of Puerto Rico: A Political Study of Changing Values and Institutions.* Henry Wells. Cambridge, MA: Harvard University Press; 1969. 440 pp.

4257. *Movement of the People: Essays on Independence.* Selwyn Reginald Cudjoe. Ithaca, NY: Cataloux Publications; 1983. 217 pp. About Trinidad and Tobago.

4258. *The Muslimeen Grab for Power: Race, Religion, and Revolution in Trinidad and Tobago.* Selwyn D. Ryan. Port of Spain: Inprint Caribbean; 1991. 345 pp.

4259. *The New Jewel Movement: Grenada's Revolution, 1979–1983.* Gregory Sandford; Diane B. Bendahmane, ed. Washington, DC: Center for the Study of Foreign Affairs, U.S. Dept. of State; 1985. 215 pp.

4260. *The Newer Caribbean: Decolonization, Democracy, and Development.* Paget Henry, Carl Stone, eds. Philadelphia, PA: Institute for the Study of Human Issues; 1983. 348 pp.

4261. *Notes on the Puerto Rican Revolution: An Essay on American Dominance and Caribbean Resistance.* Gordon K. Lewis. New York, NY: Monthly Review Press; 1975. 288 pp.

4262. *Of Men and Politics: The Agony of St. Lucia.* D. Sinclair DaBreo. Castries, St. Lucia: Commonwealth Publishers International; 1981. 208 pp.

4263. *One People, One Destiny: The Caribbean and Central America Today.* Don Rojas, ed. New York, NY: Pathfinder Press; 1988. 115 pp.

4264. *Onvoltooid verleden: de dekolonisatie van Suriname en de Nederlandse Antillen [Incomplete Past: The Decolonization of Suriname and the Netherlands Antilles].* Kees Lagerberg. Tilburg: Instituut voor Ontwikkelingsvraagstukken, Katholieke Universiteit Brabant; 1989. 265 pp.

4265. *The Origins of Socialism in Cuba.* James R. O'Connor. Ithaca, NY: Cornell University Press; 1970. 338 pp.

4266. *A Party Politics for Trinidad and Tobago: The Flowering of an Idea.* Lloyd Best, Allan Harris, eds. Port of Spain: Tapia House Group; 1991. 91 pp.

4267. *Party Politics in Belize.* Assad Shoman. Belize City: Cubola Productions; 1987. 91 pp.

4268. *Party Politics in Puerto Rico.* Robert William Anderson. Stanford, CA: Stanford University Press; 1972. 269 pp. Reprint of the 1965 ed.

4269. *Party Politics in the West Indies.* Cyril Lionel Robert James. San Juan, Trinidad/Tobago: Inprint Caribbean; 1984. 184 pp. Reprint, with a new introd., of the 1962 ed.

4270. *Peace, Development, and Security in the Caribbean: Perspectives to the Year 2000.* Anthony T. Bryan, John Edward Greene, Timothy M. Shaw, eds. New York, NY: St. Martin's Press; 1990. 332 pp.

4271. *Póker de espanto en el Caribe.* Juan Bosch. Santo Domingo: Editora Alfa y Omega; 1988. 217 pp.

4272. *A Political and Social History of Guyana, 1945–1983.* Thomas J. Spinner. Boulder, CO: Westview Press; 1984. 244 pp.

4273. *The Political Status of Puerto Rico.* Pamela S. Falk, ed. Lexington, MA: Lexington Books; 1986. 125 pp.

4274. *Politics in Jamaica.* Anthony Payne. New York, NY: St. Martin's Press; 1988. 196 pp.

4275. *The Politics of Change: A Jamaican Testament.* Michael Manley. New ed. Washington, DC: Howard University Press; 1990. 252 pp.

4276. *The Politics of External Influence in the Dominican Republic.* Michael J. Kryzanek, Howard John Wiarda. New York, NY: Praeger; 1988. 186 pp.

4277. *The Politics of Surinam and the Netherlands Antilles.* Albert L. Gastmann. Río Piedras, P.R.: Institute of Caribbean Studies, University of Puerto Rico; 1968. 185 pp.

4278. *Politics on Bonaire: An Anthropological Study.* Anke Klomp; Dirk H. van der Elst, tr. Assen: Van Gorcum; 1987. 215 pp. Translation of *Politiek op Bonaire.*

4279. *Politics, Projects, and People: Institutional Development in Haiti.* Derick W. Brinkerhoff, Jean Claude García Zamor, eds. New York, NY: Praeger; 1986. 288 pp.

4280. *Politics, Public Administration and Rural Development in the Caribbean.* Hans F. Tilly, ed. Munich: Weltforum Verlag; 1983. 296 pp.

4281. *Presidentes, juntas, consejos, triunviratos y gabinetes de la República Dominicana, 1844–1984.* Juan Ventura. Santo Domingo: Publicaciones ONAP; 1985. 147 pp.

4282. *Problemas del Caribe contemporáneo/Contemporary Caribbean Issues.* Angel Calderón Cruz, ed. Río Piedras, P.R.: Instituto de Estudios del Caribe, Universidad de Puerto Rico; 1979. 180 pp.

4283. *Problems of Administration in an Emergent Nation: A Case Study of Jamaica.* B. L. St. John Hamilton. New York, NY: Praeger; 1964. 218 pp.

4284. *Problems of Succession in Cuba.* Jaime Suchlicki, ed. Coral Gables, FL: North-South Center, University of Miami; 1985. 105 pp.

4285. *Public Management: The Eastern Caribbean Experience.* Jamal Khan. Leiden: Caraïbische Afdeling, Koninklijk Instituut voor Taal-, Land- en Volkenkunde; 1987. 348 pp. Reprint of the 1982 ed.

4286. *Puerto Rico's Statehood Movement.* Edgardo Meléndez. New York, NY: Greenwood Press; 1988. 194 pp.

4287. *Puerto Rico: Commonwealth or Colony?* Roberta Ann Johnson. New York, NY: Praeger; 1980. 199 pp.

4288. *Puerto Rico: Equality and Freedom at Issue.* Juan M. García-Passalacqua. New York, NY: Praeger; 1984. 175 pp.

4289. *Puerto Rico: Freedom and Power in the Caribbean.* Gordon K. Lewis. New York, NY: Monthly Review Press; 1974. 626 pp. Reprint of the 1963 ed.

4290. *La question nationale en Guadeloupe et en Martinique: essai sur l'histoire politique.* Alain Philippe Blérald. Paris: L'Harmattan; 1988. 211 pp.

4291. *The Quiet Revolution in the Bahamas*. Doris L. Johnson. Nassau: Family Islands Press; 1972. 177 pp.

4292. *Race and Politics in the Bahamas*. Colin A. Hughes. New York, NY: St. Martin's Press; 1981. 250 pp.

4293. *Race, Class, and Political Symbols: Rastafari and Reggae in Jamaican Politics*. Anita M. Waters. New Brunswick, NJ: Transaction Books; 1989. 343 pp. Reprint of the 1985 ed.

4294. *Radiographie d'une dictature: Haïti et Duvalier*. Gérard Pierre-Charles. Ed. refondue et augm. Port-au-Prince: [s.n.]; 1986. 205 pp. Originally published in Spanish under title *Haití, radiografía de una dictadura;* reprint of the 1973 (rev.) ed.

4295. *The Rainy Season: Haiti Since Duvalier*. Amy Wilentz. New York, NY: Simon and Schuster; 1989. 427 pp.

4296. *Readings in Government and Politics of the West Indies*. Trevor Munroe, Rupert Lewis, eds. Rev. ed. Mona, Jamaica: Dept. of Government, University of the West Indies; 1971. 270 pp. First ed. (1967) by A. W. Singham [et al.].

4297. *Recht, commercie en kolonialisme in West-Indië: vanaf de zestiende tot in de negentiende eeuw [Law, Commerce and Colonialism in the West Indies: From the Sixteenth to the Nineteenth Century]*. A. J. M. Kunst. Zutphen: Walburg Pers; 1981. 374 pp.

4298. *Reflexiones sobre Cuba y su futuro*. Luis Aguilar León. 2a ed., corr. y aum. Miami, FL: Ediciones Universal; 1992. 192 pp.

4299. *El régimen de partidos y el sistema electoral en la República Dominicana*. Frank Moya Pons, ed. Santo Domingo: FORUM; 1986. 174 p. Spine title *Partidos y sistema electoral*.

4300. *La région Guyane, 1960–1983*. Elie Castor, Georges Othily. Paris: L'Harmattan; 1984. 388 pp.

4301. *La retraite aux flambeaux: société et politique en Martinique*. Fred Constant. Paris: Editions caribéennes; 1988. 246 pp.

4302. *A Revolution Aborted: The Lessons of Grenada*. Jorge Heine, ed. Pittsburgh, PA: University of Pittsburgh Press; 1990. 351 pp.

4303. *Revolution and Counterrevolution in Central America and the Caribbean*. Donald E. Schulz, Douglas H. Graham, eds. Boulder, CO: Westview Press; 1984. 555 pp.

4304. *Revolution and Intervention in Grenada: The New Jewel Movement, the United States, and the Caribbean*. Kai P. Schoenhals, Richard A. Melanson. Boulder, CO: Westview Press; 1985. 211 pp.

4305. *Revolution and Reaction in Cuba, 1933–1960: A Political Sociology from Machado to Castro*. Samuel Farber. Middletown, CT: Wesleyan University Press; 1976. 283 pp.

4306. *Roots of Revolution: Radical Thought in Cuba*. Sheldon B. Liss. Lincoln, NE: University of Nebraska Press; 1987. 269 pp.

4307. *Royal Government and Political Conflict in Jamaica, 1729–1783*. George Metcalf. London: Longmans; 1965. 256 pp.

4308. *Rule Britannia: Politics in British Montserrat*. Howard A. Fergus. Plymouth, Montserrat: University Centre, University of the West Indies; 1985. 115 pp.

4309. *The Second Revolution in Cuba*. Joseph P. Morray. New York, NY: Monthly Review Press; 1963. 173 pp.

4310. *Size, Self-Determination, and International Relations: The Caribbean*. Conference on the Independence of Very Small States with Special Reference to the Caribbean (1974, University of the West Indies); Vaughan A. Lewis, ed. Mona, Jamaica: Institute of Social and Economic Research, University of the West Indies; 1976. 358 pp.

4311. *Socialism in Cuba*. Leo Huberman, Paul Marlor Sweezy. New York, NY: Monthly Review Press; 1969. 221 pp.

4312. *Socialist Cuba: Past Interpretations and Future Challenges*. Sergio G. Roca, ed. Boulder, CO: Westview Press; 1988. 253 pp.

4313. *Society and Politics in the Caribbean*. Colin G. Clarke, ed. New York, NY: St. Martin's Press; 1991. 295 pp.

4314. *The Sociology of Political Independence: A Study of Nationalist Attitudes Among West Indian Leaders*. Charles C. Moskos. Cambridge, MA: Schenkman; 1967. 120 pp.

4315. *The Stability of the Caribbean*. Robert Moss, ed. Washington, DC: Center for Strategic and International Studies, Georgetown University; 1973. 137 pp. Report of a seminar held at Ditchley Park, Oxfordshire, U.K., May 18–20, 1973.

4316. *State Systems in the Eastern Caribbean: Historical and Contemporary Features*. Emmanuel W. Riviere. Mona, Jamaica: Institute of Social and Economic Research, University of the West Indies; 1990. 122 pp.

4317. *The Stricken Land: The Story of Puerto Rico*. Rexford Guy Tugwell. New York, NY: Greenwood Press; 1968. 704 pp. Reprint of the 1946 ed.

4318. *The Suffering Grass: Superpowers and Regional Conflict in Southern Africa and the Caribbean*. Thomas George Weiss, James G. Blight, eds. Boulder, CO: L. Rienner; 1992. 182 pp.

4319. *Surinam: Politics, Economics, and Society*. Henk E. Chin, Hans Buddingh. New York, NY: F. Pinter; 1987. 192 pp.

4320. *Towards an Alternative for Central America and the Caribbean*. George Irvin, Xabier Gorostiaga, eds. Boston, MA: Allen and Unwin; 1985. 273 pp.

4321. *Transformation and Struggle: Cuba Faces the 1990's.* Sandor Halebsky, John M. Kirk, Rafael Hernández, eds. New York, NY: Praeger; 1990. 291 pp.

4322. *Transition to Democracy in the Caribbean: Haiti, Guyana, and Suriname.* United States, Congress, House, Committee on Foreign Affairs, Subcommittee on Western Hemisphere Affairs. Washington, DC: GPO; 1991. 110 pp.

4323. *Trials and Triumphs: The Long Road to a Middle Class Society in the U.S. Virgin Islands.* Earle B. Ottley. Charlotte Amalie, V.I.: Ottley; 1982. 438 pp.

4324. *Trinidad and Tobago: Democracy and Development in the Caribbean.* Scott B. MacDonald. New York, NY: Praeger; 1986. 231 pp.

4325. *Trinidad and Tobago: The Independence Experience, 1962–1987.* Selwyn D. Ryan, Gloria Gordon, eds. St. Augustine, Trinidad/Tobago: Institute of Social and Economic Research, University of the West Indies; 1988. 599 pp.

4326. *Trouble in Guyana: An Account of People, Personalities, and Politics as They Were in British Guiana.* Peter Simms. London: Allen and Unwin; 1966. 198 pp.

4327. *The Troubled and the Troubling Caribbean.* Roy Arthur Glasgow, Winston E. Langley, eds. Lewiston, NY: Edwin Mellen Press; 1989. 347 pp.

4328. *The Unfinished Experiment: Democracy in the Dominican Republic.* Juan Bosch. New York, NY: Praeger; 1965. 239 pp. Spanish ed. has title *Crisis de la democracia de América en la República Dominicana.*

4329. *Urban Nationalism: A Study of Political Development in Trinidad.* Alvin Magid. Gainesville, FL: University Presses of Florida; 1988. 294 pp.

4330. *The Virgin Islands: From Naval Base to New Deal.* Luther Harris Evans. Westport, CT: Greenwood Press; 1975. 365 pp. Reprint of the 1945 ed.

4331. *The West Indies and the Development of Colonial Government, 1801–1834.* D. J. Murray. Oxford: Clarendon Press; 1965. 264 pp.

4332. *The West Indies at the Crossroads.* Earl Gooding. Cambridge, MA: Schenkman; 1981. 243 pp.

4333. *The West Indies Federation: Perspectives on a New Nation.* David Lowenthal, ed. Westport, CT: Greenwood Press; 1976. 142 pp. Reprint of the 1961 ed.

4334. *The Wild Coast: An Account of Politics in Guyana.* Reynold A. Burrowes. Cambridge, MA: Schenkman; 1984. 348 pp.

4335. *Will Insularity and Political Opportunism Defeat Caribbean Integration?* D. Sinclair DaBreo. Castries, St. Lucia: Commonwealth Publishers International; 1988. 100 pp.

2. CONSTITUTION, LAW, AND HUMAN RIGHTS

4336. *Apuntes para una historia de la legislación y administración colonial en Cuba, 1511–1800.* José Luciano Franco. Havana: Editorial de Ciencias Sociales; 1985. 426 pp.

4337. *Caribbean Democracy and Law Reform: Report.* Seminar on Caribbean Democracy and Law Reform (1988, Kingston); Bustamante Institute of Public and International Affairs, ed. Kingston: The Institute; 1989. 69 pp.

4338. *Caribbean Perspectives on International Law and Organizations.* B. G. Ramcharan, Laurel B. Francis, eds. Boston, MA: M. Nijhoff; 1989. 468 pp.

4339. *Changing Caribbean Constitutions.* Francis Alexis. Bridgetown: Carib Research and Publications; 1987. 281 pp. Reprint of the 1983 ed.

4340. *Commonwealth Caribbean Legal Essays.* Francis Alexis, P. K. Menon, Dorcas White, eds. Cave Hill, Barbados: Faculty of Law, University of the West Indies; 1982. 303 pp.

4341. *Commonwealth Caribbean Legal Systems: A Study of Small Jurisdictions.* Velma Newton. Bridgetown: Triumph Publications; 1988. 325 pp.

4342. *Comparative Law Studies: Law and Legal Systems of the Commonwealth Caribbean States and the Other Members of the Organization of American States.* Seminar of Comparison on Law and Legal Systems of the Commonwealth Caribbean States (1983, Bridgetown). Organization of American States, ed. Rev. ed. Washington, DC: General Secretariat, OAS; 1987. 176 pp.

4343. *La constitucionalidad en Santo Domingo: período 1492–1844.* Julio G. Campillo Pérez. Santo Domingo: Publicaciones ONAP; 1983. 176 pp.

4344. *Constituciones cubanas desde 1812 hasta nuestros días.* Leonel-Antonio de la Cuesta, ed.; recopilación bibliográfica de Rolando A. Alum. New York, NY: Ediciones Exilio; 1974. 539 pp.

4345. *Constitutional Change in the British West Indies, 1880–1903: With Special Reference to Jamaica, British Guiana, and Trinidad.* H. A. Will. Oxford: Clarendon Press; 1970. 331 pp.

4346. *The Constitutional Development of Jamaica, 1660 to 1729.* Agnes Mary Whitson. Manchester, Eng.: Manchester University Press; 1929. 182 pp.

4347. *Constitutional Development of the West Indies, 1922–1968: A Selection from the Major Documents.* Ann Spackman. St. Lawrence, Barbados: Caribbean Universities Press; 1975. 619 pp.

4348. *Constitutional Development in Guyana, 1621–1978.* Mohammed Shahabuddeen. Georgetown: Shahabuddeen; 1978. 685 pp.

4349. *A Constitutional History of British Guiana.* Cecil Clementi. London: Macmillan; 1937. 546 pp.

4350. *The Constitutional Law of Jamaica.* Lloyd G. Barnett. New York, NY: Oxford University Press; 1977. 468 pp.

4351. *Crime and Nation-Building in the Caribbean: The Legacy of Legal Barriers.* Cynthia Mahabir. Cambridge, MA: Schenkman; 1985. 276 pp.

4352. *Cuba and the Rule of Law.* International Commission of Jurists. Geneva: The Commission; 1962. 267 pp.

4353. *Custom and Conflict on a Bahamian Out-Island.* Jerome Wendell Lurry-Wright. Lanham, MD: University Press of America; 1987. 188 pp. About Mayaguana Island.

4354. *Derecho constitucional de Estados Unidos y Puerto Rico: documentos—jurisprudencia—anotaciones—preguntas.* Raúl Serrano Geyls, Demetrio Fernández, Efrén Rivera Ramos. San Juan: Colegio de Abogados de Puerto Rico; 1986–1988. 2 vols.

4355. *Los derechos civiles en la cultura puertorriqueña.* Eduardo Seda Bonilla. 5a ed., rev. Río Piedras, P.R.: Ediciones Bayoán; 1991. 256 pp. Also published under title *La cultura política de Puerto Rico.*

4356. *Los derechos humanos en República Dominicana, 1492–1984.* Luis Gómez. Santo Domingo: Editora Universitaria, Universidad Autónoma de Santo Domingo; 1984. 502 pp.

4357. *Elements of Bahamian Law.* Leonard J. Knowles. 2d ed. Nassau: Nassau Guardian; 1989. 147 pp.

4358. *Estado Libre Asociado de Puerto Rico: antecedentes, creación y desarrollo hasta la época presente.* Antonio Fernós Isern. Río Piedras, P.R.: Editorial de la Universidad de Puerto Rico; 1988. 623 pp. Reprint of the 1974 ed.

4359. *Family Law in the Commonwealth Caribbean.* Gloria Cumper, Stephanie Daly. Mona, Jamaica: University of the West Indies; 1979. 256 pp.

4360. *Freedom in the Caribbean: A Study in Constitutional Change.* Fred Phillips. Dobbs Ferry, NY: Oceana Publications; 1977. 737 pp.

4360a. *Fundamental Rights in Commonwealth Caribbean Constitutions.* Margaret DeMerieux. St. Michael, Barbados: Faculty of Law Library, University of the West Indies; 1992. 507 pp.

4361. *Historia constitucional de Cuba.* Enrique Hernández Corujo. Havana: Compañía Editora de Libros y Folletos; 1960. 2 vols.

4362. *Historia constitucional de Puerto Rico.* José Trías Monge. Río Piedras, P.R.: Editorial de la Universidad de Puerto Rico; 1980–1983. 4 vols.

4363. *Human Rights and Development: Report.* Seminar on Human Rights and Their Promotion in the Caribbean (1977, Barbados). International Commission of Jurists [and] Organisation of Commonwealth Caribbean Bar Associations, eds. Bridgetown: Cedar Press; 1978. 190 pp.

4364. *Human Rights in a United States Colony.* Louise Cripps Samoiloff. Cambridge, MA: Schenkman; 1982. 191 pp. About Puerto Rico.

4365. *Human Rights in Cuba: An Experiential Perspective.* Juan M. Clark, Angel De Fana, Amaya Sánchez. Miami, FL: Saeta Ediciones; 1991. 122 pp.

4366. *Human Rights in Jamaica.* Paul Chevigny, Lois Whitman, Bell Gale Chevigny. New York, NY: Americas Watch Committee; 1986. 64 pp.

4367. *Human Rights in Latin America and the Caribbean.* Peter Blanchard, Peter Landstreet, eds. Toronto: Canadian Scholars' Press; 1989. 431 pp.

4368. *The Human Rights Situation in Suriname.* Inter-American Commission on Human Rights. Second report. Washington, DC: General Secretariat, Organization of American States; 1985. 69 pp.

4369. *Interpretación de los derechos civiles en Puerto Rico.* José Julio Santa-Pinter. Río Piedras, P.R.: Editorial de la Universidad de Puerto Rico; 1980. 302 pp.

4370. *La justicia en la República Dominicana.* Frank Moya Pons, ed. Santo Domingo: Editora Amigo del Hogar; 1987. 117 pp.

4371. *Law and the Political Environment in Guyana.* Rudolph William James, Harold A. Lutchman. Georgetown: Institute of Development Studies, University of Guyana; 1984. 215 pp.

4372. *Law in the West Indies: Some Recent Trends.* British Institute of International and Comparative Law, ed. London: The Institute; 1966. 152 pp.

4373. *The Legal System of Guyana.* Mohammed Shahabuddeen. Georgetown: Guyana Printers; 1973. 523 pp.

4374. *Legalidad y derechos humanos en Cuba.* Domingo Jorge Delgado. Miami, FL: Saeta Ediciones; 1991. 162 pp.

4375. *Maritime Issues in the Caribbean: Proceedings.* Conference on Maritime Issues in the Caribbean (1981, Florida International University); Farrokh Jhabvala, ed. Miami, FL: University Presses of Florida; 1983. 130 pp.

4376. *The More Things Change: Human Rights in Haiti.* Americas Watch Committee. New York, NY: The Committee; 1989. 126 pp.

4377. *A New Law of the Sea for the Caribbean: An Examination of Marine Law and Policy Issues in the Lesser Antilles.* Edgar Gold, ed. New York, NY: Springer-Verlag; 1988. 276 pp.

4378. *El poder judicial en Cuba.* Vicente Viñuela. Miami, FL: Ediciones Universal; 1991. 396 pp.

4379. *Revolution and Criminal Justice: The Cuban Experiment, 1959–1983.* Adèle G. van der Plas; Peter Mason, tr. Amsterdam: CEDLA; 1987. 328 pp.

4380. *El sistema constitucional dominicano.* Julio Brea Franco. Santo Domingo: Editorial CENAPEC; 1986. 2 vols. Reprint of the 1983 ed.

4381. *The Situation of Human Rights in Cuba.* Inter-American Commission on Human Rights. Seventh report. Washington, DC: General Secretariat, Organization of American States; 1983. 183 pp.

4382. *The Situation of Human Rights in Haiti.* Inter-American Commission on Human Rights. [Rev. ed.]. Washington, DC: General Secretariat, Organization of American States; 1990. 63 pp.

4383. *Le Statut juridique de la mer des Caraïbes.* Geneviève Brocard. Paris: Presses universitaires de France; 1979. 351 pp.

4384. *West Indian Constitutions: Post Independence Reform.* Fred Phillips. New York, NY: Oceana Publications; 1985. 370 pp.

4385. *West Indisch Plakaatboek [West Indian Book of Edicts].* Jacob Adriaan Schiltkamp, Jacobus Thomas de Smidt, eds. Amsterdam: Emmering; 1973– [vols. 1–3+].

3. FOREIGN RELATIONS

a. General Works

4386. *The Bear in the Back Yard: Moscow's Caribbean Strategy.* Timothy Ashby. Lexington, MA: Lexington Books; 1987. 240 pp.

4387. *The Belize Issue.* J. Ann Zammit. London: Latin American Bureau; 1978. 77 pp.

4388. *Belize: The Controversy Between Guatemala and Great Britain over the Territory of British Honduras in Central America.* William J. Bianchi. New York, NY: Las Américas; 1959. 142 pp.

4389. *Britain and Her Treaties on Belize (British Honduras): Guatemala Has the Right to Reinstate the Entire Territory of Belize.* José Luis Mendoza; Lilly de Jongh Osborne, tr. Guatemala: [s.n.]; 1959. 301 pp. Translation of *Inglaterra y sus pactos sobre Belice;* reprint of the 1946 ed.

4390. *Canada and the Commonwealth Caribbean.* Brian Douglas Tennyson, ed. Lanham, MD: University Press of America; 1988. 395 pp.

4391. *The Caribbean Commission: Background of Cooperation in the West Indies.* Bernard L. Poole. Columbia, SC: University of South Carolina Press; 1951. 303 pp.

4392. *The Caribbean in World Affairs: The Foreign Policies of the English-Speaking States.* Jacqueline Anne Braveboy-Wagner. Boulder, CO: Westview Press; 1989. 244 pp.

4393. *Caribbean Integration: The Politics of Regionalism.* W. Andrew Axline. New York, NY: Nichols; 1979. 233 pp.

4394. *The Caribbean: Contemporary International Relations.* Conference on the Caribbean (Seventh, 1956, University of Florida); Alva Curtis Wilgus, ed. Gainesville, FL: University of Florida Press; 1957. 330 pp.

4395. *The Caribbean: Its Hemispheric Role.* Conference on the Caribbean (Seventeenth, 1966, University of Florida); Alva Curtis Wilgus, ed. Gainesville, FL: University of Florida Press; 1967. 202 pp.

4396. *El Caribe en la política exterior de Cuba: balance de 30 años, 1959–1989.* Gerardo González Núñez. Santo Domingo: Ediciones CIPROS; 1991. 95 pp.

4397. *El Caribe entre Europa y América: evolución y perspectivas.* Luis Beltrán, Andrés Serbín, eds. Caracas: Editorial Nueva Sociedad; 1992. 131 pp.

4398. *Caribe y América Latina.* Lulú Giménez Saldivia. Caracas: Monte Avila Editores; 1991. 239 pp.

4399. *Castro, the Kremlin, and Communism in Latin America.* D. Bruce Jackson. Baltimore, MD: Johns Hopkins University Press; 1969. 163 pp.

4400. *Colossus Challenged: The Struggle for Caribbean Influence.* H. Michael Erisman, John D. Martz, eds. Boulder, CO: Westview Press; 1982. 260 pp.

4401. *The Communist Challenge in the Caribbean and Central America.* Howard John Wiarda [et al.]. Washington, DC: American Enterprise Institute for Public Policy Research; 1987. 249 pp.

4402. *Conflict, Peace and Development in the Caribbean: Papers.* "Peace and Development in the Caribbean" Conference (1988, University of the West Indies); Jorge Rodríguez Beruff, J. Peter Figueroa, John Edward Greene, eds. New York, NY: St. Martin's Press; 1991. 294 pp.

4403. *Confrontation in the Caribbean Basin: International Perspectives on Security, Sovereignty, and Survival.* Alan Adelman, Reid Reading, eds. Pittsburgh, PA: Center for Latin American Studies, University of Pittsburgh; 1984. 307 pp.

4404. *Contemporary International Relations of the Caribbean.* Basil A. Ince, ed. St. Augustine, Trinidad/Tobago: Institute of International Relations, University of the West Indies; 1979. 367 pp.

4405. *Cuba en España: una gloriosa página de internacionalismo.* Alberto Alfonso Bello, Juan Pérez Díaz. Havana: Editorial de Ciencias Sociales; 1990. 275 pp.

4406. *Cuba in Africa.* Carmelo Mesa-Lago, June S. Belkin, eds. Pittsburgh, PA: Center for Latin American Studies, University of Pittsburgh; 1982. 230 pp.

4407. *Cuba in the World.* Cole Blasier, Carmelo Mesa-Lago, eds. Pittsburgh, PA: University of Pittsburgh Press; 1979. 343 pp.

4408. *Cuba's Foreign Policy in the Middle East.* Damián J. Fernández. Boulder, CO: Westview Press; 1988. 160 pp.

4409. *Cuba's International Relations: The Anatomy of a Nationalistic Foreign Policy.* H. Michael Erisman. Boulder, CO: Westview Press; 1985. 203 pp.

4410. *Cuba: The International Dimension.* Georges A. Fauriol, Eva Loser, eds. New Brunswick, NJ: Transaction Publishers; 1990. 449 pp.

4411. *Cuban Foreign Policy: Caribbean Tempest.* Pamela S. Falk. Lexington, MA: Lexington Books; 1986. 336 pp.

4412. *Cuban Foreign Policy Confronts a New International Order.* H. Michael Erisman, John M. Kirk, eds. Boulder, CO: L. Rienner; 1991. 241 pp.

4413. *Cuban Internationalism in Sub-Saharan Africa.* Sergio Díaz-Briquets, ed. Pittsburgh, PA: Duquesne University Press; 1989. 211 pp.

4414. *Curaçao and Guzmán Blanco: A Case Study of Small Power Politics in the Caribbean.* Cornelis Christiaan Goslinga. Boston, MA: M. Nijhoff; 1975. 143 pp.

4415. *Diplomacy or War: The Guyana-Venezuela Border Controversy.* Jai Narine Singh. Georgetown: Singh; 1982. 170 pp.

4416. *Documents on International Relations in the Caribbean.* Roy Preiswerk, ed. Río Piedras, P.R.: Institute of Caribbean Studies, University of Puerto Rico; 1970. 853 pp.

4417. *Estudios del Caribe en Venezuela.* Rita Giacalone de Romero, ed. Caracas: Consejo de Desarrollo Científico y Humanístico, Universidad Central de Venezuela; 1988. 219 pp.

4418. *Europe and the Caribbean.* Paul K. Sutton, ed. London: Macmillan Caribbean; 1991. 260 pp.

4419. *Foreign Policy Behavior of Caribbean States: Guyana, Haiti, and Jamaica.* Georges A. Fauriol. Lanham, MD: University Press of America; 1984. 338 pp.

4420. *A Foreign Policy in Transition: Moscow's Retreat from Central America and the Caribbean, 1985–1992.* Jan S. Adams. Durham, NC: Duke University Press; 1992. 248 pp.

4421. *French Diplomacy in the Caribbean and the American Revolution.* Roopnarine John Singh. Hicksville, NY: Exposition Press; 1977. 235 pp.

4422. *Geopolítica de las relaciones de Venezuela con el Caribe.* Simposio "Geopolítica de las Relaciones de Venezuela con el Caribe" (1982, Caracas); Demetrio Boersner [et al.]; Andrés Serbín, ed. Caracas: Fondo Editorial Acta Científica; 1983. 317 pp.

4423. *Great Britain and the Caribbean, 1901–1913: A Study in Anglo-American Relations.* Warren G. Kneer. East Lansing, MI: Michigan State University Press; 1975. 242 pp.

4424. *Historia de la cuestión fronteriza dominico-haitiana.* Manuel Arturo Peña Battle. 2a ed. Santo Domingo: Sociedad Dominicana de Bibliófilos; 1988. 483 pp.

4425. *Historia diplomática de Santo Domingo, 1492–1861.* Carlos Federico Pérez. Santo Domingo: Universidad Nacional Pedro Henríquez Ureña; 1973. 445 pp.

4426. *The International Crisis in the Caribbean.* Anthony Payne. Baltimore, MD: Johns Hopkins University Press; 1984. 177 pp.

4427. *La isla al revés: Haití y el destino dominicano.* Joaquín Balaguer. Santo Domingo: Fundación José Antonio Caro; 1990. 257 pp. Reprint of the 1983 ed.

4428. *Issues in Caribbean International Relations.* Basil A. Ince [et al.], eds. Lanham, MD: University Press of America; 1983. 349 pp.

4429. *The New Cuban Presence in the Caribbean.* Barry B. Levine, ed. Boulder, CO: Westview Press; 1983. 274 pp.

4430. *The Organization of American States and the Commonwealth Caribbean: Perspectives on Security, Crisis and Reform.* Anthony T. Bryan, ed. St. Augustine, Trinidad/Tobago: Institute of International Relations, University of the West Indies; 1986. 100 pp.

4431. *Patterns of Foreign Influence in the Caribbean.* Emanuel Jehuda De Kadt, ed. New York, NY: Oxford University Press; 1972. 188 pp.

4432. *Patterns of International Cooperation in the Caribbean, 1942–1969.* Herbert Corkran. Dallas, TX: Southern Methodist University Press; 1970. 285 pp.

4433. *Presencia de Puerto Rico en la historia de Cuba: una aportación al estudio de la historia antillana.* Joaquín Freire. San Juan: Instituto de Cultura Puertorriqueña; 1975. 212 pp. Reprint of the 1966 ed.

4434. *Puerto Rico and the International Process: New Roles in Association.* William Michael Reisman. St. Paul, MN: West Publishing; 1975. 224 pp.

4435. *Puerto Rico en las relaciones internacionales del Caribe.* Carmen Gautier Mayoral, Angel I. Rivera Ortiz, Idsa E. Alegría Ortega, eds. Río Piedras, P.R.: Ediciones Huracán; 1990. 197 pp.

4436. *Pursuing Postdependency Politics: South-South Relations in the Caribbean.* H. Michael Erisman. Boulder, CO: L. Rienner; 1992. 164 pp.

4437. *Reflections on the Failure of the First West Indian Federation.* Hugh W. Springer. New York, NY: AMS Press; 1973. 66 pp. Reprint of the 1962 ed.

4438. *Relaciones internacionales y estructuras sociopolíticas en el Caribe.* Gérard Pierre-Charles [et al.]. Mexico City: Instituto de Investigaciones Sociales, Universidad Nacional Autónoma de México; 1980. 222 pp.

4439. *Relaciones internacionales en la Cuenca del Caribe y la política de Colombia.* Juan Tokatlian, Klaus Schubert, eds. Bogotá: Cámara de Comercio; 1982. 591 pp.

4440. *La République d'Haïti et la République Dominicaine: les aspects divers d'un problème d'histoire, de géographie et d'ethnologie.* Jean Price-Mars. Port-au-Prince: [s.n.]; 1953. 2 vols.

4441. *The Restless Caribbean: Changing Patterns of International Relations.* Richard Millett, W. Marvin Will, eds. New York, NY: Praeger; 1979. 295 pp.

4442. *Revolutionary Cuba in the World Arena.* Martin Weinstein, ed. Philadelphia, PA: Institute for the Study of Human Issues; 1979. 169 pp.

4443. *Russia in the Caribbean.* James Daniel Theberge, ed. Washington, DC: Center for Strategic and International Studies, Georgetown University; 1973. 2 vols.

4444. *Soviet Seapower in the Caribbean: Political and Strategic Implications.* James Daniel Theberge, ed. New York, NY: Praeger; 1972. 175 pp.

4445. *The Soviet Union and Cuba: Interests and Influence.* Walter Raymond Duncan. New York, NY: Praeger; 1985. 220 pp.

4446. *The Soviet Union and Cuba.* Peter Shearman. New York, NY: Routledge and Kegan Paul; 1987. 103 pp.

4447. *Terrorism: The Cuban Connection.* Roger W. Fontaine. New York, NY: C. Russak; 1988. 199 pp.

4448. *To Make a World Safe for Revolution: Cuba's Foreign Policy.* Jorge I. Domínguez. Cambridge, MA: Harvard University Press; 1989. 365 pp.

4449. *USA, USSR, and the Caribbean: The New Realities—A Symposium.* Bustamante Institute of Public and International Affairs [and] Press Association of Jamaica, eds. Kingston: The Institute; 1990. 90 pp.

4450. *The USSR and the Cuban Revolution: Soviet Ideological and Strategical Perspectives, 1959–77.* Jacques Lévesque; Deanna Drendel Leboeuf, tr. New York, NY: Praeger; 1978. 215 pp. Translation of *L'USSR et la révolution cubaine.*

4451. *¿Vecinos indiferentes? El Caribe de habla inglesa y América Latina.* Andrés Serbín, Anthony T. Bryan, eds. Caracas: Instituto Venezolano de Estudios Sociales y Políticos; 1990. 250 pp.

4452. *Venezuela y el Caribe: presencia cambiante.* Demetrio Boersner. Caracas: Monte Avila Editores; 1980. 142 pp. Reprint of the 1978 ed.

4453. *Venezuela y las relaciones internacionales en la cuenca del Caribe.* Andrés Serbín, ed. Caracas: Instituto Latinoamericano de Investigaciones Sociales (ILDES); 1987. 282 pp.

4454. *The Venezuela-Guyana Border Dispute: Britain's Colonial Legacy in Latin America.* Jacqueline Anne Braveboy-Wagner. Boulder, CO: Westview Press; 1984. 349 pp.

b. Relations with the United States

4455. *La administración Reagan y la Cuenca del Caribe: geopolítica y estrategia militar.* Francisco López Segrera. Havana: Editorial de Ciencias Sociales; 1989. 82 pp.

4456. *Almost a Territory: America's Attempt to Annex the Dominican Republic.* William Javier Nelson. Newark, DE: University of Delaware Press; 1990. 148 pp.

4457. *The Americans in Santo Domingo*. Melvin Moses Knight. New York, NY: Arno Press; 1970. 189 pp. Reprint of the 1928 ed.

4458. *The Banana Wars: United States Intervention in the Caribbean, 1898–1934*. Lester D. Langley. Chicago, IL: Dorsey Press; 1988. 255 pp. Reprint of the 1985 (2d) ed.

4459. *The Caribbean Challenge: U.S. Policy in a Volatile Region*. H. Michael Erisman, ed. Boulder, CO: Westview Press; 1984. 208 pp.

4460. *The Caribbean Danger Zone*. James Fred Rippy. New York, NY: Putnam; 1940. 296 pp.

4461. *The Caribbean Policy of the United States, 1890–1920*. Wilfrid Hardy Callcott. New York, NY: Octagon Books; 1977. 524 pp. Reprint of the 1942 ed.

4462. *The Caribbean Since 1900*. Chester Lloyd Jones. New York, NY: Russell and Russell; 1970. 511 pp. Reprint of the 1936 ed.

4463. *The Caribbean: Current United States Relations*. Conference on the Caribbean (Sixteenth, 1965, University of Florida); Alva Curtis Wilgus, ed. Gainesville, FL: University of Florida Press; 1966. 243 pp.

4464. *The Caribbean: Its Implications for the United States*. Virginia R. Domínguez, Jorge I. Domínguez. New York, NY: Foreign Policy Association; 1981. 80 pp.

4465. *The Caribbean: Whose Backyard?* Cheddi Jagan. [S.l.: s.n.]; 1984. 373 pp.

4466. *El Caribe bajo las redes políticas norteamericanas*. Pablo A. Maríñez. Santo Domingo: Editora Universitaria, Universidad Autónoma de Santo Domingo; 1987. 277 pp.

4467. *Carrot and Big Stick: Perspectives on U.S.-Caribbean-Jamaica Relations*. Linus A. Hoskins. Inglewood, CA: Tele-Artists; 1985. 240 pp.

4468. *Changing Course: Blueprint for Peace in Central America and the Caribbean*. PACCA (Organization). Washington, DC: Institute for Policy Studies; 1984. 116 pp.

4469. *The Closest of Enemies: A Personal and Diplomatic Account of U.S.-Cuban Relations Since 1957*. Wayne S. Smith. New York, NY: Norton; 1987. 308 pp.

4470. *Constraint of Empire: The United States and Caribbean Interventions*. Whitney T. Perkins. Westport, CT: Greenwood Press; 1981. 282 pp.

4471. *Crisis and Opportunity: U.S. Policy in Central America and the Caribbean*. Mark Falcoff, Robert Royal, eds. Washington, DC: Ethics and Public Policy Center; 1984. 491 pp.

4472. *Cuba and the U.S.: The Tangled Relationship*. Robert D. Crassweller. New York, NY: Foreign Policy Association; 1971. 63 pp.

4473. *Cuba and the United States, 1900–1935.* Russell Humke Fitzgibbon. New York, NY: Russell and Russell; 1964. 311 pp. Reprint of the 1935 ed.

4474. *Cuba and the United States: Long Range Perspectives.* Henry Wriston [et al.]; John Plank, ed. Washington, DC: Brookings Institution; 1967. 265 pp.

4475. *Cuba and the United States: Ties of Singular Intimacy.* Louis A. Pérez. Athens, GA: University of Georgia Press; 1990. 314 pp.

4476. *Cuba and the United States: Will the Cold War in the Caribbean End?* Joseph S. Tulchin, Rafael Hernández, eds. Boulder, CO: L. Rienner; 1991. 145 pp.

4477. *Cuba vs. United States: The Politics of Hostility.* Lynn Darrell Bender. 2d ed., completely rev. San Juan: Inter American University Press; 1981. 103 pp. First ed. has title *The Politics of Hostility.*

4478. *Cuba, Castro, and the United States.* Philip Wilson Bonsal. Pittsburgh, PA: University of Pittsburgh Press; 1971. 318 pp.

4479. *The Cuban Missile Crisis.* Robert A. Divine, ed. 2d ed. New York, NY: M. Wiener; 1988. 360 p.

4480. *The Cuban Policy of the United States: A Brief History.* Lester D. Langley. New York, NY: Wiley; 1968. 203 pp.

4481. *The Cuban Revolution and the United States: A Chronological History.* Jane Franklin. Melbourne, Australia: Ocean Press; 1992. 276 pp.

4482. *The Cuban Threat.* Carla Anne Robbins. New York, NY: McGraw-Hill; 1983. 351 pp.

4483. *Dagger in the Heart: American Policy Failures in Cuba.* Mario Lazo. New York, NY: Funk and Wagnalls; 1968. 426 pp.

4484. *The Diplomatic Relations of the United States with Haiti, 1776–1891.* Rayford Whittingham Logan. Millwood, NY: Kraus Reprint; 1969. 516 pp. Reprint of the 1941 ed.

4485. *The Disenchanted Island: Puerto Rico and the United States in the Twentieth Century.* Ronald Fernandez. New York, NY: Praeger; 1992. 264 pp.

4486. *The Dominican Intervention.* Abraham F. Lowenthal. Cambridge, MA: Harvard University Press; 1972. 246 pp.

4487. *The Dominican Republic Crisis, 1965: Background Paper and Proceedings.* Hammarskjöld Forum (Ninth, 1966, New York); John Carey, ed. Dobbs Ferry, NY: Oceana Publications; 1967. 164 pp.

4488. *The Dominican Revolt: A Case Study in American Policy.* Theodore Draper. New York, NY: Commentary; 1968. 208 pp.

4489. *Drive to Hegemony: The United States in the Caribbean, 1898–1917.* David F. Healy. Madison, WI: University of Wisconsin Press; 1988. 370 pp.

4490. *Essence of Decision: Explaining the Cuban Missile Crisis.* Graham T. Allison. Boston, MA: Little, Brown; 1971. 338 pp.

4491. *Los Estados Unidos en el Caribe: de la guerra fría al Plan Reagan.* Leonel Fernández. Santo Domingo: Editora Alfa y Omega; 1984. 314 pp.

4492. *The Fish Is Red: The Story of the Secret War Against Castro.* Warren Hinckle, William W. Turner. New York, NY: Harper and Row; 1981. 373 pp.

4493. *The Fourth Floor: An Account of the Castro Communist Revolution.* Earl E. T. Smith. Washington, DC: Selous Foundation Press; 1990. 262 pp. Reprint of the 1962 ed.

4494. *From Confrontation to Negotiation: U.S. Relations with Cuba.* Philip Brenner. Boulder, CO: Westview Press; 1988. 118 pp.

4495. *Geopolitics, Security, and U.S. Strategy in the Caribbean Basin.* David F. Ronfeldt. Santa Monica, CA: Rand; 1984. 93 pp.

4496. *The Good Neighbor: How the United States Wrote the History of Central America and the Caribbean.* George Black. New York, NY: Pantheon Books; 1988. 200 pp.

4497. *Gunboat Diplomacy in the Wilson Era: The U.S. Navy in Haiti, 1915–1916.* David F. Healy. Madison, WI: University of Wisconsin Press; 1976. 268 pp.

4498. *Haiti and the United States, 1714–1938.* Ludweel Lee Montague. New York, NY: Russell and Russell; 1966. 308 pp. Reprint of the 1940 ed.

4499. *Haïti et les Etats-Unis, 1804–1900.* Yves L. August. Sherbrooke, Que. [etc.]: Editions Naaman [etc.]; 1979–1987. 2 vols.

4500. *Haiti's Influence on Antebellum America: Slumbering Volcano in the Caribbean.* Alfred N. Hunt. Baton Rouge, LA: Louisiana State University Press; 1988. 196 pp.

4501. *A History of Cuba and Its Relations with the United States.* Philip Sheldon Foner. New York, NY: International Publishers; 1962– [vols. 1–2+].

4502. *Hoover's Dominican Diplomacy and the Origins of the Good Neighbour Policy.* Earl R. Curry. New York, NY: Garland; 1979. 277 pp.

4503. *How Leaders Reason: US Intervention in the Caribbean Basin and Latin America.* Alex Roberto Hybel. Cambridge, MA: B. Blackwell; 1990. 326 pp.

4504. *Imperial State and Revolution: The United States and Cuba, 1952–1986.* Morris H. Morley. New York, NY: Cambridge University Press; 1987. 571 pp.

4505. *El imperialismo yanqui y la revolución en el Caribe.* José Enamorado-Cuesta. [2a ed., rev.]. San Juan: Ediciones Puerto; 1974. 394 pp.

4506. *Intervention and Dollar Diplomacy in the Caribbean, 1900–1921*. Dana Gardner Munro. Westport, CT: Greenwood Press; 1980. 553 pp. Reprint of the 1964 ed.

4507. *Intervention and Negotiation: The United States and the Dominican Revolution*. Jerome Slater. New York, NY: Harper and Row; 1970. 254 pp.

4508. *Intervention in the Caribbean: The Dominican Crisis of 1965*. Bruce Palmer. Lexington, KY: University Press of Kentucky; 1989. 226 pp.

4509. *Military Crisis Management: U.S. Intervention in the Dominican Republic, 1965*. Herbert G. Schoonmaker. Westport, CT: Greenwood Press; 1990. 152 pp.

4510. *De Nederlandse Antillen en de Verenigde Staten van Amerika [The Netherlands Antilles and the United States of America]*. Johannes Hartog. Zutphen: Walburg Pers; 1983. 64 pp.

4511. *On Negotiating with Cuba*. Roger W. Fontaine. Washington, DC: American Enterprise Institute for Public Policy Research; 1975. 99 pp.

4512. *On the Brink: Americans and Soviets Reexamine the Cuban Missile Crisis*. James G. Blight, David A. Welch. New York, NY: Hill and Wang; 1989. 400 pp.

4513. *Puerto Rican Politics and the New Deal*. Thomas G. Mathews. New York, NY: Da Capo Press; 1976. 345 pp. Reprint of the 1960 ed.

4514. *The Puerto Rican Question*. Jorge Heine, Juan M. García-Passalacqua. New York, NY: Foreign Policy Association; 1983. 72 pp.

4515. *Puerto Rico and the United States: The Quest for a New Encounter*. Arturo Morales Carrión. San Juan: Editorial Académica; 1990. 123 pp.

4516. *Puerto Rico: A Colonial Experiment*. Raymond Carr. New York, NY: New York University Press; 1984. 477 pp.

4517. *Puerto Rico: The Search for a National Policy*. Richard J. Bloomfield, ed. Boulder, CO: Westview Press; 1985. 192 pp.

4518. *Relaciones entre los Estados Unidos y Puerto Rico; documentos básicos*. Roland I. Perusse, ed. 2a ed. Hato Rey, P.R.: Editorial Instituto Interamericano; 1987. 251 pp.

4519. *Response to Revolution: The United States and the Cuban Revolution, 1959–1961*. Richard E. Welch. Chapel Hill, NC: University of North Carolina Press; 1985. 243 pp.

4520. *Roosevelt and Batista: Good Neighbor Diplomacy in Cuba, 1933–1945*. Irwin F. Gellman. Albuquerque, NM: University of New Mexico Press; 1973. 303 pp.

4521. *Roosevelt and the Caribbean*. Howard Copeland Hill. New York, NY: Russell and Russell; 1965. 232 pp. Reprint of the 1927 ed.

4522. *Semper Fidel: America and Cuba, 1776–1988.* Michael J. Mazarr. Baltimore, MD: Nautical and Aviation Publishing Co.; 1988. 521 pp.

4523. *The Shattered Crystal Ball: Fear and Learning in the Cuban Missile Crisis.* James G. Blight. Savage, MD: Rowman and Littlefield; 1990. 199 pp.

4524. *Solidarity and Responsibilities of the United States in the Belize Case.* Virgilio Rodríguez Beteta; Walter A. Payne, tr. Guatemala City : Tip. Nacional; 1965. 137 pp.

4525. *The Southern Dream of a Caribbean Empire, 1854–1861.* Robert E. May. Athens, GA: University of Georgia Press; 1989. 304 pp. Reprint of the 1973 ed.

4526. *Struggle for the American Mediterranean: United States–European Rivalry in the Gulf-Caribbean, 1776–1904.* Lester D. Langley. Athens, GA: University of Georgia Press; 1976. 226 pp.

4527. *Subject to Solution: Problems in Cuban–U.S. Relations.* Wayne S. Smith, Esteban Morales Domínguez, eds. Boulder, CO: L. Rienner; 1988. 158 pp.

4528. *Theodore Roosevelt's Caribbean: The Panama Canal, the Monroe Doctrine, and the Latin American Context.* Richard H. Collin. Baton Rouge, LA: Louisiana State University Press; 1990. 598 pp.

4529. *Time for Decision: The United States and Puerto Rico.* Jorge Heine, ed. Lanham, MD: North-South Publishing; 1983. 302 pp.

4530. *To Speak the Truth: Why Washington's "Cold War" Against Cuba Doesn't End.* Fidel Castro, Ernesto Che Guevara. [New ed.] New York, NY: Pathfinder Press; 1992. 232 pp.

4531. *U.S. Foreign Policy in the Caribbean, Cuba, and Central America.* James N. Cortada, James W. Cortada. New York, NY: Praeger; 1985. 251 pp.

4532. *U.S. Interests and Policies in the Caribbean and Central America.* Jorge I. Domínguez. Washington, DC: American Enterprise Institute for Public Policy Research; 1982. 55 pp.

4533. *U.S. Policy in the Caribbean.* John Bartlow Martin. Boulder, CO: Westview Press; 1978. 420 pp.

4534. *U.S.–Cuban Relations in the 1990's.* Jorge I. Domínguez, Rafael Hernández, eds. Boulder, CO: Westview Press; 1989. 324 pp.

4535. *Under the Eagle: U.S. Intervention in Central America and the Caribbean.* Jenny Pearce. Boston, MA: South End Press; 1982. 295 pp.

4536. *The United States and Cuba: Hegemony and Dependent Development, 1880–1934.* Jules Robert Benjamin. Pittsburgh, PA: University of Pittsburgh Press; 1977. 266 pp.

4537. *The United States and Cuba: Business and Diplomacy, 1917–1960.* Robert Freeman Smith. New York, NY: Bookman Associates; 1962. 256 pp. Reprint of the 1960 ed.

4538. *The United States and Cuba: A Study in International Relations.* Harry Frank Guggenheim. New York, NY: Arno Press; 1970. 268 pp. Reprint of the 1934 ed.

4539. *The United States and Porto Rico.* Leo Stanton Rowe. New York, NY: Arno Press; 1975. 271 pp. Reprint of the 1904 ed.

4540. *The United States and Puerto Rico: Decolonization Options and Prospects.* Roland I. Perusse. Lanham, MD: University Press of America; 1987. 177 pp.

4541. *The United States and Santo Domingo, 1798–1873: A Chapter in Caribbean Diplomacy.* Charles Callan Tansill. Gloucester, MA: P. Smith; 1967. 487 pp. Reprint of the 1938 ed.

4542. *The United States and the Caribbean.* Chester Lloyd Jones, Henry Kittredge Norton, Parker Thomas Moon. Chicago, IL: University of Chicago Press; 1929. 229 pp.

4543. *The United States and the Caribbean Area.* Dana Gardner Munro. New York, NY: Johnson Reprint Corp.; 1966. 316 pp. Reprint of the 1934 ed.

4544. *The United States and the Caribbean.* Dexter Perkins. Rev. ed. Cambridge, MA: Harvard University Press; 1966. 197 pp.

4545. *The United States and the Caribbean.* Tad Szulc, ed. Englewood Cliffs, NJ: Prentice-Hall; 1971. 212 pp.

4546. *The United States and the Trujillo Regime.* G. Pope Atkins, Larman Curtis Wilson. New Brunswick, NJ: Rutgers University Press; 1971. 245 pp.

4547. *The United States and the Caribbean Republics, 1921–1933.* Dana Gardner Munro. Princeton, NJ: Princeton University Press; 1974. 394 pp.

4548. *The United States and the Development of the Puerto Rican Status Question, 1936–1968.* Surendra Bhana. Lawrence, KS: University Press of Kansas; 1975. 290 pp.

4549. *The United States and the Caribbean in the Twentieth Century.* Lester D. Langley. 4th ed. Athens, GA: University of Georgia Press; 1989. 341 pp. First ed. has title *The United States and the Caribbean, 1900–1970.*

4550. *The United States and the Origins of the Cuban Revolution: An Empire of Liberty in an Age of National Liberation.* Jules Robert Benjamin. Princeton, NJ: Princeton University Press; 1990. 235 pp.

4551. *The United States in Cuba, 1898–1902: Generals, Politicians, and the Search for Policy.* David F. Healy. Madison, WI: University of Wisconsin Press; 1963. 260 pp.

4552. *The United States in Puerto Rico, 1898–1900.* Edward Joseph Berbusse. Chapel Hill, NC: University of North Carolina Press; 1966. 274 pp.

4553. *The United States, Cuba, and Castro: An Essay on the Dynamics of Revolution and the Dissolution of Empire.* William Appleman Williams. New York, NY: Monthly Review Press; 1962. 179 pp.

4554. *The United States, Cuba, and the Cold War: American Failure or Communist Conspiracy?* Lester D. Langley, ed. Lexington, MA: D. C. Heath; 1970. 106 pp.

4555. *An Unwanted War: The Diplomacy of the United States and Spain over Cuba, 1895–1898.* John L. Offner. Chapel Hill, NC: University of North Carolina Press; 1992. 306 pp.

4556. *Western Interests and U.S. Policy Options in the Caribbean Basin: Report of the Atlantic Council's Working Group on the Caribbean Basin.* James R. Greene, Brent Scowcroft, eds. Boston, MA: Oelgeschlager, Gunn and Hain; 1984. 331 pp.

4557. *What Happened in Cuba? A Documentary History.* Robert Freeman Smith. New York, NY: Twayne; 1963. 360 pp.

4558. *Whirlpool: U.S. Foreign Policy Toward Latin America and the Caribbean.* Robert A. Pastor. Princeton, NJ: Princeton University Press; 1992. 338 pp.

4. EMIGRATION AND IMMIGRATION

4559. *Between Two Islands: Dominican International Migration.* Sherri Grasmuck, Patricia R. Pessar. Berkeley, CA: University of California Press; 1991. 247 pp.

4560. *The Caribbean Exodus.* Barry B. Levine, ed. New York, NY: Praeger; 1987. 293 pp.

4561. *Caribbean Migrants: Environment and Human Survival on St. Kitts and Nevis.* Bonham C. Richardson. Knoxville, TN: University of Tennessee Press; 1983. 207 pp.

4562. *Determinants of Emigration from Mexico, Central America, and the Caribbean.* Sergio Díaz-Briquets, Sidney Weintraub, eds. Boulder, CO: Westview Press; 1991. 356 pp.

4563. *Los dominicanos en Puerto Rico: migración en la semi-periferia.* Jorge Duany, ed. Río Piedras, P.R.: Ediciones Huracán; 1990. 132 pp.

4564. *Las emigraciones dominicanas a Cuba, 1795–1808.* Carlos Esteban Deive. Santo Domingo: Fundación Cultural Dominicana; 1989. 159 pp.

4565. *The "Haitian Problem": Illegal Migration to the Bahamas.* Dawn I. Marshall. Mona, Jamaica: Institute of Social and Economic Research, University of the West Indies; 1979. 239 pp.

4566. *Immigration into the West Indies in the Nineteenth Century.* K. O. Laurence. Bridgetown: Caribbean Universities Press; 1982. 79 pp. Reprint of the 1971 ed.

4567. *In Search of a Better Life: Perspectives on Migration from the Caribbean.* Ransford W. Palmer, ed. New York, NY: Praeger; 1990. 185 pp.

4568. *Inmigración y clases sociales en el Puerto Rico del siglo XIX*. Francisco Antonio Scarano, ed. Río Piedras, P.R.: Ediciones Huracán; 1981. 208 pp.

4569. *Los inmigrantes indocumentados dominicanos en Puerto Rico: realidad y mitos*. Juan E. Hernández-Cruz, ed. San Germán, P.R.: Centro de Publicaciones, Universidad Interamericana de Puerto Rico; 1989. 96 pp.

4570. *The Making of a Transnational Community: Migration, Development, and Cultural Change in the Dominican Republic*. Eugenia Georges. New York, NY: Columbia University Press; 1990. 270 pp.

4571. *Migración caribeña y un capítulo haitiano*. Ramón Antonio Veras. Santo Domingo: Editora Taller; 1985. 286 pp.

4572. *Migration and Development in the Caribbean: The Unexplored Connection*. Robert A. Pastor, ed. Boulder, CO: Westview Press; 1985. 455 pp.

4573. *Migration from the Caribbean Region: Determinants and Effects of Current Movements*. Elsa M. Chaney. Washington, DC: Center for Immigration Policy and Refugee Assistance, Georgetown University; 1985. 144 pp.

4574. *Population Movements in the Caribbean*. Malcolm Jarvis Proudfoot. New York, NY: Negro Universities Press; 1970. 187 pp. Reprint of the 1950 ed.

4575. *The Puerto Rican Migrant in St. Croix*. Clarence Ollson Senior. Río Piedras, P.R.: Social Science Research Center, University of Puerto Rico; 1947. 56 pp.

4576. *Puerto Rican Poverty and Migration: We Just Had to Try Elsewhere*. Julio Morales. New York, NY: Praeger; 1986. 253 pp.

4577. *Return Migration and Remittances: Developing a Caribbean Perspective*. William F. Stinner, Klaus De Albuquerque, Roy S. Bryce-Laporte, eds. Washington, DC: Research Institute on Immigration and Ethnic Studies, Smithsonian Institution; 1982. 322 pp.

4578. *Return Migration to Puerto Rico*. José Hernández Alvarez. Westport, CT: Greenwood Press; 1976. 153 pp. Reprint of the 1967 ed.

4579. *The Silver Men: West Indian Labour Migration to Panama, 1850–1914*. Velma Newton. Mona, Jamaica: Institute of Social and Economic Research, University of the West Indies; 1984. 218 pp.

4580. *Small Country Development and International Labor Flows: Experiences in the Caribbean*. Anthony P. Maingot, ed. Boulder, CO: Westview Press; 1991. 266 pp.

4581. *Sources for the Study of Puerto Rican Migration, 1879–1930*. Centro de Estudios Puertorriqueños (New York, NY). New York, NY: El Centro; 1982. 224 pp.

4582. *West Indian Migrants: Social and Economic Facts of Migration from the West Indies*. Robert Barry Davison. New York, NY: Oxford University Press; 1962. 89 pp.

4583. *West Indian Migration to Great Britain: A Social Geography.* Ceri Peach. New York, NY: Oxford University Press; 1968. 122 pp.

4584. *West Indian Migration: The Montserrat Case.* Stuart B. Philpott. New York, NY: Humanities Press; 1973. 210 pp.

4585. *White Collar Migrants in the Americas and the Caribbean.* Arnaud F. Marks, Hebe M. C. Vessuri, eds. Leiden: Caraïbische Afdeling, Koninklijk Instituut voor Taal-, Land- en Volkenkunde; 1983. 254 pp.

5. SPECIAL TOPIC: THE MILITARY

4586. *América Latina y el Caribe en el mundo militar.* Isaac Caro. Santiago, Chile: Facultad Latinoamericana de Ciencias Sociales (FLACSO); 1988. 245 pp.

4587. *Armée et politique en Haïti.* Kern Delince. Paris: L'Harmattan; 1979. 271 pp.

4588. *Army Politics in Cuba, 1898–1958.* Louis A. Pérez. Pittsburgh, PA: University of Pittsburgh Press; 1976. 240 pp.

4589. *Caribbean Basin Security.* Thomas H. Moorer, Georges A. Fauriol. New York, NY: Praeger; 1984. 108 pp.

4590. *Cuba and the Revolutionary Myth: The Political Education of the Cuban Rebel Army, 1953–1963.* C. Fred Judson. Boulder, CO: Westview Press; 1984. 294 pp.

4591. *The Cuban Military Under Castro.* Jaime Suchlicki, ed. Coral Gables, FL: Institute of Interamerican Studies, University of Miami; 1989. 197 pp.

4592. *La estrategia de Estados Unidos y la militarización del Caribe: ensayo sobre el desarrollo histórico de las fuerzas de seguridad y la presencia militar de Estados Unidos en el Caribe angloparlante.* Humberto García Muñíz. Río Piedras, P.R.: Instituto de Estudios del Caribe, Universidad de Puerto Rico; 1988. 361 pp.

4593. *The Evolution of the Cuban Military, 1492–1986.* Rafael Fermoselle. Miami, FL: Ediciones Universal; 1987. 585 pp.

4594. *Las Fuerzas Armadas y la política dominicana.* Marcos Rivera Cuesta. Santo Domingo: Tall. de Artes Gráficas; 1986. 529 pp.

4595. *Het legergroene Suriname [Military-Green Suriname].* Elma Verhey, Gerard van Westerloo. Amsterdam: Weekbladpers; 1983. 189 pp.

4596. *Militarization in the Non-Hispanic Caribbean.* Alma H. Young, Dion E. Phillips, eds. Boulder, CO: L. Rienner; 1986. 178 pp.

4597. *Política militar y dominación: Puerto Rico en el contexto latinoamericano.* Jorge Rodríguez Beruff. Río Piedras, P.R.: Ediciones Huracán; 1988. 270 pp.

4598. *Strategy and Security in the Caribbean.* Ivelaw L. Griffith, ed. New York, NY: Praeger; 1991. 208 pp.

4599. *Temas sobre la profesionalización militar en la República Dominicana.* José Miguel Soto Jiménez. 2a ed. Santo Domingo: Editora Corripio; 1983. 148 pp.

4600. *The United States-Caribbean Basin Military Connection: A Perspective on Regional Military-to-Military Relationships.* Curtis S. Morris. Washington, DC: American Enterprise Institute for Public Policy Research; 1983. 80 pp.

GEOGRAPHICAL INDEX

3190, 3216, 3229, 3248, 3252, 3261,
3263, 3280, 3299, 3308, 3309, 3311,
3332, 3388, 3398, 3402, 3403, 3404,
3405, 3419, 3435, 3466, 3490, 3495,
3496, 3522, 3532, 3534, 3558, 3650,
3690, 3710, 3738, 3739, 3740, 3762,
3767, 3768, 3772, 3833, 3842, 3843,
3876, 3899, 3906, 3907, 3909, 3948,
3953, 3970, 3999, 4024, 4031, 4037,
4041, 4058, 4061, 4139, 4202, 4203,
4206, 4208, 4209, 4241, 4276, 4281,
4299, 4328, 4343, 4356, 4370, 4380,
4424, 4425, 4427, 4440, 4456, 4457,
4486, 4487, 4488, 4502, 4507, 4508,
4509, 4541, 4546, 4559, 4563, 4564,
4569, 4570, 4594, 4599
See also Hispaniola
Dutch Guiana. *See* Suriname

French Guiana 1004, 1005, 1014, 1020,
1070, 1188, 1283, 1415, 1496, 1775,
1792, 1806, 1810, 1815, 1839, 1845,
2204, 2248, 2312, 2316, 2324, 2326,
2340, 2370, 2586, 2615, 2920, 2957,
3001, 3016, 3257, 3259, 3346, 3416,
3418, 3426, 3527, 3583, 3619, 3583,
3619, 3811, 3831, 4044, 4056, 4234,
4300

Grenada 1040, 1363, 1364, 1365, 1586,
1731, 1746, 1756, 2415, 2446, 2486,
2590, 2636, 2738, 2846, 2906, 2908,
2910, 2948, 3052, 3053, 3117, 3202,
3255, 3413, 3536, 3658, 3709, 3718,
3745, 3746, 3747, 3748, 3749, 3750,
3751, 3752, 3780, 3790, 3839, 3946,
4142, 4174, 4226, 4227, 4243, 4259,
4302, 4304
Grenadines. *See* St. Vincent and the
Grenadines
Guadeloupe 1002, 1046, 1110, 1492,
1493, 1495, 1665, 1816, 1839, 1844,
1874, 1888, 1914, 2052, 2053, 2087,
2101, 2103, 2104, 2119, 2166, 2220,
2254, 2288, 2650, 3001, 3058, 3289,
3323, 3414, 3415, 3566, 3608, 3636,
3647, 3893, 3921, 4290
Guiana. *See* French Guiana; Guyana; Suri-
name
Guyana 1004, 1005, 1014, 1020, 1047,
1055, 1070, 1074, 1086, 1088, 1119,
1120, 1123, 1131, 1133, 1151, 1175,
1184, 1188, 1199, 1208, 1294, 1371,

1372, 1415, 1430, 1485, 1486, 1540,
1565, 1623, 1636, 1662, 1674, 1677,
1697, 1750, 1760, 1770, 1775, 1779,
1806, 1868, 1892, 1916, 1920, 2074,
2075, 2096, 2097, 2152, 2175, 2204,
2237, 2238, 2261, 2296, 2299, 2307,
2314, 2315, 2317, 2323, 2334, 2338,
2339, 2382, 2383, 2394, 2399, 2408,
2458, 2461, 2500, 2518, 2524, 2529,
2568, 2580, 2610, 2616, 2619, 2638,
2671, 2676, 2684, 2759, 2900, 2916,
2920, 3008, 3022, 3070, 3071, 3084,
3092, 3095, 3133, 3189, 3197, 3199,
3201, 3215, 3247, 3273, 3322, 3326,
3327, 3329, 3346, 3361, 3416, 3417,
3500, 3527, 3533, 3535, 3583, 3603,
3604, 3631, 3635, 3670, 3688, 3692,
3888, 3901, 3902, 3910, 3985, 4008,
4111, 4134, 4148, 4168, 4172, 4194,
4207, 4220, 4223, 4229, 4230, 4231,
4232, 4233, 4272, 4322, 4326, 4334,
4345, 4348, 4349, 4371, 4373, 4415,
4419, 4454

Haiti 1011, 1012, 1025, 1029, 1052,
1059, 1064, 1065, 1105, 1106, 1107,
1108, 1109, 1115, 1116, 1124, 1161,
1168, 1177, 1179, 1182, 1194, 1202,
1203, 1206, 1222, 1268, 1284, 1286,
1303, 1331, 1351, 1360, 1370, 1373,
1374, 1375, 1376, 1494, 1509, 1513,
1532, 1583, 1587, 1693, 1699, 1813,
1816, 1846, 1847, 1848, 1849, 1915,
1960, 1977, 1990, 1991, 1992, 1993,
1994, 1996, 1999, 2002, 2004, 2006,
2019, 2027, 2028, 2038, 2066, 2067,
2100, 2103, 2113, 2114, 2121, 2143,
2144, 2181, 2193, 2196, 2219, 2224,
2225, 2228, 2251, 2259, 2264, 2268,
2360, 2402, 2405, 2441, 2443, 2450,
2453, 2472, 2475, 2511, 2519, 2520,
2523, 2526, 2527, 2530, 2532, 2537,
2540, 2541, 2542, 2544, 2545, 2548,
2549, 2550, 2551, 2553, 2585, 2591,
2602, 2603, 2609, 2643, 2650, 2654,
2709, 2712, 2717, 2721, 2724, 2736,
2739, 2755, 2756, 2802, 2803, 2804,
2812, 2874, 2886, 2887, 2888, 2889,
2909, 2911, 2921, 2924, 2930, 2936,
2943, 2952, 3054, 3055, 3056, 3057,
3085, 3129, 3137, 3152, 3166, 3190,
3277, 3308, 3311, 3332, 3356, 3357,
3388, 3411, 3419, 3420, 3421, 3422,

AUTHOR INDEX

Fernández Font, Marcelo 3318
Fernández Marcané, Leonardo 3975
Fernández Méndez, Eugenio 2072,
 2110, 2118, 3384, 3427, 3437, 3539,
 3682
Fernández Robaina, Tomás 1257, 1260,
 1263, 2365
Fernández Vanga, Epifanio 3919
Fernós Isern, Antonio 4358
Ferrán, Fernando I. 3261
Ferré, Rosario 3955
Ferrer, Abelardo Morales. *See* Morales
 Ferrer, Abelardo
Ferrer, Fernando Callejo. *See* Callejo Fer-
 rer, Fernando
Ferrer Canales, José 2868
Ferreras, Ramón Alberto 2757
Ferrol, Orlando 3896
Feuer, Carl Henry 3325
Fick, Carolyn E. 3671
Fido, Elaine Savory 4060
Figarola, Joel James. *See* James Figarola,
 Joel
Figueras, Francisco 3612
Figueras, Myriam 1443, 1612
Figueredo, Alfredo E. 3993
Figueroa, John J. 2206, 2207, 3968
Figueroa, José Lloréns. See Lloréns
 Figueroa, José.
Figueroa, Loida 3657
Figueroa, J. Peter 4402
Figueroa, Peter M. E. 2207
Fillipis, Daisy Cocco-De. *See* Cocco-De-
 Fillipis, Daisy
Fink, L. K. 1422
Finlay, Barbara 2791
Firmat, Gustavo Pérez. *See* Pérez Firmat,
 Gustavo
Firth, Charles Harding 1156
Fisher, Lawrence E. 2435
Fisher, Richard S. 1188
Fisher, Stephen H. 2162
Fisher, Thomas 1159
Fisk, Erma J. 1764
Fiske, Amos Kidder 1218
Fitzgerald, Frank T. 3213
Fitzgibbon, Russell Humke 2819, 4473
Flannigan, Mrs. 1057
Fleagle, Fred K. 2630
Fleischmann, Ulrich 2084, 2694, 3913
Fletcher, Richard D. 4157
Fleury, Víctor 2811
Florén Lozano, Luis 1259

Flores, Fay Fowlie-. *See* Fowlie-Flores,
 Fay
Flores Santana, Juan Antonio 2487
Flowers, Helen Leneva 2221
Floyd, Barry 1863
Floyd, Troy S. 3607
Fock, Niels 2339
Fog Olwig, Karen. *See* Olwig, Karen Fog
Follett, Helen 1858
Foner, Nancy 2208
Foner, Philip Sheldon 2798, 2913, 3702,
 4501
Fonfrías, Ernesto Juan 2707, 3897
Font, Marcelo Fernández. *See* Fernández
 Font, Marcelo
Fontaine, Roger W. 4447, 4511
Forbes, Rosita Torr 3480
Ford, Jeremiah D. M. 1291
Forde, Norma Monica 2785
Fornet, Ambrosio 3951
Fort, Gilberto V. 1344
Fortuné, Roger 1843
Fortune, Stephen Alexander 3172
Foster, Byron 2325
Foster, Charles Robert 3420
Foster, David William 1343, 1418
Foster, Phillips Wayne 2949
Fouchard, Jean 2066, 3843, 3930
Fouck, Serge Mam-Lam-. *See* Mam-Lam-
 Fouck, Serge
Fougeyrollas, Claudie Beauvue-. *See*
 Beauvue-Fougeyrollas, Claudie
Fowler, Carolyn 4109
Fowler, Frank 1697
Fowler, Henry 1154
Fowlie-Flores, Fay 1230, 1379
Fox, Annette Baker 4221
Fraginals, Manuel Moreno. *See* Moreno
 Fraginals, Manuel
Francis, Laurel B. 4338
Francis, Oswald 4245
Franciscus, John Allen 1991
Francisque, Edouard 3129
Franck, Harry Alverson 1897
Franco, Franklin J. 2369, 3740
Franco, José Luciano 4336
Franco, Julio Brea. *See* Brea Franco, Julio
Franco, Rolando 2607
Franco, Tomás Rafael Hernández. *See*
 Hernández Franco, Tomás Rafael
Frank, Waldo David 3392
Frankel, Michael L. 1802
Frankenhoff, Charles A. 2581

Merrill, Gordon Clark 3439
Merriman, Stella E. 1326
Mesa, Rosa Quintero. *See* Quintero Mesa,
 Rosa
Mesa-Lago, Carmelo 2445, 3037, 3115,
 3130, 3205, 3207, 4406, 4407
Meselson, Sarah 1577
Metcalf, George 4307
Métellus, Jean 2114
Métral, Antoine 1109
Métraux, Alfred 1848, 2551
Meyerhoff, Howard Augustus 1695
Michel, Emilio Cordero. *See* Cordero
 Michel, Emilio
Middeldyk, Rudolph Adams van. *See* Van
 Middeldyk, Rudolph Adams
Milacic, S. 1425
Milanich, Jerald T. 3640
Milbrath, Susan 3640
Miles, William F. S. 4215
Millás, José Carlos 1667
Miller, Errol 2173, 2174, 2188, 2197
Miller, Jeannette 1995
Miller, Tom 1907
Miller, Warren 1882
Millet, José 2546
Millett, Allan Reed 3774
Millett, Richard 4441
Millette, James 3697
Mills, Charles Wright 3764
Mills, Don 3173
Mills, Frank L. 2702
Mills, Gladstone E. 1599
Millspaugh, Arthur Chester 3756
Mimó, Félix Goizueta-. *See* Goizueta-
 Mimó, Félix
Mims, Stewart Lea 3160
Minà, Gianni 2818
Minc, Rose S. 4055
Mintz, Sidney Wilfred 2076, 2139,
 2343, 2563, 2654, 3241
Mitchell, Carleton 1859, 1862
Mitchell, Carlyle L. 1746
Mitchell, David 2132
Mitchell, Harold Paton 2971, 2987,
 4217
Mitchell, James F. 4155
Mitchell, William Burton 1540
Mitrasing, Frits Eduard Mangal 2311
Mock, Bernd H. 1713
Moerland, J. 3511
Mohammed, Patricia 2754
Moister, William 1215

Molen van Ee, Patricia. *See* Van Ee, Patri-
 cia Molen
Molenaar, Ruth 2876
Molinaza, José 4037
Moll, Verna Penn 1451
Momsen, Janet 2928
Monclova, Lidio Cruz. *See* Cruz Mon-
 clova, Lidio
Mondesir, Jones E. 1489
Monge, José Trías. *See* Trías Monge, José
Montague, Ludweel Lee 4498
Montalván, George P. 3176
Montalvo, María de las Mercedes Santa
 Cruz y, comtesse de Merlin *See* Mer-
 lin, María de las Mercedes Santa Cruz y
 Montalvo, comtesse de
Montaner, Carlos Alberto 3725, 3742
Montás, Eugenio Pérez. *See* Pérez Mon-
 tás, Eugenio
Montas, Michèle 1847
Montbrand, Danièle 1493
Montbrun, Christian 3566
Montejo, Esteban 3802
Montero, Aníbal Díaz. *See* Díaz Montero,
 Aníbal
Montilla, Aida Negrón de. *See* Negrón de
 Montilla, Aida
Moon, Parker Thomas 4542
Moore, Brian L. 2616
Moore, Carlos 2809
Moore, O. Ernest 3055
Moore, Ruth S. 1988
Moorer, Thomas 4589
Moorhead, Mario C. 3072
Moral, Paul 2603
Morales, Antonio Bachiller y. *See*
 Bachiller y Morales, Antonio
Morales, Humberto López. *See* López
 Morales, Humberto
Morales, Jorge Luis 3999
Morales, Julio 4576
Morales Carrión, Arturo 3486, 3683,
 3801, 4515
Morales Domínguez, Esteban 4527
Morales Ferrer, Abelardo 1270
Morales Padrón, Francisco 3663
Morán, Sarah Díez de. *See* Díez de
 Morán, Sarah
Morán Arce, Lucas 1498, 1529, 2878,
 3433
Mordecai, John 4218
Mordecai, Pamela 3982, 3986, 3991
Moré, Gustavo Luis 1398

TITLE INDEX

ABOUT THE AUTHOR

MARIAN GOSLINGA is the Latin American and Caribbean Librarian at Florida International University. She was born in Rotterdam, Netherlands, and has lived in Curaçao (Netherlands Antilles), Venezuela, and Mexico before coming to the USA. She has a B.A. in International Relations from the University of the Americas (Mexico), an M.A. in Latin American History and an M.L.S., both from the University of California (Berkeley). Ms. Goslinga has done extensive research on the Caribbean and was the bibliographer for *Caribbean Review* from 1979 to 1988. Since 1988 she has been the bibliographer for *Hemisphere*. She is a regular contributor to the *Hispanic American Periodicals Index* (HAPI). She has also written several book reviews and articles for the *European Review of Latin American and Caribbean Studies,* the *New West Indian Guide,* and the *Inter-American Review of Bibliography*. Her *Women in the Caribbean* was published as Dialogue No. 134 in the Occasional Paper series of the Latin American Center, Florida International University. She is an active member of SALALM (Seminar on the Acquisition of Latin American Library Materials) and ACURIL (Association of Caribbean University and Research Libraries).

DATE DUE